PAINTING OF THE

BAROQUE

EPOCHS & STYLES

PAINTING OF THE
BAROQUE

Edited by
Ingo F. Walther

by Andreas Prater
and Hermann Bauer

TASCHEN

KÖLN LISBOA LONDON NEW YORK PARIS TOKYO

**This book was printed on 100% chlorine-free
bleached paper in accordance with the TCF standard.**

© 1997 Benedikt Taschen Verlag GmbH
Hohenzollernring 53, D-50672 Köln
Editing and production: Ingo F. Walther, Alling
Cover design: Angelika Taschen, Köln;
Mark Thomson, London
English translation: Ishbel Flett, Frankfurt/Main;
Gisela Parker, Twickenham

Printed in Portugal
ISBN 3–8228–8253–4
GB

Contents

BAROQUE

INTRODUCTION 9 The painting of the 17th century in Italy, France, England, Germany and Spain

ITALY

Annibale Carracci	27	The Beaneater
	27	"Domine, quo vadis?" (Christ Appearing to St Peter on the Appian Way)
	28	The Martyrdom of St Stephen
	28	The Lamentation of Christ
	29	Triumph of Bacchus and Ariadne
Orazio Gentileschi	30	The Lute Player
Caravaggio	30	Basket of Fruit
	31	The Fortune Teller (La Zingara)
	31	The Supper at Emmaus
	32	Bacchus
	33	The Crucifixion of St Peter
	33	The Entombment
Guido Reni	34	The Massacre of the Innocents
	34	The Baptism of Christ
Cristofano Allori	35	Judith with the Head of Holofernes
Francesco Albani	35	Sacra Famiglia (The Holy Family)
Domenichino	36	The Maiden and the Unicorn
Bernardo Strozzi	36	Vanitas Allegory
Giovanni Lanfranco	37	Hagar in the Wilderness
Domenico Fetti	37	Melancholy
Guercino	38	The Return of the Prodigal Son
Pietro da Cortona	38	Holy Family Resting on the Flight to Egypt
Mattia Preti	39	The Tribute Money
Salvator Rosa	39	Democritus in Meditation
Evaristo Baschenis	40	Still Life with Musical Instruments
Luca Giordano	40	The Fall of the Rebel Angels
Baciccio	41	The Apotheosis of St Ignatius
Giuseppe Maria Crespi	41	The Flea

FRANCE

Quentin Varin	42	Presentation of Christ in the Temple
Simon Vouet	42	Saturn, Conquered by Amor, Venus and Hope
Louis Le Nain	43	La Charette (The Cart)
	43	Peasants at their Cottage Door
Georges de La Tour	44	Hurdy-Gurdy Player
	44	The Card-Sharp with the Ace of Spades
	45	St Sebastian Attended by St Irene
Valentin de Boulogne	46	The Concert
Lubin Baugin	46	Still Life with Chessboard (The Five Senses)
Nicolas Poussin	47	Midas and Bacchus
	47	Landscape with Three Men
	48	Echo and Narcissus
	48	Moses Trampling on Pharaoh's Crown
	49	St Cecilia
Claude Lorrain	50	Landscape with Cephalus and Procris Reunited by Diana
	50	Landscape with Apollo and Mercury
	51	Seaport at Sunrise

Philippe de Champaigne	52	Ex Voto (Mother Superior Catherine-Agnès Arnauld and Sister Catherine de Sainte-Suzanne, the Daughter of the Artist)
Gaspard Dughet	52	Landscape with St Augustine and the Mystery of the Trinity
Sébastien Bourdon	53	The Finding of Moses
Pierre Mignard	53	Girl Blowing Soap Bubbles (Marie-Anne de Bourbon)
Charles Le Brun	54	The Martyrdom of St John the Evangelist at the Porta Latina
	54	Chancellor Séguier at the Entry of Louis XIV into Paris in 1660
Eustache Le Sueur	55	Melpomene, Erato and Polymnia
Hyacinthe Rigaud	55	Portrait of Louis XIV

ENGLAND

| Nicholas Hilliard | 56 | Portrait of George Clifford, Earl of Cumberland |
| Peter Lely | 56 | Henrietta Maria of France, Queen of England |

GERMANY

Adam Elsheimer	57	The Glorification of the Cross
	57	The Flight to Egypt
Georg Flegel	58	Still Life
Johann Liss	58	The Death of Cleopatra
Johann Heinrich Schönfeld	59	Il Tempo (Chronos)
Joachim von Sandrart	59	November
Johann Carl Loth	60	Mercury Piping to Argus
Johann Michael Rottmayr	60	St Benno

SPAIN

Juan Sánchez Cotán	61	Still Life (Quince, Cabbage, Melon and Cucumber)
Jusepe de Ribera	61	The Boy with the Clubfoot
	62	Archimedes
	62	Martyrdom of St Bartholomew
	63	St Christopher
Francisco de Zurbarán	64	The Death of St Bonaventura
	64	St Hugo of Grenoble in the Carthusian Refectory
	65	St Margaret
	66	The Ecstacy of St Francis
	66	Still Life with Lemons, Oranges and Rose
Alonso Cano	67	St Isidore and the Miracle of the Well
Bartolomé Esteban Murillo	67	Annunciation
	68	La Immaculada
	68	The Toilette
	69	The Little Fruit Seller
Juan de Valdés Leal	70	Allegory of Death
Claudio Coello	70	King Charles II
Diego Velázquez	71	Christ in the House of Martha and Mary
	71	Los Borrachos (The Drinkers)
	72	The Surrender of Breda
	72	Prince Balthasar Carlos, Equestrian
	73	A Dwarf Sitting on the Floor (Don Sebastián de Morra)
	74	Venus at her Mirror (The Rokeby Venus)
	74	Las Meninas (The Maids of Honour)

BAROQUE IN THE NETHERLANDS

INTRODUCTION 75 Dutch and Flemish painting in the 17th century

Abraham Bloemaert 93 Landscape with Peasants Resting
Joos de Momper 93 Winter Landscape
Jan Brueghel the Elder 94 Great Fish-Market
 94 Landscape with Windmills
 95 The Holy Family
Peter Paul Rubens 96 The Four Philosophers (Self-portrait with the Artist's Brother Philipp, Justus Lipsius and Johannes Wouverius)
 96 Stormy Landscape with Philemon and Baucis
 97 Rubens with his first Wife Isabella Brant in the Honeysuckle Bower
 98 The Landing of Marie de' Médici at Marseilles
 98 The Rape of the Daughters of Leucippus
 99 Hippopotamus and Crocodile Hunt
 100 The Three Graces
Pieter Lastman 100 Odysseus and Nausicaa
Frans Hals 101 Banquet of the Officers of the Saint George Civic Guard in Haarlem
 101 Young Man with a Skull (Vanitas)
 102 The Merry Drinker
 102 The Gypsy Girl
 103 Portrait of Willem van Heythuysen
 104 Regentesses of the Old Men's Almshouse in Haarlem
Dirck Hals 104 Merry Company
Roelant Savery 105 Landscape with Birds
Frans Snyders 105 Stil Life
Frans Francken the Younger 106 Supper at the House of Burgomaster Rockox
Cornelis de Vos 106 The Family of the Artist
Hendrik Avercamp 107 Winter Scene at Yselmuiden
Hendrick Terbrugghen 107 The Duo
Jacob Jordaens 108 Allegory of Fertility
 108 The Family of the Artist
 109 The Satyr and the Farmer's Family
Willem Claesz. Heda 110 Still Life
Gerrit van Honthorst 110 The Incredulity of St Thomas
Jan van Goyen 111 Landscape with Dunes
 111 River Landscape
Pieter Claesz. 112 Still Life with Musical Instruments
Thomas de Keyser 112 Equestrian Portrait of Pieter Schout
Anthony van Dyck 113 Susanna and the Elders
 113 St Martin Dividing his Cloak
 114 Portrait of Maria Louisa de Tassis
 114 The Count of Arundel and his Son Thomas
 115 Equestrian Portrait of Charles I
Salomon van Ruysdael 116 The Crossing at Nimwegen
Pieter Jansz. Saenredam 116 Church Interior in Utrecht
Adriaen Brouwer 117 The Operation
 117 Peasants Smoking and Drinking
Rembrandt Harmensz. van Rijn 118 The Artist in his Studio
 118 The Anatomy Lesson of Dr. Nicolaes Tulp
 119 The Night Watch (The Company of Captain Frans Banning Cocq and of Lieutnant Willem van Ruytenburch)
 120 Self-portrait aged 63
 121 The Descent from the Cross
 121 The Slaughtered Ox
 122 The Syndics of the Amsterdam Clothmakers' Guild (The Syndics)
 122 Aristotle Contemplating the Bust of Homer

Jan Davidsz. de Heem	123	Still Life
Judith Leyster	123	Carousing Couple
Jan Asselijn	124	Italian Landscape with the Ruins of a Roman Bridge and Aqueduct
Frans Post	124	Hacienda
Adriaen van Ostade	125	Peasants Carousing in a Tavern
David Teniers the Younger	125	Twelfth Night (The King Drinks)
Gerard Dou	126	The Dropsical Lady (The Doctor's Visit)
Emanuel de Witte	126	Church Interior
Gerard Terborch	127	The Card-Players
	127	The Letter
Philips Koninck	128	Village on a Hill
Willem Kalf	128	Still Life
Aelbert Cuyp	129	Rooster and Hens
Abraham van Beyeren	129	Still Life with Lobster
Carel Fabritius	130	The Goldfinch
Paulus Potter	130	Peasant Family with Animals
Jan Steen	131	The Lovesick Woman
	131	The World Upside Down
Jan van de Capelle	132	Shipping Scene with a Dutch Yacht Firing a Salute
Willem van de Velde the Younger	132	The Cannon Shot
Jacob van Ruisdael	133	Two Watermills and an Open Sluice near Singraven
Jan Siberechts	134	Landscape with Rainbow, Henley-on-Thames
Samuel van Hoogstraten	134	Still Life
Pieter de Hooch	135	A Woman and her Maid in a Courtyard
	135	The Card-Players
Frans van Mieris	136	Carousing Couple
Gabriel Metsu	136	The King Drinks (The Beanfeast)
Meindert Hobbema	137	Avenue at Middelharnis
Jan Vermeer	138	The Lacemaker
	138	Woman Holding a Balance
	139	View of Delft
	140	Allegory of Painting (The Artist's Studio)
	140	Young Woman Seated at a Virginal
BIOGRAPHIES	141	

Andreas Prater

BAROQUE

The painting of the 17th century in Italy, France, England, Germany and Spain

The age of the Baroque, between absolutism and the Enlightenment, is acknowledged as the last all-European style. Long regarded as merely an eccentric offshoot of the Renaissance, Baroque presents a complex and dynamic variety of form and expression in stark contrast to the controlled moderation of Neoclassicism.

Worldly joys and sensuality, religious spirituality and stringent asceticism, wide formal diversity and strict regulation all went hand in hand. At the same time, theatricality and stagelike settings entered the world of art with the advent of illusionism. Pageantry, pomp and courtly ceremony were not simply an expression of Baroque exuberance, but also an artistic device in the portrayal of crowd scenes.

In Rome, Caravaggio succeeded in achieving a decisive breakthrough with his dramatic use of chiaroscuro, while in Bologna it was the Carracci who established the Baroque style of painting. French art was dominated by the heroic landscapes of Poussin, the night pieces of La Tour, and Claude Lorrain's lyrical handling of light. In Spain, we find the warm colority of Murillo, the contemplative piety of Ribera and Zurbarán and the forcefully expressive court portraits by Velázquez, while Germany's contribution to Baroque painting reached its zenith in the delicate landscapes of Adam Elsheimer.

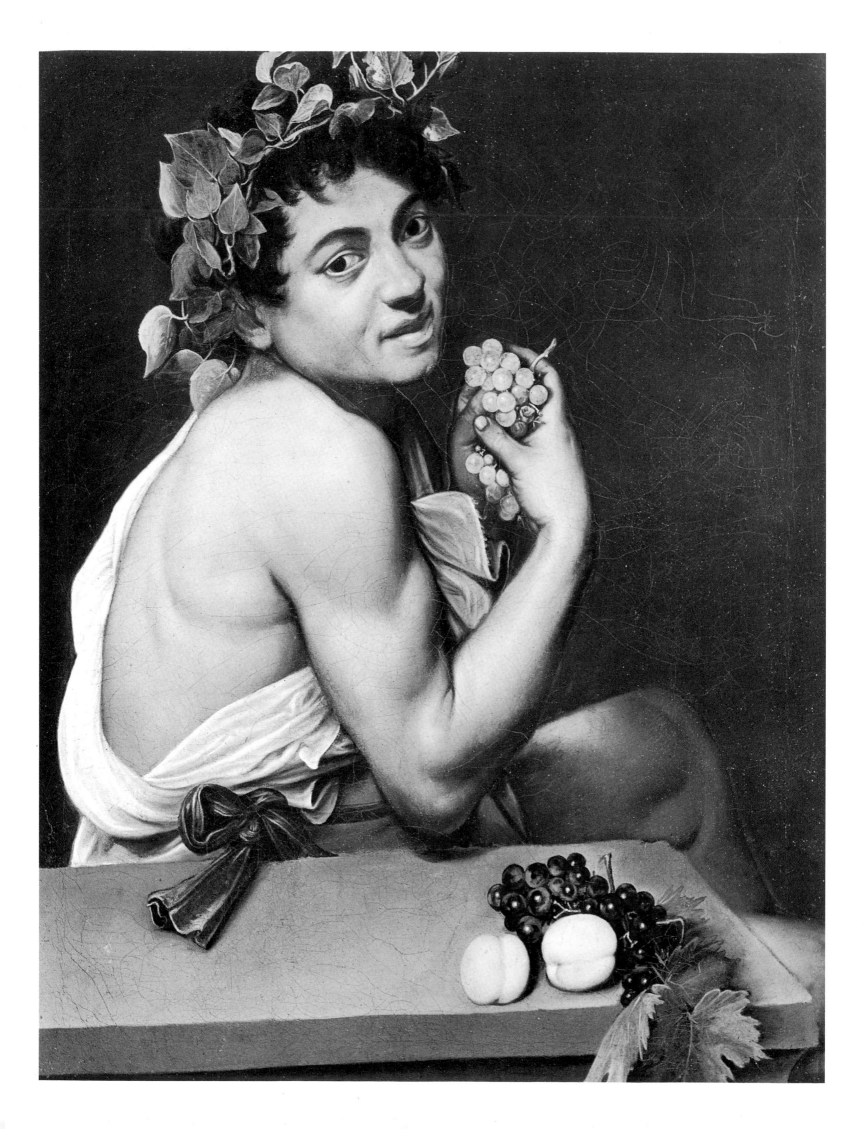

The naming of an era

No other period in the history of European art has proved so difficult to pin down in terms of academic and scholarly definition, in describing its characteristic phenomena, in specifying its time span and in exploring its spiritual and intellectual background. Ever since scholars turned their attention to the Baroque age a century ago, their research has been marked by contradiction and controversy to an extent paralleled only by Mannerism, itself a term coined at a fairly late stage in academic research in order to classify the transition between Renaissance and Baroque.

At the time, such questions of period and epoch were unknown, and the term "baroque" as we know it was unheard of. Neither the patrons nor the painters themselves, nor the theoreticians of art, of whom there were many, actually used this term to describe artistic procedures and achievements. Unlike Rococo, which adopted the expression *goût rococo* for itself, the style we wish to examine here was described, at most, by its contemporaries as *grand goût* in keeping with the absolutist world view of the 17th century and the patrons' desire for prestige and pomp. Only in the workshops and studios do we find the word "baroque" used to describe the curving lines of furniture and the dissolution of firm contours in painting. In the satirical and burlesque literature of Italy, we find the word "barocco" in use from around 1570 to describe an odd or witty idea.

It was the rationalist art critics of the mid-18th century who began employing the term to describe a style they saw as a florid, bizarre and thoroughly tasteless travesty of all the rules of art. Adherents of the new classicist doctrine were well aware of the key role played by certain masters of the previous era, amongst them Gianlorenzo Bernini (1598–1680), whom they held responsible for nothing less than a general decline in artistic standards – an evil whose roots they traced back to Michelangelo. By around the end of the 18th century and the beginning of the 19th, the term had already entered common usage in a thoroughly pejorative sense and, with that, its transformation from polemical insult to accepted stylistic epithet was virtually inevitable, following the same time-honoured pattern by which Gothic, to name but one other similar example, also became an accepted and neutral term. In fact, it was the avantgarde artists of the 19th century who eventually established a more positive attitude to what had hitherto been regarded as the "style of decadence". The works of Diego Velázquez (1599–1660), Peter Paul Rubens (1577–1640), Rembrandt (1606–1669) and Frans Hals (1591–1656) possessed specific painterly qualities in which the Impressionists, at any rate, took a keen interest.

Caravaggio
The Young Bacchus, c. 1591–1593
Oil on canvas, 66 x 53 cm
Rome, Galleria Borghese

The major monographic work on Diego Velázquez and his century published in Bonn in 1888 by the German art historian Carl Justi (1832–1912) applied a new approach to the era, seen through the eyes of a generation already influenced by the Impressionist sensitivity for light, colority and tone which had begun to permit a revaluation of the Baroque. The emergence of this more positive historical reception was to culminate in the work of the Swiss art historian Heinrich Wölfflin (1864–1945) and the Austrian art historian Alois Riegl (1858–1905), to name but two. Rome was designated the cradle and capital of Baroque and the stylistic characteristics of the period were distinguished systematically and normatively from those of the Renaissance.

Constant factors

Renaissance and Mannerism are widely regarded as the direct stylistic precursors of the Baroque. Indeed, there is much to be said for the art historical view that the period from the Early Renaissance of the 15th century through to the Neoclassicism of the late 18th century constituted a single and continuous cultural development. In terms of content and theme, there are a number of constant factors which, for all their modal and aesthetic differences, certainly indicate an undeniable homogeneity. The principle of illusionism, for instance, creating a sense of spatial expansion in which monumental mural and ceiling painting transcends the bounds of real architecture into illusory celestial realms, is just one example of a leitmotif that first emerged in the Early Renaissance and was then taken to its full artistic and theoretical flowering in Baroque art.

The theme of column orders, for example, dominated the formal architectural syntax of the day. Even such radical innovators as Michelangelo in the 16th century or Bernini and Francesco Borromini (1599–1667) in the 17th century merely elaborated on their stylistic potential without ever actually questioning the underlying principle. The same is true of the portrayal of ancient gods and mythological heroes in paintings that were neither objects of some neo-heathen worship nor purely decorative designs, but mythologically charged bearers of meaning capable of elevating a contemporary event to a higher plane of historical and mythological reality.

Other variables in painting include the use of chiaroscuro and the triad of cardinal colours, the juxtaposition of the primaries – red, yellow and blue – which are blended to create all other colours. As a counterpoint to this colorism, we find the non-coloured chiaroscuro with its extremes of black and white which modifies the palette of the artist to provide countless possibilities. The awareness that chiaroscuro provides a means of portraying light and darkness as elementary factors in the overall structure and texture of the painting rather than as a means of depicting specific lighting conditions is still relatively new at this stage.

A further constant factor is the use of allegory and, with that, the humanistic love of coded statements which were regarded as evidence of the potential significance inherent in all things as bearers of coded and decipherable messages. 15th century hieroglyphics, heraldry and Baroque iconology are all documented in an extraordinary wealth of publications, bearing witness to a profound belief in the fundamental kinship of word and image that forms the basis for an imperturbable faith in the universal legibility of all natural and man-made signs.

The ephemeral monument

These otherwise constant factors were to play a new and unique role in Baroque art, primarily because of the era's hitherto unparalleled capacity for synthesis which is so powerfully manifested in the Baroque "grand scheme" which not only sought a fusion of architecture, sculpture, painting and ornamentation such as we may find in churches and palaces, but also arranged festivities and celebrations to unite the arts in a spiritual and worldly ceremony, enriching them with music, poetry and dance. Today, all we tend to see of the Baroque grand scheme is the shell, magnificent as it may be, which served as a lavish setting for those temporary festivities that breathed life and cohesion into the *Gesamtkunstwerk* or total work of art. This pursuit of ceremony and ephemeral pageantry may be regarded as a specific characteristic of the Baroque era. The dynamic movement so frequently associated with Baroque art can be found in its exuberant facades and interiors, in the soaring figures that whirl through teeming ceiling paintings as though propelled by some supernatural force, and in the emotional expression of their faces and gestures; it is aimed at breaking down the contradiction between transience and permanence in a way that could be achieved only symbolically within the scope of pompous ceremony. No other era was so keenly aware of the fragility of earthly bonds. It is no coincidence that enormous intellectual and material investments were made time and time again in temporary structures, visual programmes and decorations for triumphal processions and ceremonies, *trionfi* and *entrées solennelles* as well as for the *castra doloris* structures built for funeral services.

This seeming paradox of what might best be described as "ephemeral monuments" reached its zenith in the Baroque love of firework displays. Unlike today's firework displays, these were distinctly pictorial, and their planners and designers enjoyed as much esteem as the best and most highly regarded artists. The people of the Baroque age would have made no distinction between "art" and the magnificent artifice of a firework display, for the purist 19th century notion of art that was to break the *Gesamtkunstwerk* down into its individual component parts was still a long way off.

New pictorial themes

Any attempt to determine the specific differences – apart from individual stylistic criteria – between Baroque art and the eras that went before it must take into account the great widening of thematic fields that occurred at that time. Unlike Mannerism, Baroque painting achieved some genuine innovations. The things that Baroque artists found worthy of portraying were no longer restricted to religious and secular history, portraiture and allegory – all of which focused on a classical concept of the liberty and greatness of man. The visual world of the Baroque explored new areas: apotheosis and state portrait, landscape, genre and still life, caricature and anamorphosis (deliberate distortion or elongation of figures).

None of these tasks was entirely new in itself, and all of them had forerunners. What was new, however, was that what had once been the extreme had now become the accepted form of an era. A common feature is that, although all are based retrospectively on the humanist visual concepts of the Renaissance with its anthropocentric principles, they nevertheless invariably point beyond these. For example, *The Apotheosis of St Ignatius* by Baciccio (1639–1709) is not so much a glorification of the saint himself as a glorification of the Jesuit order; and when Charles Le Brun (1619–1690) portrays chancellor Séguier in a ceremonial procession in the full regalia of his office, it is not the person of the chancellor who is manifested in this state portrait, but the concept of the absolutist state as such. The landscapes of Annibale Carracci (1560–1609) or Nicolas Poussin (c. 1593/94–1665) may not be entirely devoid of human life, but they are innovative in that they present a landscape untamed by human hand and one that seems to possess an independence and autonomy far beyond the scope of its pictorial role as the mere setting for an event. In many ways, the genre painting also goes beyond the boundaries of the individual. The art critics of the 19th century quite rightly referred to this as a "social portrait" and the findings of more recent art historiography confirm that interpretation in revealing the moral or universal significance behind the scenes of everyday life. The same applies to the highly popular still life painting which expressly excludes all human participation and whose frequently edifying significance is cloaked in a veritable cult of sensuality. The Renaissance notion of the great and beautiful human individual is decisively countered by the Baroque love of anamorphosis and caricature, whose "invention" and dissemination originated in the school of the Carracci. The comic and the ridiculous have remained a legitimate and inalienable aspect of art ever since.

Finally, there is a singular phenomenon of Italian and German Late Baroque that deserves mention here: the *bozzetto* as an independent work of art. A bozzetto is generally a small painting sketchily executed as a draft in preparation for a mural or ceiling painting and often used as the basis for a contract between patron and painter. One example of this is

Annibale Carracci
The Jealous Cyclops Polyphemus Hurls a Rock at Acis, the Beloved
of the Sea Nymph Galatea, c. 1595–1605. Fresco. Rome, Palazzo Farnese

Annibale Carracci
The Virgin Appears to SS Luke
and Catharine, 1592
Oil on canvas, 401 x 226 cm
Paris, Musée National du Louvre

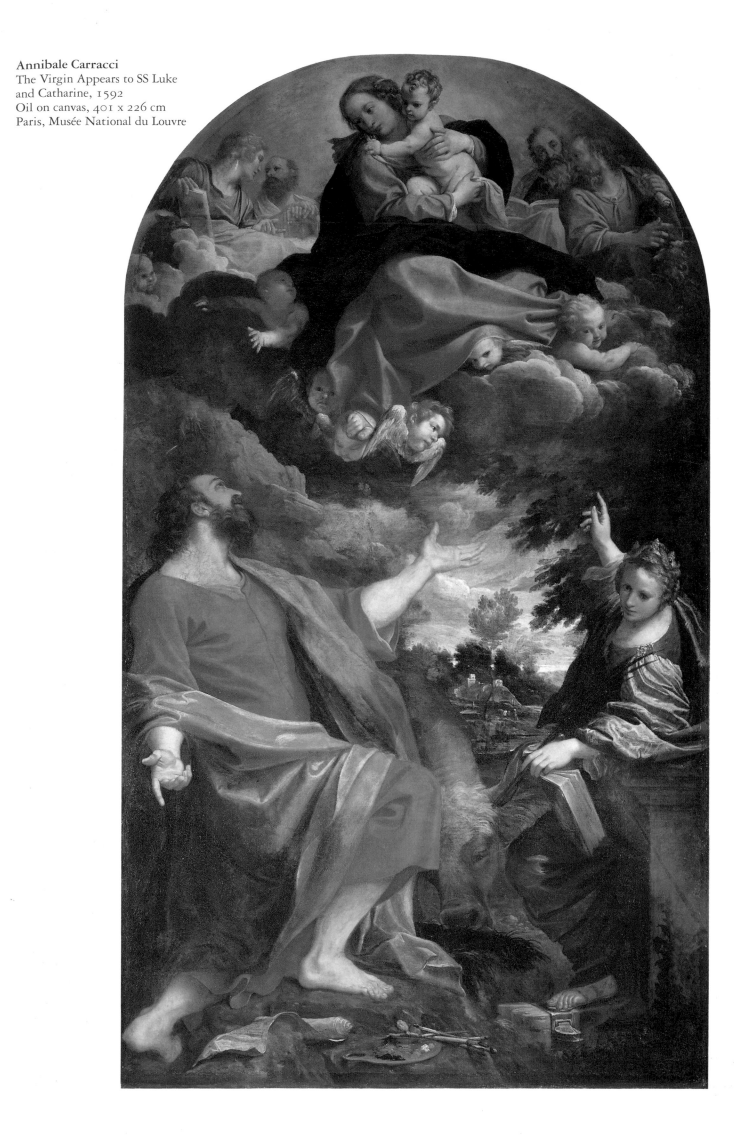

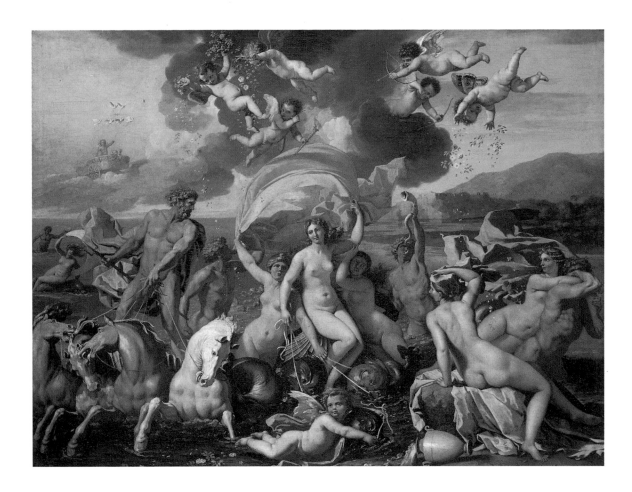

Nicolas Poussin
Triumph of Neptune and
Amphitrite, 1634
Oil on canvas, 114.5 x 146.6cm
Philadelphia (PA), Philadelphia
Museum of Art

Baciccio's *bozzetto* of *The Apotheosis of St Ignatius* (ill. p. 41).
Yet from these rather humble and entirely functional begin-
nings, the bozzetto gradually took on an independent value,
becoming a collectors' item and a gallery object in its own
right. A kind of interim zone was thus created – neither fre-
sco nor panel painting – without encroaching upon any of
the intentions, aims or functions of painting in other areas.
In this respect, the bozzetto is an independent creation in
which the widely divergent intentions of the Baroque meet
and merge: the monumental and the intimate, the sketchy
drawing with its fleeting brushwork and the richly coloured
texture of the completed fresco, the transportable framed
panel painting and the vision of celestial expanses. It com-
bines the ephemeral and the permanent, the fluid and the
firm, immutability and metamorphosis. The bozzetto is a
painting in the making, its very state of work-in-progress
constituting a form in its own right, and imbued with an in-
herent potential that epitomizes a highly specific aspect of
Baroque visuality.

New imagery
Whereas Renaissance artists concentrated on the problem of
imagery in terms of the problem of portraying God's cre-
ation of man after his own image, the artists of the Baroque
era sought to transcend the natural world with the aid of cer-
tain artifices, dramatic and extroverted pathos and illusion-
ism on the one hand and extreme close-up, internalization,
alienation and distortion of reality on the other hand. The il-

lusionism of *trompe-l'œil* the artifice of sophisticated technical
innovations and the miraculous world of the stage set with
its mechanical devices were as much a part of these means as
the notion of transposing the whole life of a ruler such as
Louis XIV (1638–1715), his palace, his court and the entire
state into another, allegorical reality – that of the sun-state
and the sun-king.

An essential and fundamental element of Baroque visual
concepts is the allegory. Baroque allegory involves rather
more than mere personification in the sense of visualizing an
abstract concept or situation by endowing a human figure
with certain attributes. Indeed, one might say that the exten-
sion of allegorical functions into the fields of landscape,
genre, still life and caricature are all part of the iconological
style of the Baroque. Allegorically conceived figures, scenes
and metaphors were used as components of pictorial pro-
grammes of great complexity, varying from country to
country in accordance with the respective needs and projec-
tions of the various nations, which were beginning to emerge
more distinctly than ever before in the 17th century.

A particularly fine example of this is the ceiling fresco by
Pietro da Cortona (1596–1669) for the great hall of the Pa-
lazzo Barberini in Rome (1633–1639), which has come to
be regarded as a work that opened a new chapter in Baroque
decoration. Its portrayal of the fame of the Barberini as a gift
of Divine Providence is the centre and focal point of this
large-scale composition. The entire picture is an allegory
glorifying the pontificate of the Barbarini pope Urban VIII.

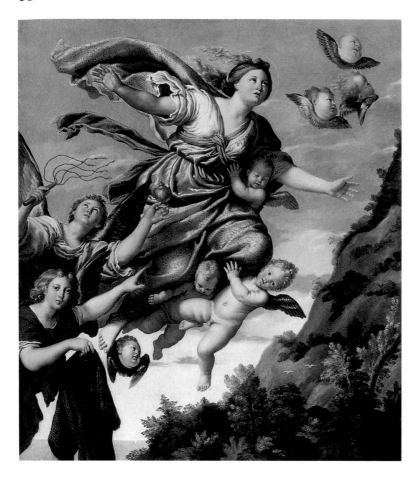

Domenichino
The Assumption of Mary Magdalen into Heaven, c. 1617–1621
Oil on canvas, 129 x 100cm
St Petersburg, Hermitage

Painted architectural elements, ornaments and painted sculptures form an organizational structure within which the secondary elements of the programme designed by the Barberini court poet Francesco Bracciolini (1566–1645) are distributed. The fresco includes every form of painting: allegory and history, myth, landscape and even still life.

Another noteworthy example is the ceiling fresco in the collegiate library of the monastry of St Florian near Linz in Austria, painted in 1747 by Bartholomäus Altomonte (1702–1783). The creator of his *concetto*, or thematic concept, was Daniel Gran (1694–1757), a *pictor doctus* or scholarly painter. The centre of the ceiling presents the main allegory: the marriage (*connubium*) of science and virtue through religion. The system of placing the key concept at the centre of a large allegorical structure was widely adopted.

New visuality

The great synthesizing power of the Baroque visual concept is expressed not only in the iconography of such allegorical "marriages", but is also immediately and sensually palpable in the relationship between the disciplines. Architecture and painting were united in a new overall visual concept. In the Renaissance, paintings were either integrated into an architectural framework that strictly respected the architectural boundaries or else they were conceived perspectively as views through a window. Certainly, there were already inherent similarities: painting had adopted architectonic, sculptural and decorative elements. The Baroque, however, brought a mutual interaction between painting and architecture, with light being handled in such a way as to create a smoothly continuous transition from built environment to illusionistic space. In the Baroque era, architecture itself became highly pictorial, and can indeed be best appreciated with this in mind. Admittedly, this is only one of the possibilities opened up by Baroque painting, for at the same time the process of pictorial autonomy, one of the most far-reaching innovations of the Renaissance, was being pursued even more radically. It was not until the Baroque age that the works so aptly described as "cabinet paintings" became widespread. These cabinet paintings had no specific cult or propaganda function and were sought solely as works of art for collection. Indeed – and it is this that is new – this was the sole purpose for which they were produced.

The great Roman collections of the 17th century, those of the Giustiniani or the Barberini, indicate that paintings were not purchased and grouped according to motif and content, but coveted instead for their artistic value, their rarity and the fame of their creators. The early collection history of a painting by Caravaggio, who played a major role in the emergence of the early independent gallery painting, illustrates this well. Joachim von Sandrart (1609–1688), the widely travelled painter and art critic, reported in his *Teutsche Academie* of the advice he had given to Marchese Vincenzo Giustiniani (died 1637), an extraordinarily ambitious patron and art collector, with regard to Caravaggio's *Amor Vincit* (now in Berlin, Gemäldegalerie): "He (Caravaggio) painted for the patron Marchese Justinian a life-size cupid in the form of a boy of about twelve, sitting on the globe and holding his bow above him in his right hand, with all manner of art instruments to his left, including books for study and a laurel wreath upon the books; cupid was painted with large brown eagle wings, altogether drawn in correctura with strong colority, clean and rounded as in life. This work was to be seen publicly in a room with a hundred and twenty others painted by the finest artists but at my advice it was covered with a dark green silken curtain and shown last of all when everything else had been perused to satisfaction for otherwise it would have made all the other rarities pale in comparison so that this work may justifiably be described as an eclipse of all paintings."

Rome as the capital of the Baroque

This newfound possibility of regarding art primarily as art for its own sake opened up a whole new dimension of further and predominantly aesthetic potential for synthesis involving conscious references to other artists and their styles. In the early stages of the Baroque, Rome was the place where

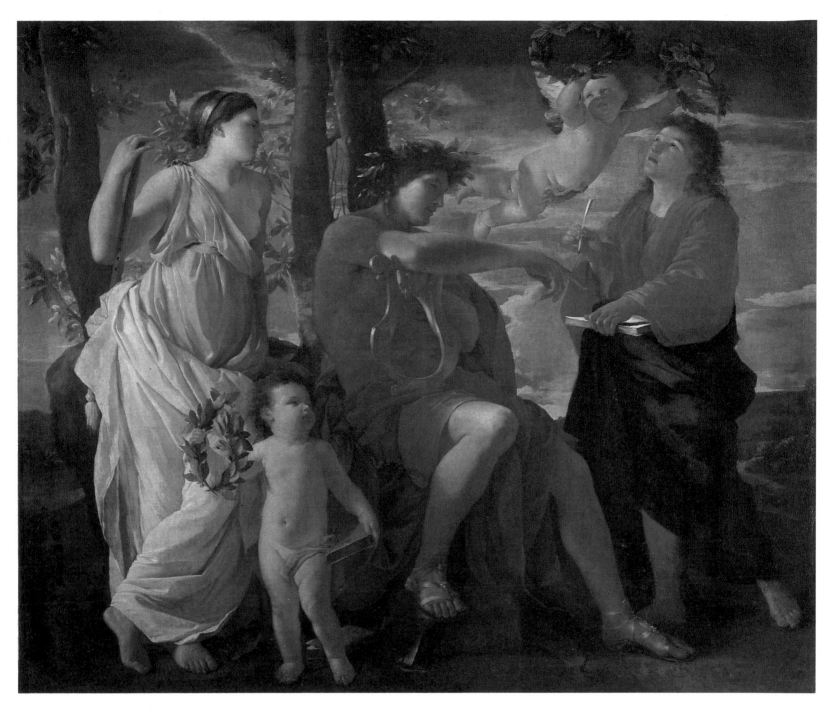

Nicolas Poussin
The Poet's Inspiration, c. 1630
Oil on canvas, 182,5 x 213 cm
Paris, Musée National du Louvre

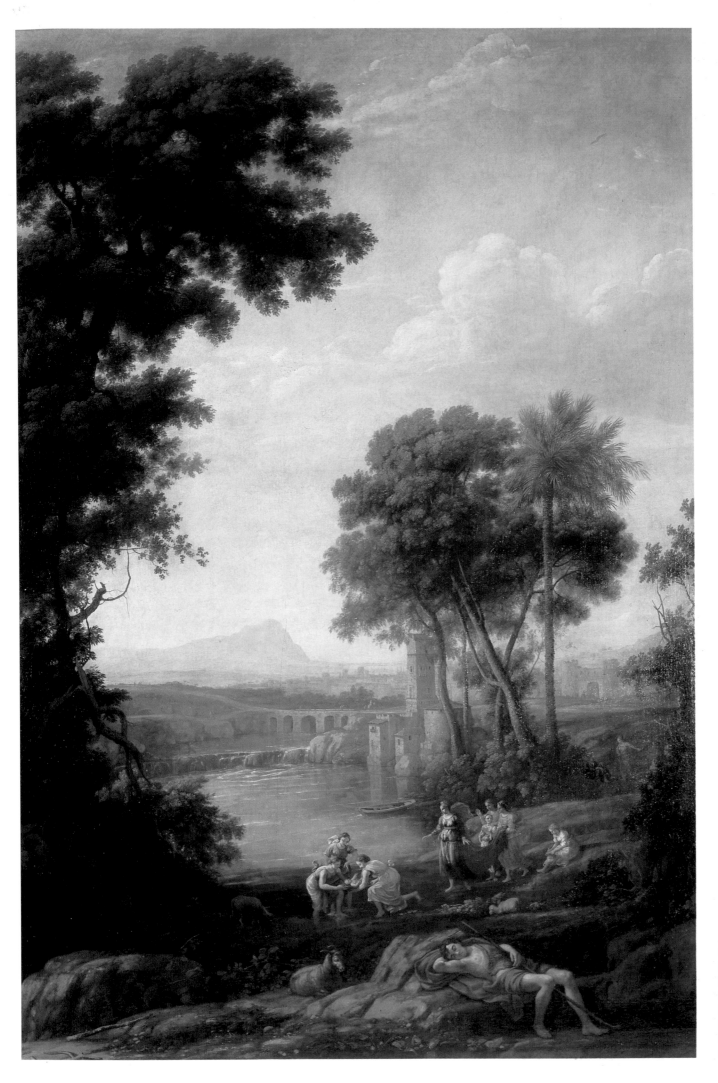

Claude Lorrain
Moses Rescued
from the Waters,
c. 1639/40
Oil on canvas,
209 x 138 cm
Madrid, Museo
del Prado

the decisive structures of a "Renaissance of the Renaissance" began to take shape. The fact that the Baroque emerged in Rome remains a valid tenet in the history of stylistic development. Yet whereas architecture developed along more or less continuous and uniform lines – the architectural history of St Peter's or Il Gesù springs to mind – early Baroque painting ran a considerably more dramatic and incalculable course. Annibale Carracci, with his studio of family members and academic artists, and Caravaggio, tend to be regarded if not as rivals, then at least as opposites in terms of artistic thesis and anti-thesis. Indeed, anyone who has visited the Cerasi chapel in Santa Maria del Popolo and has seen Caravaggio's *Crucifixion of St Peter* and his *Conversion of Saul* together with Annibale Carracci's *Assumption of the Virgin* immediately realizes that one of the most exciting challeges taken up by the subsequent generation of painters must surely have been the quest to unite the dramatic "tenebroso" of the artist from Lombardy with the Neoclassical grace of the artists from Bologna.

Annibale's decoration of the Galleria Farnese (ill. p. 29) was to be of seminal importance to Roman and Baroque monumental painting. The return to monumentality played a decisive role in itself. On the other hand, Caravaggio's handling of great themes with humility was equally significant. The heightened realism of the large-scale work went hand in hand with the increasing realism invested in exploring the trivial, the everyday and the ordinary. Different as these two starting points may be, both are based on compositional inventions of the high Renaissance. Giorgione, Titian, Raphael, Michelangelo and Correggio are the names that must be mentioned here as "forefathers" of the Baroque. Yet it was Rubens, perhaps the most universal visual thinker of the Baroque age, who was the first to succeed in drawing all these sources together in a true synthesis and establishing them throughout the courts of Europe.

It is frequently and quite rightly stressed that a general weariness and dissatisfaction with late Mannerist formal conventions may well have contributed towards certain reforms. Early Baroque in Rome may justifiably be described as anti-Mannerist. One key concept – the rediscovery of an idealistic natural portrayal based on High Renaissance art – could already be found in the work of Francesco Barocci (c. 1535–1612) of Urbino, even before the Carracci studio adopted it as the mainstay of their artistic programme. Caravaggio's rigorous realism, on the other hand, is programmatic in the sense that he broke with the classical ideals which Mannerism had stripped of meaning; the ideals of "buon costume", of "invenzione", of "disegno", of "decoro" and of "scienza" (invention and draftsmanship, pleasing decor and scholarship) as Caravaggio's most vehement critic, Giovanni Pietro Bellori (c. 1615–1696) claimed.

It was in Rome, however, that the paths of Italian, French, German and Netherlandish artists were to cross. National characteristics were more clearly articulated in the Baroque era than ever before. Only the city whose cosmopolitan open-mindedness and generous patronage had captivated so many artists failed to create its own local style of painting; the international talents who lived in Rome and fuelled its role as myth, topos and idea were far too diverse and independent for that.

Stylistic pluralism in the early Baroque

These artists closely studied the latest contemporary trends whose sheer diversity called for synthesis, as embodied in the didactic concept of the Carracci studio and in the roughshod maverick approach of Caravaggio. Rome was not a historically transfigured city of dreams echoing with the plaintive cry of its ruins, but a vibrant metropolis where temporal and spiritual patrons of almost decadent liberality set the tone and whose individuality made any attempt at establishing a single early Baroque style impossible. To divide the artists of the day into the followers of Caravaggio on the one hand and the followers of the Carraccis on the other, would be all too simplistic and quite misleading.

Though the Carracci students Francesco Albani (1578–1660) and Domenichino (1581–1641), and the Caravaggio-influenced artists Carlo Saraceni (c. 1580/85–1620) and Guercino (1591–1666) often tend to be played off against each other, such comparisons merely outline a very general trend. After all, not only was there a degree of mutual esteem between these artists, but their successors also found a lasting and fertile source of inspiration for the development of Baroque painterly form in a combination of their extraordinarily innovatory achievements. Indeed, the very notion that it is impossible to unite idealists and naturalists is a doctrine that emerged relatively late and one that has remained beyond the bounds of artistic practice. Even in the œuvre of such an archetypal classicist as Guido Reni (1575–1642) there is a considerable body of evidence bearing witness to the intensity with which he studied the work of his "opponents".

Only for a very few highly independent talents such as Adam Elsheimer (1578–1610) or Velázquez did the question of association with one particular school or certain dominant influences play no role at all. The same is true of Pietro da Cortona, that master of Roman fresco painting who was also a distinguished architect and an experienced sculptor. It was a combination of these talents that enabled him to tackle such vast spaces as the ceiling of the Palazzo Barberini. He was a decorative painter of the highest stature: not only did he apply architectural and sculptural elements as painterly elements, but he even combined painterly and sculptural components, as we can see in some of the ceiling paintings of the Palazzo Pitti – a system that was to be of enormous significance for the future possibilities of Baroque interior decor.

While it is undoubtedly true to maintain that specifically national schools did not emerge until the Baroque, we can also say with some justification that the international exchange of ideas and fluctuation of artists had never been so intense. This intellectual climate made it possible, to cite just one example, for the German painter Johann Liss (c. 1595– c. 1629/30) to represent the Venetian painting of his day with a standard of quality and temperament no local artist could match. It was a time of expanding horizons, assisted by the spread of printed reproductions which made a number of pictorial inventions – admittedly without colour – more rapidly accessible and available to a broader public. Rubens employed engraving studios which made his compositions famous throughout Europe. Many painters also began exploring the possibilities of printing, using it to create their own independent pictorial compositions, resulting in new inventions such as mezzotint and aquatint which soon found a place alongside more current techniques of engraving and etching.

It seems as though this internationalization of European painting in the Baroque, triggered by all these factors, also led to a distinct articulation of national schools, for it was only now that artists had the possibility of choosing from a huge range of old and modern art. The choice of an inspirational model may well have been the decisive factor that kept both the microcosm and the macrocosm of Baroque art in perpetual motion. It is the constant topic of all academic and educational reflections – from the Accademia degli Incaminati of the Carracci to the Parisian Académie Royale where a vehement debate raged between "Rubenists" and "Poussinists" regarding the predominance of colour or line. For the individual artist, this choice was as existential and decisive as it was for the commune or the prince who determined prevailing taste through his patronage and who frequently sealed the fate, overnight, of artists who had fallen out of favour.

Few nations famed for their distinctive artistic culture are so unequivocally indebted to the importation of foreign influences – in this case Italian and Flemish – as France. Yet what could be more French than the timeless landscapes of Claude Lorrain (1600–1682), the heroic harmony of man and nature in the work of Poussin, the crisp portraiture of Philippe de Champaigne (1602–1674) or the mathematical clarity in the still lifes of Lubin Baugin (c. 1610/12–1663)? Their origins in the work of Domenichino and in the art of Flanders and Holland may be proven, but it is not the decisive factor. It was the power of transformation that breathed life into the very substance of art and shaped the face of French Baroque.

The incredible capacity for metamorphosis that astounded his contemporaries in the work of Sébastien Bourdon (1616–1671), an artist who could fool even the connoisseur with his paintings in the style of Poussin, the Le Nain brothers, or an Italian or Dutch painter, is a phenomenon of crucial importance not only in terms of an individual artist's personal choice of role model but also in terms of France's position with regard to the sources of Baroque painting. It certainly sheds some light on this aspect of the era. The purist cult of genius we have inherited from the 19th century has given us a tendency to disparage such phenomena as mere eclecticism, hampering our understanding of the complex processes that informed the stylistic creation of the Baroque. In order to reassess it, we must first seek to understand the Baroque attitude to imitation.

Counter-Reformation and absolutism

Of all the explanations offered in an interpretation of Baroque history, there are two which have become firmly established, both for good reason. The first regards Baroque as the style of the Counter-Reformation. As long as the forms of Protestant Baroque are not ignored and as long as the Counter-Reformation is not regarded as the seminal principle from which a certain style emerged, but which wilingly adopted that style as a convenient instrument of religious propaganda, this interpretation is acceptable. It is, after all, remarkable that such influential figures as the reform popes Pius V (1504–1572), Gregor XIII (1502–1585) and Sixtus V (1521–1590) as well as the great founders of religious orders Thomas Cajetanus (1469–1534, Ignatius of Loyola (1491–1556), Filippo Neri (1515–1595) and Carl Borromäus (1538–1584) seem to have lacked any artistic policy pointing specifically towards the Baroque.

The second political theory is similarly flawed. It regards Baroque art as the perfect expression of absolutist claims to power in the state. This functional equation is also acceptable as long as we bear in mind that the early absolutist states – such as Florence under Cosimo I de' Medici (1519–1574) in the second half of the 16th century – were not actually centres of early Baroque art, and that the origins of this style are to be sought instead in Bologna and Rome, far from the ideals of the absolutist sovereign and the absolutist state of the 17th century.

France

A classic example of Baroque art in the service of absolutism can be found in France under the reign of Louis XIV. For the early Baroque period of the first half of the 17th century, developments in France were of little significance. The French sun did not rise until the second half of the century and, when it did, it shone with a brilliance and exemplary power that dazzled the aristocracy of Europe. It is tempting to surmise that it was only through the example of France that Baroque became the absolutist style – that is, if it can be described as a style at all. Though it was by no means new for art, and indeed all the arts, to be used as a vehicle for political ideals, never before had this purpose been organized to

such perfection through institutions and directors wielding so much power nor through projects on such a grand scale.

When Louis took the reins of power in 1661 following the death of the French prime minister Cardinal Jules Mazarin (1602–1661), thereby reuniting monarch and state in one person, he chose Jean-Baptiste Colbert (1619–1683) as his advisor in matters of art. Colbert began in 1663 with the reorganization of the Manufacture Royale des Meubles de la Couronne, which was entrusted with producing all manner of luxury furnishing and decoration, including tapestries. At the same time, Colbert acted as the political head of the Académie Royale de Peinture et de Sculpture, founded in 1648, whose artistic director was Le Brun, and in doing so he made the academy an instrument of royal artistic policy. Appointed *surintendant des bâtiments* from 1664, Colbert founded the Académie Royale d'Architecture in 1671 and was henceforth in charge of supervising all architectural projects and training new architects. In 1666, this process of centralization culminated in the creation of the Académie de France in Rome, a move that distinctly curbed the freedom of artistic life in the eternal city by exercising greater control over the French students there. At the same time, however, this same institution gave Paris a firm foothold in the promised land of art, on which it subsequently based its claim to a role as the "second Rome" in matters of art. Bernini's failure in Paris is also to be regarded in the light of this particular situation.

Baroque art is inextricably linked with the concept of the academy, and consequently with academic theory and debate, even to the point of pursuing theory as an independent discipline without necessarily requiring that it should have any effect on actual art policy. One example of this can be found in the famous debate, mentioned above, between the Rubenists and the Poussinists (in reference to their respective symbolic figureheads Rubens and Poussin) regarding the superiority of colour or line in painting. The key factor in this respect – a feature of the Baroque in general, as it were – is in fact the principle of polarity, along very much the same lines as the rivalry that had previously erupted between the "eclectic" followers of the Carracci and the "naturalistic" followers of Caravaggio in Rome, albeit under somewhat different circumstances.

Whether a colourist such as Jean-Antoine Watteau (1684–1721) may seriously be considered in terms of this theoretical debate and the triumph of colour over line must remain an open question. Although he may have been the only French painter to have seen in the works of Rubens an inherent coloristic kinship-by-choice, whereas a Rubenist like Pierre Mignard (1612–1695) went no further than superficial adaptation, his ground-breaking work had already begun to pave the way towards a new era that found itself weary of the "grand goût".

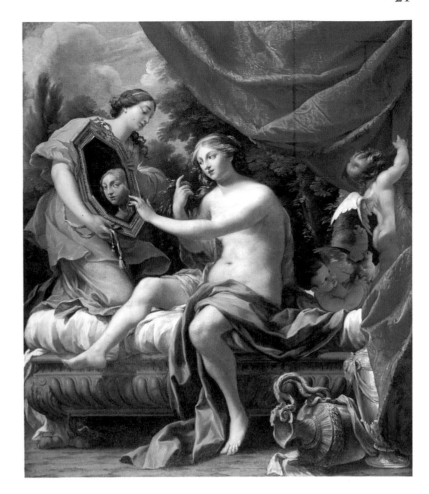

Simon Vouet
The Toilet of Venus, c. 1628–1639
Oil on canvas, 183.8 x 153cm
Cincinnati (OH), Cincinnati Art Museum

As regards the equation of Baroque and absolutism mentioned above – which, while not entirely incorrect, is certainly not unproblematic – it cannot be denied, particularly in the case of Louis XIII, Colbert and Le Brun, that a significant proportion of French painters went their own way, ignoring centralized art policies. Ironically, the very artist who was seminally important to the Neoclassical doctrine, Poussin himself, the epitome of French painting during the 17th century – a century which the French often refer to as their "golden age" of painting – was so deeply disappointed by Paris (to which he had been summoned as court painter by Louis XIII) that he returned within the space of just eighteen months to Rome, the city that had also become the chosen home of Claude Lorrain. Nevertheless, even at such a distance, both these artists were to exert an influence on the spirit of French painting that would prove to be more lasting and profound than any of their colleagues residing in Paris, including Le Brun himself.

Independent, but no less highly esteemed, were the Le Nain brothers Antoine (c. 1588–1648), Louis (c. 1593–1648) and Mathieu (1607–1677), Georges de La Tour (1593–1652) and last but not least, the great engraver Jacques Callot (c. 1592/93–1635), whose cycle *The Horrors of*

War produced in 1632/33 held up the cracked mirror of negative counter-image against the sovereign claim to the glorification of politics through art.

The non-academic tendencies in French painting were powerful indeed. Their realism, inspired by Caravaggio, enjoyed not only bourgeois approval, but occasionally gained royal acceptance as well. Louis XIV even had all the paintings removed from his room and replaced by a single work: Georges La Tour's *St Sebastian* (ill. p.45). In his bedroom, he had five works by Valentin de Boulogne (1594–1632) and what is more, the king had also purchased paintings by Caravaggio.

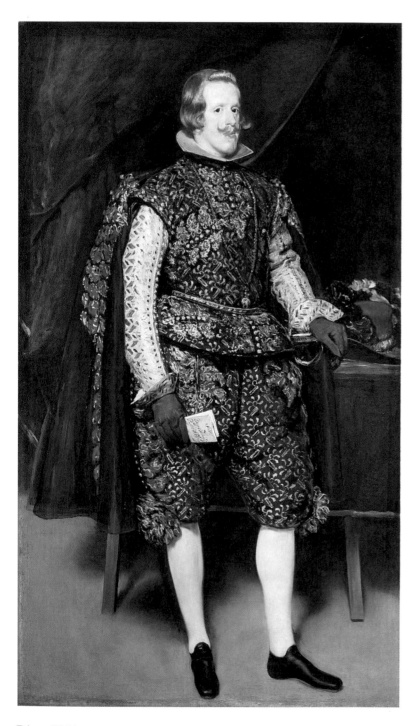

Diego Velázquez
Portrait of Philip IV of Spain in Brown and Silver, 1631–1632
Oil on canvas, 199.5 x 113cm
London, National Gallery

Naples

In considering these two very different centres of Baroque painting – Rome and Paris – we should not forget the third major centre, Naples. The city had only recently taken on such a role. Before the 17th century, the painting here had barely achieved European stature; the city had no independent artistic tradition that might have triggered a new movement in the way the High Renaissance had emerged in Rome. It is for this reason that Neapolitan Baroque painting also lacks the harmonizing classical touch that might have moderated its tendency towards audacious non-conformity. An important aspect is the fact that Caravaggio spent some time in this city, where he created the masterpieces of his later style. His chiaroscuro and his earthy realism were to pave the way for the entire century. It is interesting to note that although Domenichino and Giovanni Lanfranco (1582–1647) also spent some time in Naples, this seems to have had no particular influence.

A unique feature of Neapolitan art of the period is the dissolution of pictorial structure into a pattern of daubs of colours referred to as "macchia", for which its exponents are described as "macchiettista". This sketchy style of painting, sometimes erroneously referred to as "impressionistic", is the stylistic instrument of an improvizational and virtuoso painting which does not concern itself with iconographic content, but concentrates instead on presenting cavaliers in battle, bawdy "bambocciata" and genre scenes from the lives of soldiers and vagabonds. The leading representative of this style is the painter and poet Salvator Rosa (1615–1673) who was a brilliant master of all thematic fields and whose particular speciality was battle scenes. Of all the painters of the era, he may certainly be described as the one with the most flamboyant imagination. He has left us as his heritage the unforeseen, fickle and unpredictable stroke of the imagination that has come to be known as the "capriccio". Since Salvator Rosa, it is impossible to think of Baroque painting without the capriccio.

The most popular representatives of Neapolitan Baroque painting have always been Mattia Preti (1613–1699) and Luca Giordano (1634–1705), known to his contemporaries as "fa presto" in reference to the prodigious speed at which he is said to have painted. Giordano is acknowledged as a great Neapolitan fresco painter who went beyond the scope of local style, exploring Roman influences, especially that of Pietro da Cortona.

The importance of Naples in the field of Baroque painting is further enhanced by a curious circumstance: the city's position as a Spanish dominion. Naples would play an influential role in the development of Spanish Baroque painting and would be an important source of inspiration for its painters. A key figure in this respect is the Naples-based Spanish artist Jusepe de Ribera (1591–1652), the main exponent of Neapolitan Caravaggism.

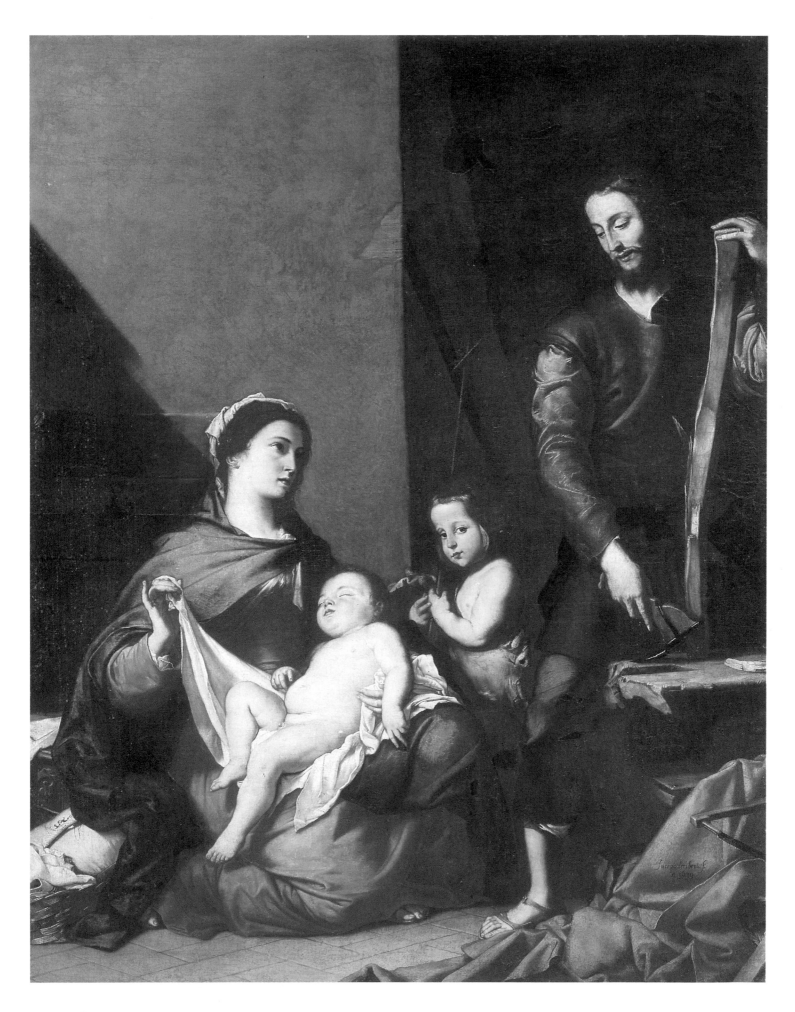

Juseppe de Ribera
The Holy Family, 1639
Oil on canvas, 253 x 196 cm
Toledo, Museo de Santa Cruz

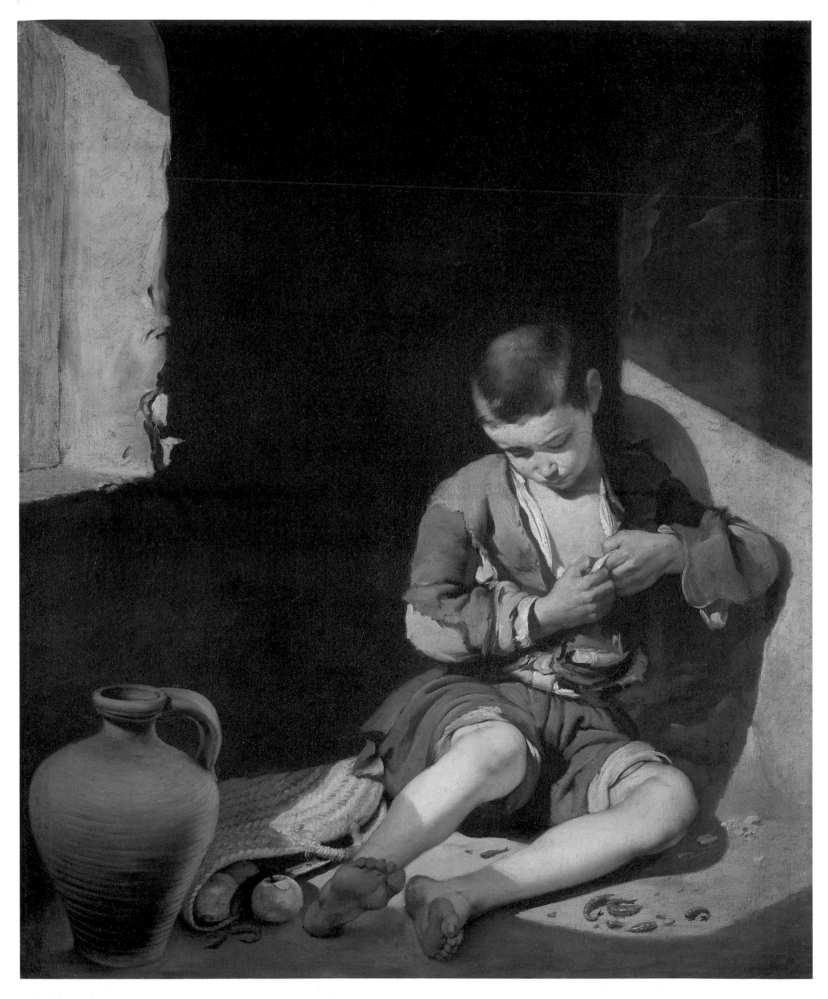

Bartolomé Esteban Murillo
Beggar Boy, c. 1650
Oil on canvas, 134 x 100 cm
Paris, Musée National du Louvre

Spain

Certain external factors have to be taken into consideration when addressing the subject of Spanish Baroque painting. First of all, we should bear in mind the extremely low social status of painters, a situation against which the generation of Spanish artists following El Greco still continued to struggle. Much of our information about their lot comes from El Greco's own no longer fully extant writings on architecture, sculpture and painting, together with the modest 17th century contributions of Francisco Pacheco (1564–1654), Vincente Carducho (c. 1576–1638) and Juan Bautista Martínez del Mazo (1612–1667), whose writings were also aimed at enhancing the social stature of artists – an aim that had already borne fruit in Italy a full two centuries previously.

Dependent as Spanish painters were on outside contacts in order to keep pace with artistic developments in Italy and the Netherlands, they themselves had very little influence on the rest of Europe until the 19th century. This is due to the circumstances which also shaped the specific physiognomy of Spanish Baroque. Its "golden age" coincided with the Spanish government's progressive loss of power and prestige. Such events as the defeat of the Armada by the English, dealing a fatal blow to Spain's marine power, the ceasefire negotiated with Protestant Holland in 1609 after a long and wearing struggle, and the eventual recognition of this small country's independence in 1648, are only the most spectacular outward signs of the decline and fatigue that had gripped the country as the result of decades of aggressive power politics.

The Spanish court under Philipp II (1527–1598) had few commissions to award that would have been attractive to foreign artists. Though Rubens did produce a number of works in Madrid, we should remember that this Flemish artist was working in the service of the crown as a Spanish subject and a diplomat.

Apart from representative, prestigious and diplomatic portraits, the only works commissioned by the Spanish court were the cycles of battle paintings for the Salon de Reinos, Francisco de Zurbarán's (1598–1664) *Hercules* cycle, and the mythologies for the royal hunting lodge of Torre de la Parada executed by the Rubens studio. This lack of courtly commissions and the low social status of artists in Spain are two important factors which were further exacerbated by an absence of aristocratic and bourgeois patronage. The Spanish nobility led a distinctly Don Quixotic life and the repertory of Baroque themes held little appeal for them as they tilted at windmills to escape the reality of their own insignificance. Only the church felt an increased need for paintings, and welcomed the stylistic devices that had emerged in the Roman Counter-Reformation. Cloyingly sweet Immaculadas – an iconographic speciality since El Greco – the delicate portrayals of the infant Jesus by Bartolomé Esteban Murillo (c. 1617/18–1682) and the austere, enigmatic portraits of

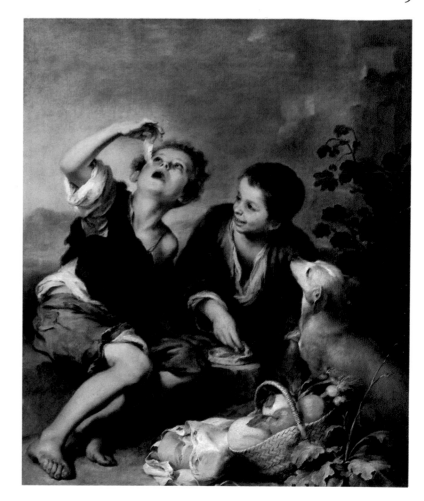

Bartolomé Esteban Murillo
The Pie Eater, c. 1662–1672
Oil on canvas, 124 x 102 cm
Munich, Bayerische Staatsgemäldesammlungen,
Alte Pinakothek

saints by Zurbarán represent the extremes of Spanish religious painting in this era.

The advent of Caravaggism also acted as an important stimulus on Spanish art, where it fell on the fertile soil of a local chiaroscuro technique based on Netherlandish and late Mannerist painting. In Seville, home to what was probably the leading Spanish school of painting in the 17th century, this produced a highly distinctive variation of earthy, brown-toned painting in which the colour structure of a canvas was reduced to its bare essentials, at times even paring it down to little or no colour so that each hue seemed to take on the function of a light intimately merged with the very substance of the paint itself. In Zurbarán's *The Ecstasy of St Francis* (ill. p. 66) it is no longer a sudden and glaring burst of light from some outside source that heightens the sense of supernatural emotional excitement as an accompanying rhetorical gesture; nor is there any natural source of light of the kind employed by the followers of Caravaggio to create their unnatural light effects. Zurbarán's chiaroscuro is inherent within the colours themselves, and the surfaces of his objects are bathed in it. In this merging of light, that most immaterial of all things, with the clay-like hues of the very humblest of all materials – to be found in the earthy tones of so

many portraits, still lifes and genre scenes – Spanish Baroque painting possesses a spiritual quality that lends it a unique position in European art.

Velázquez, in his early period, is also a highly original representative of this Spanish tenebroso. In an early work such as *The Water Seller of Seville* (London, Wellington Museum), he undertakes to transform a simple glass of water, ennobled by the cool and silvery breaking of the light, into an enigmatic and precious object and to reflect this in the sphere of experience of the characters. Velázquez turned briefly to the genre pieces of kitchens and cellars known as "bodegones", but he never specialized in any direction and went on to expand his repertory beyond the routine commissions of court, portraiture, children's portraits, equestrian portraits, to such an extent that, apart from mural and ceiling painting, which played only a minor role in Baroque Spain anyway, his œuvre covers all the major thematic fields of the time. It includes the female nude in the form of the *Rokeby Venus* (ill. p. 74), the only surviving example of four portrayals of Venus – an extremely rare subject matter in Spanish painting – as well as mythological and sacred history paintings and the great allegories of painting which he integrated into his *Weavers* (Madrid, Prado) and into his famous portrait of the family of Philipp IV known as *Las Meninas* (ill. p. 74). In his time, Velázquez was a contemplative painter, a man of ideas and a thinker who upheld the value of human dignity as none had done before. His great painting of the *Surrender of Breda* (ill. p. 72) is not a picture of subjection, but of conciliation. Even in his portraits, so popular at court, of the dwarves, fools and idiots who were regarded at the time as living caricatures, Velázquez imbues these individuals with an undeniable dignity that brooks no mockery. In spite of these achievements, or perhaps precisely because of the personal qualities that produced them, Velázquez was nevertheless one of those artistic personalities who could not create a following or a school of painting.

Germany

Whereas it was unusual for Spanish painters to travel to Rome and Italy (Ribera was the exception, and he never returned from Naples), it was common practice for German Baroque painters to spend as much as several years abroad in the Netherlands, Italy or even in both these countries. Leaving aside the greatest and most decisive intervention in early Baroque artistic development in Germany, the Thirty Years War, we find the most important reason for the fluctuation of artists is their lack of a territorial centre of their own in the Holy Roman Empire of the German Nation which, as a capital city, might have been able to establish certain stylistic standards, creating some uniformity in German Baroque painting.

The German love affair with Venice begins with Hans Rottenhammer (1564–1625), who settled in that city in 1589. The Frankfurt artist Adam Elsheimer joined him there and in 1600 both these artists were to find their chosen home in Rome. Venice was also the destination of the Holstein artist Johann Liss (d. 1629) and the Munich artist Johann Carl Loth (1632–1698). Whereas Loth combined the Roman tenebroso of Caravaggio with a Venetian handling of colour, Liss brought Netherlandish elements with him from Amsterdam and Haarlem, integrating them into Venetian painting, of which these two German artists were regarded as the leading representatives in the 17th century. Their influence on German painting, at least in the case of Liss, was limited.

Other artists, such as Johann Heinrich Schönfeld (1609–1682), who passed on his Roman and Neapolitan experience on his return, had a more widespread impact as mediators of foreign schools of painting. One of the most significant results of this propensity for travel was Sandrart's "Teutsche Academie der edlen Bau-, Bild- und Mahlerey-Künste" published in Nuremberg in 1675–1679. It is an invaluable source of theoretical and historical documents comparable to Vasari's *Lives of the Artists* and may be regarded as a fundamental work of German art historiography.

Sandrart, a highly esteemed artist and a respected authority, had founded an academy in 1662. At his initiative, it was situated in Nuremberg, but it was barely able to fulfil its intended function of an influential centre of art that could set standards. In the light of overall developments in Europe, and given the role played by the academies in other countries during this period, it came a little too late.

ANNIBALE CARRACCI

1560–1609

The interest taken by artists and art buyers in worldly images of "humble" everyday life has always been of particular socio-cultural significance. Initial forays in this direction led to the evolution of the so-called "genre" scene, already evident in Franco-Flemish tapestries of the 15th century and in the works of Pieter Aertsen and Willem Beuckelaer in the mid-16th century. Without their example, its emergence in early Italian Baroque would probably have been quite unthinkable. The Northern Italian schools, in particular, which had always been receptive to Flemish influences, for example, showed a keen interest in the realism of the genre.

A simple peasant or farm labourer is sitting down to a meal. With a wooden spoon, he greedily scoops white beans from a bowl. Onions, bread, a plate of vegetable pie, a glass half full of wine and a brightly striped earthenware jug are standing on the table. Everything in the picture is homely and simple. The food, the man, his clothing, his loud table manners and his furtive, and hardly inviting, glance towards the spectator. None of this would be particularly striking in comparison with the examples of other painters.

What is truly new and quite astonishing, however, is the fact that Annibale's painterly technique and artistic approach are entirely in keeping with the rough and ready subject matter. Matt, earthy colours are applied to the canvas in thick and rugged brushstrokes. The compositional simplicity makes no attempt at sophisticated perspective or spatial structure, and the simple alignment of objects on the table is portrayed in almost clumsy foreshortening. What is revolutionary about this painting, of which several prelimin-ary studies exist, is the deliberate lack of artifice or skill – an approach that actually makes it all the more compelling.

This tale from the life of St Peter is recorded in the collection of legends written down by Jacobus a Voragine in the 13th century. It tells how the apostle, having triumphed over Simon Magus, was persuaded by the Christians of Rome to leave town. Jacobus a Voragine relates how Peter encountered Christ on the Appian way and asked "Quo vadis domine" (Whither goest thou, master?), to which Christ replied "To Rome, to be crucified anew."

This apocryphal legend is in fact the beginning of Peter's own martyrdom. This would certainly explain the vigorous movements in Carracci's painting, with the apostle recoiling in terror. It is not the unexpected encounter with the risen Christ that has taken the apostle aback, but his awareness of his own human frailty. Annibale's magnificent rhetoric reminds the spectator of Christ's call to turn back.

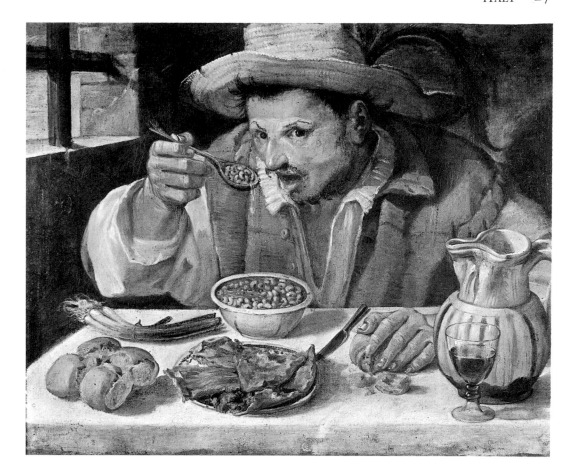

Annibale Carracci
The Beaneater, c. 1580–1590
Oil on canvas, 57 x 68 cm
Rome, Galleria Colonna

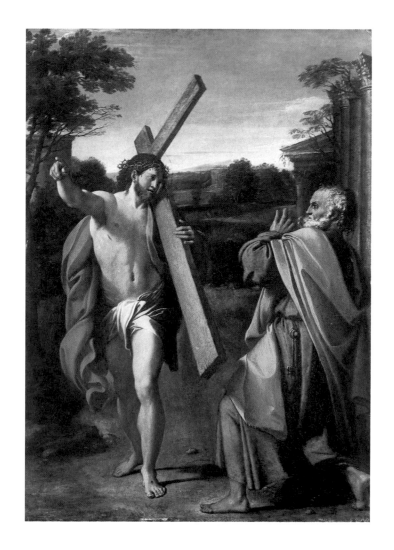

Annibale Carracci
"Domine, quo vadis?"
(Christ Appearing to St Peter
on the Appian Way),
c. 1601/02
Oil on panel, 77.4 x 56.3 cm
London, National Gallery

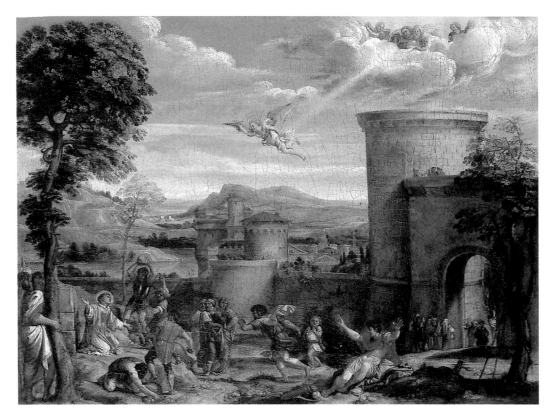

Annibale Carracci
The Martyrdom of St Stephen, c. 1603/04
Oil on canvas, 51 x 68 cm
Paris, Musée National du Louvre

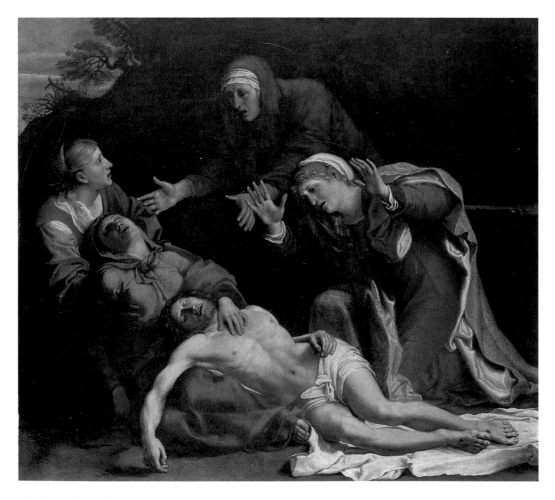

Annibale Carracci
The Lamentation of Christ, 1606
Oil on canvas, 92.8 x 103.2 cm
London, National Gallery

ANNIBALE CARRACCI
1560–1609

This small panel showing the martyrdom of St Stephen reveals a very different side of Annibale's art, and one that fully confirms his consummate skill in applying the stylistic means appropriate to the theme.

Before the walls of the city, a group of men has gathered to execute Stephen, a deacon of Christian faith. The martyr is already on his knees and bleeding. He pays no heed to the stones being brandished menacingly against him, for already an angel is floating towards him bearing the crown and palm frond of the martyr. It is a celestial messenger from the golden realms of heaven which can be seen beyond the parted clouds, revealing a glimpse of God and Christ, who – visible only to the saint – have appeared to witness his martyrdom. A number of individual movements over a broad area have been skilfully drawn together against a sweeping landscape background.

The great finesse of of this painting with its meticulous draughtsmanship and its strong yet delicate colority reveals a mastery of compositional organization capable of lending superb form to a dramatic event.

In this *Lamentation*, a late work executed in 1606, Carracci has achieved a degree of monumentality in his narration of an episode from the Passion of Christ that certainly bears comparison with Caravaggio's *Entombment* in the Vatican. As in the work of the Lombard artist, it is a profound sense of gravity that determines the character of the composition here. None of the figures, not even the woman standing in the centre, is fully upright. Stooping, she stretches her arms out towards Mary, who has fallen backwards in a swoon. The composition is structured by the portrayal of reclining, crouching, bent and stooping positions and by the unusual motif of the three figures in staggered graduation behind one another. The upper edge of the painting seems to be drawn down low so that not one of the figures is able to stand in an upright full-length position. All of this contributes towards conveying the gravity and heaviness of the dead Christ, not only physically, but also psychologically: the view of Christ's dead body does not call for an upright statuary figure as in a memorial, but seeks an equivalent to the deep sense of melancholy, as expressed in the gestures and body language of the grieving women.

Other compositional devices would also suggest that the artist intended to trigger a similar mood in the spectator. The grouping of the figures can hardly be called beautiful or harmonious. A deep rift has been torn between the two Marys with the dead Christ and the two mourners, and although the body of Christ is the common bond between the mourning women, he is also presented as an isolated figure in the eyes of the spectator. The pallor of his body stands out against the full and heavy colority of the robes and the gloomy silhouette of the tomb.

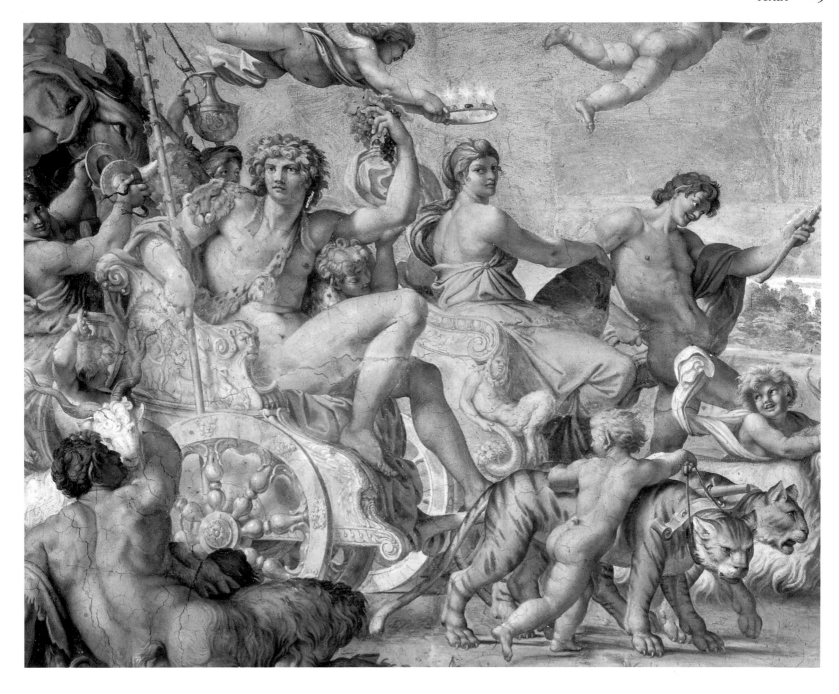

As the 16th century drew to a close, a certain weariness of the forms of late Mannerism, which dominated the entire European art scene by the second half of the century, was becoming evident. In this respect, the early Baroque in Italy may also be regarded as a conscious and critically motivated phase of reform in every field of art.

The school of the Bolognese artists Lodovico, Agostino and Annibale Carracci formulated this approach clearly by founding an academy. A masterpiece of this reform movement was the huge cycle of paintings commissioned to decorate the Galleria Farnese in Rome, created under the auspices of Annibale Carracci, who was responsible for its planning and execution.

The grand mythological programme representing the power of love by way of example of the Olympian gods went hand in hand with an aesthetic concept that was to be of fundamental importance for all subsequent Baroque fresco painting. The underlying motivation of the academy is clearly evident in this major work; it is aimed at a revival of the natural ideal once embodied by the art of the High Renaissance.

Bernini, master of Roman Baroque, expressed this aim in his assessment of Annibale, who, he claimed, had "combined all that is good, fusing the grace and drawing of Raphael, the knowledge and anatomy of Michelangelo, the nobility and manner of Correggio, the colour of Titian and the invention of Giulio Romano and Mantegna".

The result of this approach based on synthesis was not a work of stale eclecticism, but a visual world of enormous vitality in which it was possible to develop a single programme – based on Ovid's Metamorphoses – over a vast area while at the same time jettisoning the more esoteric elements of Mannerism in order to convey the heady eroticism and physicality of the myths with greater immediacy.

In the bridal procession of Bacchus and Ariadne, which fills the central area of the ceiling, these qualities merge to the most highly condensed composition of the Farnese Gallery.

Annibale Carracci
Triumph of Bacchus and Ariadne, c. 1595–1605
Ceiling painting (detail)
Rome, Palazzo Farnese

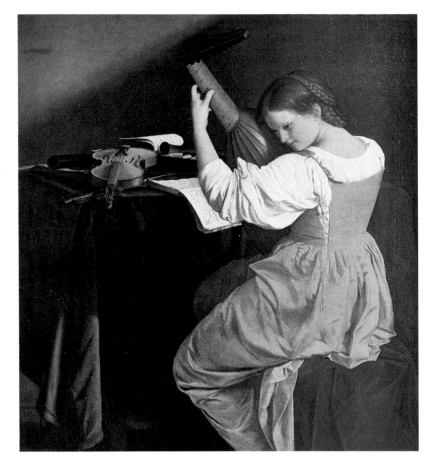

Orazio Gentileschi
The Lute Player, c. 1626
Oil on canvas, 144 x 130 cm
Washington, National Gallery of Art

ORAZIO GENTILESCHI
1563– C. 1639/40

Of all the major followers of Caravaggio in Italy, Gentileschi is surely the strongest personality. Yet it was not so much the tenebroso and the dramatic handling of light in the middle and later period of the Lombard artists, but the clear and cool colority of Caravaggio's early work that he has taken up and adopted with great originality.

The Lute Player, produced around the time of his emigration to England, is one of Gentileschi's most famous works. A young girl in a lemon-yellow dress is seated with her back to the spectator at a table on which a violin, a shawm and two music scores are lying. Listening intently, the girl has lifted the lute to her ear, and is concentrating her entire attention on the chord that the fingers of her left hand are strumming on the broad body of the instrument.

It is not easy to interpret this painting, particularly as it was created in a period when allegorical messages tended to be conveyed through seemingly everyday genre scenes. The fact that she is listening so intently would certainly suggest an allegory of hearing, but it is just as possible that this is intended as a portrayal of Harmonia, the pleasing combination of different parts, as suggested by the nineteen strings of the double lute the girl is playing.

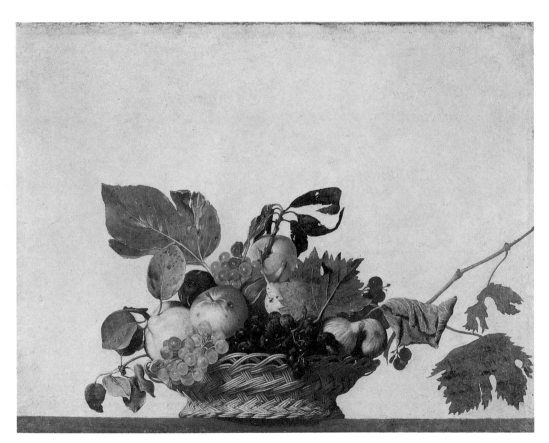

Caravaggio
Basket of Fruit, c. 1596
Oil on canvas, 46 x 64 cm
Milan, Biblioteca Ambrosiana

CARAVAGGIO
1573–1610

Caravaggio is reported to have claimed that he put as much effort into painting a vase of flowers as he did into painting human figures. Such an attitude not only calls into question the hierarchy of pictorial genres that had prevailed since Alberti, but also marks the beginning of a tradition of European still life painting that was to develop continuously from then on.

Whereas, until then, there had only been occasional cases of "pure" object paintings – one by Carpaccio, a hunting trophy by Barbari and a message (1506) about one Antonio da Crevalcore, who is said to have made a "painting full of fruit" – from Caravaggio onwards, still life was to be the most popular of genres. It is a response to the increase of private art collections and their demand for profane and virtuoso painting.

Caravaggio compensated for the apparent loss of contentual gravity in an astonishing way. The basket is at eye level and juts out over the edge of the table into the real space of the spectator.

In this formal exaggeration and with a viewpoint liberated from all attributive connotations, the otherwise trivial object takes on an unheard of monumentality that renders the secret lives of objects, the play of light on their surfaces and the variety of their textures worthy of such painting.

With *The Fortune Teller (La Zingara)*, Caravaggio introduced, around 1594/95, a subject into Italian painting that was known, if at all, only in Netherlandish paintings: the so-called genre, depicting scenes of everyday life, but with a hidden or underlying meaning intended for the edification of the observant spectator.

A foppishly dressed young man, a milksop with no experience of life, gives his right hand to a young girl whose expression is difficult to define, in order to have his future read. His ideas about his future are effectively influenced by the astute young gypsy girl, whose gentle caress in tracing the lines of his hand captivates the handsome young fool so completely that he fails to notice his ring being drawn from his finger. This anecdotal narrative could be further embroidered, and indeed the painting invites us to do so as much through the plot it portrays as through what it tells us of the two characters by way of their clothing. The feathered hat, the gloves and the showy, oversized dagger immediately tell us who we are dealing with here. Similarly, the gypsy girl with her light linen shirt and her exotic wrap is intended as a "type" rather than as an individual person.

This means, of course, that what we have here is not an anecdote of two specific people, but an everyday tale. No specification of place or time detracts our attention from the point of the story, which gives the spectator a sense of complacent superiority as well as aesthetic pleasure.

The gospel according to St Luke (24:13–32) tells of the meeting of two apostles with the resurrected Christ. It is only during the meal that his companions recognize him in the way he blesses and breaks the bread. But with that, the vision of Christ vanishes. In the gospel according to St Mark (16:12) he is said to have appeared to them "in an other form" which is why Caravaggio did not paint him with a beard at the age of his crucifixion, but as a youth.

The host seems interested but somewhat confused at the surprise and emotion shown by the apostles. The light falling sharply from the top left to illuminate the scene has all the suddenness of the moment of recognition. It captures the climax of the story, the moment at which seeing becomes recognizing. In other words, the lighting in the painting is not merely illumination, but also an allegory. It models the objects, makes them visible to the eye and is at the same time a spiritual portrayal of the revelation, the vision, that will be gone in an instant.

Caravaggio has offset the transience of this fleeting moment in the tranquility of his still life on the table. On the surfaces of the glasses, crockery, bread and fruit, poultry and vine leaves, he unfurls all the sensual magic of textural portrayal in a manner hitherto unprecedented in Italian painting.

The realism with which Caravaggio treated even religious subjects – apostles who look like labourers, the plump and slightly feminine figure of Christ – met with the vehement disapproval of the clergy.

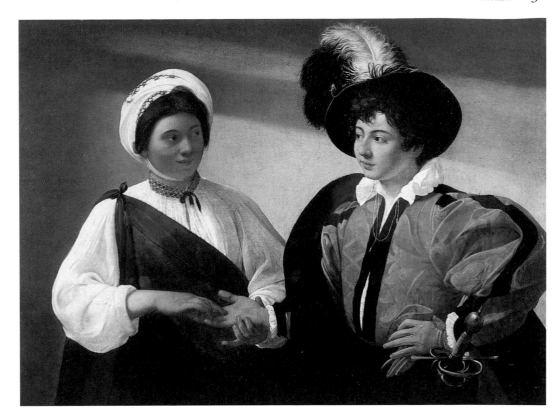

Caravaggio
The Fortune Teller (La Zingara),
c. 1594/95
Oil on canvas, 99 x 131 cm
Paris, Musée National du Louvre

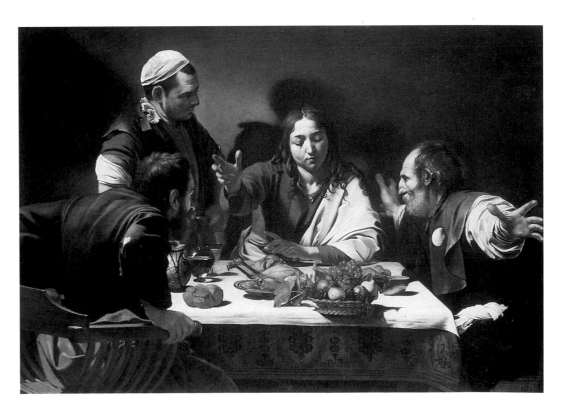

Caravaggio
The Supper at Emmaus, c. 1596–1602
Oil on canvas, 140 x 197 cm
London, National Gallery

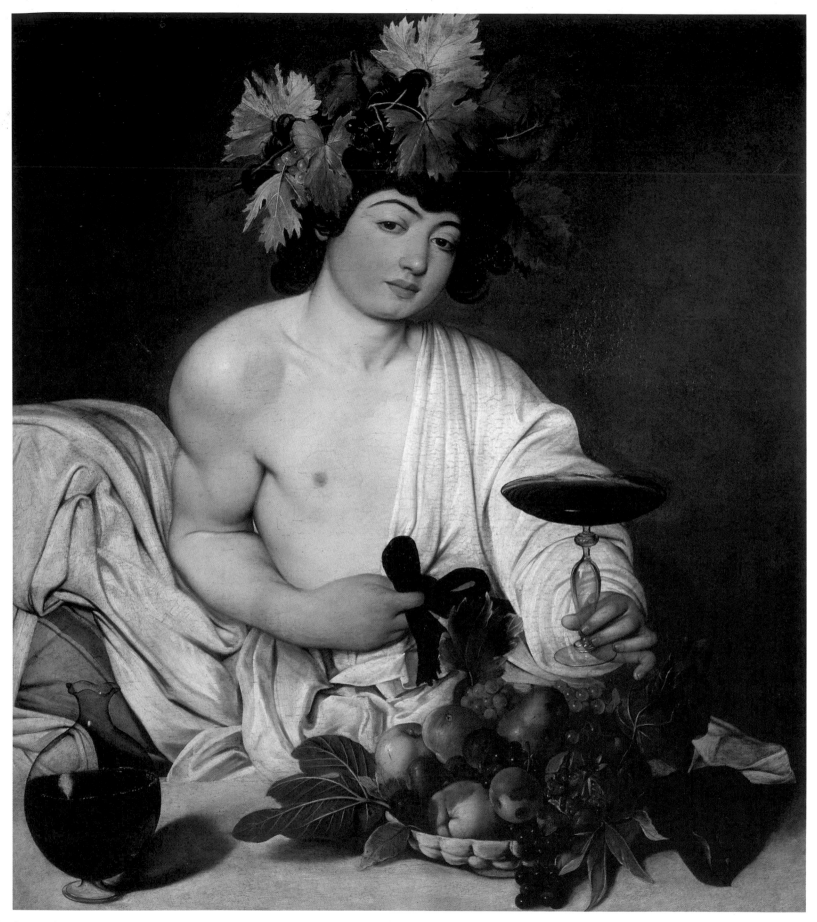

Caravaggio
Bacchus, c. 1598
Oil on canvas, 98 x 85 cm
Florence, Galleria degli Uffizi

CARAVAGGIO

1573–1610

In order to understand the historical position of Caravaggio's art, we have to be aware of his peerless and revolutionary handling of subject matter. This is true not only of his religious themes, but also of his secular themes. His Bacchus no longer appears to us like an ancient god, or the Olympian vision of the High Renaissance and Mannerism. Instead, Caravaggio paints a rather vulgar and effeminately preened youth, who turns his plump face towards us and offers us wine from a goblet held by pertly cocked fingers with grimy nails. This is not Bacchus himself, but some perfectly ordinary individual dressed up as Bacchus, who looks at us rather wearily and yet alertly.

On the one hand, by turning this heathen figure into a somewhat ambiguous purveyor of pleasures, Caravaggio is certainly the great realist he is always claimed to be. On the other hand, however, the sensual lyricism of his painting is so overwhelming that any suspicion of caricature or travesty would be inappropriate.

Something similar can be found in the *Crucifixion of St Peter* in the church of Santa Maria del Popolo, where it is one of two paintings in the Cerasi chapel. Three shady characters, their faces hidden or turned away, are pulling, dragging and pushing the cross to which Peter has been nailed by the feet with his head down.

Caravaggio's St Peter is not a heroic martyr, nor a Herculean hero in the manner of Michelangelo, but an old man suffering pain and in fear of death. The scene, set on some stoney field, is grim. The dark, impenetrable background draws the spectator's gaze back again to the sharply illuminated figures who remind us, through the banal ugliness of their actions and movements – note the yellow rear and filthy feet of the lower figure – that the death of the apostle was not a heroic drama, but a wretched and humiliating execution.

Of all Caravaggio's paintings, *The Entombment* is probably the most monumental. A strictly symmetrical group is built up from the slab of stone that juts diagonally out of the background.

The painting is from the altar of the Chiesa Nuova in Rome, which is dedicated to the Pietà. The enbalming of the corpse and the entombment are actually secondary to the the Mourning of Mary which is the focal point of the lamentation.

Nothing distinguished Caravaggio's history paintings more strongly from the art of the Renaissance than his refusal to portray the human individual as sublime, beautiful and heroic. His figures are bowed, bent, cowering, reclining or stooped. The self-confident and the statuesque have been replaced by humility and subjection.

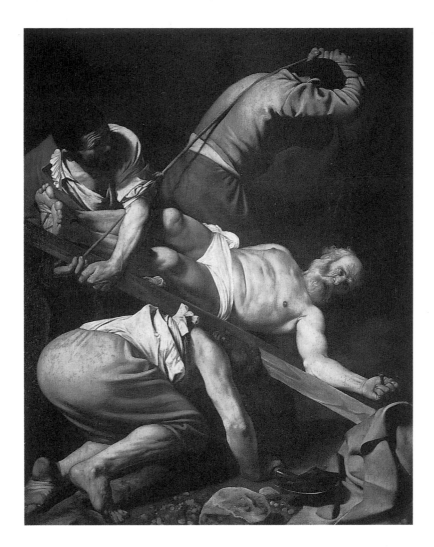

Caravaggio
The Crucifixion of
St Peter, 1601
Oil on canvas,
230 x 175 cm
Rome, Santa Maria
del Popolo

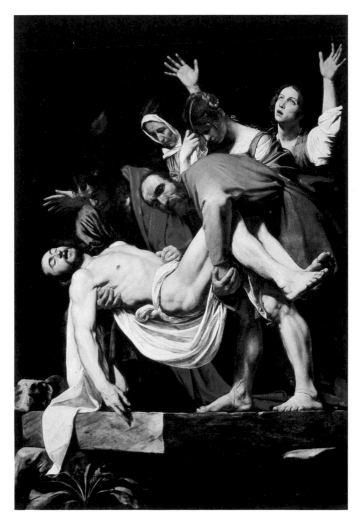

Caravaggio
The Entombment, c. 1602–1604
Oil on canvas, 300 x 203 cm
Rome, Musei Vaticani, Pinacoteca
Vaticana

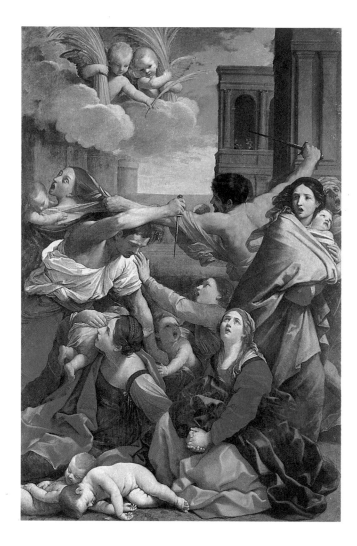

Guido Reni
The Massacre of the Innocents, 1611
Oil on canvas, 268 x 170 cm
Bologna, Pinacoteca Nazionale

GUIDO RENI
1575–1642

Though the historical significance of Caravaggio and his enormous influence on Baroque painting cannot be overlooked, we should not ignore the the fact that there was considerable resistance against the more extreme tendencies in his art, such as the loss of the heroic sphere, or the presentation of the everyday and the ordinary. His greatest rival, whose influence was to extend far beyond that of Caravaggio well into the 18th and 19th centuries, was undoubtedly the Bolognese artist Guido Reni. An early work such as *The Massacre of the Innocents* bears clear traces of his initial links with Caravaggio and, at the same time, already reveals the most important arguments against him.

Before a landscape bathed in light, but set with dark and heavy architecture, a group of eight adults and eight children (including the putti distributing the palm fronds of victory) has been skilfully arranged. The unusual vertical format, rarely used for this theme, and above all the symmetrical structure of figural counterparts indicate that Reni was particularly interested in a specific problem of composition: that of achieving a balance between centripedal and centrifugal movement while combining them in a static pictorial structure. Reni also seeks to achieve this equilibrium in his expression of effects and in the distribution of colour accents.

Reni's *Baptism of Christ*, created in the mid 1620s as a major masterpiece of his mature style, is based on principles of composition similar to those applied in *The Massacre of the Innocents*. The painting is built up into three clearly distinct planes. At the very front, Christ bows beneath the baptismal cup, which John the Baptist pours over him with his raised right hand. The Baptist is standing or, rather, slightly kneeling over Christ on the banks of the Jordan. Below the arc formed by these two figures facing each other in humility, we see two angels who, together with a third figure at the outside left, are holding Christ's robes in readiness. Behind that, the trees, clouds and deep blue sky combine to create a sense of indefinable distance from which the Holy Spirit floats down in the form of a dove.

The entire scene, in its structure and colority, is of overwhelming simplicity. The act of baptism itself is entirely void of bright colours. The matt and shimmering flesh tones of the two nude figures stand out clearly against the middle ground and background, where everything is dominated by the solemn purity of the three primary colours red, yellow and blue. On another level, however, all the figures are closely linked in that expression of complete spiritual devotion that Reni could convey like no other artist.

Reni was able to create a balance of strictly disciplined compositional form and profound sentiment that his many imitators failed to achieve.

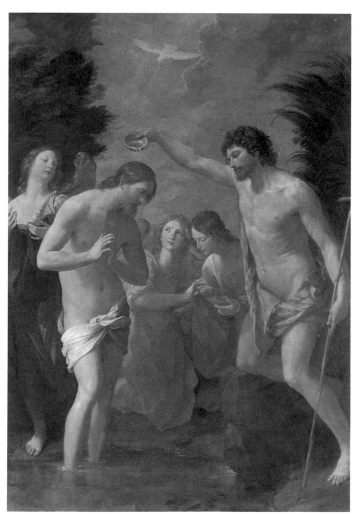

Guido Reni
The Baptism of Christ, c. 1623
Oil on canvas, 263.5 x 186.5 cm
Vienna, Kunsthistorisches Museum

CHRISTOFANO ALLORI

1577–1621

Christofano Allori trained in the school of his father and his grandfather, the leading Florentine Mannerist Agnolo Allori, known as Bronzino. Even if Christofano may be regarded as an artist who broke with late Mannerist tendencies and went on to become an express proponent of early Baroque reform ideas, he nevertheless continues to borrow certain traits of "Mannerist physiognomy" in order to heighten the effect of a picture. In his most famous painting, *Judith with the Head of Holofernes*, the extreme contrast between the dark and bearded head of Holofernes and the angelic face of his murderess owes much to the Mannerist school in which he was trained.

Allori is said to have created a portrait of his mistress Mazzafirra in the figure of Judith and her mother in the figure of the elderly servant woman. The head of Holofernes may be a self-portrait. If this is true, the picture would certainly be a classic example of the so-called "portrait historié" in which real figures are presented as figures from history. Whether or not this is true, the significance of this painting lies predominantly in the enormous erotic tension that emanates not only from the faces of Judith and Holofernes, but also from the sensuality with which the Old Testament heroine is portrayed. This major theme of triumph over tyranny had never before been presented from this point of view.

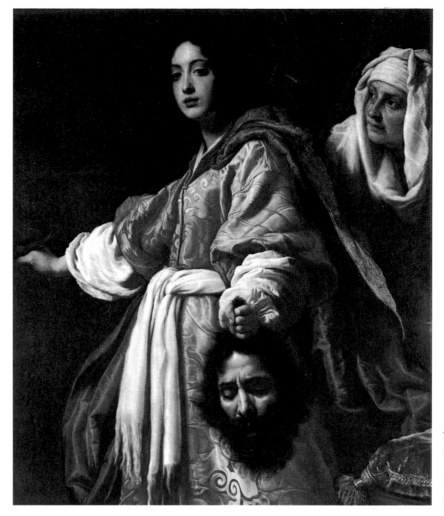

Cristofano Allori
Judith with the Head of Holofernes, 1613
Oil on canvas, 139 x 116cm
Florence, Galleria Pitti

FRANCESCO ALBANI

1578–1660

Albani is a typical representative of the reform movement introduced by Carracci. As a student of the Bolognese artists and a colleague of Annibale who collaborated on the decoration of the Aldobrandini lunettes, he had developed a degree of confidence in his choice and application of stylistic means that allowed him not only to handle large wall areas, but also to create small and intimate devotional pictures.

In his *Sacra Famiglia* or *Holy Family* Albani finds that characteristic blend of sovereign grace and delicacy that today's spectator may find slightly disturbing. Those of us who regard such emotional emphasis and charm with some suspicion tend to forget the specific tasks and needs these pictures were intended to fulfil in order to satisfy a highly educated and cultivated group of buyers. The usual setting for pictures on this theme was a niche in the bedroom of a patrician house or palace intended for devotional purposes. This function also explains some of the typical traits of such a picture: the intimacy of a family gathering, framed by fragments of great architecture, the gestures of devotion of the two angels and the meditative attitude of the elderly Joseph – all signals with which the contemporary spectator would have been able to identify clearly.

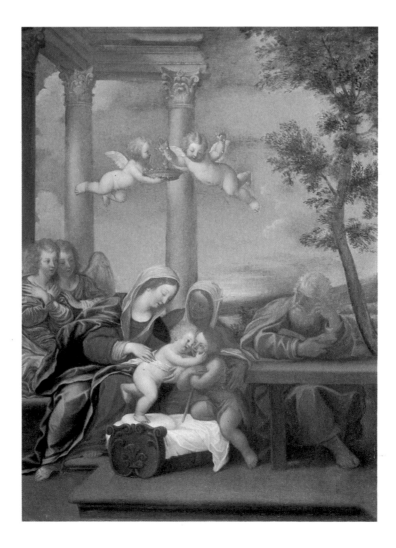

Francesco Albani
Sacra Famiglia (The Holy Family), c. 1630–1635
Oil on canvas, 57 x 43cm
Florence, Galleria Pitti

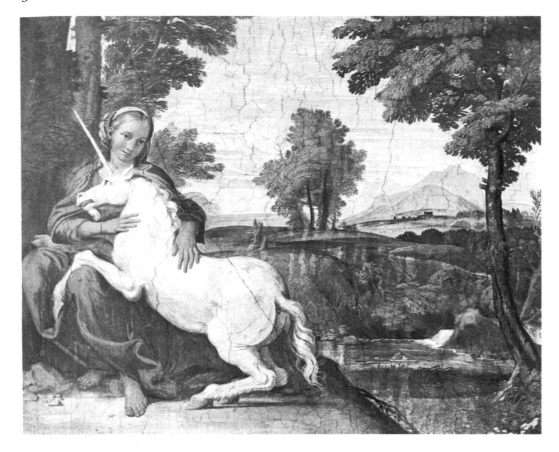

Domenichino
The Maiden and the Unicorn, c. 1602
Fresco. Rome, Palazzo Farnese

DOMENICHINO
1581–1641

The Maiden and the Unicorn is part of the decor commissioned for the Galleria Farnese under the artistic directorship of Annibale Carracci. The fresco above the south-east wall was identified at an early stage as the work of his student Domenichino, yet scholars still disagree as to the extent to which it was executed alone.

Whatever aspects of this painting may be comparable with Annibale's own compositions, this work betrays a very different temperament indeed. The strict avoidance of dynamic spatial diagonals and the grouping of unicorn and maiden parallel to the picture plane correspond much more closely to Domenichino's "classicistic" orientation and his preference for the art of the Renaissance, including the paintings of Raphael. Psychologically, too, much speaks for this painting's entire execution by Domenichino. The unicorn is not merely an attribute of the virgin. In the tradition of this allegory of chastity, the unicorn seeks refuge in the lap of a virgin. Domenichino emphasizes the shyness of these two sensitive creatures who have moved out of the centre of the picture towards the edge of the woods. Instead of the full-blooded sensuality of Annibale's figures in the Galleria Farnese, Domenichino conveys an expression of quiet and gentle introversion.

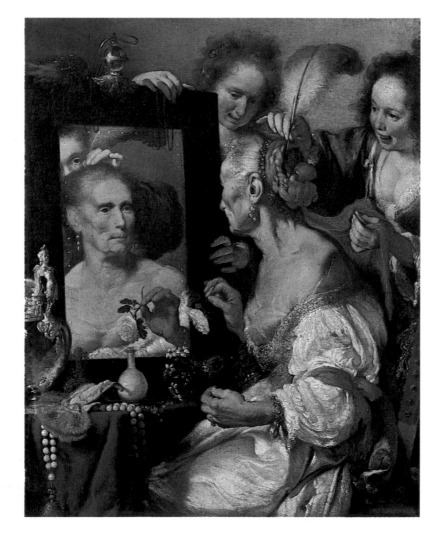

Bernardo Strozzi
Vanitas Allegory,
c. 1635
Oil on canvas,
132 x 108 cm
Bologna, Private
collection

BERNARDO STROZZI
1581–1644

Shortly after completing his apprenticeship, Strozzi entered the capuchin convent of Santa Barbara in Genoa. Although he was to leave the convent later as a lay preacher, his ascetic inner attitude is evident throughout his œuvre. Here, he portrays an old woman with jaded skin and white hair who is denying herself the dignity of old age. She is having her hair sumptuously styled and ornamented with ribbons and feathers, is wearing a youthful, low-cut dress and admiring herself with pleasure in the mirror.

The theme of this painting has a long tradition: the old woman who has not learned to give her life any other meaning but that of ornament and vanity, and who is unable to see the truth or recognize her true self in the mirror. Strozzi's formulation, however, is both individual and new. It makes the most of the surface values, deliberately contrasting the wrinkled skin of the old woman with the fresh complexion of her servant and juxtaposing the firm and rounded forms of youth with the withered slackness of old age. He reveals in the mirror that the old woman's red cheeks are painted with rouge, and he places a blossoming, scented rose in her wrinkled hand. He also shows us the uncriticizing complacency on her face, leaving it up to the spectator to deduce a sense of embarrassment, emptiness, transparent illusion and moral warning.

GIOVANNI LANFRANCO

1582–1647

Sarah, Abraham's childless wife, brought her Egyptian maid Hagar to him so that he would produce an heir with her. However, when she herself bore Isaac, she demanded of her husband: "Cast out this bondwoman and her son: for the son of this bondwoman shall not be heir with my son, even with Isaac." (Genesis 21:10) Hagar and Ismael wandered in the wilderness, dying of thirst. Yet God heard the lamentations of the mother and sent her an angel who showed her the way to a spring and prophesied that her son would be the founder of a great nation.

In the painting, Hagar, who has been crying, is just lifting her head to look up at the angel in astonishment; her child, half hidden behind her shoulder, is also looking up incredulously at the kindly angel who has taken Hagar by the arm and is showing her the way to the water. It is the handling of colour, in particular, that highlights the unexpected aspect of the occurrence so clearly: against the gloomy brown of the wasteland, the sumptuous red and midnight-blue of Hagar's robes radiate like a lamentation of pathos. Her pale, exhausted face is turned towards the shining figure of the angel that seems to have brought light with it. Light bathes the figure, and radiates from the angel towards Hagar, rising in a pale cloud behind the angel and enflaming the orange of his hair and robe.

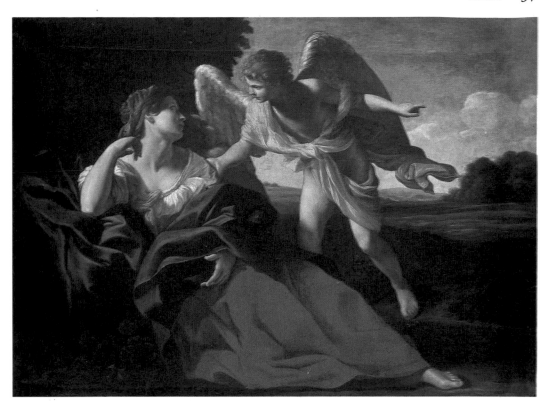

Giovanni Lanfranco
Hagar in the Wilderness, undated
Oil on canvas, 138 x 159 cm
Paris, Musée National du Louvre

DOMENICO FETTI

c. 1589–1623

Melancholy quite literally means "black bile" – indicating the origins of this concept based on the ancient theory of the four body fluids that were believed to determine an individual's temperament.

According to this theory, the emotions and personality traits could be explained by specific physical attributes and were associated with certain qualities: in this case all things dry, cold and heavy. Accordingly, melancholy is associated with the element of earth, the season of winter, the astronomical constellation of Saturn, the leaden star.

Fetti portrays all this in his painting: the head of the woman lies heavy in her hand, her flesh is heavy, her eyelids heavy. The setting is a gloomy landscape of ruins, with no green shoots of spring and without the fruits of summer. Brown tones dominate.

Yet the philosophical temperament of melancholy, rediscovered by the Neoplatonic philosophers in Florence, is already evident. The deep contemplation of the skull, the abandoned tools (plane, palette, brush and plaster model of a torso), the unused attributes of science (astrolabe, book and geometric theory) show that melancholy is not simply a creature helpless against fits of depression, but also a talented and knowing creature, whose inaction stems only from an awareness of insoluble problems.

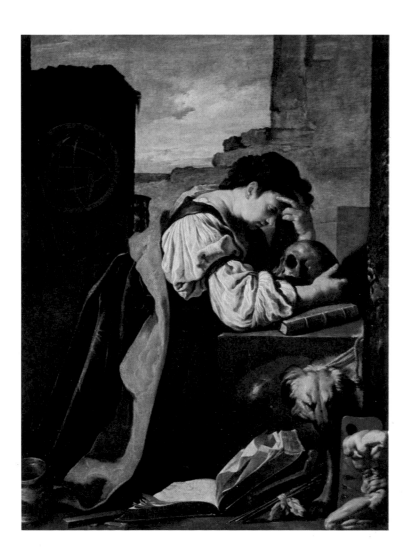

Domenico Fetti
Melancholy, c. 1620
Oil on canvas,
168 x 128 cm
Paris, Musée National du Louvre

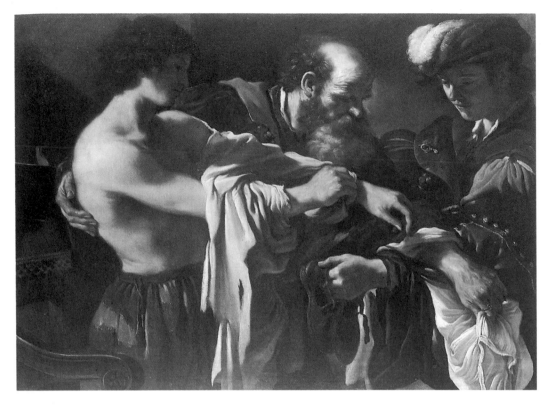

Guercino
The Return of the Prodigal Son, 1619
Oil on canvas, 106.5 x 143.5 cm
Vienna, Kunsthistorisches Museum

GUERCINO
1591–1666

This work is from Guercino's early period, when he was beginning to achieve some initial fame and was already familiar with both the main trends of early Italian Baroque, Caravaggism and the Bolognese reform of the Annibale Carracci school. His decision to use the approach of Caravaggio may have something to do with the choice of subject matter, contrasting the humility of human existence and the possibilities of costume as disguise – a concept formulated by Caravaggio in his paintings for San Luigi and frequently taken up by his followers.

Guercino does not portray the return of the prodigal son as a scene of recognition or joy, choosing instead to depict a more tranquil motif from the biblical parable – the moment when he is given fine robes to wear. On the left in the painting, the young man has stood up and is removing the rags of the swineherd, while an old man, presumably his father, places a hand on his shoulder and takes a clean shirt from the other, foppishly dressed young man who is holding new clothes over his outstretched arm and new shoes in his hand. By using light and shade to divide the group, Guercino lends a singular autonomy to the dynamics of the outstretched and grasping hands, thereby intensifying the narrative in a most unusual way.

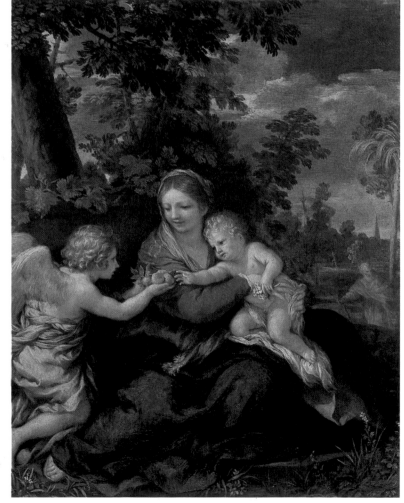

Pietro da Cortona
Holy Family Resting on
the Flight to Egypt,
c. 1643
Oil on copper, 48 x 39 cm
Munich, Bayerische Staats-
gemäldesammlungen,
Alte Pinakothek

PIETRO DA CORTONA
1596–1669

This small painting of the Madonna by the great fresco artist and architect Cortona, founder of Roman High Baroque, may be regarded as the very epitome of a Baroque devotional picture. It shows the Holy Family resting on the flight to Egypt. Joseph is approaching in the background, while in the foreground an angel is offering fruit to refresh the child.

Yet the expression "devotional picture" should be used with caution, for the question of specific types in this genre is still the subject of lively debate and much research remains to be conducted into the eras after the Middle Ages.

Nevertheless, even at first glance, it is clear that the intimacy of Cortona's Madonna painting has more than just an aesthetic intention; it is meant to influence the mood of the spectator in a manner conducive to private prayer. The question of the devotional picture is somewhat complicated by Cortona's use of elements taken from the pagan vocabulary of early Roman Baroque – the idyllic, the pastoral, the antique bucolic landscape with its shady trees and wild wine – in keeping with the increasingly aesthetic interests of clients and buyers. Cortona's powers of synthesis are evident in the way he applies them successfully to create an ecclesiastical image of great atmosphere.

MATTIA PRETI
1613–1699

Preti's biographer Dominici reports that this painting *The Tribute Money* was executed in Malta, where the painter had travelled in 1660 as a Knight of Malta in order to work on the decoration of the cathedral of San Giovanni. The painting is of particular interest in view of Preti's encounter with the works of Caravaggio who had executed some important paintings in Malta after 1607. The theme treated here is the biblical tale culminating in Christ's fateful words: "Render therefore unto Caesar the things which are Caesar's; and unto God the things that are God's." (St Matthew, 22:21) In the dark brown tones of the painting, we can barely make out the six figures half illuminated by a light from some indiscernible source. The tax collector pauses in his writing as Peter hands him the coin. Only this pause indicates the miracle that has just occurred: Peter found the coin in a fish he had caught at the command of Christ (St Matthew 17:24). The turban of a man, a hand holding a pen, another holding a coin, a face in profile with a deeply lined forehead, turned towards another face of which we can recognize only the temple and the nose, a bald head, a little red fabric and the heavy folds of a rough brown cloth are the scattered but not unconnected fragments from which our gaze wanders to and fro, reconstructing the narrative.

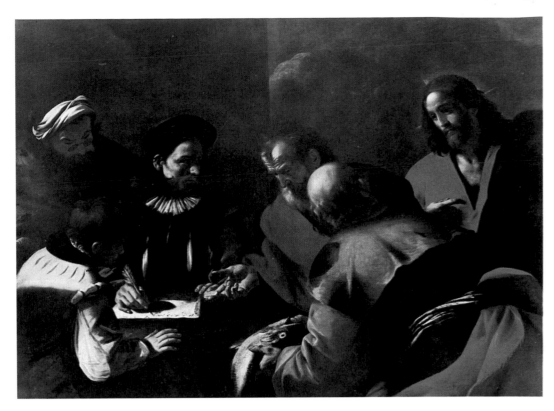

Mattia Preti
The Tribute Money, c. 1640
Oil on canvas, 193 x 143 cm
Milan, Pinacoteca di Brera

SALVATOR ROSA
1615–1673

Democritus, the great pre-Socratic philosopher and founder of a strictly materialist concept of the world sought new explanations for birth and death, appearance and disappearance. According to his theory of "atomism", atoms are the smallest parts of all substancesl, uniting and dividing in eternal swirling movements. His ethical system called for a life of moderation and tranquillity foregoing most sensual joys.

Rosa depicts him in the traditional pose of melancholy, amidst a setting of decay, destruction and desolation. Animal skulls and bones, symbols of the past greatness of antiquity (vase, altar and herm) and symbols of fallen power (the dead eagle) are featured in this wasteland overcast with heavy grey clouds. An owl high in the tree is his only living companion, both a sign of night and of wisdom. Rosa's Democritus is not the philosopher who has reached the goal of his contemplation, nor does he represent serene tranquillity or the superior cognitive powers of the analytic mind. Instead, we see a forsaken thinker contemplating the things that have been the subject of his intellectual endeavours: death, the past, turbulent disquietude, fragmentation. The vanitas symbolism of the objects does not go unanswered: in the figure of the pensive philosopher lies the germ of a response, still caught in melancholy lethargy.

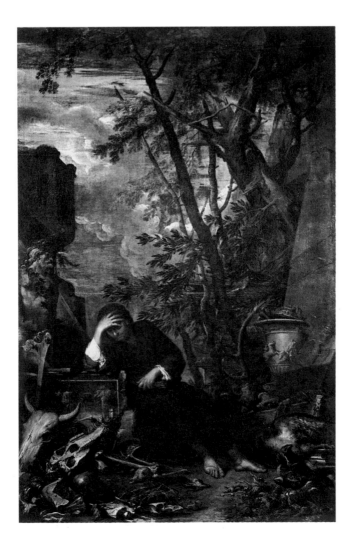

Salvator Rosa
Democritus in Meditation, c. 1650
Oil on canvas, 344 x 214 cm
Copenhagen, Statens Museum for Kunst

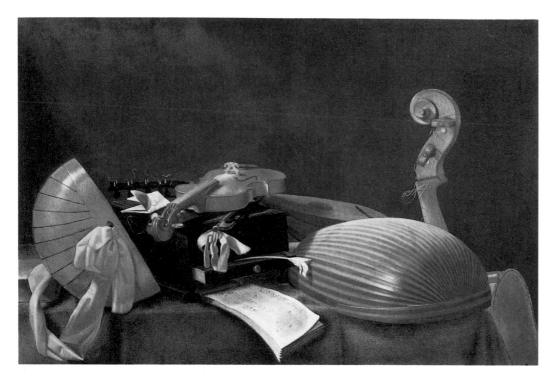

Evaristo Baschenis
Still Life with Musical Instruments, c. 1650
Oil on canvas, 115 x 160 cm
Bergamo, Galleria dell' Accademia Carrara

EVARISTO BASCHENIS
1617–1677

Baschenis, an artist from Bergamo, was a highly specialized painter who worked almost exclusively on the portrayal of stringed instruments. The nearby town of Cremona, a famous centre of violin and lute making, provided him with his models. However, unlike the Netherlandish artists, who often used musical instruments as symbols of hearing, while the transience of the notes recalled the transience of life, Baschenis does not paint scenes of allegorical or moral significance. His emphasis lies on the aesthetic and decorative aspects, as reflected in his singular attention to painterly and ornamental detail in portraying these instruments.

A theorbo, a tenor lute and a descant lute, as well as a violin with bow can be seen together with a writing box, a quill and a book of music set on a table against which a cello is leaning. A mysterious life develops between these objects. The mild sheen on the surface of the woods and the changing hues on the body of the lute create a visual autonomy that almost makes us forget the actual purpose of these instruments. Their curves present unusual viewpoints as though by chance. These musical objects are an almost tangible feast of tranquillity for the eyes.

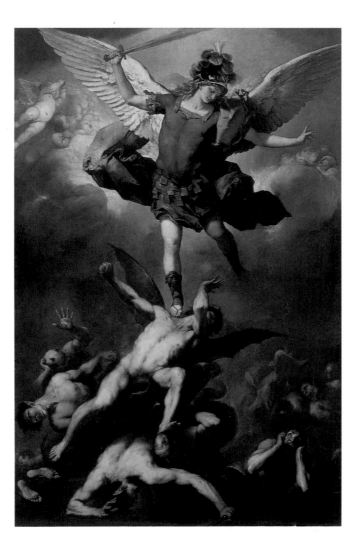

Luca Giordano
The Fall of the Rebel Angels, 1666
Oil on canvas, 419 x 283 cm
Vienna, Kunsthistorisches Museum

LUCA GIORDANO
1634–1705

The fall of the rebel angels is the greatest single theme of the Counter-Reformation. It is a theme that allowed a church in conflict to present its propaganda in the form of its struggle against all forms of heresy. At the same time, the theme of the struggling angel also symbolized the triumph of light over the rebellion of the powers of darkness – giving the painter an opportunity to create a chiaroscuro charged with meaning, in which heaven and hell, the incense of the blessed and the brimstone of the damned are contrasted in an extremely confined space, creating an arc of tension within which the knight-like angel spreads his broad wings and wields his sword in a sweeping gesture of victory.

Giordano sets the scene with relatively few figures compared to, say, Rubens' *Great Last Judgement*. Against a background of deep golden light, the archangel balances with an almost balletic movement on the heavy breast of Lucifer, entangled amidst a group of his servants, his angular and batlike wings cutting through the hazy sfumato of the hellfire. What appears at first glance to be so dramatic is not in fact the depiction of a struggle as such. Michael is not attacking the figures from hell with his sword, but is holding it aloft like a sign, as though his mere appearance were enough to cast Satan and his followers into eternal damnation.

BACICCIO
1639–1709

This small oil painting showing the *Apotheosis of St Ignatius*, the founder of the Jesuit order, is a bozzetto – a preparatory sketch for the fresco Baciccio executed for the vaulting of the left transept of the order's principal church of Il Gesù in Rome. The bozzetto differs from the fresco only in a few of the angel figures and in the use of stronger colours. Although the apotheosis of the saint has a firm place in the overall ecclesiastical programme of the church, from which it cannot be dissociated, this oil study is nevertheless an independent painting, executed with greater care than one might expect of a sketch.

The saint is carried heavenwards by a group of music-making, flower-strewing angels that are inebriated with joy. His arms spread wide, he soars towards a golden stream of light that is breaking through from the depths of the heavens. Baciccio does not treat this supernatural triumphal procession as a transcendental vision, but as a real occurrence. The body of the saint and the angels are not transcended by light, but are sculpturally tangible, and in its earthly corporeality, the painting mediates between the world of the spectator and the light whose source remains invisible to us, but which is perceptible in the figure of the saint.

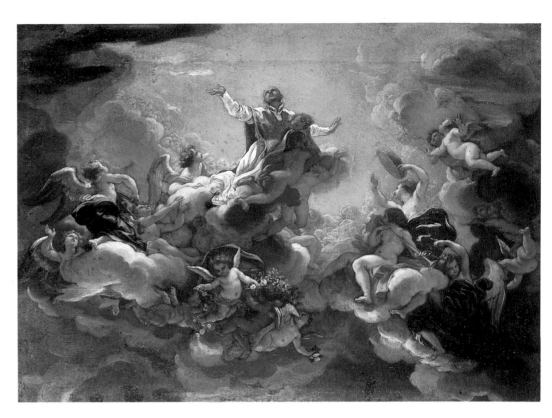

Baciccio
The Apotheosis of St Ignatius, c. 1685
Oil on canvas, 48 x 63.5 cm
Rome, Galleria Nazionale

GIUSEPPE MARIA CRESPI
1665–1747

Through the oiled paper in the window frame, a milky light falls into the humble servant's room. Clothing is scattered untidily on the floor and thrown over a roughly made bench. A few household objects and some washing on a bar hang against the bare brick wall, whose only remaining decoration consists of a few personal items. The pretty woman who lives in this room, a maid or servant girl, is sitting on the edge of the bed, dressed only in a shift. As she concentrates on her search for a flea that has probably hidden on her breast, she reveals her round knees, her plump arms and her well formed shoulder.

The complete intimacy of this scene and the still life of the utensils anticipates a theme that was to become typical of late 18th century taste: innocence glimpsed unawares. Although there are a number of allegorical reflections – the little dog at the end of the bed, the roses in the vase next to the cosmetic jar – they nevertheless do not seriously mean to identify this girl with Venus. The "keyhole perspective" also leaves it up to the spectator to choose his or her own interpretation of the scene.

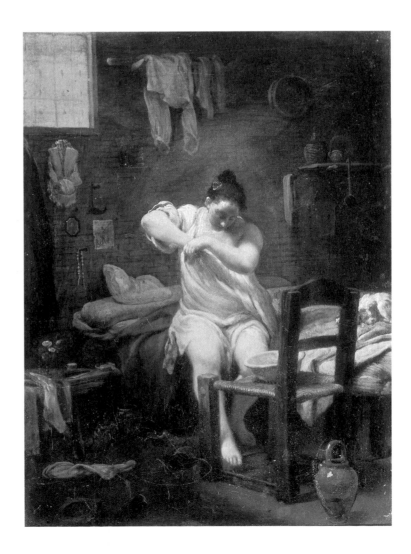

Giuseppe Maria Crespi
The Flea, c. 1707–1709
Oil on copper, 46 x 34 cm
Florence, Galleria degli Uffizi

Quentin Varin
Presentation of Christ in
the Temple, c. 1618–1620
Grisaille, 46 x 36.5 cm
Beauvais, Musée
Départemental de l'Oise

QUENTIN VARIN
c. 1570–1634

The scene shows Mary, who has freed her son
from service in the temple by bringing a sacri-
fice, for Jewish custom requires that the first-
born belongs to Yaweh. In the gospel accord-
ing to St Luke, this is linked to the purifica-
tion sacrifice of the mother, indicated here by
the doves in the basket of the servant girl. Old
Simeon is a seer who recognizes the divinity of
the child immediately.

Varin's painting, which is hardly a master-
piece of French art, gives some indication of
the high stylistic quality of even the minor
masters of the Baroque. This is a so-called gri-
saille picture, which means it is painted en-
tirely in monochromatic grey tones. Similar
monochromatic paintings had existed since
the late Middle Ages in other forms, generally
derived from coloured earth. Varin's *Presenta-
tion of Christ in the Temple* explores the subtle
boundary between a palette reduced entirely
to black and white and the traces of a delicate
germ of colour. The grey is by no means col-
ourless. Varin has mixed it using a dark green-
ish earth, brown and a slightly yellowish
white; what is more, he lets the dark red tone
of the canvas grounding shine through some
thinly painted areas, for example the altar
cloth, thereby achieving a texture of extreme
sensitivity.

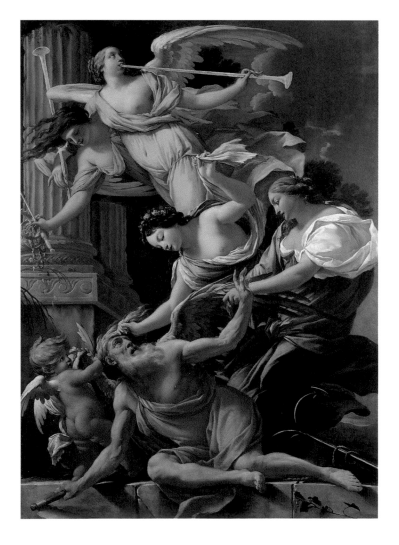

Simon Vouet
Saturn, Conquered by Amor,
Venus and Hope, c. 1645/46
Oil on canvas, 187 x 142 cm
Bourges, Musée du Berry

SIMON VOUET
1590–1649

Vouet had spent 15 years in Italy when
Louis XIII and Cardinal Richelieu called him
back to France to make him the artistic rep-
resentative of their ideas, ideals and ideology.
What made Vouet seem the right man for the
job was not only his virtuoso painterly skills,
but also his preference for large-scale yet beau-
tifully balanced composition. In addition to
religious themes, he also favoured allegorical
depictions.

Saturn as an old man, with his attribute,
the scythe, in his hand, has fallen to the
ground – he embodies time. A young woman
is pulling hard at one of his wings and the an-
chor at her feet indicates that she represents
Hope. Beside her, a beautiful woman with a
bare breast is tugging at his grey hair – she
represents Truth. Above this group, in an
iridescent robe, floats Fama, the figure of
fame, who announces her presence with a
trumpet. She has placed her arm around a
figure whose hair is blowing forwards – the
traditional attribute of Occasio, the fortunate
occasion – with the insignia of power and
wealth in her hand, which are also the at-
tributes of Fortuna, the allegory of luck or
good fortune. The luminous colours, the dra-
matic and yet masterly movement, are equival-
ents of the affirmative content of the allegory.

LOUIS LE NAIN

C. 1593–1648

We cannot be entirely sure as to which of the three Le Nain brothers actually painted this picture. Right up to the present day, art historians have been unable to determine the individual contributions to their joint works. Their peasant paintings – which constitute only a part of their overall œuvre – brought them fame, particularly in the 19th century.

There is a considerable risk of judging them primarily on grounds of their humble rural genre scenes. They do not present poverty imbued with profound religious faith (as do the works of Murillo), but already show signs of interpreting the "simple life" in the sense of an idyll. The richly nuanced use of brown and grey tones, heightened by a few scarlet accents, takes on a sophisticated independence for which the subject matter serves merely as external legitimation. The delicacy of colour finds its counterpart in the composition. The children on the haycart, the mother with the infant on her lap, the little swineherd with two girls: each form distinctly separate groups which, at the same time, are like the verses of a song praising the beauties of rural life – a song sung by a city dweller of high society.

This is a picture of unforgettable gravity. Far removed from the so-called bambocciada with which Le Nain's peasant paintings are generally compared, there is not the slightest hint of caricature or humour here. The few figures grouped around an almost empty centre show nothing of the pleasant side of rural life so frequently depicted as serene and edifying. Le Nain's peasant family is not in Arcadia, and nobody familiar with the peasants and herds of this poetic realm in the 17th century is likely to have misconstrued it in this vein. Few paintings cast such an accusing shadow on the art of the Baroque with its exuberant celebration of sensual pleasures.

On the right, a man in rags stands beside a boy who is sitting on the ground, his legs stretched out before him with a cockerel on his lap; opposite him is a woman on a chair and, in the background, a young woman with a child in her arms stands on the steps of the dilapidated house from whose windows and doors the other inhabitants peer out shyly. The figures are quite motionless. Neither joy nor sadness, anticipation nor rejection can be detected in their faces. Only the great indifference of their earnest gaze calls upon the spectator to take a similar stance and underpins the realism of the composition in its portrayal of an unapproachable dignity that brooks neither the rhetoric of accusation nor transfiguration.

The art of Le Nain is direct. Neither allegory, nor symbol, nor history: everything is meant just as we see it.

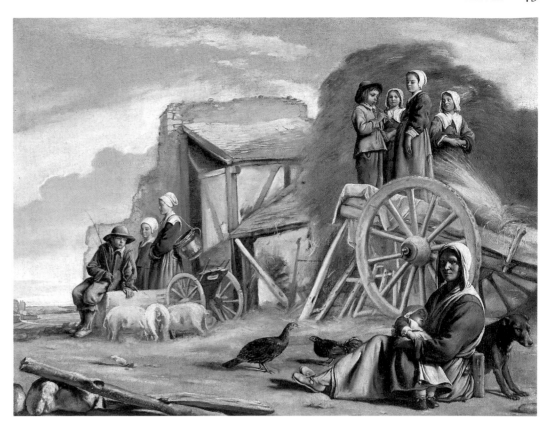

Louis Le Nain
La Charette (The Cart), 1641
Oil on canvas, 56 x 72 cm
Paris, Musée National du Louvre

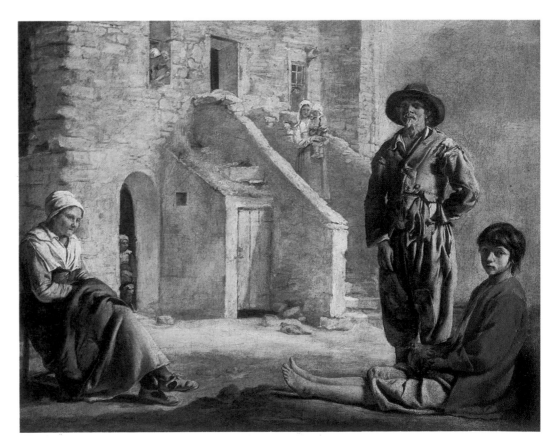

Louis Le Nain
Peasants at their Cottage Door, undated
Oil on canvas, 55 x 68 cm
San Francisco (CA), The Fine Arts Museums of San
Francisco, California Palace of the Legion of Honor

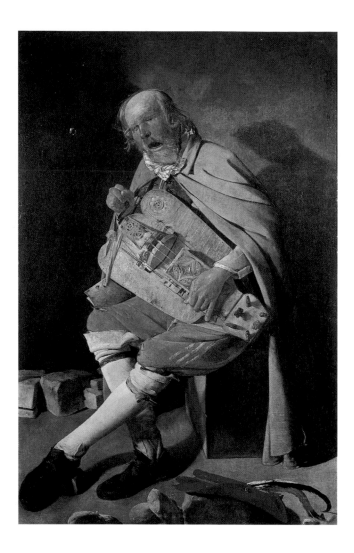

Georges de La Tour
Hurdy-Gurdy Player,
c. 1620–1630
Oil on canvas, 162 x 105 cm
Nantes, Musée des Beaux-Arts

GEORGES DE LA TOUR
1593–1652

The brutal realism and brackish, earthy colours brightened by a single vibrant red immediately call to mind the Spanish painting to which the works of this artist from Lorraine have frequently been attributed. "Repulsive, cruel truth; a Spanish painting attributed to Bartolomé Esteban Murillo. It is not without charm. Fine colours, realistic expression…" Such was the ambivalence with which Stendhal, an experienced connoisseur of Italian and French painting, described his impressions in "Mémoires d'un touriste", astutely pinpointing the very core of this portrayal: its seemingly paradoxical attempt to apply the cultivated art of painting to a thoroughly miserable subject matter. We can almost hear the discordant voice of the blind man with his hurdy-gurdy. Yet this unflattering presentation does not represent a sympathetic attitude to the socially disadvantaged of the day. On the contrary. Subjects of this kind were intended to amuse high society, who enjoyed gracing the walls of their patrician homes with such melodramatic scenes.

The moralizing genre of painting made popular by Caravaggio includes the painting of the trickster. An inexperienced, wealthy and opulently dressed young man is being cheated at cards in the dubious company of a courtesan with her lover and a conspirative servant girl. Wine and the promise of erotic adventure have made the young dandy so light-headed that he does not notice the unsubtle trick of an ace being drawn from his opponent's belt. Such depictions may be regarded as brothel scenes – a woman drinking wine in the company of men could be nothing but a whore in the eyes of a 17th century spectator. The three accomplices are after the young man's money, and they communicate with each other through glances and subtle gestures. The spectator becomes a witness and the sideways glance of the servant girl seems to make the spectator an accomplice as well.

In the 17th century, St Sebastian was one of the most important of all patron saints. Prayers were offered to him seeking protection against disease, especially the plague, which had affected the region of Lorraine particularly severely. In reference to the medieval legend in which the widow Irene takes pity upon the martyr who has been left for dead, we clearly see the expectations of care and attendance demanded of this saint. La Tour has painted a night scene illuminated by the torch Irene is holding. Grief, empathy and a range of light that runs from dazzling brilliance to deepest darkness all add up to a moving and meditative comment on charitable kindness.

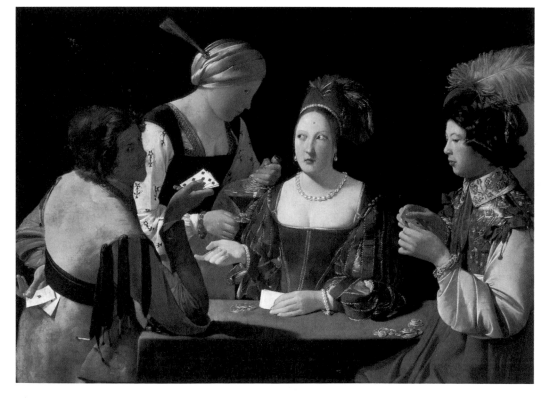

Georges de La Tour
The Card-Sharp with the Ace of Spades, c. 1620–1640
Oil on canvas, 106 x 146cm
Paris, Musée National du Louvre

Georges de La Tour
St Sebastian Attended by St Irene, c. 1634–1643
Oil on canvas, 160 x 129cm
Berlin, Gemäldegalerie

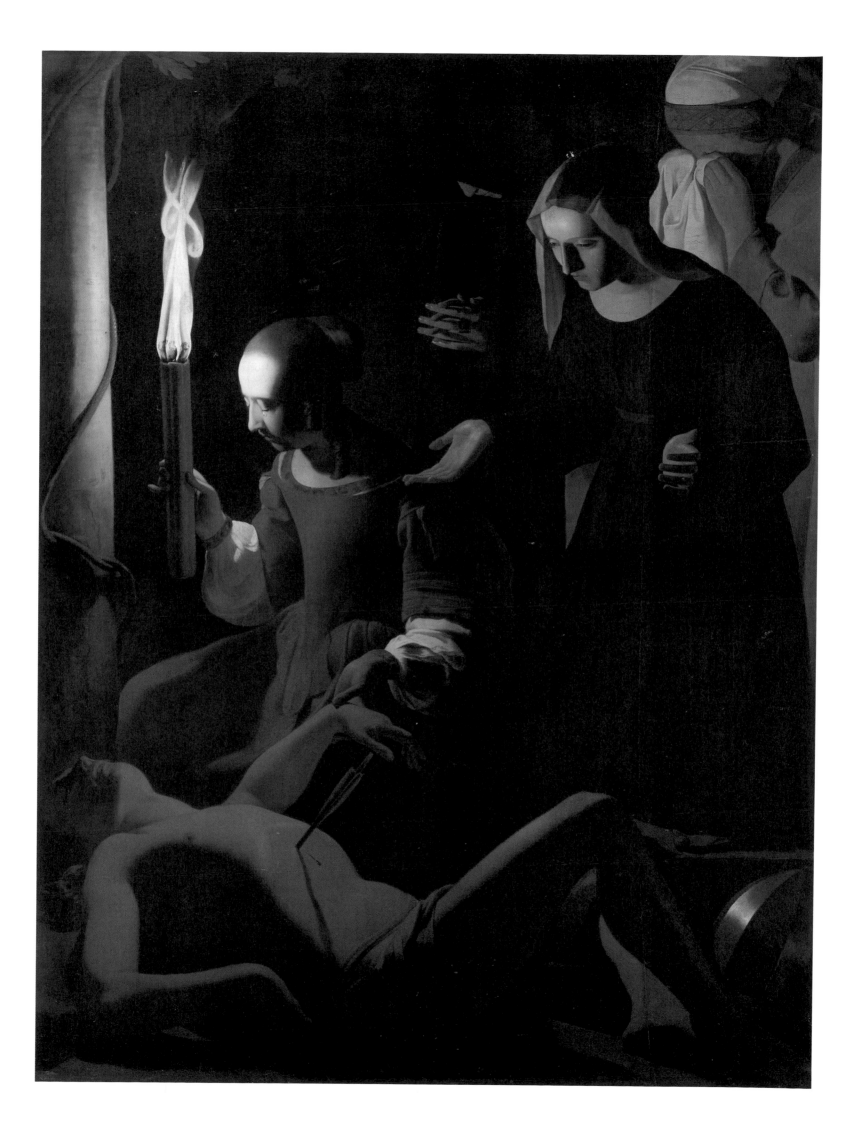

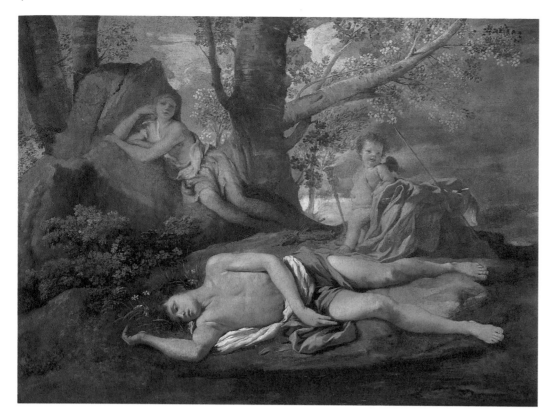

Nicolas Poussin
Echo and Narcissus, c. 1627/28
Oil on canvas, 74 x 100 cm
Paris, Musée National du Louvre

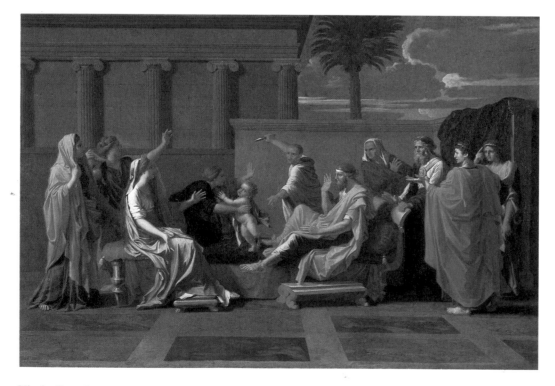

Nicolas Poussin
Moses Trampling on the Pharaoh's Crown, 1645
Oil on canvas, 99 x 142.2 cm
Woburn Abbey, Duke of Bedford collection

NICOLAS POUSSIN
c. 1593/94–1665

According to Ovid's Metamorphoses, the nymph Echo fell in love with the beautiful young Narcissus. However, her love was unrequited and she wasted away in sorrow until only her voice – echo – remained. Later, Narcissus caught sight of his own reflection in a pool, and was so enamoured of the beautiful youth beyond his reach that his self-love destroyed him and he turned into the flower that bears his name.

Poussin has painted Narcissus reclining by the waterside with the pallor of death upon him, and narcissi already growing by his head. Behind him is Amor with the torch that ignited the love of Echo, whose incorporeally elegiac image can be seen amidst the rocks.

A text by Josephus Flavius, *Antiquitatis Judaicae*, tells how the daughter of the Pharaoh, finding the baby Moses amongst the rushes, decided to present the child to her father. Her father plays with the child and, in fun, places his crown on the baby's head. Moses casts the crown to the ground, so that it breaks. The high priest, recognizing the boy as the one who has been prophesied to overthrow the Pharaoh, makes to kill him. Only an appeal invoking the child's innocence and the future judgement of God save Moses.

Poussin uses a wide variety of rhetorical gestures in order to express the various reactions to the incident in a classical mode. The gestural drama reaches its climax in the "dialogue" between the high priest who has raised his dagger to strike the child and the raised left arm of the nurse-maid behind the Pharaoh's daughter.

The iconography of St Cecilia did not always depict the martyr as a musician. Raphael, for example, portrayed her listening enthralled to the sounds of celestial harmonies in such transports of delight that the instruments of earthly music fell from her hands. Poussin's interpretation, on the other hand, shows her playing music herself.

Against a background of landscape and classical architecture, a putto draws a red drape to the side above the saint, creating the backdrop for an intimate concert. St Cecilia is playing on a keyboard instrument, accompanied by two singing angels who are standing before a column. In this way, Poussin has created a synthesis between the earthly musicianship of the saint and the strains of celestial music. Through the involvement of the angels, the earthly sounds are transformed into celestial harmony, beyond the hearing of profane ears, but visualized in the full-toned chord created by the cardinal trio of red, yellow and blue, which is played in every possible modulation from brightly illuminated planes to areas of darkness.

Nicolas Poussin
St Cecilia, c. 1627/28
Oil on canvas, 118 x 88 cm
Madrid, Museo del Prado

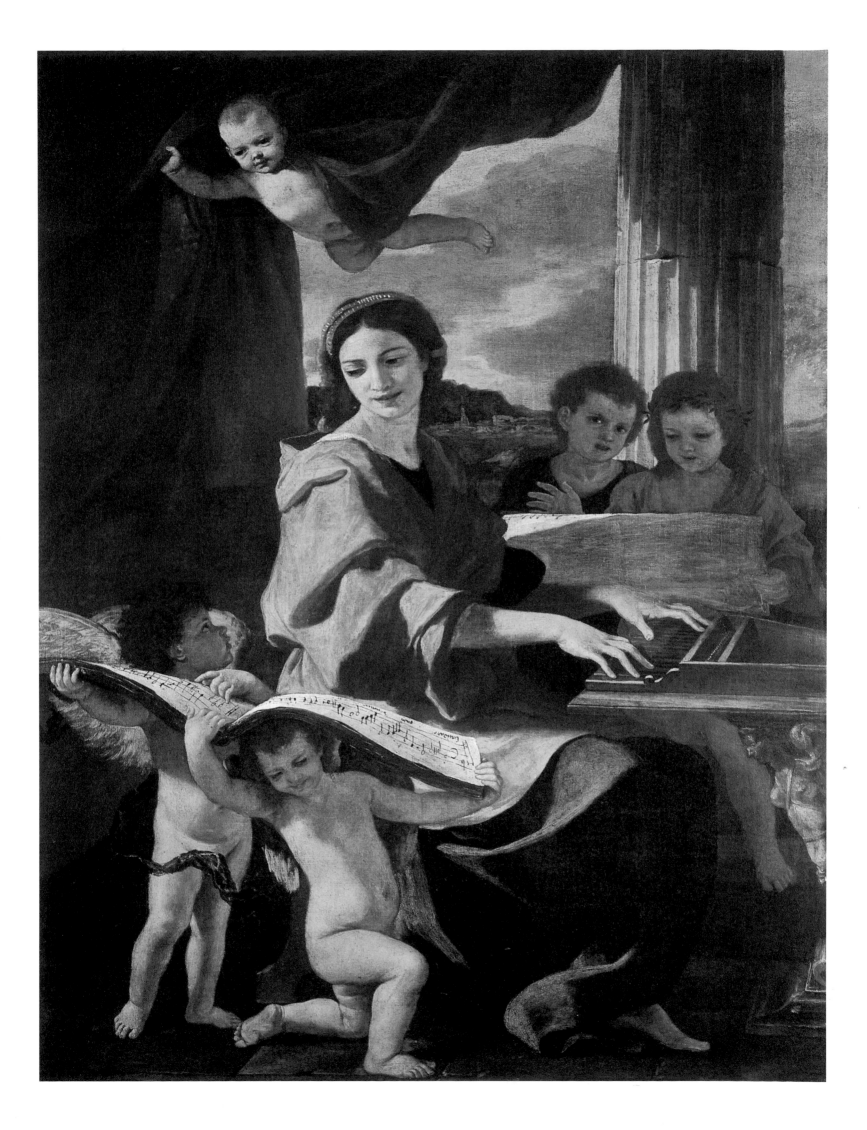

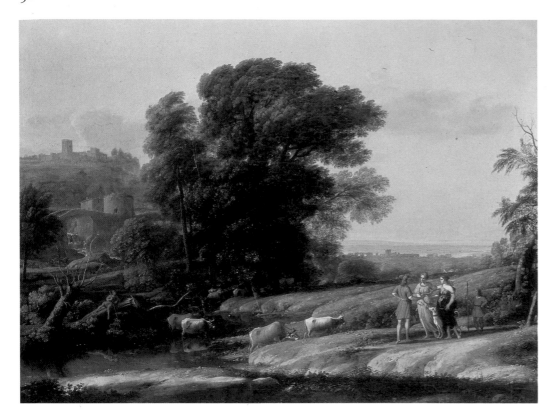

Claude Lorrain
Landscape with Cephalus and Procris Reunited by Diana, 1645
Oil on canvas, 102 x 132 cm
London, National Gallery

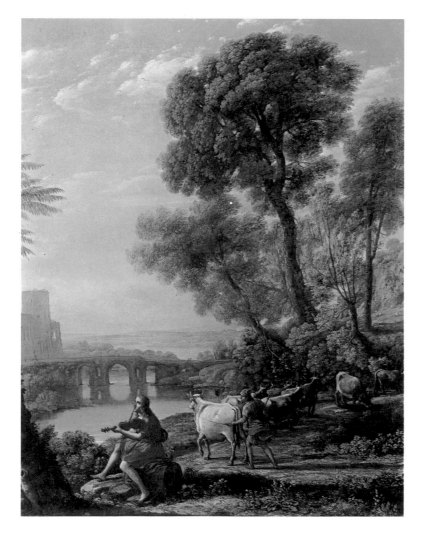

Claude Lorrain
Landscape with Apollo
and Mercury, c. 1645
Oil on canvas,
55 x 45 cm
Rome, Galleria
Doria-Pamphilj

CLAUDE LORRAIN
1600–1682

Claude Lorrain is perhaps the first artist we may justly describe as a landscape painter in the modern sense. His specialization in this field was determined by his lifestyle and his working method, his intensively meditative observation of nature and his open-air sketches. His classification as a pure landscape painter seems at first to contradict the fact that, in spite of his obvious lack of talent in the portrayal of figures, he refused to forego their inclusion in his landscapes and frequently had them painted by his assistants or artist colleagues.

The people in his paintings, however small and seemingly irrelevant they may appear, are obviously more than mere staffage or props in the sense of a decorative element. They are part of the landscape itself, the embodiment of its respective character through mythological narrative, in which nature becomes the scene of an encounter between the mortal and the divine.

Nothing in this scene showing the reconciliation of Cephalus and Procris through Diana points towards the tragic end that begins to unfold here. The tale is told by Ovid in his Metamorphoses: Procris flees from her husband Cephalus, who has accused her of being unfaithful to him, and turns to Diana and her hunters. Diana gives her a hound and a magic javelin that never misses its mark. Procris gives both to Cephalus on their reconciliation, which Claude – unlike Ovid – describes as occurring in the presence of Diana. To the spectator at the time, the rest of the story, in which jealousy seals the fate of the couple, would have been evident. Tortured by fears of her husband's unfaithfulness, Procris hides in the bushes to spy on him. Cephalus, alarmed by a rustling sound, casts his spear into the bushes and unwittingly kills Procris. In view of this background, Claude's peaceful painting has to be interpreted as a warning against unfaithfulness and jealousy.

This pastoral scene with Apollo and Mercury suppresses all suggestion of enmity in this remarkable act of divine cattle-rustling related in the tale of the theft of Admetus' cattle. If ever the transposition of poetic concepts into works of painting were appropriate, then surely in a painting such as this one, in which a truly lyrical theme – Apollo playing, singing and so immersed in his music that he does not even notice Mercury surreptitiously leading away the peerless cattle of Admetus. The lyricism lies in the affinity between the rapt emotional state of Apollo, which seems to merge with the atmosphere of the landscape, and the light-drenched expanses of the plain through which the shimmering river flows. It was a widespread concept in Baroque art theory that poetry was verbal painting and painting was silent poetry, a concept fully expressed in this work.

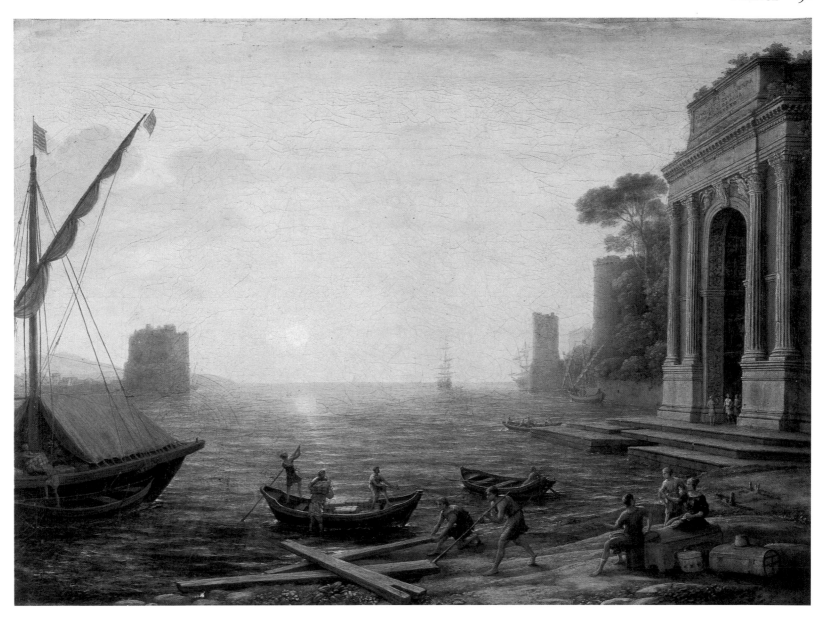

The great "inner" theme of 17th century painting is light: illumination from some invisible source contrasted with all-powerful darkness; as in the work of Caravaggio, the living light of a candle whose pale white flame permeates every nuance of shadow; as in the work of Georges de La Tour; or a view of the sun – boldly attempted for the first time by Claude Lorrain – shimmering through the fragile veil of the morning haze and dissolving the wide horizon of the sea with distant sails, landscapes with mountains, cities and towers.

This light seems to reach the spectator from a world of the imagination rather than reality. The port with its Roman triumphal arch and crumbling defence walls may well be the setting for a scene from everday life in ancient times. Yet what we see here is not a reconstruction of classical antiquity. The ancient buildings are overgrown by bushes and grass; antiquity is merely an image, a ruin recalling a timeless world in which a transfiguring sun casts a morning light without shadow. Just as it is impossible to pinpoint the century in which the people of a Claude Lorrain painting live, so too is it impossible to name the countries where his landscapes might be found.

Like no other artist before him, Lorrain made poetic reality the subject of his painting.

In the painting *Seaport at sunrise* Claude Lorrain shows bales of goods being transported between a cargo boat and the nearby shore using small boats. We cannot even tell for sure whether the goods are being transported towards the cargo boat or away from it. The labourers, the conversation on the shore and the group by the triumphal arch are mere staffage, little more than attributes of the landscape. This is not a scene of contemporary or ancient poetry, and the great classical ruins are not peopled by figures from mythology. In his own way, Claude Lorrain contributed towards genre painting and the preference of his epoch for portrayals of ordinary people. One might describe this transposition of everyday life into the past as "genre historié" – in much the same way that we use the term "portrait historié" to describe the technique, so popular in the Netherlands, of depicting living personalities as biblical or mythological figures.

Claude Lorrain
Seaport at Sunrise, 1674
Oil on canvas, 72 x 96 cm
Munich, Bayerische Staatsgemälde-
sammlungen, Alte Pinakothek

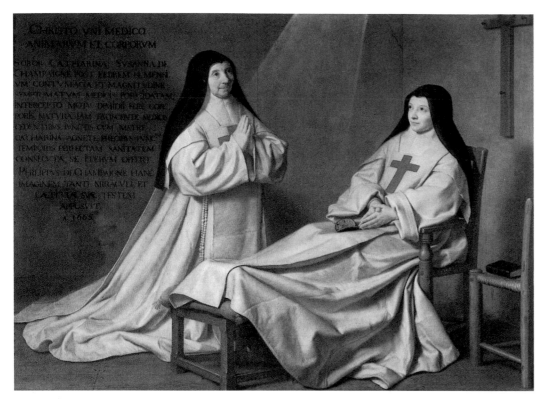

Philippe de Champaigne
Ex Voto (Mother Superior Cathérine-Agnès Arnauld
und Sister Cathérine de Sainte-Suzanne, the Daughter
of the Artist), 1662
Oil on canvas, 165 x 229 cm
Paris, Musée National du Louvre

PHILIPPE DE CHAMPAIGNE
1602–1674

The Flemish-born painter Philippe de Champaigne was the leading portraitist at the court of Marie de Médici and Louis XIII. His profound Catholic faith began to find increasingly clear expression in his art after a number of personal blows of fate; his wife died in 1638 and his son in 1642. Both his daughters entered the famous convent of Port-Royal. The youngest died in 1655 and one year later, the elder sister took her vows under the name Cathérine-Suzanne.

We have to be aware of these details in order to understand the *Ex Voto*, for this painting is closely linked with the personal sentiments of the artist. It shows two nuns dressed in the habit of their order. The elderly nun is kneeling and praying with an expression of contentment on her face, while the younger nun is seated on a chair, her legs stretched out to rest on a footstool, joining the elderly nun in prayer. A lengthy Latin inscript explains the story. Champaigne's daughter Cathérine, the younger of the two nuns in the painting, had been struck by paralysis and had regained her health after nine days of prayer. It is a mark of his faith that the artist does not portray the miraculous healing itself, but the prayer of his daughter and her Mother Superior.

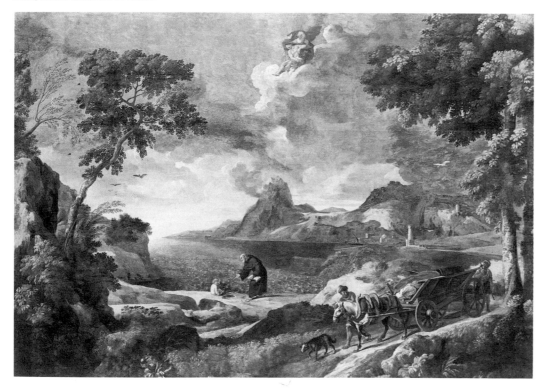

Gaspard Dughet
Landscape with St Augustine and the Mystery
of the Trinity, c. 1651–1653
Oil on canvas, 278.5 x 385.5 cm
Rome, Galleria Doria-Pamphilj

GASPARD DUGHET
1615–1675

A brother-in-law and student of Poussin, Dughet soon developed his own expressive syntax, particularly in landscape painting, which bears evidence of his familiarity with the works of Elsheimer, Rosa and Bril. Here, too, we sense his different temperament, for excitement and fantasy enliven the peaceful tranquillity of the landscape. The enigma of nature becomes the subject matter, creating new relationships between the pictorial space and the subject matter. According to legend, St Augustine was walking on the beach of Ostia, contemplating the problem of the Holy Trinity (which appears here as a vision in the clouds) when he noticed a child trying to spoon the sea into a hole in the sand. On pointing out the futility of the task, he received the response that it was equally futile to attempts to explain the mystery of the Holy Trinity.

In Dughet's painting, the legend is rendered plausible by the portrayal of the landscape. The intensive atmosphere – the brooding expanses of the sea, the looming storm, the gathering clouds – create a sense of anticipation as though the spectator, too, must seek to understand some mystery. At the same time, the spectator senses the triviality of human existence reflected in the small figures set in a universal landscape.

SÉBASTIEN BOURDON
1616–1671

Because of his skilful mastery of a wide variety
of styles, Sébastien Bourdon has never
achieved a clear-cut position as an artist. One
of the strongest influences on his painting was
undoubtedly Nicolas Poussin. This is clearly
reflected in *The Finding of Moses*, which is a
particularly fine example of Bourdon's skill in
handling the subjects of other artists with
great originality.

An informal yet dignified procession of
figures has approached the banks of the Nile
where two men have recovered the basket with
the infant and are handing it over to the ser-
vant women. However familiar the classical
robes of Poussin may appear here, the treat-
ment of landscape and the handling of colour
are entirely different. A sense of distance is cre-
ated, structured by light and shadow, sil-
houettes and laconic modelling, and dotted
with dark masses of vegetation and grey archi-
tecture.

This imaginary landscape presented in
sweeping planes contrasts sharply with the
gentle modelling of the robes. Any association
with Poussin or other artists tends to be dis-
pelled by the strongly contrasting portrayal of
the figures and the landscape.

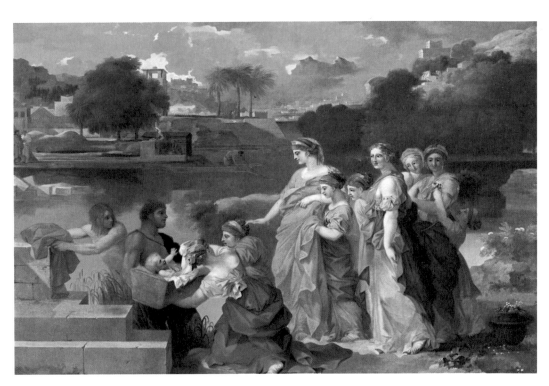

Sébastien Bourdon
The Finding of Moses, c. 1650
Oil on canvas, 119.6 x 172.8 cm
Washington, National Gallery of Art

PIERRE MIGNARD
1612–1695

Mignard's artistic career is condensed in this
painting. He trained primarily in the Paris
workshop of Vouet, the great master of finely
balanced classicistic compositions, and ele-
gantly allegorical formulation. This is re-
flected in the appealing pose of the girl and
the dignified blue drapes of her robe, more ap-
propriate to the Venus of Vouet than to the
portrait of a child.

What is more, the allegory itself also refers
to Mignard's teacher; the notion of the individ-
ual as a soap bubble – "homo bulla" – points
to the transience of human existence, a con-
cept that is further underlined by the watch
Mignard has painted on the table. We might
also muse on whether the shell containing the
soap is intended to indicate Venus, whose at-
tribute it is.

Mignard's close reading of Titian's works is
also evidenced by the little dog and the land-
scape so frequently found in Titian's Madonna
paintings. Just four years before his death,
Mignard was appointed "peintre du roi" as suc-
cessor to Le Brun, whose artistic bounds he
surpasses in this portrait. The pathos of
vanitas and the pomp of representation do not
set a rigid pattern here, for the vitality of the
child's personality clearly predominates over
the Baroque pictorial traditions.

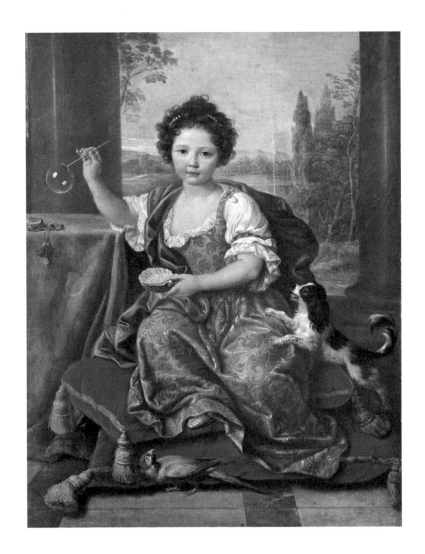

Pierre Mignard
Girl Blowing Soap
Bubbles, 1674
(Marie-Anne de
Bourbon)
Oil on canvas,
132 x 96 cm
Versailles, Châteaux
de Versailles

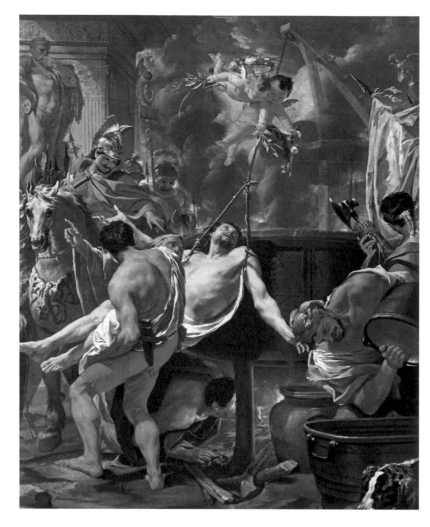

Charles Le Brun
The Martyrdom of
St John the Evangelist
at the Porta Latina,
c. 1641/42
Oil on canvas,
282 x 224 cm
Paris, Saint-Nicolas
du Chardonnet

Charles Le Brun
Chancellor Séguier at the Entry of Louis XIV
into Paris in 1660, 1660
Oil on canvas, 295 x 351 cm
Paris, Musée National du Louvre

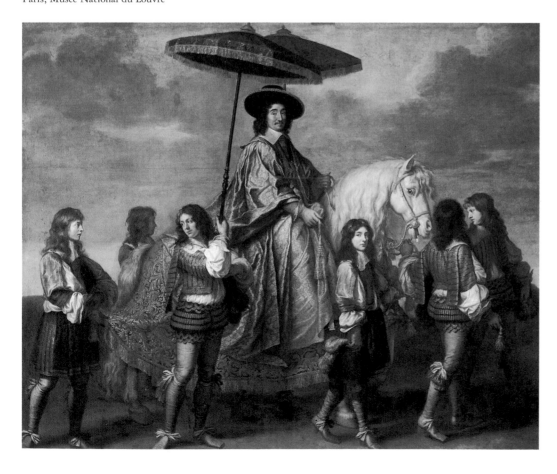

CHARLES LE BRUN
1619–1690

Le Brun might well be described as the one
figure who best symbolizes art policy under
Louis XIV. In 1638, at the age of just nine-
teen, he became court painter and two years
later Richelieu commissioned him to produce
three major works. This painting, probably
commissioned by the guild of painters, sculp-
tors and gilders of the city of Paris, may well
have constituted an important step in his me-
teoric career.

The martyrdom of John the Evangelist
plays a special role amongst the reports and
legends of the disciples of Christ. According
to legend, John was arrested under Trajan in
Rome at the Porta Latina and thrown into a
vat of burning oil, but survived unhurt and
was even rejuvenated. Although he later died
a natural death, he was accorded the rank of
martyr.

Le Brun has chosen to portray the dramatic
moment at which he is lifted into the boiling,
steaming vat. Menacing idols and horseback
soldiers bearing the symbols of imperial power
flank the scene. Yet just as his executors are
making their final preparations and fanning
the flames, the doomed man receives the di-
vine message of martyrdom, with laurel
wreaths and flowers. The visible triumph of
faith at the moment of extreme physical
danger is the subject of all portrayals of mar-
tyrdom, but only high Baroque painting
found formulations capable of balancing the
spiritual rapture of a saint against manifesta-
tions of physical brutality.

The equestrian portrait of the chancellor Sé-
guier shows Le Brun's first great patron, for
whom his own father, a minor sculptor, had al-
ready worked previously. Séguier helped the
ambitious young painter to enter the studio of
the famous Simon Vouet and financed his jour-
ney to Rome which not only allowed him to
stay in the promised land of art study, but also
gave him the opportunity of meeting Nicolas
Poussin.

The chancellor, magnificently dressed and
seated on a white horse draped in a sumptuous
caparison is surrounded by six pages who are
leading the horse at a suitable pace and shad-
ing their master with parasols as a sign of his
high office. There is something almost exotic
about the picture and we soon realize that this
impression is due to a certain ambiguity in the
subject matter.

On the one hand, the chancellor is pre-
sented in the highest ceremonial dignity, in an
official portrait that says little about his indi-
vidual personality; on the other hand, how-
ever, this equestrian portrait is only an imagin-
ary aspect of the ceremonial entry of Louis XIV
into Paris in the year 1660 and, as such, it is a
history painting in the tradition of the "en-
trées solennelles" which were an important
component in the ceremonial representation of
monarchy and officialdom from the time of
François I onwards.

EUSTACHE LE SUEUR
1616–1655

Three girls, crowned with wreathes, are playing music in an Arcadian setting. One is seated gracefully on the ground, with a musical score on her lap, singing to the accompaniment of the viola da gamba played by a second girl, who has turned her gaze heavenwards for inspiration. The third figure, slightly in the background, is listening and casts an earnest glance towards the spectator. There can be little doubt as to their identity.

If they are not the Three Graces, they can be none other than the three muses of poetry. The first is probably Melpomene, the muse of tragic poetry, the figure with the bare breast is Erato, the muse of erotic poetry and mime, while the singer is undoubtedly Polymnia, to whom the writers of lyrical hymns turned for inspiration.

Another trio is also indicated here: Le Sueur has portrayed the close sisterly ties and their various traits by a simple colouristic means. He has used yellow, red and blue, the primary colours from which all other colours spring. In this way, just as the three muses embody all of poetry, so too do their clothes contain the entire colour spectrum of the painter.

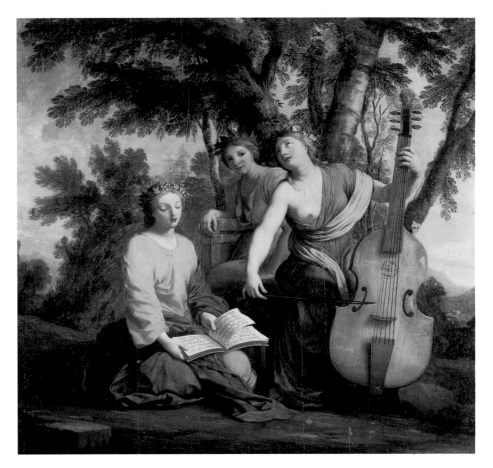

Eustache Le Sueur
Melpomene, Erato and Polymnia,
c. 1652–1655
Oil on canvas, 130 x 130cm
Paris, Musée National du Louvre

HYACINTHE RIGAUD
1659–1743

This famous portrait is regarded as the very epitome of the absolutist ruler portrait. Yet it represents more than just power, pomp and circumstance. The sumptuous red and gold drapery is not only a motif of dignity, but also creates a framework that echoes the drapes of the ornate, ermine-lined robe. The blue velvet brocade ornamented with the golden fleurs-de-lis of the house of Bourbon is repeated in the upholstery of the chair, the cushion and the cloth draped over the table below it: the king quite clearly "sets the tone".

A monumental marble column on a high plinth is draped in such a way that it does not detract from the height of the figure. Louis is presented in an elegantly angled pose, situated well above the standpoint of the spectator to whom he seems to turn his attention graciously, but without reducing the stability of his stance.

Rigaud's consummate mastery of portraiture is particularly evident in the way he depicts the king's facial expression: his distanced unapproachability are not founded in Neoclassicist idealization, but in the candour of an ageing, impenetrable physiognomy. The lips are closed decisively and with a hint of irony, the eyes have a harsh, dark sheen, while the narrow nose suggests intolerance. This is a ruler who is neither good nor evil, but beyond all moral categories.

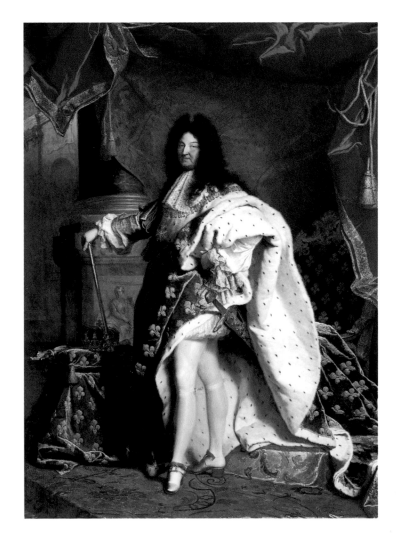

Hyacinthe Rigaud
Portrait of Louis XIV, 1701
Oil on canvas, 279 x 190cm
Paris, Musée National du Louvre

Nicholas Hilliard
Portrait of George Clifford,
Earl of Cumberland, c. 1590
Mixed media on parchment,
25.7 x 17.8cm
Greenwich, National Maritime
Museum

NICHOLAS HILLIARD
C. 1547–1619

Nicholas Hilliard, a goldsmith and miniatur-
ist, is one of the lesser known yet highly im-
portant artists of early Baroque. His unique
achievement lies in his creation of a type of
courtly portraiture unparalleled in European
painting at the time. By his own admission,
he was influenced by Hans Holbein, that
peerless master of the portrait miniature, for
whom Hilliard expressed his unreserved ad-
miration in his writings.

However, Hilliard's sophisticated and finely
executed miniatures have little in common
with the work of his German forerunner, apart
from their mastery of fine technique and cer-
tain aesthetic principles such as the avoidance
of chiaroscuro and strong modelling. These are
features of an absolutely aristocratic stance in
keeping with the attitudes displayed by the
very people he painted.

Hilliard's portrait of George Clifford, Earl
of Cumberland, from c. 1590, is a full-figure
portrait, which is quite rare, and it is one of
this artist's most complex works. This success-
ful naval leader was a favourite of Elizabeth I
and his feathered hat also bears the Queen's
glove as a mark of distinction which adds the
finishing touch to his courtly apparel in the
guise of a knight.

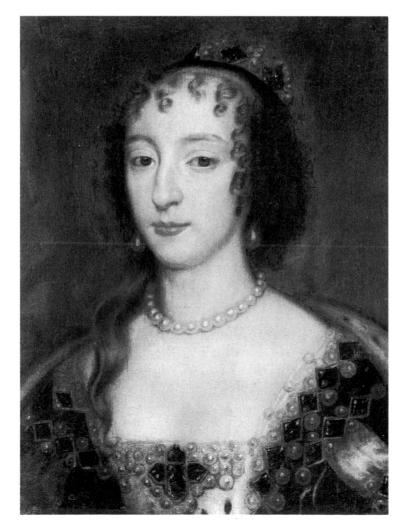

Peter Lely
Henrietta Maria of
France, Queen of
England, 1660
Oil on canvas,
49 x 39cm
Chantily, Musée Condé

PETER LELY
1618–1680

Portraiture, which was to become the single
most brilliant achievement of English paint-
ing in the 18th century, was a field dominated
in the 17th century by foreign artists who re-
ceived many commissions from the royal
court. The leading exponents of this period
were van Dyck and Lely. This portrait of Hen-
rietta Maria, the daughter of King Henry IV
of France and Marie de Médici is an idealized
portrait.

In 1660, when her oldest son succeeded to
the throne as Charles II of Great Britain and
Ireland, Henrietta Maria returned to England
where she died at the age of 51, marking the
end of a turbulent life. She had married
Charles I in 1625, but soon fell out of favour
with Parliament and the people because of
her support for English Catholics. Later, she
tried in vain and with great personal commit-
ment, to help her husband from the Nether-
lands. After his execution, she entered a
French convent and later lived in bitter pov-
erty in Paris.

Lely portrays her here as a beautiful and
dignified woman in royal dress with an ex-
pression of suffering on her lips and a look of
aloof mourning in her eyes. This is no longer a
Baroque representative portrait, but tends far
more in the direction of an individual inter-
pretative portrayal. The nature of her life's jour-
ney is hidden by her reserved facial expression.

ADAM ELSHEIMER
1578–1610

The cross as the focal point of the "gloria del paradiso" is revered by the saints and the elect of the heavenly realm who surround the cross on banks of clouds. On the right, we recognize the patriarchs, including Moses, Abraham and King David. We also see Jonas sitting on the fish, looking up towards the cross, and St Catherine and Mary Magdalene in a sisterly embrace. In the foreground, there is a disputation between St Sebastian and Pope Gregory, St Jerome, St Ambrose and St Augustine, with the first Christian martyrs St Stephen and St Laurence. The cross, clutched by a kneeling female figure who is probably an embodiment of Faith, is surrounded by angels bearing the instruments of the Passion, above which we can make out the Evangelists and Apostles. At the head of a procession of angels streaming into the dazzling light of the background, which is flooded with an overwhelming brightness, we can see the Coronation of the Virgin.

Elsheimer's unique art is evident in the astonishing illusion of remarkable breadth and depth achieved by this small panel painting. Here, space is no longer simply a problem of continuously reduced scale, but also one of simultaneous graduation of colour and the distribution of light and darkness. This creates interlocking areas of colour and light which, though perceived by the eye, nevertheless take on the quality of a vision. This painting, originally part of a triptych, is widely regarded as Elsheimer's greatest masterpiece.

This small painting is undoubtedly the most beautiful example of the night scenes that brought Elsheimer so much fame. Four sources of light illuminate the greenish-blue landscape with its starry sky: the full moon on the right above the trees fringing a lake, its reflection in the water, the campfire of the cowherds on the left, from which a column of sparks rises into the darkness of the tree tops, and finally the torch in the hand of Joseph, who is leading the ass with Mary and the child. Each of these sources of light models the objects in the immediate surroundings only fragmentarily, so that illuminated areas are directly juxtaposed with unlit areas. Our gaze is drawn across expanses of impenetrable darkness, settling upon islands of fine draughtsmanship, and following the vaulted silhouettes of the tree tops.

Here, night is portrayed as a miracle that can help the holy family on their flight to Egypt. Elsheimer has succeeded in evoking a sense of danger and comfort at the same time entirely by means of the atmospheric values of his use of light and shadow. It would therefore be wrong to place the emphasis entirely on the subject of landscape. This picture represents something entirely new in the field of religious imagery, with landscape opening up possibilities of exploring new narrative contents.

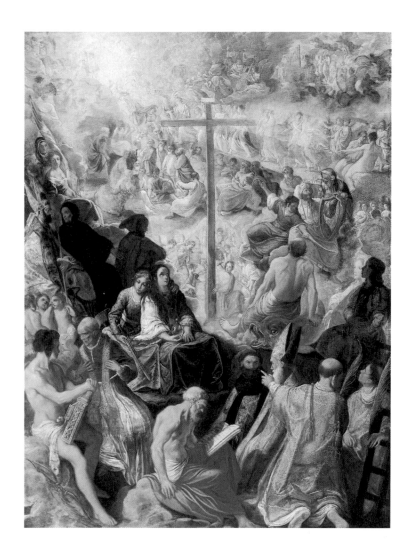

Adam Elsheimer
The Glorification of the Cross, c. 1605
Oil on copper, 48.5 x 36cm
Frankfurt am Main, Städelsches Kunstinstitut

Adam Elsheimer
The Flight to Egypt, 1609
Oil auf Kupfer, 31 x 41 cm
Munich, Bayerische Staatsgemäldesammlungen, Alte Pinakothek

Georg Flegel
Still Life, undated
Oil on copper, 78 x 67 cm
Munich, Bayerische Staatsgemälde-
sammlungen, Alte Pinakothek

GEORG FLEGEL
C. 1566–1638

Flegel, Germany's first purely still life painter,
is believed to have worked in the studio of the
Flemish artist Lukas van Valckenborch as a
painter of flowers, metalware and fruit, a fact
that would certainly appear to be borne out by
this painting.

The very Netherlandish-looking bouquet of
flowers with tulips, carnations, roses and nar-
cissi, is as superbly painted as the silver vase
ornamented with golden mascarons in which
it has been placed. The different qualities of
silver, gold and pewter, their various degrees
of brilliance, hardness and finish have been
rendered in painstaking detail. The heavy pew-
ter plates are juxtaposed with an elegant, fine-
rimmed silver dish and a golden-lidded
chalice bearing a fine statuette of Mars. The
blade of the knife at the edge of the table, the
dish of hazelnuts, the lid and edge of the
brown earthenware jug – all are variations on
the artist's theme.

The display of foodstuffs seems less im-
pressive at first glance, and arranged almost at
random. Everything seems to be arranged by
pure chance, so much so in fact that an alle-
gorical interpretation seems unlikely. Though
the composition may appear purely cumula-
tive, it is nevertheless precisely calculated, es-
pecially in the masterly distribution of colour
highlights.

Johann Liss
The Death of Cleopatra, c. 1622–1624
Oil on canvas, 97.5 x 85.5 cm
Munich, Bayerische Staatsgemälde-
sammlungen, Alte Pinakothek

JOHANN LISS
C. 1595–C. 1629/30

Cleopatra, Queen of Egypt, committed suicide
to avoid being taken prisoner by Octavius,
who had conquered Anthony, Cleopatra's lover
and Octavius' rival for supremacy in Rome.
Plutarch reports that the Queen wished to die
by a serpent's bite, for the ancient Egyptians
believed that this death ensured immortality.

The artist has not chosen to portray the dra-
matic climax, nor the decision to commit
suicide, nor even the snake bite itself, but the
moment in which the tension begins to sub-
side. The serpent has done its deadly work,
and the young black servant boy holding the
basket of flowers is staring with terror-struck
eyes at the snake in it, while a servant woman
supports her swooning mistress. On the sur-
face of things, very little seems to be happen-
ing in this picture, with everything concen-
trated on the transition between life and
death. All the light falls on the young Queen,
bathing her body in warm and sensuous
colours. All of life itself seems to be concen-
trated in the colour of her flesh on the thresh-
old of death, whose advent is suggested by her
sinking arm and overcast gaze. The central mo-
ment in this painting is one of transition, and
this is reflected in the move from light to dark-
ness and in the strong graduation of colours
from the background to the foreground.

JOHANN HEINRICH SCHÖNFELD
1609–1682

We have little information about Schönfeld's life. One of the few reports available is a diary entry by the German architect and art collector, Joseph Furttenbach of Ulm, which tells us that "he spent eighteen years in Italy, twelve of them in Naples.". Living in Naples and experiencing its piety and its works of art had a profound effect on the work of this German artist from Biberach around 1643/44. During this period, the serenity and lightness of his mythological and Old Testament themes give way to dark renderings of predominantly Christian subjects, but also this picture of *Chronos*.

A thin, balding old man can be seen in a deeply melancholic pose in a gloomy setting, his arm resting on a plinth that bears the inscription "Il tempo" (time). On it stands an hourglass and an extinguished candle as symbols of transience and mortality, while in the foreground, a putto sits on a skull blowing soap bubbles – further metaphors of the triviality of human life. The predominant brown tones of the painting, broken only by the blue of the loincloth, make a similar statement: it is not a dark varnish, but an intrinsic quality of the painting itself. All colour as a sign of vitality and exitence have been purged from the pictorial realm. The Chronos we see before us is no longer the philosopher of decay and fragility, but part of it.

Johann Heinrich Schönfeld
Il Tempo (Chronos), c. 1645
Oil on canvas, 102 x 77 cm
Augsburg, Deutsche Barock-
galerie im Schaezlerpalais

JOACHIM VON SANDRART
1609–1688

Sandrart, best known for his major art history published in 1675 under the title "Teutsche Academie" is one of the few artist-writers whose painterly œuvre was on a par with his literary ambitions.

For Prince Maximilian of Bavaria, Sandrart painted allegories of day and night as well as a cycle of twelve paintings of the months of the year for the dining room of the Old Palace in Schleissheim. The months, accompanied by verses, were widely distributed in the form of engravings. They are illustrated by life-size half figures set in landscapes or interiors and show characteristic activities associated with the respective seasons and surrounded by their natural attributes. November, under the zodiac sign of Sagittarius the hunter, shows a hunter's return. With his nervous dogs on a short leash and his catch slung over his shoulder, he is heading towards a castle in the middle distance. A keen wind tears the leaves from the trees and scatters them through the air.

Landscape and genre, still life and allegory are combined in a picture that epitomizes the month of November in concentrated form. Only briefly and in passing does the hunter glance to one side, and once more we find an allegorical personification of time passing.

Joachim von Sandrart
November, 1643
Oil on canvas,
149 x 123.5 cm
Munich, Bayerische
Staatsgemälde-
sammlungen

Johann Carl Loth
Mercury Piping to Argus, before 1660
Oil on canvas, 117 x 100 cm
London, National Gallery

JOHANN CARL LOTH
1632–1698

A certain form of half-figure painting had become modern through the influence of Caravaggio, who had painted a number of genre scenes, such as *The Fortune Teller* (ill. p. 31), and mythological paintings, such as *Bacchus* (ill. p. 32), in this manner and whose earliest works had conjured up an erotically mythological world full of half-figure portrayals of singularly feminine young boys. The tastes and preferences of certain patrons and collectors had also contributed to this trend, but the form as such continued to remain extremely popular, particularly in history paintings in which the intimacy of a moment called for the appeal of a heightened physical proximity.

In this painting, Loth tells how Argus of the many eyes was tricked by Mercury. Juno, the mistress of Jupiter, had set Argus to guard the nymph Io, who had been turned into a heifer. Mercury approached the herdsman and lulled him to sleep with the music of his pipe, then killed him. At first glance, one might think that Loth has transformed this cruel plan into an idyllic pastoral scene. Yet there is something menacing in the dark background and in the deep-set eyes of the two men. The fiery red drape covering Mercury's dagger and the flexing of his muscles herald the murder.

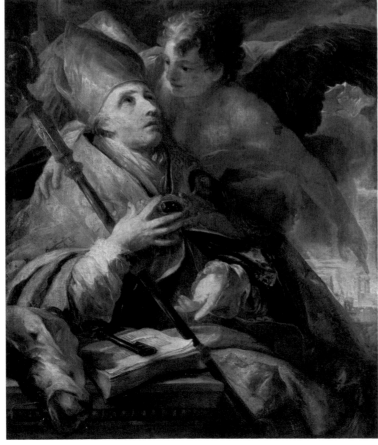

Johann Michael Rottmayr
St Benno, 1702
Oil on canvas, 118 x 100 cm
Munich, Bayerische Staatsgemäldesammlungen

JOHANN MICHAEL ROTTMAYR
1654–1730

In 1688, the artist returned from a thirteen-year stay in Venice, where he had worked in Loth's studio. By the time this painting was executed, he had already developed the influence of the Venetian treatment of colour into a highly distinctive style, based on southern German traditions.

Benno, scion of a Thuringian noble family, was Bishop of Meissen from 1066–1106. According to legend, he is said to have thrown the keys of his cathedral into the river Elbe only to find them again in the belly of a fish on his return. From 1580 onwards, his relics were kept in the Frauenkirche in Munich, and he soon became the patron saint of Munich and Bavaria.

What is typically South German about Rottmayr's portrayal of the moment when the saint finds the key, is his handling of the human figures. Benno does not appear as an enraptured saint, but as an old man, pale with fright, incredulously pointing out the miraculous event to an angel. The angel, a figure of serene vitality, places a reassuring arm on the shoulder of the astonished man.

What is real in this painting is not the historic figure of Benno, but the fish with its belly slit open, the key and the young angel. The faith of the saint, and indeed that of the painter, is clearly reflected in the realism of the miracle.

JUAN SÁNCHEZ COTÁN
1561–1627

Everyday objects: a melon, cut open to reveal its pale pink flesh, a knobbly cucumber, a yellow apple that is past its best, a cabbage with thick leaves. Parallel to the picture plane, a smooth frame delineates the opening for a window. From the direction of the spectator, light falls upon the parapet, on which the slice of melon and the cucumber are placed so that they jut over slightly and thereby they seem to be almost within reach – a *trompe l'œil* effect that was particularly popular in Netherlandish painting in the 17th century. The head of cabbage and the apple, suspended on threads that presumably have been attached to the upper frame, are dangling over the gaping darkness.

Even if the objects are arranged so that they seem close enough to touch, they are nevertheless distanced. For all the naturalism with which they are depicted, the isolation of each object, heightened further by the black background, makes each of them seem extremely artificial and lends them a monumental, almost sculptural gravity. The centre of the picture is empty and the arrangement seems coincidental; the dimension of the painted picture is denied. The disturbing evocation of the painted picture is the main theme.

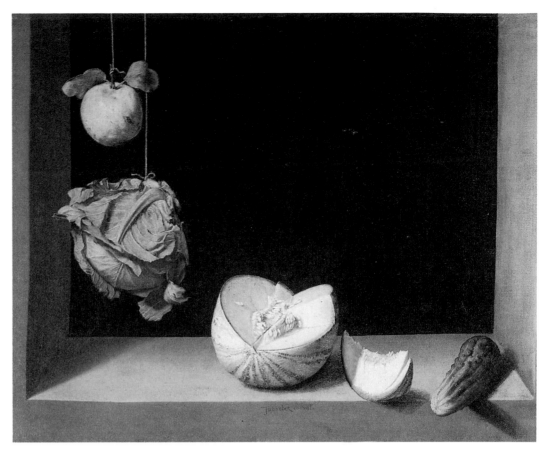

Juan Sánchez Cotán
Still Life (Quince, Cabbage, Melon and Cucumber), c. 1602 (?)
Oil on canvas, 65 x 81 cm
San Diego (CA), The Fine Arts Gallery of San Diego

JUSEPE DE RIBERA
1591–1652

Standing in a sweeping landscape, dressed in patched brown clothes, barefoot and shouldering a crutch, his disability is evident: his deformed foot is at the centre of the spectator's field of vision. In his left hand, this pitiable creature holds a note with the inscription: "DA MIHI ELIMO/SINAM PROPTER/ AMOREM DEI" ("Give me alms, for the love of God").

Described in this way, the painting would appear to be an image of misery, humiliation and begging. Yet what meets the eye, contradicts such an unequivocal statement. The boy whose face is aged beyond his years stands proud and upright against the landscape in the background. He looks directly downwards at the spectator with a relaxed gaze of experience and superiority. The boy's mouth is opened in a relatively unattractive gummy grin that permits no patronizing sympathy. Ribera has created a monument to the justice of God. He shows up our hierarchical thinking, our worldly expectations of the gratitude of the poor, to whom we give alms. The apparently miserable, valueless individual stands here like a monument admonishing us to remember that all creatures are equal before God. This boy is not begging for mercy. He is claiming his right to it.

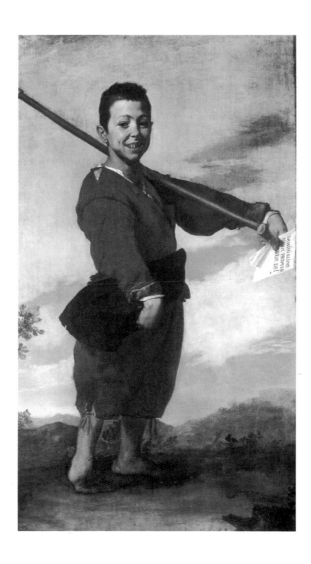

Jusepe de Ribera
The Boy with the Clubfoot, 1642
Oil on canvas, 164 x 92 cm
Paris, Musée National du Louvre

Jusepe de Ribera
Archimedes, 1630
Oil on canvas, 125 x 81 cm
Madrid, Museo del Prado

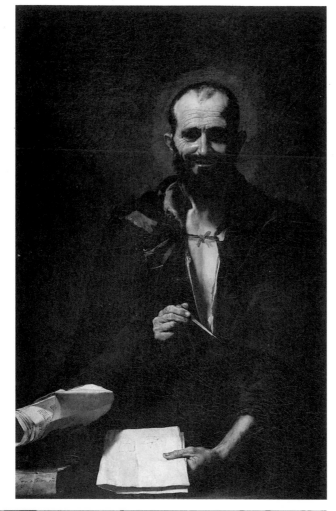

Bottom:
Jusepe de Ribera
Martyrdom of
St Bartholomew, 1630
Oil on canvas, 234 x 234 cm
Madrid, Museo del Prado

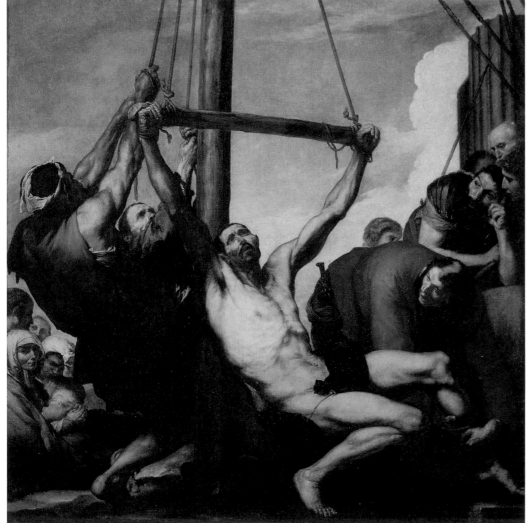

JUSEPE DE RIBERA
1591–1652

The image we have today of the ancient scholar owes much to the classicistic ideals of the 19th century. This concept of cool distance and noble gravity is contradicted sharply by such a painting as Ribera's *Archimedes*: the great physicist, mathematician and natural scientist is shown here as a toothless old Spaniard. His weathered, wrinkled face has none of the marbled pallor of scholarship. In one thin hand, he holds a pile of papers and in the other a compass. His nails are dirty, his dress unkempt, and an old cloak is thrown carelessly over his undershirt, open to reveal his chest. Archimedes looks at us with a broad grin, and seems as close to the everyday life of Ribera's contemporaries as the artist's paintings of the saints. We find no monumental dignity here, only the dignity of a strong personality.

Like Caravaggio in his *Crucifixion of St Peter* (ill. p. 33), Ribera contradicts the canonical concept of the heroic martyr who bears his torture with quiet patience and the serene assurance of salvation. Bartholomew, apostle and preacher, who was flayed and murdered by King Astyages in the Armenian town of Albanapolis, is portrayed by Ribera as a weak elderly man, whose fear of death and desperation are clearly written in his face. The louts dragging him up by a beam before the eyes of the curious onlookers are concentrating fully on their task. The question of guilt and innocence remains unanswered for the incident is still very much in the present.

According to legend, the giant Ophorus carried the infant Christ across a river at night, and was pressed down below the surface of the water by the weight of the child, thereby being baptized. Thereafter he received the name Christophorus ("bearer of Christ"). In this night scene, Ribera reiterates the legend, but he adds more: he brings life to the figure of the giant, lending him an expression of incredulity and astonishment at the sight of the infant Christ. His physical power is evident in the drawing of his muscles of arms and shoulders. Paradoxically yet fittingly, Ribera has given him the flickering shadow of all-devouring ecstasy that predominates in a heightened form in his depictions of monks. It is a scene of superficial poverty without the brilliance of colour and luminosity. The miraculous experience of Christophorus is neither majestic nor historic, but is a sacred occurrence repeated daily before our very eyes.

Jusepe de Ribera
St Christopher, 1637
Oil on canvas, 127 x 100 cm
Madrid, Museo del Prado

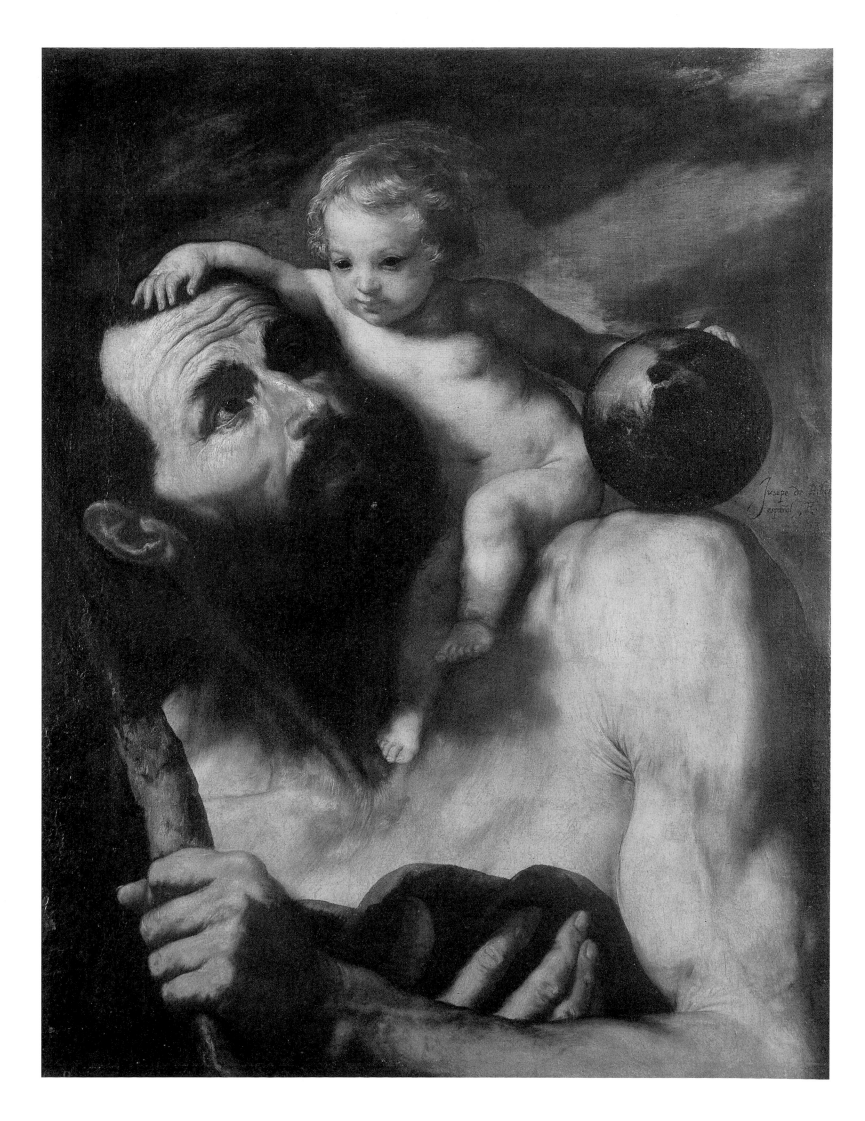

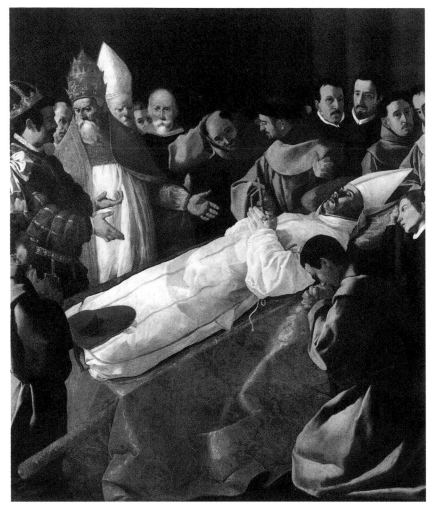

Francisco de Zurbarán
The Death of St Bonaventura, 1629
Oil on canvas, 245 x 220 cm
Paris, Musée National du Louvre

Francisco de Zurbarán St Hugo of Grenoble
in the Carthusian Refectory, c. 1633
Oil on canvas, 102 x 168 cm
Sevilla, Museo de Bellas Artes

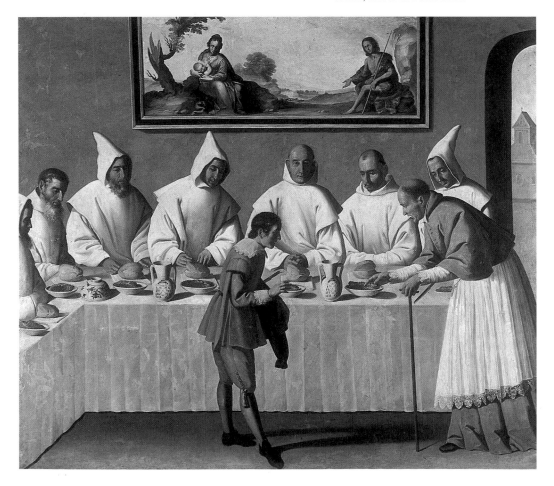

FRANCISCO DE ZURBARÁN
1598–1664

Dressed in the brilliant white robes of a bishop, grasping the cross in his folded hands, the body of the saint lies in state on a bier draped in sumptuous brocade, with the red biretta of the cardinal at his feet. Pope Gregory X, who had appointed him cardinal bishop of Albano in 1273 stands, a white bearded man, beside the king, to whom he appears to be explaining the merits of the dead man. Most of the mourners, however, are simple Franciscan monks in their greyish brown habits, pensively praying or meditatively contemplating the dead man. He is indeed one of them, and the wan complexion of his tranquil face appears to mirror the dull hue of the habits. The great scholar and administrator of his order is here placed between the representatives of ecclesiastical and worldly power and the world of simple Franciscan brotherhood. He was accorded the title of "doctor seraphicus", meaning the "brilliant teacher full of love". This is what Zurbarán paints: the teacher bound to practical life, his face filled with mystical desire even in death.

Zurbarán's painting of a Carthusian refectory intensely reflects the ideal of this order of hermit monks: simplicity, sobriety and quiet contemplation. The room is unadorned, but for a painting showing the Virgin and Child with John the Baptist in the wilderness – an inspiration to the monks. An arched doorway opens out towards a typically simple Carthusian church. The monks, dressed in white cassocks, are seated at the table on which there are only plates of bread. With the exception of one monk whose hands are folded in prayer, they are all completely immersed in introspective contemplation with their eyes cast down, apparently paying no attention to the guest to whom the elderly abbot, St Hugo, appears to be explaining the life of the monastery. This painting exudes an atmosphere of tranquillity unaffected by the event portrayed.

The apocryphal legend of the life and death of Margaret of Antioch was known in the western world as early as the 7th century. Cast out by her heathen father, she was martyred in the Diocletian persecution of Christians and decapitated. In the course of the centuries, more and more legends grew up around this popular martyr. Zurbarán has portrayed her with straw hat and staff, in the costume of a Spanish shepherdess. Behind her we see the dragon which she is said to have overcome with the sign of the cross. Completely inactive, with the Bible in her left hand and a woven shepherd's bag over her arm, she gazes at the spectator with a sweetly childish face. This painting does not tell the turbulent episodes of her life, but shows a saintly woman revered in the home country of the painter.

Francisco de Zurbarán
St Margaret, c. 1630–1635
Oil on canvas, 192 x 112 cm
London, National Gallery

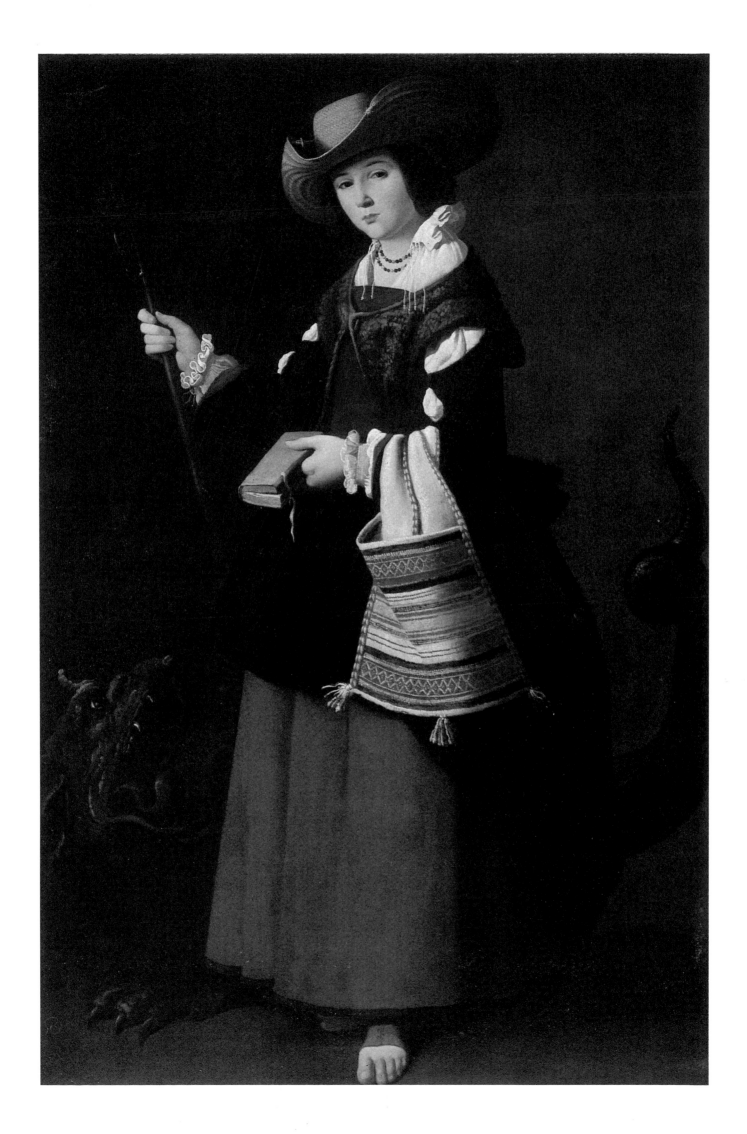

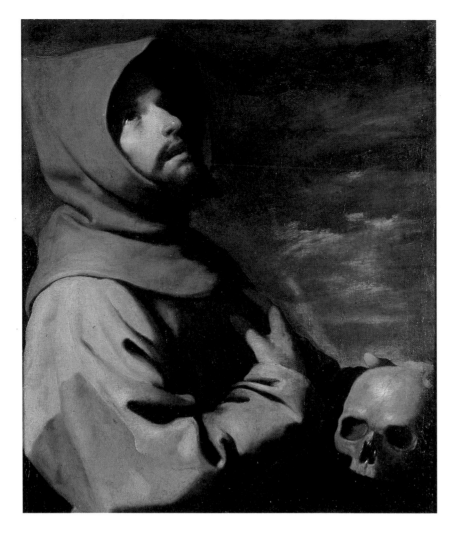

Francisco de Zurbarán
The Ecstacy of St Francis, c. 1660
Oil on canvas, 65 x 53 cm
Munich, Bayerische Staatsgemälde-
sammlungen, Alte Pinakothek

FRANCISCO DE ZURBARÁN
1598–1664

Born in 1181 or 1182 in Assisi as the son of a
wealthy draper, he died in poverty in the same
town on 3 October 1226. Francis' life of pov-
erty, humility, selflessness and serene neigh-
bourly love made the order of Friars Minor
which he founded one of the most widespread
religious orders in the entire western world.
Following the council of Trent in the mid
16th century, St Francis was invariably por-
trayed as an ascetic, penitent and ecstatic
monk, frequently dressed in the habit of the
Capuchin monks and with a skull as attribute.

Zurbarán's saint bears the entire complex-
ity of this figure. This is Francis the ascetic,
dressed in a brown habit, without signs of of-
fice or adornment. This is the humble Francis
dressed in the colours of the earth. This is
Francis the ecstatic monk, who has received
the stigmata of the five wounds. His young
face is raised heavenwards in contemplation,
one hand placed upon his heart, the other on
the skull, the sign of meditation. He is shown
as a holy man of spiritual profundity and scho-
larly intellect, as reflected in his facial traits.
Yet he is not a monk who is alienated from
daily life and caught up entirely in his mysti-
cal passion, but a man close to life, as Zurba-
rán shows. His "portrait" is an allegory of faith
and simplicity.

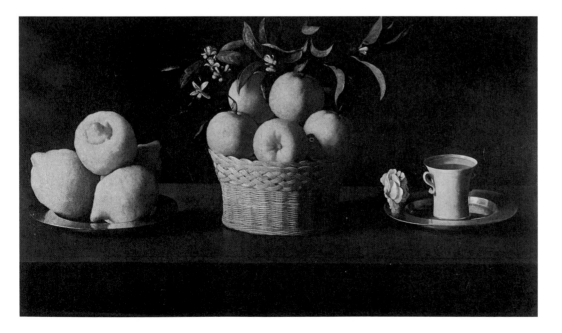

Francisco de Zurbarán
Still Life with Lemons, Oranges and Rose, 1633
Oil on canvas, 60 x 107 cm
Pasadena (CA), Norton Simon Museum of Art

In the œuvre of Zurbarán, religious themes
predominate, with particular emphasis on asce-
ticism. He also painted many still lifes, which,
however, reflect the same qualities of asceti-
cism, quiet contemplation and introversion for
his choice of objects indicates the transience of
human life.

Zurbarán does not do so by presenting a
clock, a skull or an hourglass. Instead, on a
brilliantly polished table, he shows us a pew-
ter plate with lemons, a basket of oranges com-
plete with leaves and blossoms, and a fine
china cup on a silver saucer on which lies a
rose in full bloom. Though lemons signify
wealth in a Netherlandish still life, they have
a very different meaning here, in the country
where they actually grow. Even so, they are
not represented as the fruits of daily life, but
presented with all the solemn celebration of an
offering on an altar.

As in the paintings of his contemporary
Sánchez Cotán, Zurbarán isolates the individ-
ual objects from one another – even the com-
position appears to be a conscious though not
excessively artificial arrangement. Against the
dark background, the objects are completely
static, and appear to be torn out of the context
of everyday life. The human beings to whom
they apparently belong have no place here.

ALONSO CANO
1601–1667

This painting, hailed by Cano's contemporaries as a masterpiece, was part of the main altar in the no longer extant church of Santa María in Madrid. Damaged and all but forgotten, the painting entered the Prado in 1941, where its qualities can now be appreciated as they fully deserve.

According to legend, the son of St Isidore fell into a well. Through the prayers of the saint and his wife, the water level rose miraculously so that the child was brought safely to the surface. Here, we see St Isidore standing in front of the well with his arms spread wide. The young woman is helping the child out of the well and looking towards her husband with an expression of astonishment on her face. Two servant girls in the background are commenting with eloquent gestures on the miracle. Two children and a dog, drawn towards the overflowing water, also discuss the event.

Cano links two themes in this painting: the miracle itself and the recognition of Isidore's saintliness by the women. For the artist, this means presenting him in the manner of history painting and religious portraiture at the same time. He has solved this problem of duality by presenting the saint as an almost incidental figure barely involved in the event, a fact which has frequently been misinterpreted as a weakness of this painting.

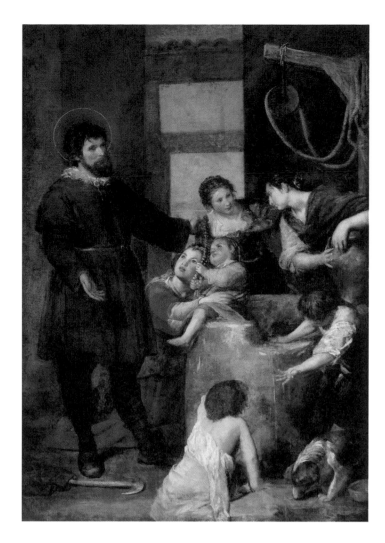

Alonso Cano
St Isidore and the Miracle of the Well, c. 1646–1648
Oil on canvas, 216 x 149 cm
Madrid, Museo del Prado

BARTOLOMÉ ESTEBAN MURILLO
c. 1617/18–1682

She is not shown in the thralls of mystical rapture, nor in those of devotion. Murillo's Mary is a very young woman with an almost childlike face, who is kneeling at her prie-dieu, her eyes cast pensively downwards. She has set aside her basket of handiwork and seems to have been disturbed by an angel in the midst of her prayers. Were it not for the presence of his wings, even the angel would seem to be a very worldly creature. He is not floating in some uncertain sphere, nor is he a vision, but is kneeling on the floor tiles. Strong-limbed and barefoot, almost like a peasant, his pretty face is framed by dark locks. With one hand, he points towards the dove of the Holy Spirit, which floats above their heads in a truly unearthly and intangible celestial vision. With the other hand, he makes a gesture of persuasion: he seems to be explaining the purpose of his mission quite vigorously to Mary.

Although the event seems plausible in a distinctly earthly manner – even the putti in the clouds do not alter this impression – the miracle is clear. Mary's innocence, underlined by the lily as a symbol of purity, is of such intensity that the spectator senses her quiet reservation, the excited anticipation of the prophesied miracle and her astonishment at the experience.

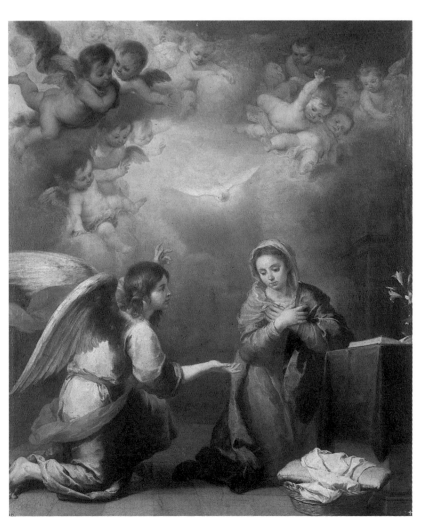

Bartolomé Esteban Murillo
Annunciation, c. 1660–1665
Oil on canvas, 125 x 103 cm
Madrid, Museo del Prado

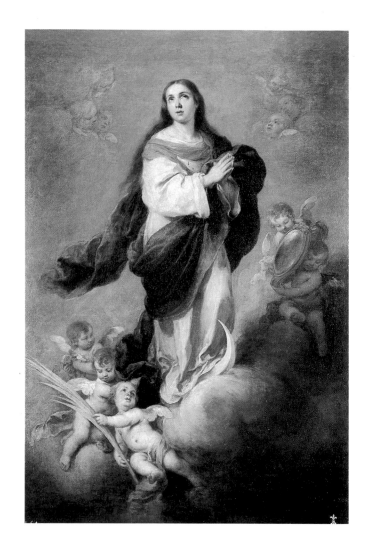

Bartolomé Esteban Murillo
La Immaculada, undated
Oil on canvas, 96 x 64 cm
Madrid, Museo del Prado

BARTOLOMÉ ESTEBAN MURILLO
C. 1617/18–1682

Murillo's *Immaculada* has nothing of a Queen of Heavens. Standing on a crescent moon, as described in the Apocalypse, surrounded by angels holding the mirror as a sign of purity and the palm frond as a sign of suffering, she stands in a relatively unaffected poses. Her face is pale, her eyes gaze upwards in yearning. We can sense the pain she has experienced and her mourning for her son. Quiet and introverted, she epitomises the humble anticipation of the hereafter, transfigured only by a mild smile, that is a hallmark of Murillo's paintings of this period; the *Estilo vaporoso* – the vaporous style.

The room is so dark that we can hardly make out the objects in it: beneath the little window aperture stands a rough-hewn wooden table, on which there is an earthenware jug and a white cloth. Another earthenware jug stands on the floor. At the right-hand edge of the painting, we see a spindle and distaff on a stool. The old woman who has just set them aside is now crouching down to look for lice in the little boy's hair. He is sitting on the floor, leaning against her knee and petting a little dog that is begging for a piece of the bread the boy is stuffing into his mouth. Both figures are very poorly dressed, and the few details of the room further emphasize the impression of poverty.
Murillo is probably the only Baroque painter of rank to have portrayed poverty with such kind and conciliatory traits. There is no sign here of the wealthy man's notion of the picturesque simple life, so frequently found in this genre. Murillo chooses the colours of the earth. The earthenware dishes, the stones of the wall, the wood of the furniture, the faces and clothes of the two figures, all are united by this warm colouring which seems so natural that it does not even raise the question of poverty or wealth, happiness or unhappiness.

A little girl with the face of a Madonna, a contented little boy examining the earnings she holds in her hand and a basket full of grapes which is, in itself, a still life of the highest quality. Does this painting show us a life free from worry?
The apparent poverty of the two figures, their unchild-like but necessary employment suggest a sense of hopelessness and misery. And yet these children seem to exude an air of rapt serenity and contented enjoyment of life. Herein lies Murillo's Christian message: because these children do not see their poverty as a burden, and because they do not regard their existence as joyless, they are beautiful and "dignified". It is thus a painting that could adorn the walls of any ruler's palace.

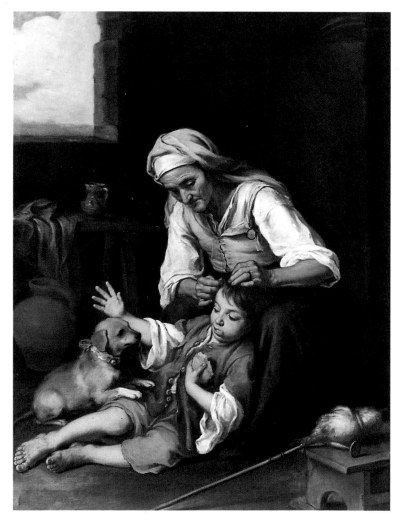

Bartolomé Esteban Murillo
The Toilette, c. 1670–1675
Oil on canvas, 147 x 113 cm
Munich, Bayerische Staats-
gemäldesammlungen,
Alte Pinakothek

Bartolomé Esteban Murillo
The Little Fruit Seller, c. 1670–1675
Oil on canvas, 149 x 113 cm
Munich, Bayerische Staatsgemälde-
sammlungen, Alte Pinakothek

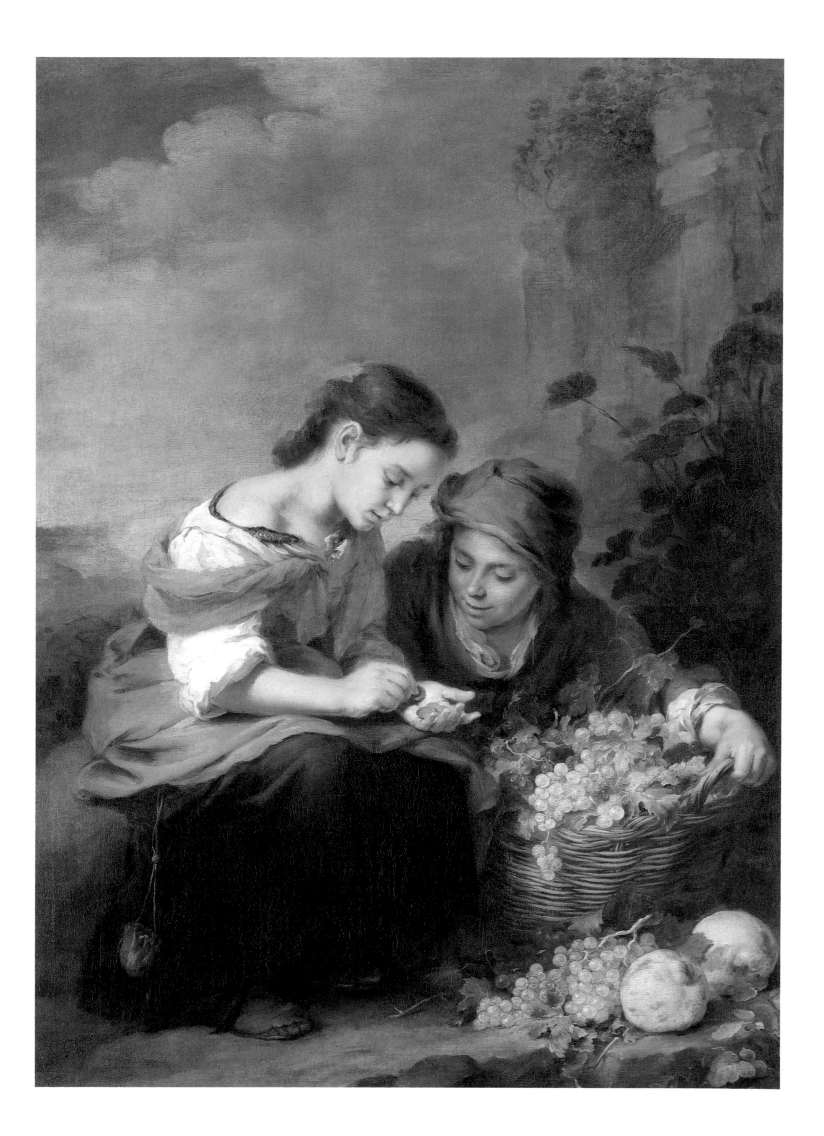

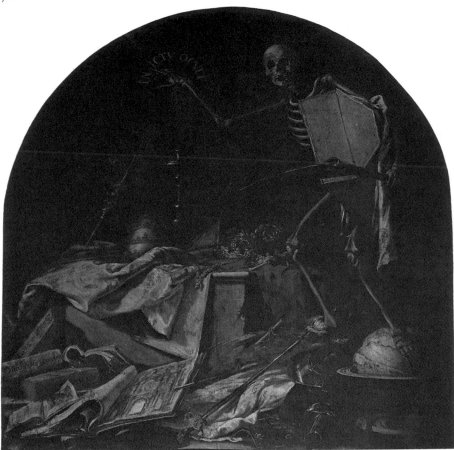

Juan de Valdés Leal
Allegory of Death, 1672
Oil on canvas, 220 x 216cm
Sevilla, Hospital de la Caridad

JUAN DE VALDÉS LEAL
1622–1690

Of all the great painters of the school of Seville – alongside Zurbarán, Velázquez and Murillo – the distinctive style of Valdés Leal is the most difficult to place. Only two major allegories on the transience of life and on death which he himself is said to have described as "hieroglyphs of our afterlife" have remained truly popular. His patron, Don Miguel de Mañara, was a Knight of the Order of Calatrava who became a benefactor of the brotherhood of the hospital and its church in penitence for his previous life of decadence. The epitaph on his grave succinctly describes the spirit that commissioned such a powerful vanitas still life: "Here lie the bones and ashes of the worst person who ever lived on earth". His last will and testament contains the most humble self-accusation not only as a great sinner, but also as an adulterer, robber and servant of the devil.

The *Allegory of Death* presents the triumph of the grim reaper, who sweeps into the picture as an imposing figure. One skeletal foot stands on the globe, while the other stands on armaments, the trappings of office and insignia of power. Under his arm, he carries a coffin and in his hand a scythe. As his right hand snuffs out the life-light represented by the candle, he stares at the spectator from the very depths of his empty eye-sockets.

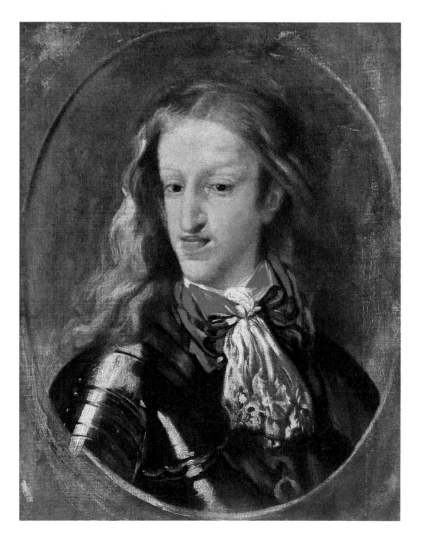

Claudio Coello
King Charles II,
c. 1675–1680
Oil on canvas,
66 x 56cm
Madrid, Museo
del Prado

CLAUDIO COELLO
1642–1693

One of the most important tasks of a court painter in the age of absolutism was portraiture, either in the form of an individual, family or group portrait. Most of these commissioned works were sent to other royal houses. Whatever the occasion in each respective case, a portrait of this kind invariably had the primary function of representing the court.

Coello's unfinished portrait of King Charles II gives us an opportunity of seeing how the artist worked. The three-quarter profile of the young king is set in a medallion. Coello has concentrated on depicting the brilliance of the shining armour and the rich folds of the bow, using free and spontaneous brush-strokes. Reproductions of a portrait of Charles II from the Städel in Frankfurt, lost in 1945, suggests that Coello toned down these lavish details somewhat in a later version. In comparison to paintings of Alsonso Sánchez Coello, who had worked for the Spanish court a hundred years earlier, Claudio Coello's view of the monarch has little of the stringency of courtly ceremony. He is the last major representative of the Spanish tradition of painting that reached its climax in the Mannerism of the 16th century.

DIEGO VELÁZQUEZ
1599–1660

In this early work, Velázquez refers to the gospel according to St Luke, which tells of a visit by Christ to the house of Martha and Mary. While Mary sat at his feet to listen to his words, Martha busied herself with work in the kitchen; eventually, she came to him and said: "Lord, dost thou not care that my sister has left me to serve alone? Bid her therefore that she help me." To which Christ replied, "Martha, Martha, thou art careful and troubled about many things; but one thing is needful: and Mary has chosen that good part, which shall not be taken away from her." (St Luke 10:40–42).

The composition of the painting, with a kitchen scene in the tradition of the "bodegones" taking up the foreground, while the scene involving Christ is presented as a view or a mirror image, is clearly influenced by the art of the Netherlands. Even the plump, ruddy-cheeked figure of Martha and the still life arrangement of fish, garlic, eggs and paprika, recall examples of Northern European art. Moreover, this picture is charged with a strange sense of tension and restlessness. The events reflected in the mirror, bathed in a mild light and exuding an atmosphere peace and calm, are contrasted with the foreground image of loud and busy work. Through highlighting and formal diversity, the artist sets a scene that is clearly dissatisfactory to Martha. She is not concentrating on her work, but gazes full of yearning, on the verge of tears, and slightly angrily, as though she already realized that Mary had chosen the better part.

Velázquez painted this picture of Bacchus surrounded by eight drinkers for Philipp IV, who hung it in his summer bedroom. The painting is not only unique in his œuvre, but is very rare indeed in Spanish painting as a whole, which does not generally have the drinking scenes so familiar in Flemish and Netherlandish painting. Drunkenness was regarded in Spain as a contemptible vice and "borracho" (drunkard) was the most scathing of insults. At the royal court, it seems to have been considered highly entertaining to invite low-lifers from the comedy theatres and inebriate them for the amusement of the ladies. But what kind of a Wine God is this we see, crowning his followers with ivy, said to cool the heat of wine, and consorting with peasants who grin out of the painting and clearly find the spectator, that is to say the king, a very funny sight indeed? The authority of the god whose presence delights them lends them a sense of majesty as well. And in view of the delightful travesty of royal honours in which Bacchus is indulging, they too have turned the tables and are laughing in the faces of those who would laugh at them. Is this Bacchus merely a myth born of wine, an embodiment of those lowly joys which the nobleman snubs? Or is the god a courtier having precisely the kind of fun at which the ladies liked to laugh? As only Caravaggio before him, Velázquez has portrayed Bacchus (or rather Dionysos) as the God of the mask, the theatre and disguise.

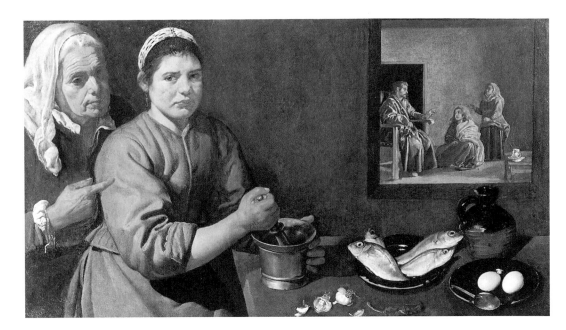

Diego Velázquez
Christ in the House of Martha and Mary, 1618
Oil on canvas, 60 x 103.5 cm
London, National Gallery

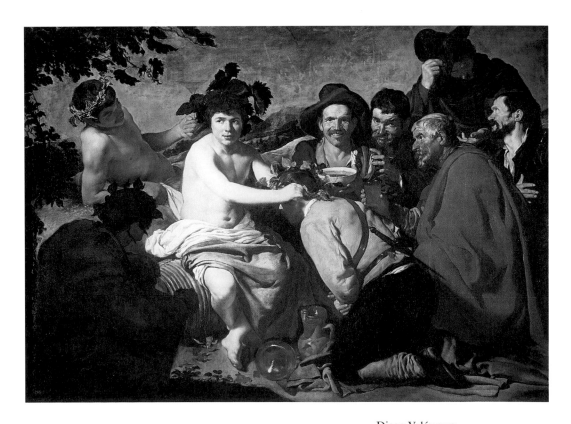

Diego Velázquez
Los Borrachos (The Drinkers), 1628/29
Oil on canvas, 165.5 x 227.5 cm
Madrid, Museo del Prado

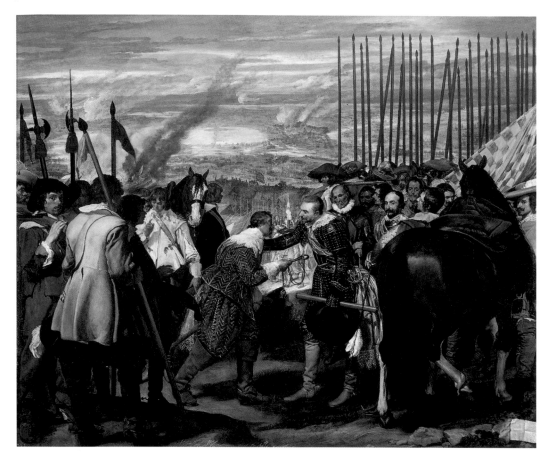

Diego Velázquez
The Surrender of Breda, 1634/35
Oil on canvas, 307.5 x 370.5 cm
Madrid, Museo del Prado

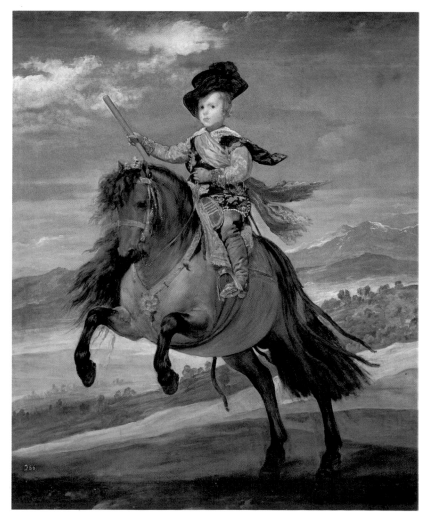

Diego Velázquez
Prince Baltasar Carlos,
Equestrian, c. 1634/35
Oil on canvas,
209.5 x 174 cm
Madrid, Museo del
Prado

DIEGO VELÁZQUEZ
1599–1660

The main problem of a history painting featuring a large number of figures is the question of how to handle the crowd scenes. Velázquez initially tackles this difficulty by dividing the picture plane into two levels – a higher area of action on which the main event is acted out as on a stage, and an area below it in which we see the city and harbour of Breda and the sea. The stage-like situation is further emphasized by various foreground elements. The two military leaders – the defeated commandant of Breda handing over the keys of the fortress to the Spanish commander Spinola – are immediately recognizable as the protagonists because the view opens up behind them towards the otherwise hidden background, whereas to the right and left the respective military entourage is grouped like stage extras. Yet Velázquez does not portray them as anonymous soldiers. Amongst the group of Spanish victors brandishing their lances, we can make out just as many individual expressions of exhaustion as we can amongst the resigned group of defeated Dutch soldiers.

In the field of royal portraiture, the portrait of the infant or child ruler poses a particular problem to the artist. A majestic pose, sumptuous clothing and the traditional outward trappings of dignity inevitably clash with the very nature of childhood. Velázquez solves this problem by placing the child on a sturdy horse so that the little figure is raised, as on a monumental plinth, to the "correct" position in the picture. This view is further vindicated by a sweeping landscape whose unspoilt nature creates an uncontrived link with the serious, yet still softly contoured and unspoilt mien of the child's face.

Although the dwarf Don Sebastián de Morra is portrayed in full figure, he is not standing in a self-confident pose or elegantly seated on a chair, but is sitting on the bare earth with his feet stretched out in front of him. This low position not only shows up the sumptuous clothing for the clownish apparel it is, but also heightens the intended effect: the court fool is at the mercy of the spectator. Such pictorial devices reveal the voyeurism with which the royal rulers made these people the objects of their shameless whimsy, caprice and power. At the same time, however, the artist is also making another statement: this court fool is giving nothing away, neither a smile, nor any buffoonery. Immobile, scrutinizing and impenetrable, his dark eyes are fixed on the spectator, who somehow feels caught out by such a gaze and turns away.

Diego Velázquez
A Dwarf Sitting on the Floor
(Don Sebastián de Morra) c. 1645
Oil on canvas, 106.5 x 81.5 cm
Madrid, Museo del Prado

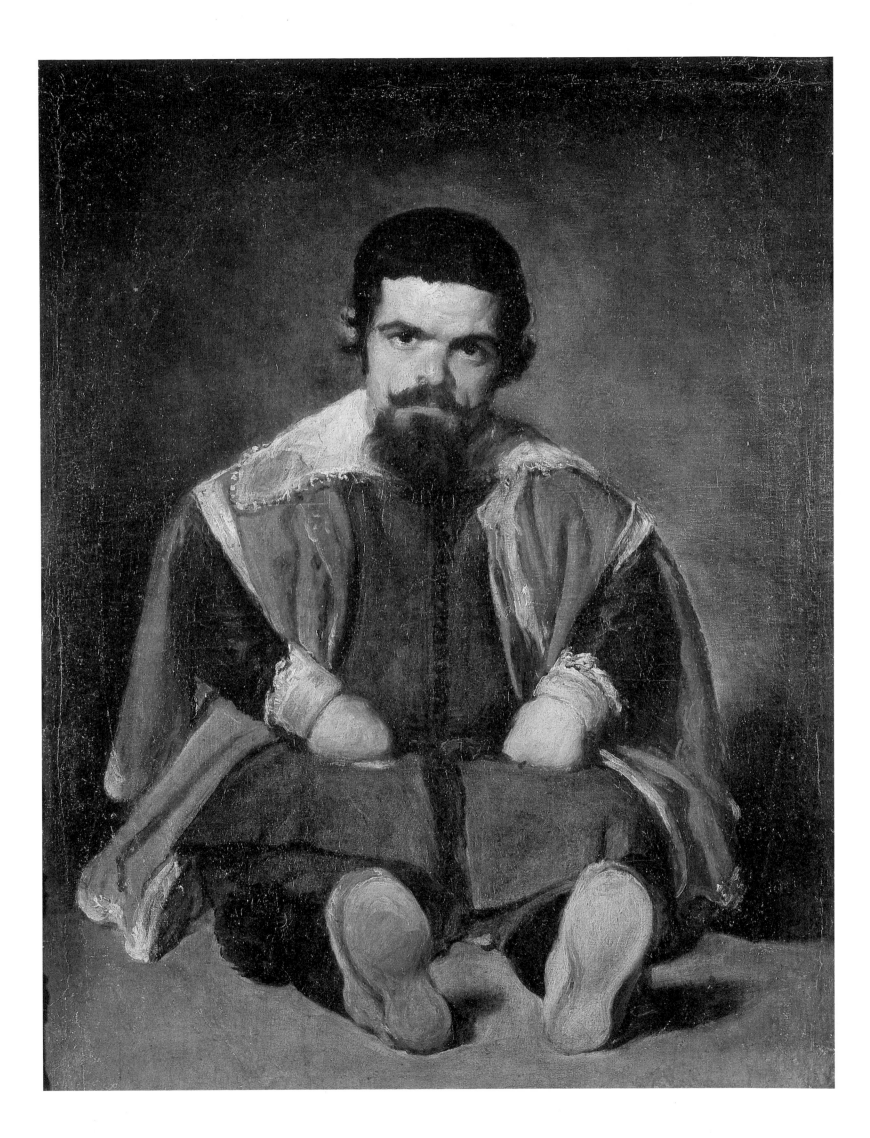

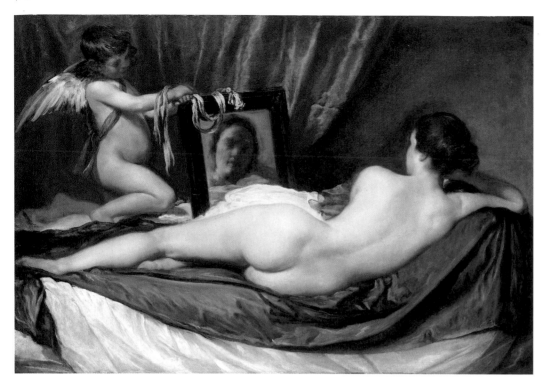

Diego Velázquez
Venus at her Mirror (The Rokeby Venus), c. 1644–1648
Oil on canvas, 122.5 x 177 cm
London, National Gallery

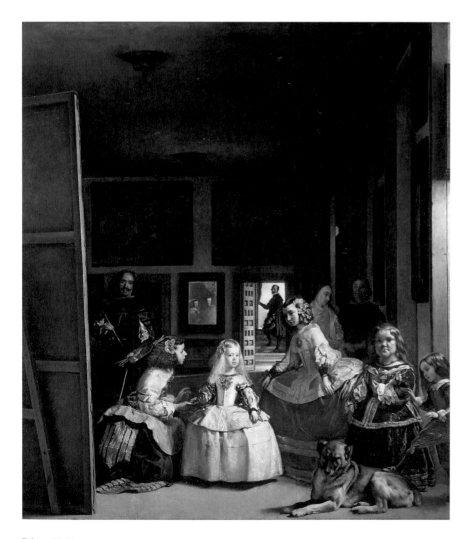

Diego Velázquez
Las Meninas (The Maids of Honour), 1656/57
Oil on canvas, 318 x 276 cm
Madrid, Museo del Prado

DIEGO VELÁZQUEZ
1599–1660

The Rokeby Venus is widely regarded, along with Titian's *Venus of Urbino*, as one of the most beautiful and significant portrayals of Venus in the history of western painting. Yet it is virtually impossible to explain the magic of this painting. The consistent reduction of colour to lucid red, gentle blue, clear white and a warm reddish-brown allows the skin tone of Venus – blended, incidentally, only from the other colours in the painting – to emerge as an independent hue whose sumptuous sheen dominates everything else.

Venus is presented in a sensually erotic pose, and yet she seems chaste and is so completely merged with the overall image that she cannot be touched. Cupid, disarmed, without his bow and arrow, is holding a mirror, his hands bound by fragile pink fetters, condemned to do nothing and completely immersed in contemplation of the beautiful goddess. The mirror image – in defiance of all laws of optics – does not reveal the other side of Venus, but only permits a vague and blurred reflection of her facial traits. This may in fact indicate the underlying meaning of the picture: it is not intended as a specific female nude, nor even as a portrayal of Venus, but as an image of self-absorbed beauty. The goddess of love appears here as a mythical being with neither aim nor purpose, needing no scene of action, but blossoming before our very eyes as an image of beauty itself.

This is a composition of enormous representational impact. The Infanta Margarita stands proudly amongst her maids of honour, with a dwarf to the right. Although she is the smallest, she is clearly the central figure; one of her maids is kneeling before her, and the other leaning towards her, so that the standing Infanta, with her broad hooped skirt, becomes the fulcrum of the movement. The dwarf, about the same size as the Infanta, is so ugly that Margarita appears delicate, fragile and precious in comparison. On the left in the painting, dark and calm, the painter himself can be seen standing at his vast canvas. Above the head of the Infanta, we see the ruling couple reflected in the mirror.

The spatial structure and positioning of the figures is such that the group of Las Meninas around the Infanta appears to be standing on "our" side, opposite Philip and his wife. Not only is the "performance" for their benefit, but the attention of the painter is also concentrated on them, for he appears to be working on their portrait. Although they can only be seen in the mirror reflection, the king and queen are the actual focus of the painting towards which everything else is directed. As spectators, we realize that we are excluded from the scene, for in our place stands the ruling couple. What seems at first glance to be an "open" painting proves to be completely hermetic – a statement further intensified by the fact that the painting in front of Velázquez is completely hidden from our view.

Hermann Bauer

BAROQUE IN THE NETHERLANDS

Dutch and Flemish painting in the 17th century

In the 17th century, following the division of the country, painting in the Netherlands blossomed in what came to be known as its Golden Age. Rubens in the Catholic south of the country and Rembrandt in the Protestant north represent the contrasts and kinships of Baroque painting at its zenith.

Whereas Rubens, with his monumental creations for nobility and the Church, forged a link between the mortal, earthly world and the realms of Heaven or Olympus, Rembrandt's subtle chiaroscuro revealed the hidden depths of the human soul, creating a new dimension in portraiture.

Alongside these artists of genius, we also find the outstanding portraiture of Frans Hals and van Dyck, the landscapes of Ruisdael, van Goyen and Hobbema, the allegories of Jordaens, the still lifes of Heda and Kalf, the genre scenes of Brouwer, Steen, Terboch and de Hooch. The painting of the era culminates in Vermeer's interiors – masterpieces in the handling of light and harmony of colour.

Rubens and Rembrandt:
the Southern and Northern Netherlands

When Rembrandt was commissioned by Prince Frederick Henry of Orange (1584–1647) to paint five scenes from the Passion of Christ, most of which are now in the Alte Pinakothek in Munich (ill. p. 315), he corresponded between 1636 and 1639 with the Prince's governor-secretary Constantijn Huygens (1596–1687). In one of seven surviving letters, Rembrandt writes of the *Entombment*, stating that he had taken great care to render "die meeste ende natureelste beweechgelickheijt" ("the greatest and most natural movement") and explaining that this was why he had spent so much time on the painting. This "greatest and most natural movement" of which he speaks in his letter refers as much to the subtle and realistic portrayal of the figures as to the expression of their inner emotion.

A Mannerist artist of the 16th century would have couched a description of his work in very different terms. He would have emphasized the skill, artifice and inventiveness of the painting. Rembrandt's comment referred to something else. It evoked a quality that was to become a fundamental feature of Baroque painting, particularly in the Netherlands. Rembrandt was talking about realism and about a new and more intimate approach to the way the world looks. He was also talking about a new dimension of pathos and expression – "natureelste beweechgelikheijt".

Rembrandt's *Passion of Christ* cycle is the early work of a Dutch artist. It coincides with the late work of the Flemish painter Peter Paul Rubens. Between 1636 and 1638, Rubens was working on a series of designs for a major mythological cycle, part of which he executed personally, that had been commissioned by the King of Spain to decorate the royal hunting lodge of Torre de la Parada near Madrid. Irrelevant as the all too frequent attempts to compare Rembrandt and Rubens may often be, they can nevertheless provide some interesting insights: what Rembrandt regarded as a commission, Rubens regarded as the enriching culmination of his life's work. In Rubens' later work, we find an increase in pathos and dramatic expression.

"It is almost wondrous that the outstanding Rembrandt von Ryn, coming from the countryside, and from a milling family, should have been imbued by nature with such noble art that he has been able, through his own hard work, natural inclination and preference, to achieve such a high rank in art... and because of his natural talent, unstinting hard work and constant practice it was no disadvantage to him that he did not visit Italy and other places where one might

study Antiquity and Art Theory, nor that he was unable to seek edification in books, for he could read only Netherlandish, and that but poorly. Neverthless, he remained constant in his chosen custom and did not shy from defying our rules of art in anatomy and human proportion, defying perspective and the example of ancient statues, defying the draughtsmanship of Raphael and scholarly teachings, nor did he shy from railing against the academies that are so necessary to our profession, contradicting them, in vain, by proclaiming that we should look to nature alone and brook no other rules..." wrote Joachim von Sandrart in his *Teutsche Akademie*, an art history published in 1675, based on the Italian model and influenced by classical theory. His assessment is by no means incompetent. After all, Sandrart had spent several years in Holland and knew Rembrandt personally. His views are particularly interesting on two points: the fact that he feels obliged to add – alongside the academic values of the beautiful and the true – nature as Rembrandt's sole instance and, secondly, the fact that he acknowledges an independent Dutch, and indeed national, art.

National pride had already begun to emerge before Rembrandt arrived on the scene. Huygens, mentioned above, secretary to the Prince of Orange, wrote of Rembrandt's 1629 painting *Judas Returning the 30 Pieces of Silver*: "Let all of Italy come forth and all things magnificent and admirable since Antiquity..."

In Ruben's major paintings of the 1630s, from his altarpieces to his designs for civic stagings such as the *pompa introitus* designed to welcome the Infante Ferdinand as regent of Flanders, from his mythological scenes such as the decoration of the Torre de la Parada near Madrid, to his landscapes, we find an increasing density and centrality, with each painting gaining significance from the attribution of essential characteristic and objects to content – a density in which light and colour play an important role.

Certain criteria of Netherlandish painting were clearly established even before Rubens and Rembrandt: realism and the faithful rendering of objects. Their contribution, however, is the presentation of pathos and movement; increased pictorial expressiveness achieved by centering and by profound handling of colour and light.

There are limits to the usefulness of any comparison between the late Rubens and the early Rembrandt, and such comparisons invariably tend to be used to highlight certain polarities. On the one hand, we have an aristocratic painter and cosmpolitan sophisticate sought after by the ruling houses of Europe and the Church. On the other hand, we have a miller's son from Leiden whose attempts at running a patrician house in Amsterdam are doomed to failure, and who eventually withdraws to the margins of the ghetto, avoiding human contact and devoting himself entirely to his painting. Such clear-cut contrasts tend to overlook a number of factors that these men actually had in common. Rubens,

Peter Paul Rubens
Portrait of Susanne Fourment (Le Chapeau de paille), c. 1625
Oil on panel, 79 x 54.5 cm
London, National Gallery

Rembrandt Harmensz. van Rijn
Self-portrait, 1658
Oil on canvas, 133.5 x 104 cm
New York, The Frick Collection

had to look beyond the confines of Antwerp, to Italy, motherland of the arts, in order to establish a name for himself. Under political pressure, Rubens' work became increasingly outward-looking, while the newly rich and proud city of Amsterdam boasted that Rembrandt had never been to Italy, and the latter's art became increasingly introverted and his radius of movement diminished in Amsterdam.

In 1566, the largely Calvinist Gueux who had revolted against Spanish rule sacked the Catholic churches and monasteries of Antwerp (at the time a city with a population of some 120,000) in a violent "breaking of the images". The Spanish rulers responded by calling in the Inquisition, Margaret of Austria, duchess of Parma (1522–1586) resigned from her post as governor-general, and troops headed by the Duke of Alba (1507–1582) marched in. Many Protestants fled the country, including the lawyer Jan Rubens, who went with the entourage of Prince William of Orange (1533–1584) to Cologne, where his intimate liaison with the wife of the governor-general resulted in his banishment to Siegen. It was in Siegen that his son Peter Paul was born and registered as "Lutheran".

After the death of Jan Rubens, his widow and children returned to Antwerp – she had evidently remained Catholic – where Peter Paul attended the Latin school, just as Rembrandt had briefly done in Leiden. However, he soon had to earn his own living, and became page to a widowed countess. Shortly afterwards, he was apprenticed to a painter of whom we know little more than the name: Tobias Verhaechts (1561–1631). Later, he was apprenticed to the renowned Adam van Noort (1562–1641) and finally studied for four years under Otto van Veen (1556–1629), a Mannerist of international stature.

Though Rubens went to Italy to learn his craft, his evident talent allowed him to launch his career at his very first port of call, Venice, where he came to the attention of the Duke of Mantua and was employed at his court. Rubens' tasks included producing copies of Italian masters and portraits of the ducal family. By the time he was sent on a diplomatic mission to Spain io 1603, he was creating his own paintings, producing copies and the works of old masters. He was back in Italy a year later, finally returning to settle in Antwerp in 1608.

In the Southern Netherlands, which had remained Spanish and Catholic, a certain degree of normality was beginning to return to everday life, with churches and monasteries being rebuilt and restored. Thanks to the patronage of the art-loving Infanta Isabel Clara Eugenia (1566–1633), a sister of King Philip III of Spain (1578–1621), Rubens had a more than adequate supply of work from court, municipality and church.

Rubens' great historical achievement was his synthesis of the traditions of classical painting in a previously unimaginable way that created dynamic perspectives rather than stati-

as the son of Protestant emigrants, did not embark upon the educational or professional path that had been charted for him and, like Rembrandt, he was largely self-taught, even though he later played the role of *uomo universale*. Both of them had an enormous impact on the world of art, becoming the masters of their century and forming schools of art – both literally and metaphorically – that shaped the development of painting. Moreover, they were the only artists in the Netherlands to practise every genre of painting, from history painting to portraiture; at the same time, they advocated a return to specialization in painting. Rubens trained and employed specialists for flowers, genre figures and even for "Rubens-style" painting. Virtually every Dutch specialist was indebted to Rembrandt, from "fine" painting to *trompe l'œil* illusionism and even portraiture.

The rise of painting in the Netherlands coincided with a period of political turbulence in which the country was divided once and for all both by religion and political rule. It was a period when Antwerp lost much of its wealth and power, just as Amsterdam's star was rising. The fact that Rubens was commissioned by the church and the nobility was due to some extent at least to the fact that he initially

Rembrandt Harmensz. van Rijn
Hendrickje Bathing in a River, 1654
Oil on wood, 61,8 x 47 cm
London, National Gallery

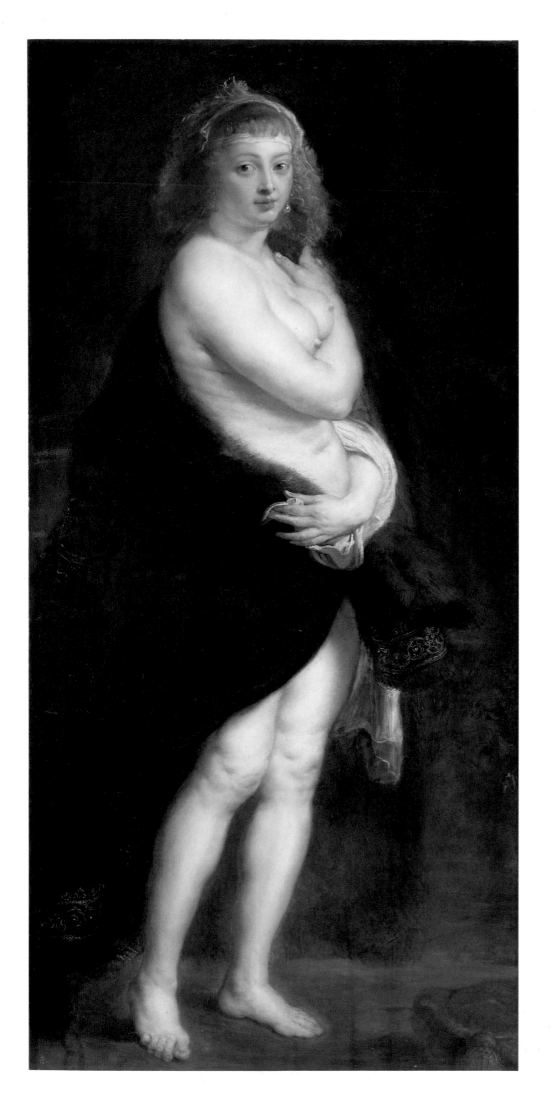

Peter Paul Rubens
The Little Fur (Helene Fourment), after 1635
Oil on wood, 176 x 83 cm
Vienna, Kunsthistorisches Museum

cally retrospective structures. He was to become the painter of the new Baroque era, the exponent of an art that transcended the borders between reality and meta-reality, transforming the static props of the Renaissance into exuberantly theatrical scenes. He was to become the painter of a spiritual and worldly apotheosis, presenting by sensual means the deification of the great and the good, and their entry into the world of eternity and conceptuality. He adopted the *Assumption* or *Ascension* as his foremost theme, in all its variations, creating images of beings ascending to celestial heights and descending into the sphere of the sensually palpable, for his ecclesiastical patrons of the Counter-Reformation and "courtly society".

When Rembrandt was born in Leiden in 1606, the northern provinces of the Netherlands governed by stadholder Maurice of Nassau, Prince of Orange (1567–1625) had only been fully independent of Spanish rule since 1596, under the terms of a truce that was to last until 1621. The Peace of Westphalia in 1648, which also marked the end of the Thirty Years' War, recognized the Northern Netherlands and at the same time separated them for good from the southern provinces, which remained Spanish, coming under Austrian rule in 1714.

The province of Holland took the leading role within the union of Zeeland, Gelderland, Overijssel, Drenthe, Friesland and Groningen. By closing off the Scheldt, Antwerp's access to the sea, Holland crushed the city which, in the 16th century, had been the wealthiest trading centre of the north, while Amsterdam rose to unprecedented prosperity. Holland rivalled England as a seafaring power, gaining a virtual monopoly on cargo shipping, dominating the Baltic grain trade and establishing colonial bases in the East Indies, West Indies, North and South America. Above all, Amsterdam was a flourishing centre of finance, and the importance of its "exchange bank" was comparable to that of Wall Street today. In 1602, a number of trading companies joined forces to create the Dutch East Indian Trading Company, triggering a hitherto unimaginable flow of money into Amsterdam.

The political structure of the States-General was federal, with the Princes of the House of Orange acting as stadholders or chief executives of otherwise self-governing republics in which a monied nobility of wealthy burghers emerged to take over the administration, deriving their legitimation from the liberation struggle and their financial success.

The process of political independence in the Netherlands was largely a religious struggle in which various forms of Protestantism, most notably Calvinism, took firm hold. A national synod held at Dordrecht in 1618 prohibited Catholic religious services and permitted only Calvinists to hold office. Most of the members of the House of Orange were orthodox Calvinists, and only scattered pockets of the northern provinces remained Catholic.

The history of the new northern provinces began with the iconoclasts. In his "Decalogue", John Calvin had taken a stance on the question of imagery and had called for a ban on any representation of the divine. The almost sacramental dignity with which the Catholic faith had endowed the portrayal of saints had now become a sacrilege. This turn of events narrowed the field of artists' commissions by putting an end to church decoration and altarpieces.

The creation of a new image

When Rembrandt created a series on the Passion of Christ for the Prince of Orange, these were intended as private devotional paintings. The landed nobility with their palaces provided few commissions for frescos or major decoration. The Orange palace of Huis ten Bosch was one of the few exceptions, albeit on a modest scale, and was decorated by Flemish painters. The extent to which the question of images was first and foremost a question of religious images is reflected in the fact that the production of paintings in the Netherlands grew enormously from the end of the 16th century and the balance between supply and demand became exceedingly complex. The now predominant genres showed

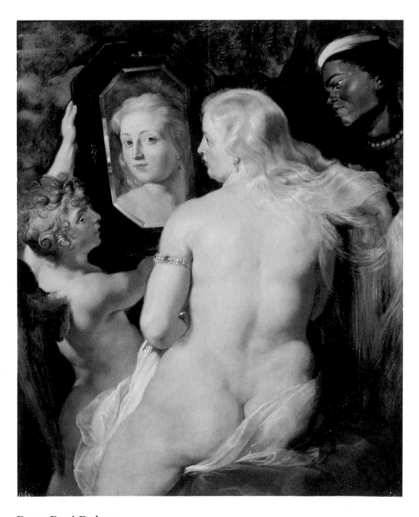

Peter Paul Rubens
Venus at a Mirror, c. 1615
Oil on panel, 124 x 98 cm
Vaduz, Sammlung Fürst von Liechtenstein

that Christian iconography had not entirely disappeared from painting. As Calvin, in his doctrine of predestination, had accorded to each individual something akin to a personal priesthood, it was inevitable that the portrait, as the depiction of the individual, should take on a new significance. Accordingy, it became an outstanding instrument in Holland as well. The image of the individual, or of a group, also indicated the position of the individual between God and the world. Where the image of God was forbidden, the allegory was all the more important. Often, in Dutch painting, we find the so-called *portrait historié*, a specific likeness, generally of several people, but in a biblical or mythological role. For example, if two brothers were reconciled after a family dispute, they might commission a portrait depicting them in the roles of Jacob and Esau to celebrate their reconciliation.

What may appear at first glance in Netherlandish painting to be a genre scene – and was long regarded as such – is almost invariably an allegory or a pointer towards some accepted "truth". Scenes of gallantry and entertainment, originating in brothel scenes, have their roots in the parable of the prodigal son. Jan Steen (c. 1625/26–1679 painted humorous

Jan Steen
Rhetoricians at a Window, c. 1662–1666
Oil on canvas, 74 x 59 cm
Philadelphia, Philadelphia Museum of Art

scenes depicting folk wisdom, allegories or proverbs. The superficial humour could also be taken at face value. The Mannerist tendency to conceal the meaning of a picture by packaging it in a rebus or intricate puzzle, was adopted and presented, in the 17th century, in a less equivocal, simpler and more obvious form.

Probably the most striking example of the way in which the allegory took the place of the religious painting is the still life or, to be more precise, the vanitas still life. The very designation "vanitas" tells us that the beautiful and pleasingly painted objects are an indication of the transience of all earthly life. The figurative meaning of a skull or a dying candle is quite obvious, and we can easily deduce that a soap bubble is likely to symbolize the triviality of life. Over and above, there exists a vast repertoire of symbolic meanings, many of which are no longer familiar to us today, with which the objects in such paintings are endowed with specific significance in much the same way as the vanitas picture. The frequent depiction of bread and wine in Dutch still lifes is, for example, an indication of the increasing use of secular surrogates to evoke the liturgical rites of the Eucharist. With the decline of religious imagery, allegorical painting flourished. However, this particular development was not restricted to the Protestant Netherlands alone. It could be found in the southern provinces, too, albeit with a considerably stronger affinity to Italian art and the traditional subject matter of Catholic painting.

Just as, in the course of the 16th century, paintings had become less and less an integral part of the architectural whole, particularly in the Netherlands, so too did the painting itself become a commodity as well as a transportable object. One indication of this development is the emergence of an art trade and exhibitions. We know that, by this time, painted canvases had become objects of speculation and that they were regarded as capital assets, accepted as payment and taken as security. With the increasing emancipation of the middle classes, the circle of buyers of paintings grew to an extent that would have been unthinkable in the early years of the 16th century when the Church, nobility and a small circle of humanist thinkers had commissioned works. A frequently quoted report by an English traveller visiting Holland in 1641 describes how he arrived at Rotterdam late in the evening to find a fair in progress, where he was astonished at the number of pictures – especially landscapes and so-called drolleries – on offer. Surmising that the reason for this was the low price of the pictures and the lack of available land as a capital investment, the author goes on to explain that peasants had the habit of investing large sums in paintings, filling their homes with them and selling them at considerable profit during their fairs.

Whether or not the prices were indeed as high as this traveller claimed, the remarkable thing about this statement is his evident surprise at the very idea of paintings being

such mobile goods. Sales exhibitions were first held in Antwerp, and in the course of the 17th century became commonplace throughout Holland. By 1640, the Guild of Painters in Utrecht had a permanent sales exhibition. In The Hague, the painters formed a corporation for sales purposes in 1656, and occasionally made attempts to standardize formats in order to rationalize sales and pricing. Even the Dutch picture frame became uniform and standardized. These ornate dark or black wooden frames were artistically formed, but also neutral and appropriate to the painting.

Whereas there had previously been agents who mediated between an aristocratic or ecclesiastical patron and the artist, the profession of art dealer now began to emerge, along with assessors and auctioneers, and Amsterdam became the centre of the art market. Painters frequently offered for sale not only their own works, but also paintings by other artists or antique works. We know, for example, that Rembrandt sold works by his students, and Arnold Houbraken (1660–1719); chronicler of 17th century art, reports that Frans Hals exploited his student Adriaen Brouwer (c.1605/06–1638).

Result and cause of the newfound mobility of paintings was the increasing specialization of individual painters on specific genres and subject matter. Delegation of work was the rule, rather than the exception. Rubens is known to have had specialists for certain aspects of painting; Jan Brueghel (1568–1625) collaborated with him, painting the flowers in some of his works. Nicolaes Berchem (1620–1683) painted incidental figures in the paintings of Jacob van Ruisdael (c.1628/29–1682). On the other hand, a landscape painting by Berchem includes a portrait of a man and woman by the portraitist Gerard Wons. In the church interiors by Pieter Saenredam (1597–1665) we frequently find incidental figures by Pieter Post (1608–1669).

As painting became increasingly equated with the production of a commodity, the status of the artist threatened to return to that of mere craftsman, the very status from which artists had emancipated themselves in the Renaissance. Rubens and Anthony van Dyck (1599–1641) succeeded in establishing themselves as a new form of artist-aristocrat, though Rubens was once sharply cut down to size by a real aristocrat. Rembrandt's attempt at this kind of upward mobility was a rather tragicomic expression of a prototype Bohemian lifestyle.

Painters who took on other kinds of work, or part-time painters, became fairly commonplace. Jan van Goyen (1596–1656) traded in tulips and real estate. Many artists of the day, including Jan Steen and Adriaen van de Velde (1636–1672) were publicans who could exhibit paintings in their taverns and who occasionally accepted them in payment. Jacob van Ruisdael was a surgeon, Philips Koninck (1619–1688) had a shipping line, Meindert Hobbema (1638–1709) was a tax collector. Few of them found painting a lucrative occupation.

Jan Brueghel the Elder
The Animals Entering the Ark, 1615
Oil on copper, 25.7 x 37 cm
London, Wellington Museum

One of the many changes that swept the Netherlands in the turbulent years of the late 16th century, apart from the emancipation of the painting as such, was the fact that this "commodity" no longer needed to be a vehicle for a certain "content" in the traditional sense, but contained objects gathered together as genres. It became far less common for specific subjects to be commissioned. Instead, certain subjects tended to be preferred or rejected by purchasers. The concept of "subject matter" which became so important in the 19th century is best used here to describe what individual specialists now produced.

Understandably enough, orders were still frequently placed for individual and and group portraits, the latter being mainly for institutions and meeting halls such as the premises of the Civic Guards, where the painting had a permanent place. Only once was a building created on the scale of a royal palace with corresponding interior decor and iconography. It was the Amsterdam City Hall, often referred to as the Cathedral of Holland. It might in fact be better described as the Versailles of this republican city. The consistent iconographical programme throughout the building is a hymn to liberty and bourgeois republican virtues. The city fathers commissioned Ferdinand Bol (1616–1680), Govaert Flinck (1615–1660) and Rembrandt to contribute to the decor, while Artus Quellinus (1609–1668) was responsible for some outstanding sculptural work on the building. At any rate, the artists at work here were specialists in the field of history painting – the most highly esteemed genre of the time and the only one that was more or less independent of art market fluctuations.

The art market dealt primarily in specific themes and attracted an astute and critical audience who judged the works according to the conviction and skill with which a painter

portrayed worldly objects and the subtlety with which he could convey an underlying message of "truth". Dutch Baroque painting emerged in this artistic climate of specialization in a wide variety of subjects. The more the artists specialized in individual sectors, the more intensive the impact of the individual paintings became.

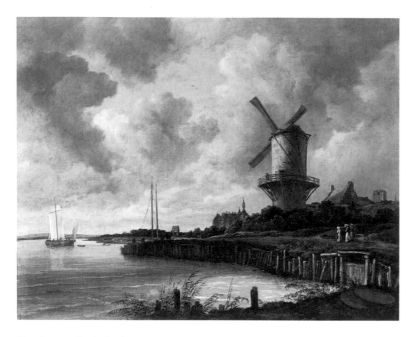

Jacob van Ruisdael
The Windmill at Wijk bij Duurstede, c. 1670
Oil on canvas, 83 x 101 cm
Amsterdam, Rijksmuseum

A number of pictorial genres were developed to high standards of purity. Whereas, in Mannerist painting, the individual components had consituted a partial aspect of some wider context, a process of emancipation was now taking place which can best be illustrated by way of example of the still life. Initially, in the kitchen scenes, pantry scenes, marketplaces or households painted by such artists as Pieter Aertsen (1508–1575) or Joachim Beuckelaer (c.1530/35–c.1575/78), the objects and items of the kitchen or marketplace take up most of the painting, while a biblical scene tucked away somewhere in the background indicated the actual meaning of the work. One of the most important steps on the way towards Baroque painting lies in this rejection of the complex superimposition of different layers of meaning; by abandoning the overwrought breadth and scope of Mannerism, the picture could be broken down into individual and independently valid parts, liberating the close-up still life from such contextual strictures. Landscape painting evolved along similar lines. Pieter Brueghel the Elder (c.1525/30–1569) had already created landscapes of great intensity in their evocation of atmosphere, season and mood. Yet they are also invariably "universal landscapes" (like those

of Patinier) in which the range of the visible and the raised standpoint – potentially a bird's eye view – invariably add something increasingly conscious, considered, symbolic and significant, whereas the landscape painting of the 17th century no longer depicts "summer" or "winter" as such, but a landscape or a seascape on a summer's day or on a winter's day.

This should not be misconstrued. Baroque painters did not paint outdoors at their easels, as the artists of the School of Barbizon would later do in 19th century France. They might, at most, make some sketches outdoors, or they might take notes or even record a situation using the *camera obscura*, which aided accuracy in drawing details, before executing the painting in the studio. While bearing these facts in mind, we should nevertheless take care to avoid the pitfall of assuming that the Baroque artists of the Netherlands were simply "copying" reality. Even though their landscapes and vedutas may depict specific places, situations and cities, and even though their still lifes may seem almost "real" enough to touch, a number of factors provide overwhelming evidence that they are not intended to portray a detail of the visible world. We know that a number of painters, especially in Delft, used the camera obscura to make their initial studies of objects and city vedutas. Nevertheless, in the pictorial organization of a work such as the *View of Delft* (ill. p. 139) by Jan Vermeer (1632–1675) the cityscape has been altered in a barely perceptible yet highly energetic way to suit the scheme of the painting, as was common practice in such vedutas. In the still life, the process is more obvious. What appears to be a portrayal of found objects, of incidental and arbitrary items is actually specifically intended to indicate the transience and vanity of earthly existence. On another level, these objects are visually significant in terms of the way they have been arranged with the pictorial structure and aesthetic appearance of the painting in mind.

Subject matter and content – specialists and masters

One of the greatest achievements of Netherlandish Baroque painting was its creation of specific schemes within the various genres, in which a great diversity of individual objects gained their own distinctive and unprecedented dignity.

History painting ranked highest in the artistic hierarchies of the day. It referred to paintings which represented an "image of historic events" in which the actual portrayal of significant contemporary events played only a minor role. The painting by Gerard Terboch (1617–1681) depicting the Peace Treaty of Westphalia negotiated at Münster in 1648 (London, National Gallery) is in fact a group portrait showing the representatives of the signatory power. Battles and other warlike events were rather less popular subjects, with the possible exception of equestrian combat. At the same time, however, history paintings could also feature allegorical subjects from Antiquity, especially if they involved republican subjects.

Finally, history paintings might also be portrayals of biblical themes, particularly from the Old Testament.

Rembrandt addressed the Protestant variety of religious painting – the parable – in greater depth than any had done before, exploring the human factor as well as the divine. In the work of his students Flinck, Bol and Nicolaes Maes (1632–1693) this contemporaneity of the biblical and of man's relationship with God is more immediately evident, more direct and, in the "portrait historié", often dramatically presented. Nevertheless, in Dutch history painting, the ambitious aim of projecting contemporary life onto a backdrop of historical or biblical events and, on the other hand, updating ancient or biblical paradigms, are often naive, if invariably human, in its directness.

Flemish painters such as Rubens or Jacob Jordaens (1593–1678) were, in a similar sense, history painters: The difference between them and the Dutch painters lies in the distinct sensuality and corporeality of earthly appearances they achieved through their heightened colour and form, suggesting and at times revealing a sense of meta-reality.

Since the 15th century, the portrait had become an independent genre. So, too, since Dürer and the High Renaissance, had the self-portrait of the artist. In the Netherlands of the 17th century, the portrait became the primary vehicle not only for the representation of a person's social rank and standing, but also an excercise in exploring the psyche through the individual's expression. What is more, the portrait now came to represent the relationship between the individual and the community, either in the form of a family portrait (of which Rubens created some that showed bonds of deep affection), or in the group portraits of the Dutch artists in which Hals, Thomas de Keyser (c. 1596/97–1667) and Rembrandt sought successfully to depict individuality within a homogeneous group. The developments of the age are all the more evident in the light of a comparison with the group portraits created before the mid-16th century, for example by Jan van Scorel (1495–1562). Initially, they generally involved an accumulative juxtaposition of portraits (of pilgrims to Jerusalem, for instance). In the work of Hals, the occasion, the principle and the essence of a group are the determining factors in its composition. After all, Rembrandt's *Night Watch* (ill. p. 119) is also a group portrait, albeit one in which the painter admittedly goes far beyond the conventions of this particular genre, creating a highly theatrical *mis en scène*.

With the increasing secularization of places of worship in Netherlands and the loss of votive and sacred images in the wake of the iconoclasts, the church interior, or rather architecture with churches as a prime motif, became popular subjects in painting. This "concretization" of the sacred might be regarded as a kind of compensation, in much the same way as elements of the Eucharist began appearing in still lifes. The paintings of church interiors, in particular, do tell

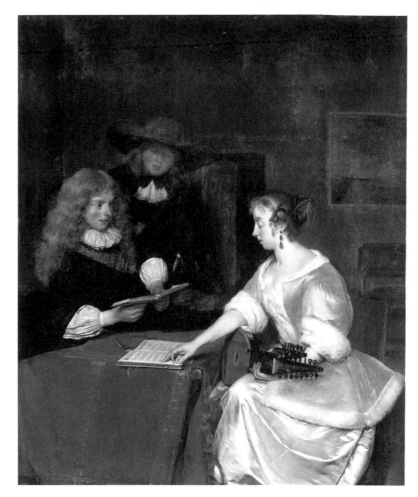

Gerard Terborch
A Concert, c. 1675
Oil on panel, 58.1 x 47.3 cm
Cincinnati (OH), Cincinnati Art Museum

us a great deal both about their development and the way they were regarded. In the works of Emanuel de Witte (c. 1617–1692) or Gerard Houckgeest (c.1600–1661), to name but two specialists in this genre, there are preachers and congregations to be seen, but it is far more common to find children playing in the outsized rooms, people strolling, or even dogs lifting a leg at a pillar – a motif that requires little interpretation. The actual subject matter of the picture is no longer the church interior itself, but the portrayal of light within a space that is perceived as space primarily because it is too large, unused and unaffected by the presence of people, its very existence as tranquil as an architectural still life.

Architectural painting developed along the following lines: Flemish artists, in particular, had a penchant for imagined spaces with surprise effects and unusual perspectives. This approach, which still bore many features of Mannerism, was later replaced by what Hans Jantzen (1881–1967) described as the "dream of reality" – views of interiors in which a portrait of architectural individuality was created, while the portrayal of the space itself remained largely dependent upon the actual detail and perspective of the picture itself. Peter Saenredam was the leading church portraitist of

Anthony van Dyck
Portrait of a Member of the Balbi Family, c. 1625
Oil on canvas, 132.7 x 120cm
Cincinnati (OH), Cincinnati Art Museum

this period. In a final stage, of which de Witte was the foremost representative, a considerably smaller detail of the interior was portrayed and showed the play of light and shadow on individual parts, pillars (cut off at the top) or corner sites, rather than on architectural structures, thereby making the atmosphere the main focus of the image.

The objects in a room, especially objects bathed in light, and the room or space itself thus became a subject of Dutch painting. Each object – person, animal, room – is presented as though caught in a brief pause for thought. There are many variations in which elements of still life painting are combined with other objects. Vermeer's interiors are like an extended space surrounding a still life. In the work of Carel Fabritius (1622–1654) we can find a view of Delft seen through the shop of a merchant of musical instruments in which a lute and a cello lie in front of the townscape like a still life.

Together with portraiture, the still life is a key genre in Netherlandish painting. In this field, too, there was considerable specialization and differences between individual schools. Haarlem concentrated on portraying banqueting tables laden with opulent dishes. Leiden focused more on vanitas still lifes full of books, jugs, tobacco pipes and writing implements. In The Hague, seafood predominated. What is more, there were considerable differences between

Flemish and Dutch still lifes as well. In Antwerp, the work of Frans Snyders (1579–1657) presents sumptuous still lifes which are invariably a theatrical staging of extremely diverse objects and precious items. If Flemish still life can be described as "extensive", Dutch still life may be called "intensive" in the sense that it draws its appeal from its concentration on only a few things. Even where the Haarlem "banquets" are based on the Flemish model, space and light are handled very differently indeed.

The landscape of the Low Countries and the sea, imagined memories of southern climes, Arcadian fields, landscape as a portrait of a certain place or an area and landscape as a projection of imagination did not become an independent genre until the Baroque era and, when it did, the Netherlands led the field. Dürer's watercolour landscapes had already helped to emancipate the genre to some extent prior to 1500. With Pieter Bruegel, such elements as mood, atmosphere and individuality took on greater independence. There is something celestial in his portrayal of the months and seasons. In the Baroque landscapes between van Goyen, Jacob van Ruisdael and Hobbema, a new element comes to the fore which had previously been a mode of illustration. Aerial views had been known since the days of Leonardo da Vinci, and artists were also well aware of the fact that objects in the distance change not only in terms of linear perspective but also in terms of light and colour. Netherlandish landscape painting took distance, space and atmosphere – the interim zone between objects in which light develops its effects – and made this the subject matter of their painting.

The French poet and playwright Paul Claudel (1868–1955) described it as follows: "I do indeed believe that we would better understand Dutch landscapes, these poems of tranquility, sources of silence, which owe their origins less to outward curiosity than to inward contemplation, if we would only learn to lend them an ear at the same time as we perceive them with our eyes. Compared to the overladen, overfilled paintings of the English and French, it is the enormous importance of emptiness over fullness that strikes us first of all. We are struck by the slowness with which a tone retained time and time again, through every shade and hue, finally alights upon an unequivocal line or form. Distance merges with the void, and the water on the wide, open spaces bears the cloud."

In other words, void and distance have become objects – a subject matter as calm as any part of a still life. The concretization of space and light are the hallmarks of Netherlandish landscape painting. It is interesting to note that the horizon of land or sea is often very low, unlike that of the early landscape paintings with their sweeping and almost universal distances. From a bird's eye view, or at least from a raised viewpoint, a sense of distance is created by placing the centre of perspective and the horizon very low. "The moist haze of the sky with its atmospheric clouds plays the main role in the

picture", according to Eduard Hüttinger. There are several versions of a view of Haarlem by Jacob van Ruisdael, in vertical format, seen from a raised point of view, but with the city so far in the distance that it actually forms the horizon, with the church spires soaring heavenwards and the clouds and haze forming a blurred boundary. It is situated in the lower third of the picture. The other two thirds are taken up by a cloudy sky. Between the spectator and the city there is a bleaching green on which lengths of locally manufactured fabric are stretched out, bathed in rays of light from the open skies. The spectator experiences the light through its effect on the objects, in the way the sun falls on the linen – as trivial as it is solemn. A similar phenomenon may be observed in the work of Vermeer, where a woman stands at a window, contemplating her pearl necklace in the light. Simple light is transformed into a ceremonious event, in its penetration of the room and in the way it falls on objects. Yet for all the mutability and transience of light, it is not brief moments that are portrayed in the interiors and landscapes, but "heightened" moments in which everday occurrences becomes celebratory moments.

Nowhere is the specialization of Netherlandish painting so evident as it is in landscape painting. There was an Italianate form which adopted elements of Italian painting as well as southern and ancient motifs. Many of these Italianate landscape painters had studied in Italy, including Herman van Swanevelt (c. 1600–1655), Berchem and Jan Asselijn (1610–1652), and they were profoundly influenced by Rosa and Lorrain. Then there were the Haarlem landscape painters who favoured low horizons and the sweeping expanses of the dykes and polders by the sea. Van Goyen initially painted in Haarlem, Jan Porcellis (c. 1584–1632), Hercules Seghers (1589/90 – c. 1633) and Salomon van Ruysdael (c. 1600/1603–1670) were members of the Haarlem Guild. Seascapes included the calm and tranquil scenes with a slight swell in the evening light (Jan van de Capelle, c. 1624/25–1679 as well as the stormy sea with endangered or capsized ships, favoured in Antwerp, and there were also paintings of shipping fleets (Willem van de Velde, 1633–1707), while the history painting of the fighting Dutch fleet barely played a role in the 17th century and lost its significance in much the same way as the battle painting.

In the Southern Netherlands, most notably under the influence of Rubens, a style of landscape painting developed which, for all their differences, bore many similarities with that of the Dutch school. This is evident, for example, in the work of Jan Siberechts (1627– c. 1700/1703) of Antwerp, who integrated Dutch elements into Flemish painting. Certain components which remained the preserve of individual specialists in Dutch painting can be found together in a single painting in the work of the Flemish artists: calm and sweeping plains together with bizarrely vibrant mountains or the idyll of of a river meandering through a shady forest

Frans Hals
Two Singing Boys, 1626
Oil on canvas, 62 x 54.5 cm
Cassel, Staatliche Kunstsammlungen

together with a sweeping view towards a distant horizon. Rubens' later work includes some of the finest landscape paintings in the history of European art. His *Landscape with Rainbow* (Munich, Alte Pinakothek, and London, National Gallery) and his *Landscape with Steen Castle* (London, National Gallery) executed around 1635 are more than mere views of the world around him. The wealth of nature is reflected in the colour spectrum, making Flemish rural life appear like some lost Arcadia, and the young men and women bringing in the harvest seem to hail from some strange metamorphosis of deities in disguise. In fact, the landscapes of Rubens are indeed frequently mythical scenes, often embodied by tiny figures. The difference between Dutch and Flemish painting might be described, albeit with some exaggeration, as follows: in Dutch painting, we find beauty rendered in a concentration of the representational, whereas in Flemish painting the representation of the world appears to be a vehicle for poetic metaphor.

Genre painting, as it has come to be known (for lack of a better description) encompasses the entire circle of social themes: portrayals of scenes from everyday life, music-making, love, rakish living, tooth-pulling, the doctor's visit or the self-portrait of the artist in his studio. Needless to say,

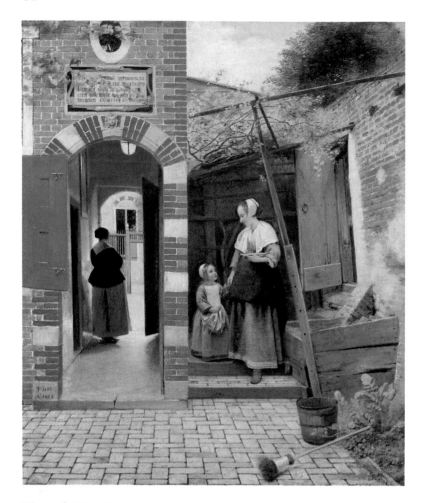

Pieter de Hooch
The Courtyard of a House in Delft, 1658
Oil on canvas, 73.5 x 60 cm
London, National Gallery

there were specialists for each individual type within the field of genre painting. Steen was regarded as a specialist of the wittily rendered "topsy-turvy world", involving moralizing or raucous scenes, while Gabriel Metsu (1629–1667) concentrated his efforts on minutely detailed portrayals of tranquil interiors. Brouwer and Adriaen van Ostade (1610–1685) made small-scale peasant genre paintings their speciality.

Though such a list could easily be extended ad infinitum, to do so would risk lending weight to a misunderstanding of Netherlandish genre painting that has been prevalent since the 19th century. This misunderstanding has tended to arise when the paintings are regarded as anecdotal, as portrayals of specific situations or as illustrations of certain activities. Such an interpretation should be treated with caution in view of the fact that, even though a work by Brouwer or Ostade may show a momentary situation or brief activity, certain elements of still life, a contemplatively introverted extension of time, may also frequently be found. This is particularly evident in the genre paintings by Vermeer, in which several people are gathered in a beautiful interior, perhaps drinking or making music, and the conversation piece with its elements of activity are continued in a traditional manner, but

where it is also clear that this is not a portrayal of activity between protagonists, but of concentration on the material world with its glasses of wine, musical intruments etc.

A scholarly debate has raged around the interpretation of one of the most important of these paintings, Vermeer's *Allegory of Painting,* also known as *The Fame of Painting* (ill. p. 140). On the one hand, it has been interpreted as an illustration, while on the other hand, successful attempts have been made to seek an iconographic interpretation at various levels, in which the artist at his easel with model is regarded not only as the theme of the painting, but also as a personification of the fame of painting. There are strong indications that such a painting is intended as a "truth" or iconographic rendering, especially as the entire range of Dutch painting has almost invariably been used as a vehicle for more or less obvious morals, proverbs or warnings. The question remains, however, as to whether, by deciphering such a painting, we can actually reveal its intended meaning or whether an anecdotal level is equally important. Much would seem to favour the latter possibility as well, given that the aesthetic value of the objects portrayed has always been of foremost importance in Dutch painting.

However, there is no need for us to choose between the extremes of iconographic coding and anecdotal genre. The very fact that such divergent interpretations of a Dutch genre painting are possible at all is in itself an indication of the ambivalence visible in the still life as well. These are pictures created by the sheer pleasure in substance, material and texture, in narrative, drama and wit, in the appearance of nature and everyday life, yet at the same time, they possess a moral and an edifying aspect. Behind the portrayal of a merry scene that an insider would immediately recognize as a brothel scene, lies the biblical parable of the prodigal son. When Steen or Gerard Dou (1613–1675) show a doctor visiting a sick patient and scrutinizing the contents of a glass phial against the light (ill. p. 126), it is first and foremost an opportunity of painting a beautiful interior and of studying the effect of light in the room and on the glass. The moral of the story, however, is to be sought in its underlying jibe: the doctor sees in the urine the signs of a pregnancy that is causing the woman's distress.

Just as we can often find the symbols of vanitas behind a still life, so too can we find the iconography of the "five senses" behind the genre or moral painting. Initially, the five senses – touch, hearing, taste, sight and smell – were rendered in the form of personifications. A graphic series after Hendrick Goltzius (1558–1617) created around the end of the 16th or beginning of the 17th century, bears inscriptions warning against indulging in the senses. In a painting by Ludovicus Finson (c. 1580–1617) the personifications are united in a single picture. Around a table there are women with musical instruments, men fondling the women, tasting wine or smelling a rose.

Pieter de Hooch
Dutch Family, c. 1662
Oil on canvas, 114 x 97 cm
Vienna, Gemäldegalerie der Akademie
der bildenden Künste

Jan Vermeer
The Milkmaid, c. 1658–1660
Oil on canvas, 45,5 x 41 cm
Amsterdam, Rijksmuseum

If the Netherlandish genre painting can be traced back to such specific types, as it can in the early period and in the works of the Utrecht school with their adoption of such formulae from the Caravaggisti, we can no longer regard it as simply a portrayal of real life in the Netherlands. What we find here is not based on the depiction of a fleeting moment, but on rather more sophisticated visual formulae of enormous vitality, developed through longstanding tradition.

In the development of an independent Netherlandish painting, so-called "Caravaggism" was extremely important. Utrecht played a particularly important role in mediating between Italy and the north. The city, having remained largely Catholic, still commissioned religious works and, what is more, had retained its contacts with Rome. The later exponents of the Utrecht school, Hendrick Terbrugghen (c. 1588–1629), Gerrit van Honthorst (1590–1656) and Dirck van Baburen (c. 1590/95–1624) all spent several years in Italy, where they also received commissions. Honthorst was employed by the Grand Duke of Tuscany and became known as "Gherardo delle Notti" – Gerard, the painter of night scenes. This nickname indicates an extremely important characteristic of the Utrecht painters. They had adopted Caravaggio's chiaroscuro, which they tended to apply in a more representational manner. Whereas Caravaggio himself sought to create a contrast between his handling of light and the dark ground, Honthorst and Terbrugghe (who may well have known Caravaggio personally), use the technique to create a night scene in which artificial sources of light such as torches or candles illuminate part of the painting so that it stands out against the darkness. The possibilities of dramatic effects, the theatrical contrasts and surprises, as well as the pathos-laden modelling of the objects in chiaroscuro, came into fashion at the same time as Italian, Spanish and French painting. The Utrecht Caravaggisti and the Tenebrosi (from the Italian "tenebroso", meaning dark or shadowy) are thus an international phenomenon. Without them, the heightened chiaroscuro contrasts in the early works of Rembrandt would be unthinkable.

With the Caravaggisti, another specific type of genre painting entered Netherlandish painting: merry social gatherings full of music-making and drinking. Behind these scenes we can generally find the iconography of the "five senses". The history of Netherlandish chiaroscuro painting begins with the Utrecht Caravaggisti. In Rembrandt's early works of the 1630s, the tension between the darkened pictorial space and the spot-like areas of illumination correspond to the realism of expression and the portrayal of objects. The more "realistic" the objects became, the greater was the dramatic tension between unmotivated and sudden points of illumination in the dark pictorial space. This is true of more or less all Netherlandish painting: in the final phases of late Mannerism, it went through a phase of Caravaggesque chiaroscuro in which the concentrated intensity of Baroque painting emerged in response to the extensive elongations of Mannerism. Just as light emphasizes and delineates the key features of the painting by contrasting it with the darkness of the surrounding scene, so too does the painting seem to have shed the ballast of Mannerist improbability. In this context, some scholars have described Dutch painting as "concave", by which they mean that the essential objects are to be found together, as in the concave hollow of a dish.

One further phenomenon would also appear to be based on techniques of chiaroscuro in the manner of Caravaggio: light itself became the subject matter of the painting. Whereas earlier works featured artificial sources of light such as candles or lanterns, artists soon turned their attention to the portrayal of sunlight, in hazy atmospheres and in interiors lit by sunlight falling through a window. Even the works of Vermeer, who shows light lying on and even modelling objects, owe much to the influence of Caravaggesque genre painting.

The early phase of Caravaggesque painting gradually gave way to colority in Dutch painting. This is strikingly obvious if we compare, say, the landscapes of Pieter Brueghel with those of van Ruisdael or van Goyen. Whereas Brueghel's

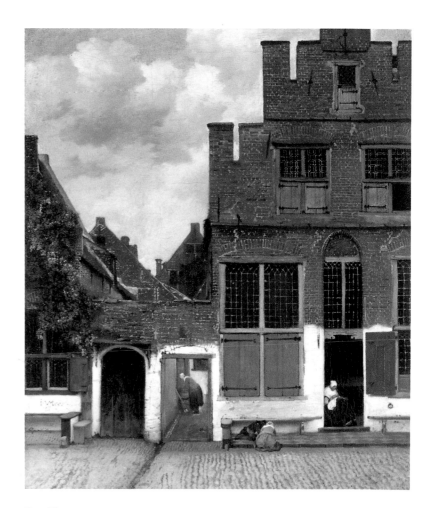

Jan Vermeer
Street in Delft ("Het Straatje"), c. 1657/58
Oil on canvas, 54.3 x 44 cm
Amsterdam, Rijksmuseum

landscapes are made up of colours juxtaposed with more or less equal emphasis, the Dutch artists of the Baroque era use similar tones bound together by non-colours. They seem to be inherent in shades of grey and brown, with a potential for colour that can only be awakened through the light.

In the work of Rembrandt during the 1640s, the contrasts that lend shape and substance to objects begin to dissolve, the spot illuminations and their shadows recede, and colour becomes less of a determining factor. The space he portrays is no longer a dark space from which the objects stand out through the handling of light, but has become a colourless background in which light and colour are potentially immanent. In this way, brown takes on a new role as an underlying value. At first a non-colour, it nevertheless seems to contain colours – red and yellow, sometimes green – which can be called up at will.

What the 19th century admired so much in the work of the Dutch artists, particularly Rembrandt, as a "gallery tone", and regarded as a mysterious artistic sleight of hand, is not a brown coating applied over the original colority of the painting, but a tonal medium containing potentially vibrant colours. In landscape painting, the counterpart to Rembrandt's "gallery tone" can be found in the "tonal" period in which such artists as van Goyen, for example, reduced the range of colours in a coastal landscape to browns, olives and blues. Taken to an extreme, they can even be

monochromatic brownish-green. These paintings may be described as "tonal" because their "tones" are subdued and reduced, yet nevertheless fully evident as tones. "We are struck by the slowness with which a tone retained time and time again, through every shade and hue, finally alights upon an unequivocal line or form. Distance merges with the void, and the water on the wide open spaces bears the cloud." With these words, Claudel speaks of the ability of Dutch paintings to portray proximity and distance, finity and infinity by means of this "tone retained".

The new Dutch painting also differs from its Mannerist forerunner in that it does not combine proximity and distance by forging some bold link, but by making the extremes of proximity and distance independent elements in their own right. Astonishing painterly methods are used to address not only distance and infinity, but also extreme proximity. For Dutch painting also tends to dissolve the visual boundaries of the painting towards the foreground, towards the spectator, in the kind of illusionistic paintings known as *trompe l'œil*. The imitation transcends the bounds of the pictorial plane towards the spectator. The curtain – a device frequently found in the works of Vermeer and Rembrandt – also has an illusionistic effect. It appears to lie within the picture plane and yet already seems to form part of the real space where the spectator is standing. In this way, the transition from real space to pictorial space is camouflaged.

ABRAHAM BLOEMAERT
1564–1651

Bloemaert lived to the age of almost ninety. He was a contemporary of Rembrandt and yet he belonged to the generation of Rembrandt's teachers. He was the leading representative of the Utrecht Mannerists and the director and founder of the Utrecht Guild of St Luke, but he continued to work well into the Baroque 17th century when a third generation of landscape painters was already emerging.

His peasant landscape contains certain Mannerist elements such as the large distance between the foreground objects and the sweeping horizon, or in the way in which he has united contrasts. The aspects of Bloemaert's work adopted by Dutch landscape painters are the picturesque elements evident in his rendering of nature and architecture. The picturesque appeal of dilapidated cottages, damaged thatching, broken fences and rotten tree trunks were to become part and parcel of Netherlandish landscape painting.

Bloemaert's œuvre also forges a link between Flemish and Dutch painting. While his portrayals of mythological themes and biblical tales lean heavily on the syntax of the international Flemish Mannerists, the dramatic realism of his rural genre paintings influenced the Dutch artists.

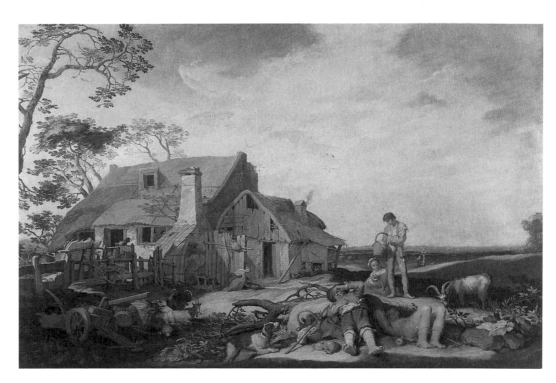

Abraham Bloemaert
Landscape with Peasants Resting, 1650
Oil on canvas, 91 x 133 cm
Berlin, Gemäldegalerie, Staatliche Museen
zu Berlin – Preußischer Kulturbesitz

JOOS DE MOMPER
1564– c. 1634/35

Momper is rightly regarded as the most important Flemish landscape painter between Pieter Brueghel and Rubens. Brueghel's influence is clearly evident in this winter landscape, and it is quite probable that his son Jan also painted a number of the figures in this picture.

Momper's personal achievement lies in his rendering of landscape as a picturesque subject matter in its own right. What we see here is no longer a great universal landscape full of symbolically charged allusions, but a scene whose aesthetic appeal is valued for its own sake. Momper's painting is divided into various planes by a kind of backdrop, against which silhouettes are highlighted by a pale light or dark, thundery clouds. People are making their way along tortuous paths on terrain that seems to be hazardous.

Rain-laden stormclouds, sunshine and snow set the atmosphere of the painting. In this respect, Momper has taken an important step towards emancipating the landscape painting as an autonomous genre in which the landscape is not merely a setting for some event, but is treated as a subject matter in its own right.

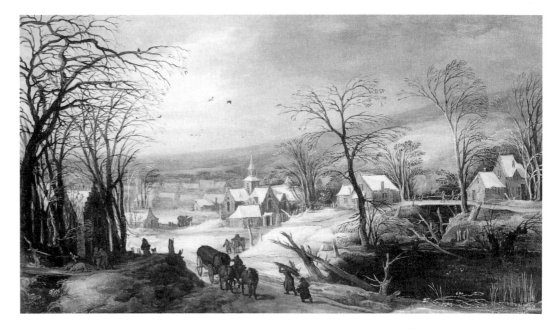

Joos de Momper
Winter Landscape, c. 1620
Oil on panel, 49.5 x 82.5 cm
Private collection

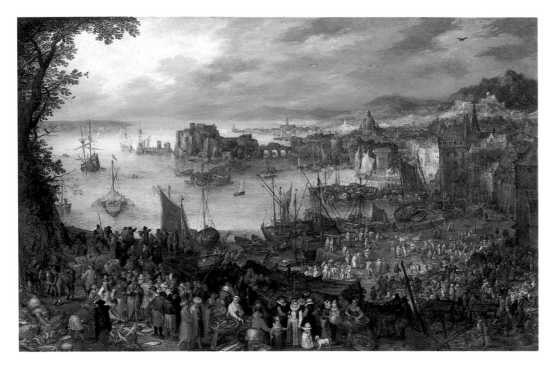

Jan Brueghel the Elder
Great Fish-Market, 1603
Oil on panel, 58.5 x 91.5 cm
Munich, Bayerische Staatsgemälde-
sammlungen, Alte Pinakothek

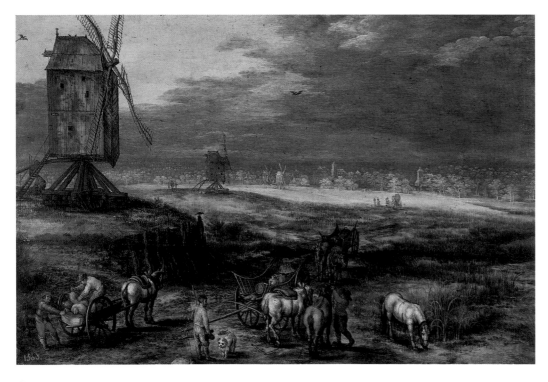

Jan Brueghel the Elder
Landscape with Windmills, c. 1607
Oil on panel, 34 x 50 cm
Madrid, Museo del Prado

JAN BRUEGHEL The Elder
1568–1625

Brueghel's *Great Fish-Market*, dating from the year 1603, contains many elements of Mannerist landscape painting. Rendered in a perspective that is almost a bird's-eye-view, the scene opens up across a downward-sloping foreground teeming with hundreds of figures grouped around the stalls and booths of a fishmarket. The eye is drawn towards the harbour in the background, out across the bay and along the coastline, past entire towns with ruins, piers and fortresses, into the depths of the mountains, whose blue merges with the sea.

What we see here is a universal landscape, but one broken down into individual themes that are soon to establish themselves as genres in their own right. Fish-market scenes of this kind were to become an independent subject in Flemish painting, for example in the works of Snyder. Still life paintings of fish, such as that displayed for sale here, would also begin to emerge. Marine painting, ruins, and even pure landscape are all to be found as elements in this painting. We even seem to be able to make out a family portrait: the group at the centre of the foreground is thought to be a self-portrait of the painter in the company of his family.

In the second decade of the century, which marks Brueghel's mature period, we find a number of landscape paintings that differ considerably from his universal landscapes. They show flat land broken by only a few motifs such as windmills or isolated cottages bathed in changing light. There is an increased sense of portraiture and figure genre is used sparingly. As in the landscapes of Rubens, peasants' carts, cutting a diagonal path, give a heightened impression of depth and distance. One of the elements which indicates that this is a Flemish landscape rather than a Dutch one is the fact that the horizon is placed fairly high in the painting.

The Holy Family leaves us in little doubt as to why the second son of Pieter Brueghel was given the nickname "Velvet" Brueghel. It is a masterpiece of "fine" painting in which elements of floral still life, landscape painting and devotional painting are combined into a harmonious whole. A magnificent garland of meticulously painted flowers and fruits reflecting the diversity of nature frames the idyllic scene like a triumphal arch. It forms the letter M for Mary, who is seated as in a "beszlozzenen garten" or hortus conclusus dominating the middle ground with the Christ child on her knee. Beside her are the angels and the lamb, slightly behind her is Joseph and in the background is a view of a landscape with grazing deer. The figures were painted by Pieter van Avont – an excellent example of the way specific painterly tasks were delegated according to artists' specializations within Netherlandish painting.

Jan Breughel the Elder The Holy Family, undated
Oil on panel, 93.5 x 72 cm. Munich, Bayerische
Staatsgemäldesammlungen, Alte Pinakothek

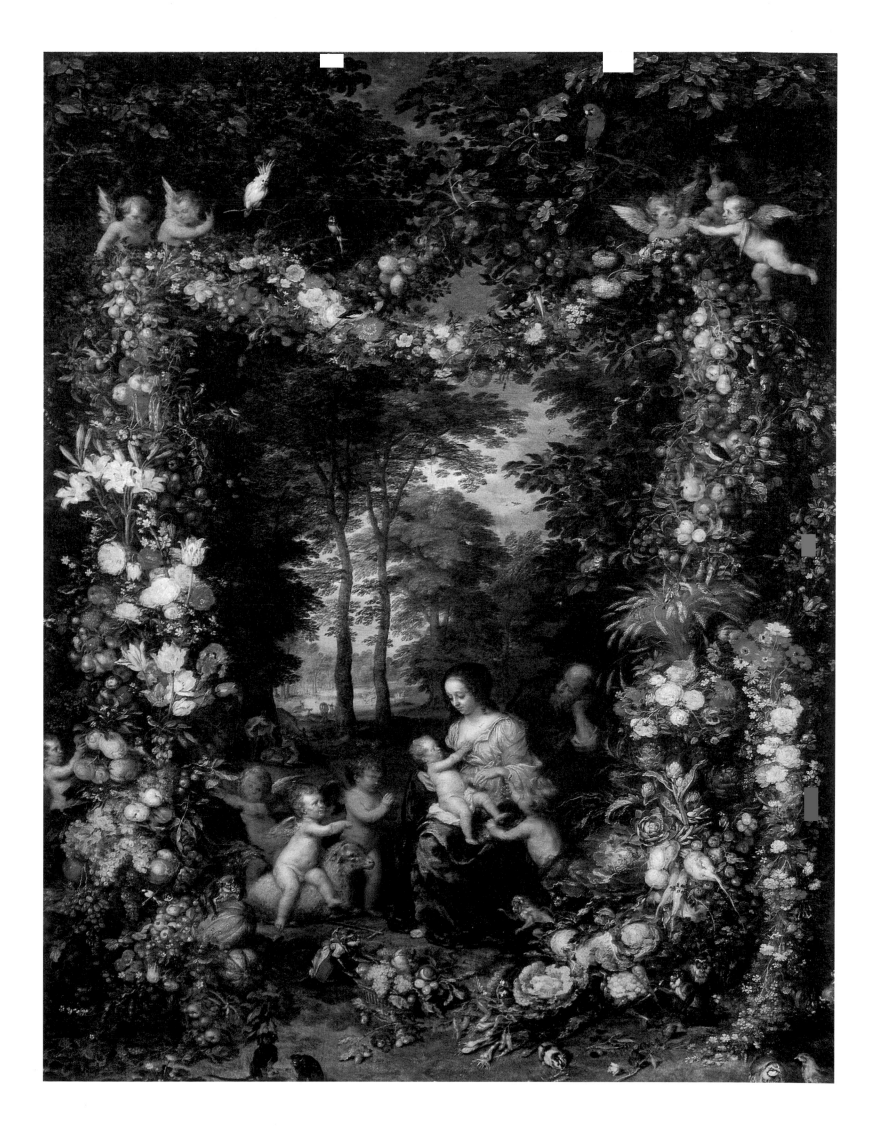

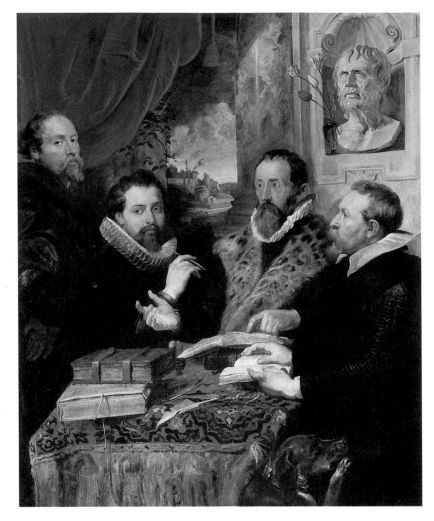

Peter Paul Rubens
The Four Philosophers (Self-portrait with the Artist's Brother Philipp,
Justus Lipsius und Johannes Wouverius), c. 1611
Oil on panel, 164 x 139 cm
Florence, Palazzo Pitti, Galleria Palatina

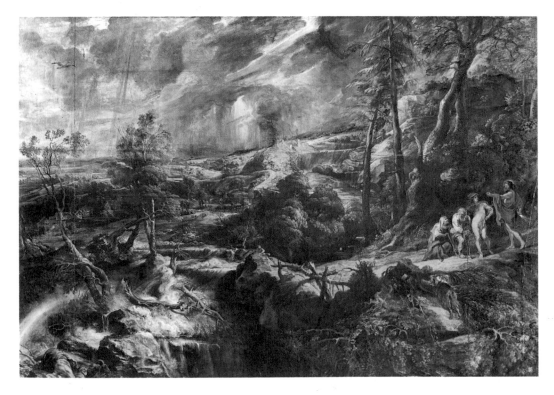

Peter Paul Rubens
Stormy Landscape with Philemon and Baucis, c. 1620
Oil on canvas, 147 x 209 cm
Vienna, Kunsthistorisches Museum

PETER PAUL RUBENS
1577–1640

In 1611, the artist's brother Philip Rubens
died suddenly. This group painting, probably
executed shortly after his death, was intended
to evoke the atmosphere of humanistic think-
ing in which the brothers grew up. On the
left-hand edge of the painting stands the artist
himself, next to him is his brother with a pen
in his hand, then their teacher, the humanist
Lipsius, and on the right Johannes van de
Wouwere. The fifth in the group, watching
over them all, is the bust of Seneca, set in a
niche with a floral tribute of tulips. Lipsius
published his writings. In the landscape in the
background, we can see the Roman Palatine.

A stream has wreaked havoc after a storm,
flooding fields and meadows, breaking trees
and now rushing towards the foreground in a
cascade. The stormy sky has begun to clear,
and a small rainbow has formed beside the
waterfall. The storm has destroyed the peace-
ful landscape.

The figures to the right of the painting in-
dicate that this is an allegory of a greater cos-
mic event. When Jupiter and Mercury de-
scended to earth in human form, only Phil-
emon and Baucis gave them hospitality. The
gods responded by flooding the entire land
with a terrible storm which spared Philemon
and Baucis and left their humble dwelling un-
scathed. Everything in this painting by Ru-
bens is in the hands of divine powers and sub-
ject to metamorphis; there is no tree or river
that cannot be transformed into a living
being, no creature that cannot be turned back
again into a river or a tree.

This double portrait was probably executed to
celebrate the marriage of Rubens to Isabella
Brant, the daughter of an Antwerp patrician.
Rubens had returned from Italy the previous
year, having achieved fame and renown at the
court of Mantua. The marriage was in keeping
with his social standing and this is also re-
flected in the painting. Rubens was familiar
with such portrayals of happily married
couples from Italian paintings of the 16th
century. However, he heightens the signific-
ance through symbolic and emblematic ref-
erences. The couple is seated in a bower of
honeysuckle, a plant frequently associated
with marital love and emotional constancy.
Their hands are joined, indicating that the
marriage ceremony has already taken place.

This portrait is remarkable for its painstak-
ingly detailed treatment of each and every ob-
ject and for the accuracy with which fabrics,
lace and embroidery are rendered. Everything
is worked like a piece of fine jewellery, as
though Rubens sought to prove his skill as a
painter.

Peter Paul Rubens
Rubens with his first Wife Isabella Brant
in the Honeysuckle Bower, c. 1609/10
Oil on canvas-covered panel, 178 x 136.5 cm
Munich, Bayerische Staatsgemälde-
sammlungen, Alte Pinakothek

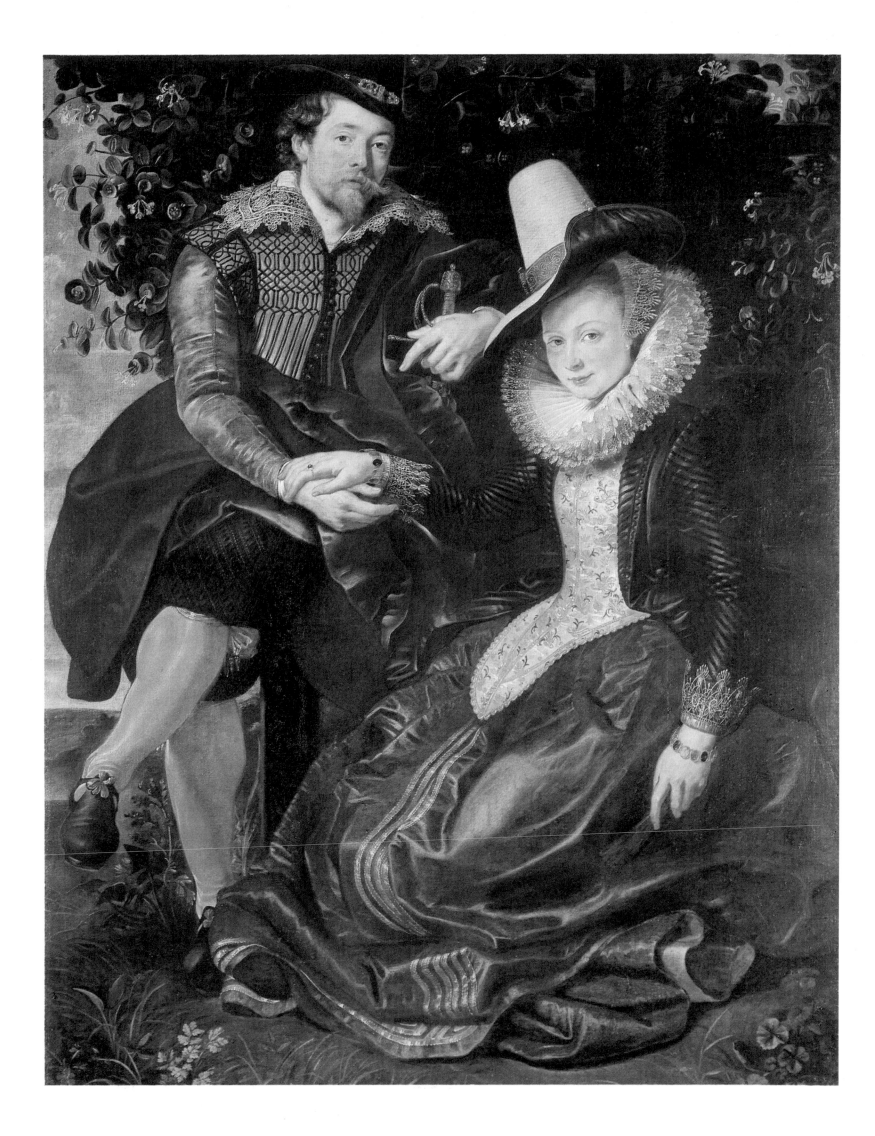

Peter Paul Rubens
The Landing of Marie de'
Médici at Marseilles,
c. 1622–1625
Oil on canvas,
394 x 295 cm
Paris, Musée National
du Louvre

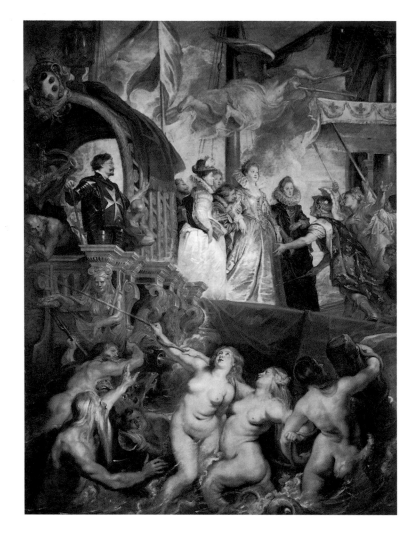

Below:
Peter Paul Rubens
The Rape of the
Daughters of Leucippus,
c. 1618
Oil on canvas,
224 x 210.5 cm
Munich, Bayerische Staats-
gemäldesammlungen,
Alte Pinakothek

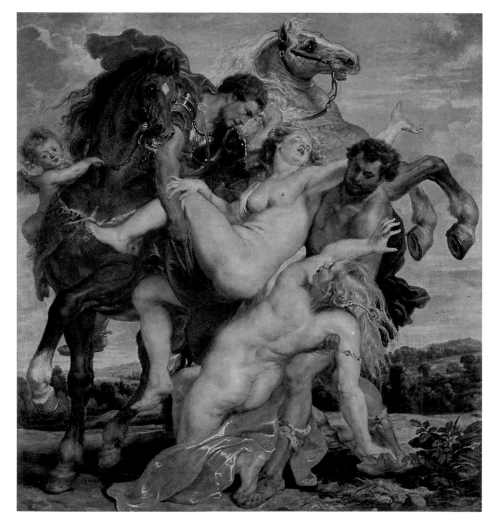

PETER PAUL RUBENS
1577–1640

In 1621, Rubens received what was probably his most important commission: a cycle of paintings for Marie de' Médici, the widowed queen consort of Henry IV of France, to decorate the upper galleries of both wings of the newly built Palais du Luxembourg. The programme was worked out by the Abbé de Saint-Ambroise. The queen, Cardinal Richelieu and Rubens all put forward proposals for the paintings, documenting and glorifying the events and deeds in the life of King Henry IV and Marie de' Médici. The cycle of twenty-one paintings now hangs in the Louvre in Paris, while sixteen preparatory sketches are in the Alte Pinakothek in Munich.

This painting depicts Marie's arrival in Marseilles on 3 November 1600. She is greeted by allegories of France and the port city. Above her floats Fama; Neptune and the Nereids have accompanied the ship to ensure a safe passage.

The commission also had a distinctly political edge. Marie had been appointed regent by the King when he entered the Clèves-Jülich war of sucession, clearly with some foreboding of his death. On the day after the coronation, Henry IV was assassinated. The widowed queen was soon embroiled in conflict with her son, the future Louis XIII. The series of paintings was therefore intended as a highly visible sign of the legitimacy of Marie's rule.

No other artist could have executed this commission in such a way, transposing historical facts into images of timeless significance, blurring the boundaries between history, mortality and the realms of the eternal powers.

The subject matter of this painting was not recognized until 1777 when the German poet Wilhelm Heinse pinpointed a scene in the Idylls of Theocritus which corresponded precisely with the scene painted by Rubens: Leda's sons Castor and Pollux (Pollux, fathered by Zeus, was immortal) carried off the two daughters of Leucippos of Argos during a wedding ceremony, even though the Leucippides were already betrothed to the twins Lynceus and Idas.

However, this painting is clearly not simply an illustration of a mythological theme. The important point is what Rubens does not portray. For example, we do not see the fight that breaks out over the Leucippides, nor the wedding celebrations nor even the pursuit. The two horsemen do not even seem to be lifting the two naked maidens onto their horses, but simply lifting them from the ground, and both have turned their eyes heavenwards in rapture. Here, we find a typical device of Rubens.

What this painting actually portrays is an apotheosis: the Leucippides are lifted from the earthly realms into the Olympic heights of celestial Zeus. Although the scene appears at first glance to be full of movement and tension, Rubens has calmed the action by allowing the movements to flow gracefully into one another.

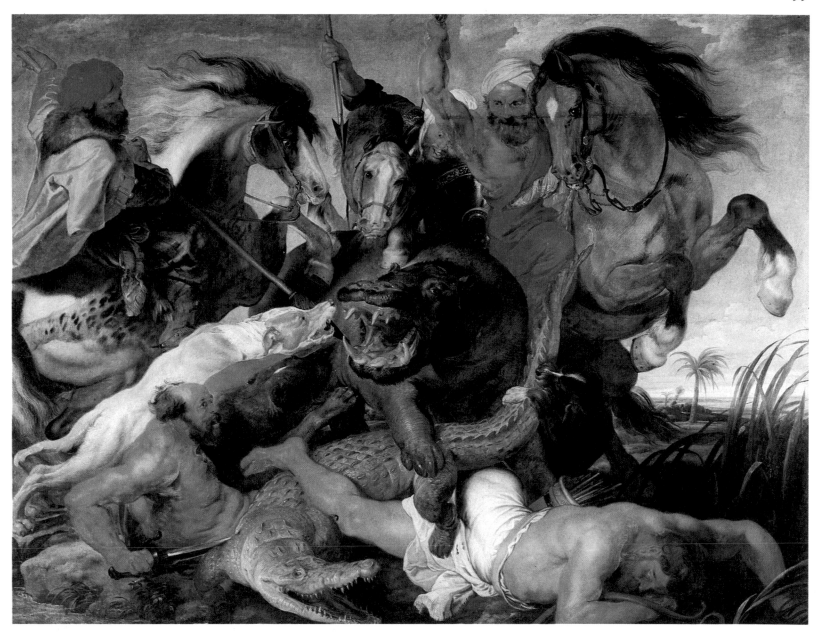

Around 1615, Maximilian I, Elector of Bavaria, commissioned Rubens to paint a series of four hunting scenes for the Old Palace in Schleissheim. In 1800, the paintings were seized by the French and removed to France, and only "a cruel hunt against monstrous crocodiles" (as Joachim von Sandrart described the painting in his *Teutsche Akademie* of 1675) was returned to Munich.

The wild hippopotamus is the focal point and centre of the composition. The action has already reached a dramatic climax; tha animal has been captured and is panting with rage, showing the hunters its teeth. The hippopotamus is rendered with such zoological precision that we must assume Rubens actually saw such an animal with his own eyes – perhaps in a royal menagerie – and drew it from nature, just as Dürer before him had drawn a rhinoceros.

Three Moorish riders are grouped around the wild animal on rearing horses, with their lances pointing towards the centre of the painting. The attack by the two dogs on the left and the hunter half-buried beneath the crocodile who is trying desperately to escape, also run in the same direction. The fight is already over for the figure lying lifeless on the ground, above whose body the view opens towards the horizon and an exotic landscape.

Far from being a realistic portrayal of a hunt, this painting is an allegory of the struggle between man and savage beast, and indeed between man and nature as a whole. Rubens uses a very similar approach in his battle scenes, underlining the fact that it is not so much the hunt as the struggle that is the theme – a struggle in which both man and beast have a chance.

The fiery horses, the snapping dogs, the clothed and unclothed bodies of the hunters – everything revolves around the body of the cumbersome yet dangerously enraged hippopotamus. Naked and clothed, smooth and scaly, black and white, mounted high and prostrate on the ground; the painting seems to be an exercise in every possible aspect of an exotic, mythical world that is both beautiful and disturbing at the same time.

Peter Paul Rubens
Hippopotamus and Crocodile Hunt, c. 1615/16
Oil on canvas, 248 x 321 cm
Munich, Bayerische Staatsgemälde-
sammlungen, Alte Pinakothek

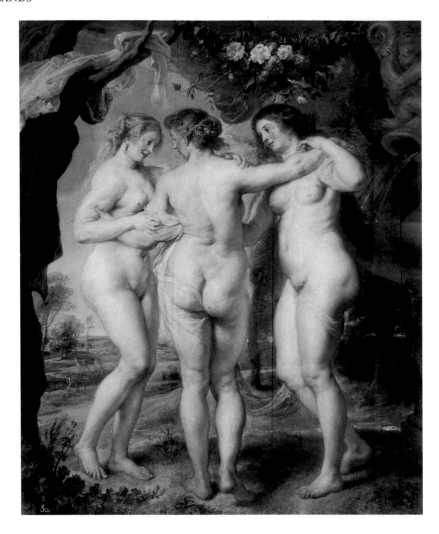

Peter Paul Rubens
The Three Graces,
1639
Oil on canvas,
221 x 181 cm
Madrid, Museo del
Prado

PETER PAUL RUBENS
1577–1640

The Three Graces is one of the artist's final
works. He had portrayed this theme several
times since about 1620, but only later adopted
the form that prevailed in classical Antiquity,
with the three figures forming a circle so that
one of them has her back to the spectator.
"They were the goddesses of pleasant charm,
of charitable deeds and of gratitude... without
them nothing would be graceful or pleasing.
They gave people friendliness, uprightness of
character, sweetness and conversation...They
were presented as three beautiful virgins and
were either completely naked or clothed in
some fine, transparent fabric...They stood
together all three so that two of their faces
were turned towards the spectator and only
one was turned away from him."

Rubens' late painting of three nude figures
magnificently illustrates the artist's extraordi-
nary handling of incarnate or human flesh
tones. Rubens builds them up using the three
primary colours yellow, red and blue. An un-
usually high proportion of blue is evident
here. In this way, the human figure bears the
same primary colours that make up the appear-
ance of the world and the entire cosmos, and
all that is gathered here in the landscape and
flowers, the sky and the trees.

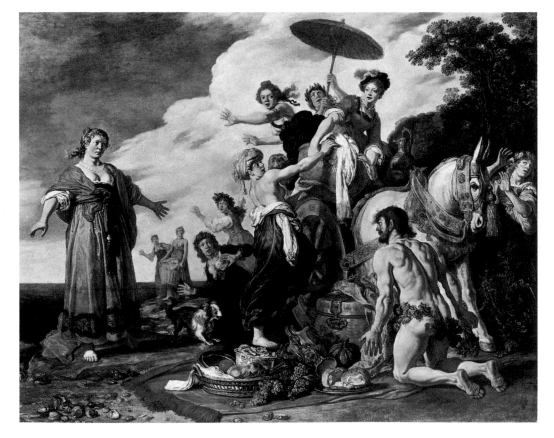

Pieter Lastman
Odysseus and Nausicaa, 1619
Oil on panel, 91.5 x 117.2 cm
Munich, Bayerische Staatsgemälde-
sammlungen, Alte Pinakothek

PIETER LASTMAN
1583–1633

The fact that Lastman visited Italy and that,
while he was there, he was profoundly in-
fluenced by Elsheimer, is evident in this paint-
ing of the shipwrecked Odysseus found naked
by Nausicaa and her entourage. The pictorial
structure, the individual gestures and formal
pathos are theatrical, and the setting itself is
charged with meaning. The artist has taken a
highly original approach in placing the
figures, with their gestures of surprise and
fright and their outstretched arms, against a
pale sky – a motif Rembrandt was soon to
adopt. One thing, however, is particularly re-
markable about this painting, and it foresha-
dows an element that is to emerge strongly in
later Dutch painting: the element of the "por-
trait historié". We have the impression here
that a historic event is being played by specific
persons, as though in a theatrical role. History
painting and the reality of the protagonists are
widely divergent.

In this painting, the naked Odysseus not
only looks like the great hero of the Trojan
war, but he is also caricatured in his all too
human role. Lastman increased the figurative
detail of his staffage and with that the realism
and narrative impact of his work. The young
Rembrandt also adopted this sense of tension.

FRANS HALS

C. 1581/85–1666

The portrait of the *Officers of the St George Civic Guard* is the first major group portrait by Frans Hals, and the first monumental civic guard painting in the new era of Dutch painting. Together with the leaders of public, charitable and professional associations, the civic guard societies were the main patrons to commission group portraits. This patronage took on considerable proportions in the course of the century. These group portraits are also of value as historical documents, for which lists were drawn up giving the names of the figures portrayed. The paintings themselves were displayed prominently on the premises of the respective association.

These civic guard portraits were an expression of the Baroque will to representation, whose tradition is rooted in the medieval era. There had been civic guards in the Netherlands since the 13th century. They had played an important role in the emancipation of the cities and towns from feudal rule and had gained considerable political and military significance in the Netherlands' struggle for independence.

Cornelis van Haarlem had already painted the officers of the St George Civic Guard in 1599. Hals, however, revolutionizes this type of painting. Instead of merely painting a row of individual portraits, he places them within a specific context by creating a banquet scene. This is not simply a moment captured at a table, but an extremely witty and calculated composition in which a scenic context is created between all the figures involved, and, on the other hand, each of the figures poses and acts independently and individually. Hals has found a new and persuasive solution to the problem of portraying a large group without difference of rank.

Although the young man holding a skull in his hand has occasionally been identified as Hamlet, this interpretation is probably incorrect. It is much more likely to be a Dutch vanitas allegory. As in corresponding still lifes featuring the same attribute, it voices a warning, calling on the spectator to think of death, even in youth. Such an interpretation may describe the content of the painting, but it still does not touch upon the actual meaning of the image. This is to be found in the way Hals has created a variation on a theme of Utrecht Caravaggism by equipping the model, a young man, with certain props and portraying him as someone posing for a painting. It is this that is the actual event or action of the painting, and as such it is very similar to the work of the young Rembrandt, who painted himself in similar garb working at his easel.

In spite of the borrowings from the Utrecht school, there are nevertheless distinct differences. The figure does not develop from the darkness towards the light, but is lit from behind. The *trompe l'œil* effects, the foreshortened hand and the skull that almost seems to jut beyond the front of the pictorial plane, are all masterly devices in which illusion is less important than painterly wit.

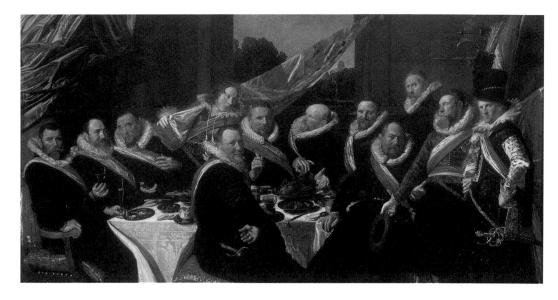

Frans Hals
Banquet of the Officers of the St George
Civic Guard in Haarlem, 1616
Oil on canvas, 175 x 324 cm
Haarlem, Frans-Hals-Museum

Frans Hals
Young Man with a Skull (Vanitas), c. 1626
Oil on canvas, 92 x 81 cm
London, National Gallery

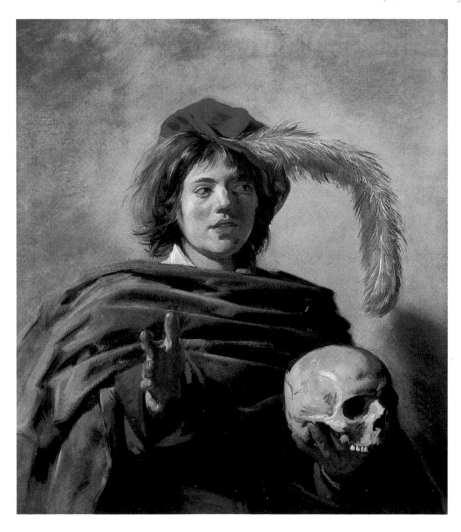

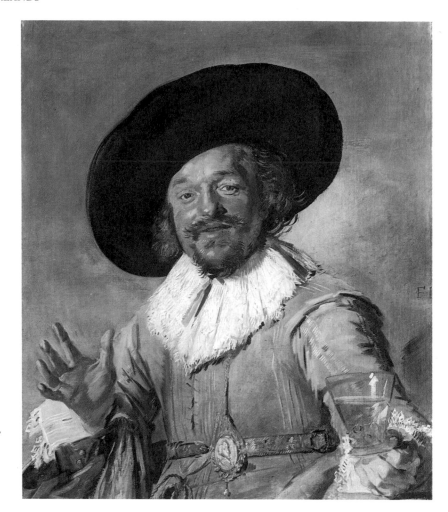

Frans Hals
The Merry Drinker,
1628
Oil on canvas,
81 x 66.5 cm
Amsterdam,
Rijksmuseum

FRANS HALS
C. 1581/85–1666

Dutch painting tends to break through the pictorial plane towards the foreground, creating *trompe-l'œil* effects. Not only does the *Merry Drinker* approach us by his gesture – offering his wine glass to us out of the painting – but the objects of the painting also seem so close that we might almost grasp them. This effect is achieved by the employment of painterly means which are almost diametrically opposed to those used in fine painting. The subject matter is not rendered imitatively but is brought to life by suggesting its appearance under the effect of light. This suggestion is evoked with such precision that the spectator gains a completely fresh impression of its appearance.

The painting known as *The Gipsy Girl* is situated somewhere between a portrait and a genre painting. Her insolent and provocative look are unequivocal, and this is also quite clearly the portrait of a specific person from the milieu of whores. As in other genre portraits of this kind, there is a certain coarseness and squalor that makes an interesting motif in itself, but these factors are offset by the brushwork.

What is important here is the sense of transience and spontaneity, the mutability of a fleeting impression that leaves no time for reflection on the moral content. Seen in this way, Hals' genre portraits are positively immoral. They glorify sensual perception and visual pleasure, making it seem ridiculous to reflect on the meaning behind them.

A wealthy merchant presents himself in noble guise. The bunch of roses, the vineleaf on the floor and the lovers in the background may well be intended as signs of mortality, recalling the labour of amassing earthly goods; perhaps the doorway draped with a curtain is the doorway of the temple of Mars, which was kept closed during times of peace in ancient Rome.

Dutch portraits tend to be full of such hidden codes which hint at the identity of the figure portrayed, and in this case they tell us that the man is a merchant who has responsibilities in times of peace and war. Neither the pose nor the symbolic attributes are meaningless signs; they are the lavish attributes of a man who presents himself as an important figure. The air of the *nouveau-riche* parvenu, to be found in so many Dutch portraits of this type, featuring showily dressed burghers, is offset by the duality of the composition in which all things of beauty are merely outward signs of dignity, full of vanity and masquerade, things of fragile and transient charm.

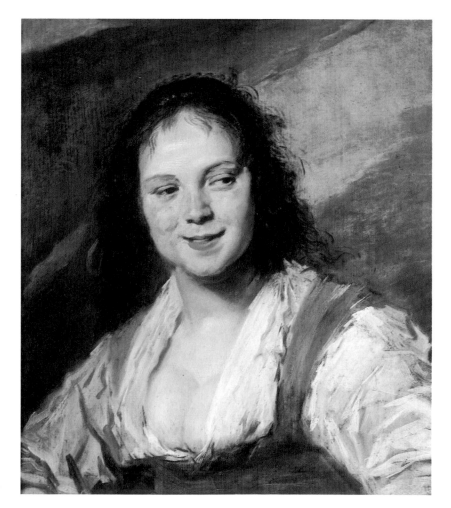

Frans Hals
The Gypsy Girl,
c. 1628–1630
Oil on panel,
58 x 52 cm
Paris, Musée
National du Louvre

Frans Hals
Portrait of Willem van Heythuysen, c. 1625–1630
Oil on canvas, 204.5 x 134.5 cm
Munich, Bayerische Staatsgemälde-
sammlungen, Alte Pinakothek

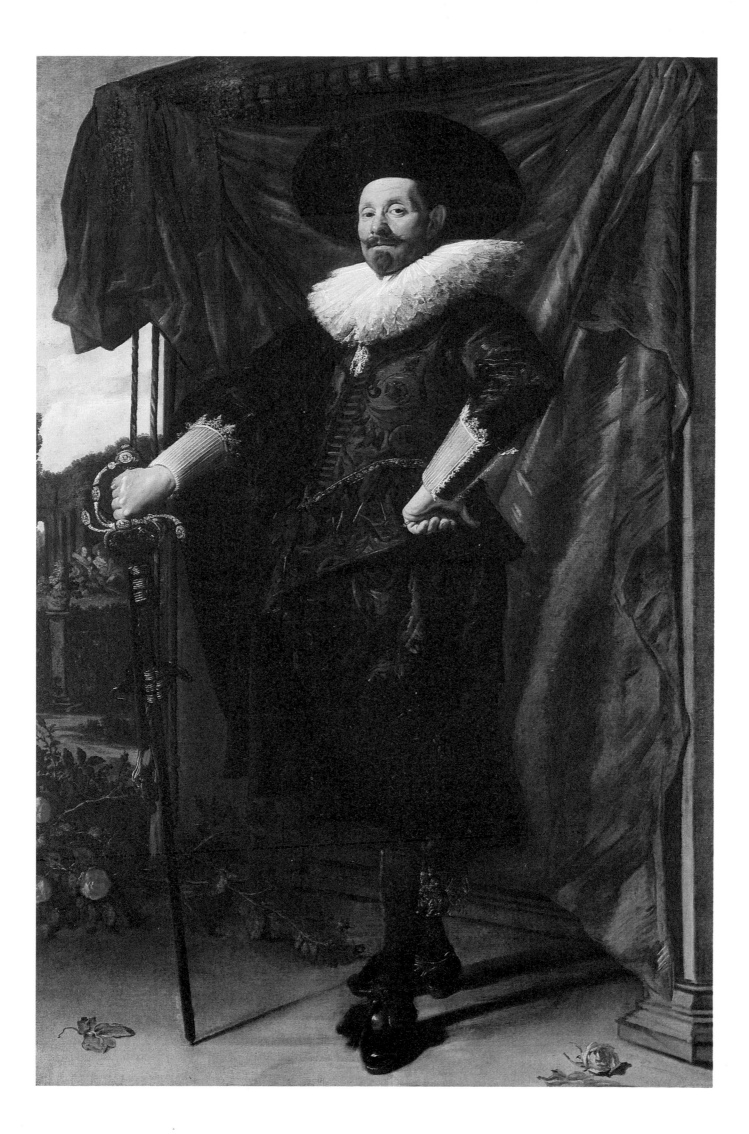

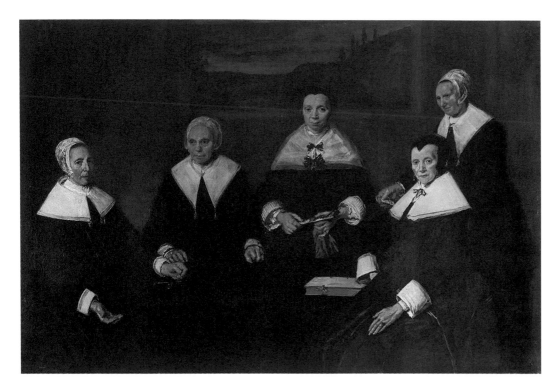

Frans Hals
Regentesses of the Old Men's Almshouse in Haarlem, 1664
Oil on canvas, 170.5 x 249.5 cm
Haarlem, Frans-Hals-Museum

FRANS HALS
C. 1581/85–1666

The two large format group portraits of the
Regents and *Regentesses of the Old Men's Almshouse
in Haarlem* are not only one of the last major
work by this artist who ranks beside Rem-
brandt as the greatest of all portrait painters,
they are also the last historically significant
examples of this genre.

Whereas Hals previously presented individ-
ual gestures, attitudes and poses in a ceremon-
ial and more than momentary context, here he
isolates the individual parts and the individ-
uals themselves. The faces above the white col-
lars seem to float against the dark ground of a
room that is difficult to distinguish. The
"breakdown" of the figurative corresponds to
the brushwork whose ductus is no longer
fluid, but broken so that it seems to crumble
into particles of colour. Here and there, a shim-
mer of red flares up through the black like the
final glimmer of dying embers in the ashes.

Whereas the iconography of vanitas and the
theme of transience were previously expressed
through specific symbols in Dutch painting,
we now find that the most vigorous genre of
all – the group portrait – has also been im-
bued with the concept of mortality. Old age
and death seem to menace, where once there
was activity and sociability.

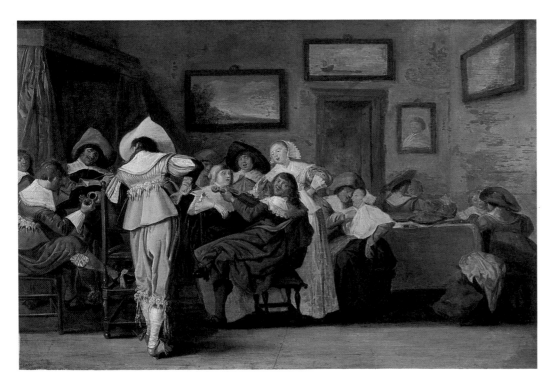

Dirck Hals
Merry Company, undated
Oil on panel, 45 x 67.5 cm
Private collection

DIRCK HALS
1591–1656

Dirck Hals was apprenticed to his older
brother Frans. Yet while Frans Hals spe-
cialized in portraiture, Dirck Hals concen-
trated primarily on genre paintings and con-
versation pieces in the manner of Esasias van
de Velde and Willem Pietersz. Buytewech.
From the 1620s onwards, he frequently had
the figures in his paintings added by his own
specialist, Dirck van Deelen. He preferred a
courtly setting and noble society, whereas his
Merry Company follows in the tradition of the
brothel painting and the tale of the prodigal
son.

The bed on the left in the background, and
the body language of the couples leave us in
little doubt as to the situation. At the same
time, however, this is also a "five senses"
scene: not only is the sense of touch satisfied,
but there is also music and singing, smoking
and drinking, while the eyes feast on an empty
jug or a bodice.

The interior also gives us an idea of how
paintings were displayed in Holland at the
time. They have been hung on a shabby wall
without any evident system: a landscape, a
marine painting, a portrait. It is clear that
paintings had by now become objects to be
taken for granted. Some might be cheaper or
more expensive, better or worse painted than
others, but they were no longer laden with
iconographic significance.

ROELANT SAVERY

1576–1639

Savery's painting, outmoded both in type and composition, adheres to the style of late Mannerism. Landscape as an imaginary combination of heterogeneous, natural and invented components, had by now been replaced by details of familiar surroundings, and animal images that seem to be taken straight from the pages of a zoological almanac had given way to portraits of domestic pets.

Savery's painting calls for a close reading and an appreciative eye. His art lies in his scholarship and well-founded knowledge, reflecting the interest of the age in the natural sciences and exotic phenomena. The new Dutch painting, on the other hand, calls for a more sensually perceptive and contemplative approach. In its narrative, the landscape with birds is comparable to those Flemish floral still lifes which, for a period, presented botanic diversity in great detail. Savery's compositional form has its origins in the paradise portrayals of the 16th century, in which Adam and Eve are shown in harmony with the animal world around them. Picturesque ruins in the manner of Maerten van Heemskerck are also common features, soon to be adopted by the Italianate landscape painters. Savery's prolific drawings are spontaneous and precise, individual studies which he then transferred to his paintings.

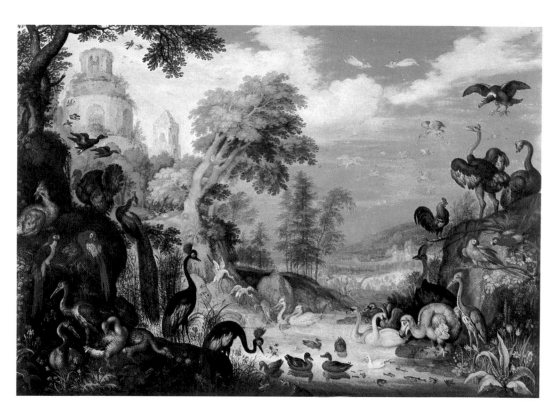

Roelant Savery
Landscape with Birds, 1628
Oil on panel, 42 x 57 cm
Vienna, Kunsthistorisches
Museum

FRANS SNYDERS

1579–1657

Just as a circle of specialists for individual genres gathered in Amsterdam around Rembrandt, the same was true in Antwerp around Rubens. Snyders frequently collaborated with him on arrangements of objects and staffage. On the other hand, Snyders also adopted Rubens' new Baroque principles into his own specialized area of still life. The result was a number of new pictorial types in this field.

He initially drew upon the great kitchen interiors and pantry paintings of the Flemish Mannerists such as Aertsen or Beuckelaer. However, whereas these artists created "epic" arrangements of enormous breadth, Snyders sought to produce more dynamic still lifes. He created the hunting still life which not only features game, but also includes certain elements of the hunt itself, and in which each animal, dead or alive, still has its own tale to tell. In his portrayal of animals, he was peerless in his time. Whereas Dutch still life presented coded "truths" and warned of the transience of earthly life, Snyders staged a theatrical drama portraying the riches of the world. Snyders' pantry scenes, a variation on the hunting still life, are equally dynamic.

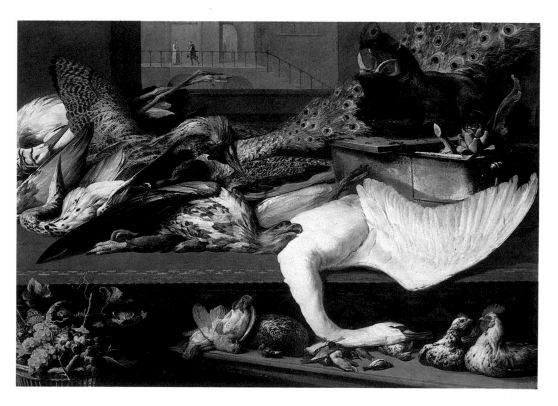

Frans Snyders
Still Life, 1614
Oil on canvas, 156 x 218 cm
Cologne, Wallraf-Richartz-Museum

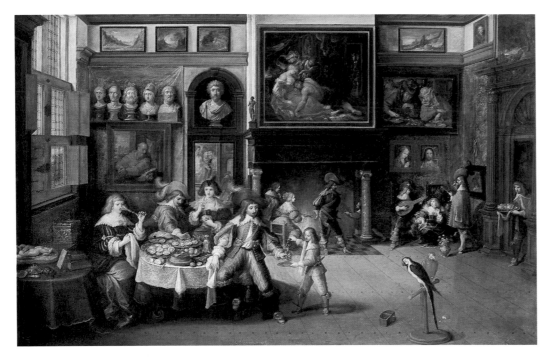

Frans Francken the Younger
Supper at the House of Burgomaster Rockox,
c. 1630–1635
Oil on panel, 62.3 x 96.5 cm
Munich, Bayerische Staatsgemälde-
sammlungen, Alte Pinakothek

FRANS FRANCKEN The Younger
1581–1642

The title of the painting tempts us to see it as
the portrayal of a specific situation. Yet we are
unable to recognize the master of the house
and, on closer inspection, the gentlemen and
ladies in the painting appear to represent a
"five senses" scene (music = hearing; man con-
templating painting = sight; lady smelling
rose = smell; wine drinker = taste; warming at
fire = touch). Above all, however, it is an al-
legory on the artistic taste of the client. The
humanistically trained lawyer and burgomas-
ter had purchased a large house in 1603 and
had converted it into an art gallery. Francken's
painting shows the main room with its finest
pieces, including antiques. Above the fireplace
hangs the Rubens painting of Samson and
Delilah, now in London. In the background,
through the doorway, we can just make out
Rubens' *Incredulity of St Thomas* which was
commissioned by Rockox for his burial cham-
ber. Several other paintings, from Massys to
Hemessen, can also be seen.

 This glimpse of a wealthy art collection also
gives us some idea of how difficult it must have
been to use what is to all intents and purposes
a medieval room as a place to display an art col-
lection. A shelf has been installed on the walls
for the antique busts, and some of the smaller
paintings are hung above the moulding that
holds the wall tapestry in place.

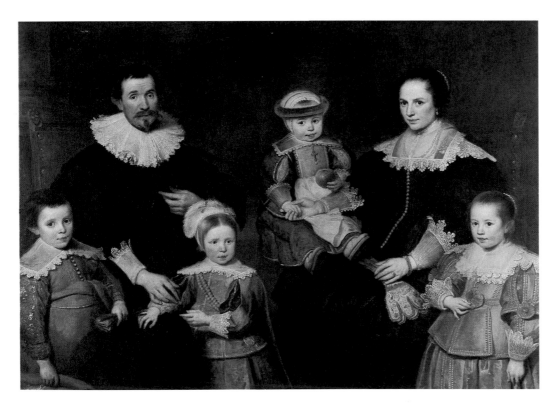

Cornelis de Vos
The Family of the Artist, c. 1630–1635
Oil on canvas, 144.5 x 203.5 cm
Ghent, Museum voor Schone Kunsten

CORNELIS DE VOS
c. 1584–1651

This portrait of the artist's family, created in
the late 1620s, allows us to pinpoint some of
the differences between Flemish and Dutch
painting. De Vos was, for a while, a colleague
of Rubens and, together with Jordaens, he ex-
ecuted designs by Rubens, including a trium-
phal arch for the entry of the Infante Ferdi-
nand in Antwerp. He was the brother-in-law
of Snyders, a skilled craftsman and a cog in the
wheel of the great Baroque machinery of the
Rubens studio.

 When it came to painting in the domain
dominated by the Dutch, namely the group
portrait, he seems to have encountered some
difficulties. Where the Dutch painters evoke
nuanced psychological differences and individ-
ual traits, de Vos produces a rather dry inven-
tory of persons. Flemish painting thrives on
scenic movement. In an attempt to inven-
torize, it loses its character.

 For the Dutch portrait painter, on the other
hand, the group portrait is a welcome chal-
lenge. Solving the problem of breaking
through the stereotype and presenting the
characters individually gave them enough ac-
tivity for any painting. De Vos was renowned
for his ability to make the eyes of his subjects
speak eloquently. Here, however, parents and
children alike all seem to be looking at the
spectator in the same way, with a slightly dis-
turbing effect.

HENDRIK AVERCAMP
1585–1635

The deaf and dumb artist Hendrik Avercamp, known as "De Stomme van Campen" was a pupil of Pieter Brueghel the Elder. As his work initially leaned heavily on his teacher's landscape paintings, it seems apt to compare the two. Whereas Brueghel imbued even the most apparently innocuous figures with some significance, some underlying moral "truth" or attribute, Avercamp made his scenes an independent genre in their own right. The rural setting of this winter scene is full of simple enjoyment.

Avercamp was particularly fond of portraying the mirror-smooth surfaces of frozen canals and lakes, on which villagers went skating or played golf, and where elegantly dressed burghers strolled.

Pieter Brueghel was the first to portray winter as an atmospheric landscape. Avercamp's winter scenes use atmosphere and the coolness of light and air as essential elements of the painting. Although his landscapes bear certain Mannerist traits, including the considerable divergence between the objects in the foreground and the depth of the painting, as well as his distribution of many figures across the scene as a whole, the tendency towards the tonality of the new Dutch landscape is already evident in his work.

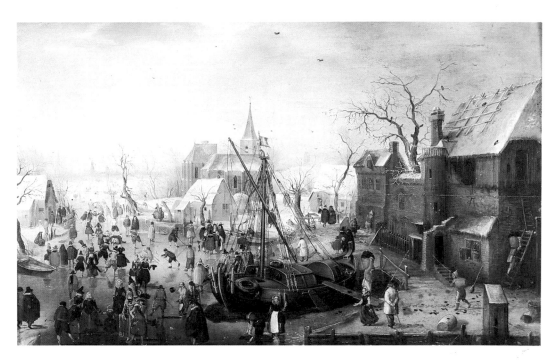

Hendrik Avercamp
Winter Scene at Yselmuiden, c. 1613
Oil on pancl, 47 x 73 cm
Geneva, Musée d'Art et d'Histoire

HENDRICK TERBRUGGHEN
C. 1588–1629

Terbrugghen's portrait of a lute player accompanied by a buxom singer who is clapping the rhythm was created a year before he died. Together with Baburen and van Honthorst, Terbrugghen was undoubtedly the most important of the Utrecht Caravaggisti, even though he gained little renown during his own lifetime.

His highly lit modelling draws the sensual and realistic appeal of his figures into the foreground of the painting. It is a "loud" painting in the sense that he makes a distinct attempt to reach the spectator with persuasively captivating painterly skills and sophisticated handling of light.

A popular and consistent iconographical structure sets the theme of such paintings, which can be broken down according to the "five senses": hearing (as in this example), smell, sight, touch and taste, often painted as a series, sometimes as personification and frequently found in Dutch genre paintings. Pictures of musicians, table rounds, banquets, raucous peasants – all are embodiments of the allegorical concepts of these "five senses". The compositional structures and formula of pathos were often adopted from existing paintings, particularly from the works of Italian artists, most notably Caravaggio.

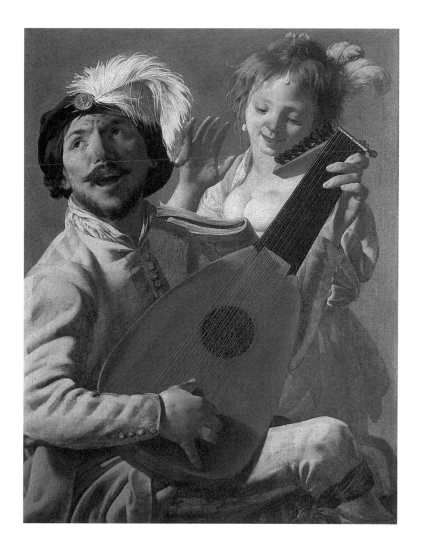

Hendrick Terbrugghen
The Duo, 1628
Oil on canvas,
106 x 82 cm
Paris, Musée National
du Louvre

Jacob Jordaens
Allegory of Fertility, c. 1622
Oil on canvas, 180 x 241 cm
Brussels, Musées Royaux des Beaux-Arts

Jacob Jordaens
The Family of the Artist, c. 1621
Oil on canvas, 181 x 187 cm
Madrid, Museo del Prado

JACOB JORDAENS
1593–1678

Amid a group of naked bodies stands a woman draped in a red robe which highlights her figure and frames the white and red grapes she is presenting to the admiring gaze of the other figures. The grapes, a divine gift, are the focal point of the painting. The female figure is probably Pomona, the goddess of fruits. At first it is the grapes that are admired by the nymphs and satyrs, who hold them contemplatively and wondering in their hands. On the left, however, we see another figure approaching. bearing a huge bundle of cherry branches, artichokes, fruit and melons. This, together with the way in which the fruits are distributed over the entire painting, recalls the sumptuous still lifes of fruit in the style of Snyders.

It is not unusual to find overlaps between two different pictorial genres in Netherlandish Baroque painting. Similarities can often be detected between a Rubens figure painting and a Brueghel flower still life, to name but one such example.

Further variations on this theme by Jordaens can be seen in Munich, Madrid and London. The liberal portrayal of human nudes is an astonishing feature of his œuvre. In this painting, which hangs in Brussels, the naked nymph with her back to us forms the symmetrical axis of the painting. To her left crouches a naked satyr, turned undaunted towards the spectator, mirrored on the right by the back of a semi-reclined female nude. Individual figures from these compositions by Jordaens can also be found in the works of Rubens.

The young woman sitting in a chair on the left can also be found in the Munich painting of *The Satyr and the Farmer's Family*. She is Catharina, the wife of the artist and daughter of Adam van Noort, to whom Jordaens was apprenticed and who also taught Rubens. She is well dressed, wearing a large ruff. She draws her cheekily smiling little daughter to her. Jordaens is standing by a chair with a lute in his hand, one foot placed slightly higher on the frame of the chair, reflecting the triumphal pose of the noble man (in the manner of placing a foot on the defeated enemy or the captured game). Slightly behind them stands a servant woman carrying a basket full of beautiful grapes.

Two further group portraits of highly original composition, *Jordaens and the Family of his Father-in-law* hang in Cassel (Gemäldegalerie) and St Petersburg (Hermitage).

The decor and the props in this family portrait clearly indicate the artist's claim to recognition as a nobleman in the sense of an artistic aristocracy. Rubens was the first to embody this status, by furnishing his home lavishly and by acquiring a palatial country house. Like Rubens, Jordaens also imbues the pathos formula and the props in his paintings with enormous vitality and humanity. Jordaens worked in Rubens' studio in 1618/19. After Rubens died in 1640, he took his place as the leading master of Flemish painting.

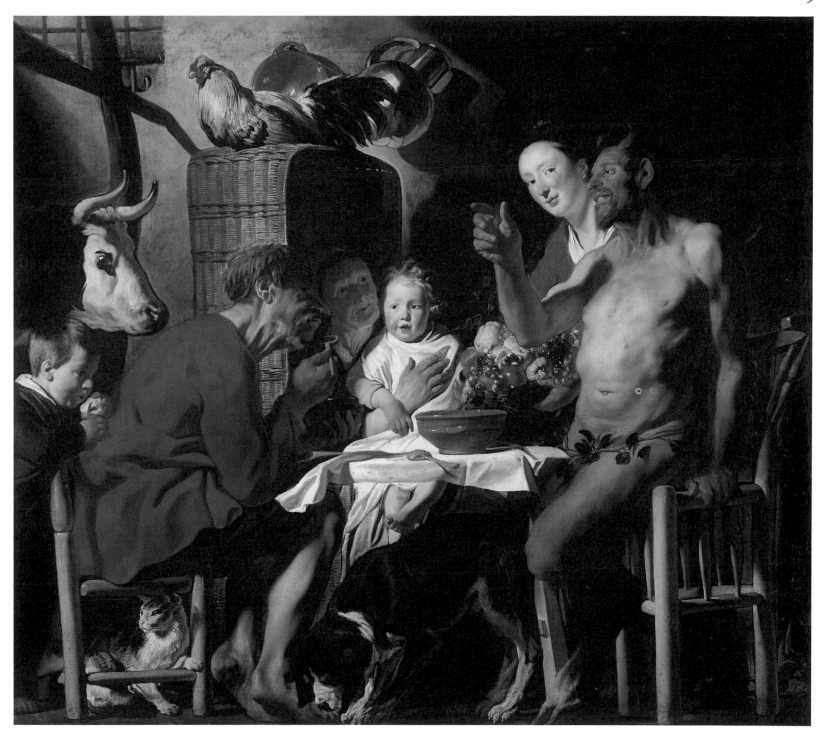

This painting is an early version of a theme Jordaens treated on numerous occasions. The strong contrasts of light and shade in the Munich version vividly recall Utrecht Caravaggism. Similarities with the works of Honthorst are also evident in the way the figures seem to be playing to the spectator, and in the modelling of the realistic corporeality against a dark ground. Contrasts are positively savoured, as in the juxtaposition of the ugly brown satyr and the pale-skinned young woman, the wrinkled old lady and the chubby-cheeked child.

This particular genre scene is based on a fable by Aesop in which a farmer invites a satyr into his home. First, he watches the farmer blowing on his hands to warm them and then blowing on his soup to cool it. The satyr, feeling he is being made a fool of, jumps up.

Jordaens does not simply illustrate the ancient fable, but links it with the genre and history painting that may be regarded as a Netherlandish invention. The naked satyr of Greek mythology has been integrated into a Flemish household. The young woman (Catherina Jordaens) and the children are almost certainly portraits. The rustic objects and the animals are typical of a Flemish household. This lively mixture of myth and genre, past and present, fable and moral was first introduced by Rubens. On another level – the finest example being the Medici cycle – Rubens also links historical reality and contemporary scenes with the world of mythology, in images that show how these intervene in human actions and deeds.

Jacob Jordaens
The Satyr and the Farmer's Family, after 1620
Oil on canvas-covered panel, 174 x 205 cm
Munich, Bayerische Staatsgemälde-
sammlungen, Alte Pinakothek

WILLEM CLAESZ. HEDA
C. 1593/94–1680

This painting shows an "ontbijtje", or break-fast table. It is a term that hardly seems fitting as a description of the still life presented here. In fact, this particular designation was originally adopted in Holland where the term "still life" was unknown before about 1650. "Ont-bijtjes" were a popular form of Haarlem vanitas painting. The leftovers of a meal are still standing on the table: the tablecloth has been pushed to one side, only part of the pie has been eaten, a goblet is overturned, a glass broken. The watch, in particular, reminds us of time passing. In these leftovers that remain after the joys of eating, we see the vanity of all earthly existence.

However, because this is such an artful ar-rangement, in which the individual things de-velop all the brilliance and appeal of their ma-terials, a certain ambiguity arises. The things intended to recall transience, destruction and decay are a joy to the eye, and their icono-graphical function becomes an alibi.

The reduction of colour allows the reflec-tions of the metal and glasses to appear all the more beautiful. Such works are known as monochrome "banketjes" in reference to the heightened appeal of surface finishes achieved by reducing tonal values.

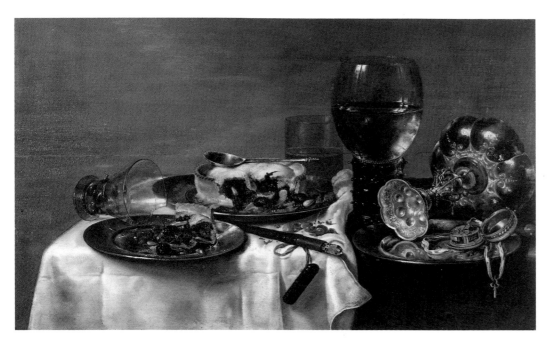

Willem Claesz. Heda
Still Life, 1631
Oil on panel, 54 x 82 cm
Dresden, Gemäldegalerie Alte Meister

GERRIT VAN HONTHORST
1590–1656

Honthorst stayed in Rome from 1610 onwards, where his preference for night scenes with spe-cial lighting effects earned him the name "Gherardo delle Notti". His *Incredulity of St Thomas* was probably painted towards the end of his stay in Italy, before his return to Utrecht in 1622. The influence of Caravaggio, whose works he had studied in Rome, cannot be over-looked. The contrast between the dark ground of the painting and the illumination of the key areas by some source of light that cannot be lo-cated enhances the realism of the scene rather than the miraculous nature of the event: Thomas has placed two fingers in the wound of Christ. Yet the superficial realism of the scene actually emphasizes its sacred character.

The source of illumination and the hand-ling of light in the works of Caravaggio and his followers are independently determined, defying completely rational calculation. In the later works of Honthorst, light tends to be portrayed more figuratively by showing a candle or a lamp, frequently covered by a figure in the foreground.

On his return to Utrecht, Honthorst be-came the leading representative of a group of painters whose work was profoundly in-fluenced by Caravaggio. It was here that he began translating the initially predominant re-ligious themes of his chiaroscuro paintings into popular genre scenes.

Gerrit van Honthorst
The Incredulity of
St Thomas, c. 1620
Oil on canvas,
125 x 99 cm
Madrid, Museo del Prado

JAN VAN GOYEN
1596–1656

These two landscapes mark the beginning of a period in Goyen's œuvre that might be described as "monochrome" or "tonal". In other words, this was a period in which he reduced his colour palette in favour of achieving atmospheric effects, by presenting a space bathed in light and haze through which colour had to penetrate. The fact that the reduction of local colouring can actually increase a sense of colour, is described by the poet Paul Claudel as follows: "I felt drawn towards, or rather captivated by, a small painting almost hidden away in a corner... It was a landscape after the manner of van Goyen, painted in a single tone as though with gilded oil on luminous smoke. But what really made me tremble as I contemplated the painting from a distance, and what made this subdued work sound out like a trumpet clarion was, as I now realize, the tiny scarlet dot beside an atom of blue, like a crystal of salt and a peppercorn."

What is actually the subject matter of Goyen's landscapes? The sparse, barely vegetated dunes, the dilapidated wooden hovels, the marram grass, the scattered little figures busying themselves with who knows what? In order to find some indication of the answer, we must turn to other still lifes of the period in which reflections and the absorption of light on the surface of objects were gradually becoming the focal point of the picture, so that the sense of space and atmosphere created by the objects, rather than the objects themselves, had become the subject matter of the painting. This is also true of the landscapes of Jacob van Ruisdael. Dunes, water, hovels, trees, all gain their significance in their role as bearers of the pictorial subject matter: atmospheric light.

Though the word "atmosphere" may be used readily enough, it should first be defined. It is not so much a question of sentimentality as of melancholy. The things portrayed are mundane, decayed, ephemeral or they are the intangibly vast and sweeping spaces of sea and sky. As such, their importance lies less in the objects themselves than in their melancholy mutability. Trivial as they may be in themselves, their appearance is one of beauty.

We might even say, with some reservations, that certain elements of the vanitas still life can also be found in the landscape painting. There, as here, the objects are not only symbols of transience, but also things of beauty. The same may be said of the objects in a work by van Goyen or Ruisdael. The land and the marks of human labour may be ruined or decayed, but they radiate beauty. Such beauty is ephemeral, just as the lighting and atmosphere in this landscape are mutable.

Van Goyen left more than a thousand paintings and, along with Jacob van Ruisdael and Hobbema, ranks amongst the most important of Dutch landscape painters.

Jan van Goyen
Landscape with Dunes, c. 1630–1635
Oil on panel, 54 x 37.5 cm
Vienna, Kunsthistorisches Museum

Jan van Goyen
River Landscape, 1636
Oil on panel, 39.5 x 60 cm
Munich, Bayerische Staatsgemälde-
sammlungen, Alte Pinakothek

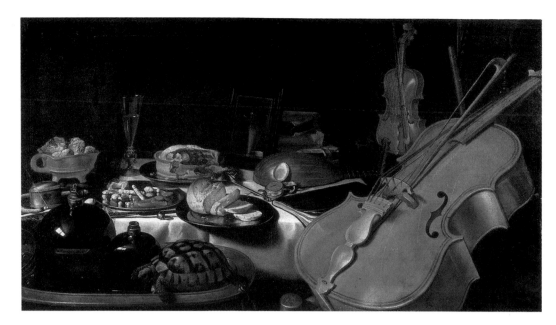

Pieter Claesz
Still Life with Musical Instruments, 1623
Oil on canvas, 69 x 122 cm
Paris, Musée National du Louvre

Thomas de Keyser
Equestrian Portrait of Pieter Schout, 1660
Oil on copper, 86 x 69.5 cm
Amsterdam, Rijksmuseum

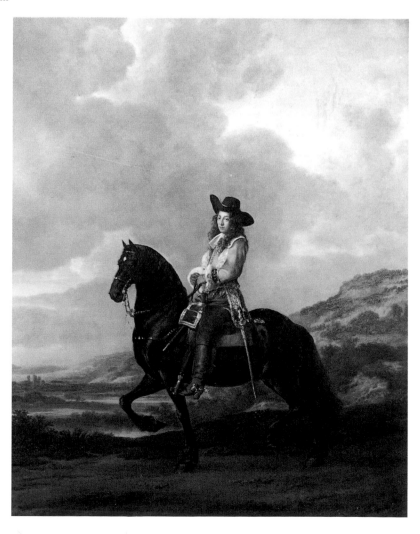

PIETER CLAESZ.
c. 1597/98–1661

A certain dichotomy is often present in Dutch still lifes. On the one hand, we find a carefully composed arrangement of beautiful objects, yet on the other hand these things are "out of use", forgotten, almost coincidental, merely lying there. The picture itself is created through the brilliance and beauty of the surfaces and finishes, the reflections of light on glass and metal or, in this case, on the wooden body of the musical instruments. Certain Mannerist leanings can still be detected in the tense handling of space and perspectival depth, with a line of flight running from the large foreground objects to the tiny items in the background. Tradition would have it that the objects in such a still life have a specific statement to make: time passes in this vain and ephemeral earthly life. All is vanitas.

A great deal could be written about the individual metaphorical significance of the objects. Bread and wine are frequently intended as a worldly expression of the Eucharist. The flesh of a nut may be a sign of the divinity of Christ, its shell may stand for the cross, a pretzel may represent the fragility of human life, while a lemon may suggest the bitterness that lies within a thing of outward beauty; pleasure, it seems to say, may end bitterly.

Yet all the warnings that may be hidden in these things are undermined by the beauty of the same objects.

THOMAS DE KEYSER
c. 1596/97–1667

The life-size equestrian portrait that found such widespread acceptance throughout the royal houses of Europe in the 17th century is rarely seen in Dutch art. The œuvre of Rembrandt and Potter includes only one example respectively. The republican attitudes prevailing in Holland seem to have been at odds with this feudal Baroque form of portrayal. On the other hand, we do find smaller equestrian portraits of wealthy burghers, especially in the work of Keyser.

In the summer of 1660, the ten-year-old Prince of Orange, later William III, visited Amsterdam with his mother Mary, daughter of Charles I of Great Britain, and entered the town in a magnificent parade of civic guards. Pieter Schout was also there and probably had this portrait painted to commemorate the event. He is mounted on his horse in noble garb with sparkling sword and yellow-brown doublet. The fine painting and tasteful colouring underline the noble attitude of this confident man. And yet his gaze seems to betray not so much the self-confidence of the ruler as the contemplative self-awareness of the citizen.

The amount of space taken up by landscape and sky is quite remarkable. The painting is not dominated by the central figure of the horseman and the space to which he is allocated. Indeed the horseman seems to have been set in the midst of a rural Dutch landscape.

ANTHONY VAN DYCK

1599–1641

This painting of *Susanna and the Elders* was executed while van Dyck was in Italy, where he stayed until 1627. It clearly reflects the inspiration of Venetian painting. The deeply luminous colours, especially the strong red of Susanna's mantle, are reminiscent of Titian, while the dynamic contrasts of movement are influenced by Tintoretto. What is more, the portrayal as a whole owes much to Caravaggist trend that was at its height at the time. The way Susanna moves forward out of the dark background, in luminous flesh tones, and the way the heads of the two elderly men create the only light accent against the dark ground, are all reminiscent of the genre painting of Honthorst or Baburen during their Roman period.

Van Dyck deliberately calculated these effects. As Susanna recoils, chaste and anxious, from the lecherous old men, she turns towards the spectator who thus becomes her protector. Contacts of this kind in which the painting involves the spectator beyond the pictorial boundaries, are often found in the work of the Caravaggisti; another typical feature is the reduction of narrative to a detail involving only a few figures in a setting that is merely hinted at.

When the church of St Martin in Zaventem commissioned van Dyck to create an altarpiece in 1621, he sent them a painting that had probably been in his studio for some time and may well have been completed around 1618. The composition is based on a drawing by Rubens and is only one of many examples of the latter's seemingly inexhaustible reservoir of invention.

The legend of St Martin sharing his coat with a freezing beggar is portrayed here with great vigour and drama. The red cloth, one end of which the saint keeps for himself, giving the other end to the heroically naked beggar sitting in the straw, is almost cut through. The composition has been built up around this point in the action, and it is here that the lines of movement and action intersect. Even the horse adds to the pathos of the scene, lowering its head and raising its foreleg in a piaffe worthy of the *haute école* of dressage, so that the rider does not need to bend down. Although this early work does not display the full harmony of colour handling van Dyck was yet to achieve, the stark contrast of red and blue is successfully toned down by using a broad palette of greys for the body of the horse and the clothing of the two beggars.

For all his dependence on the painting of Rubens, certain differences are already quite clear. Whereas Rubens uses pathos formula to indicate some higher plane of significance, in this work by van Dyck they seem rather theatrical, as though performed by actors.

Anthony van Dyck
Susanna and the Elders,
c. 1621/22
Oil on canvas, 194 x 144 cm
Munich, Bayerische Staatsgemäldesammlungen, Alte Pinakothek

Below:
Anthony van Dyck
St Martin Dividing his Cloak , c. 1618
Oil on panel,
171.6 x 158 cm
Zaventem, St Martin

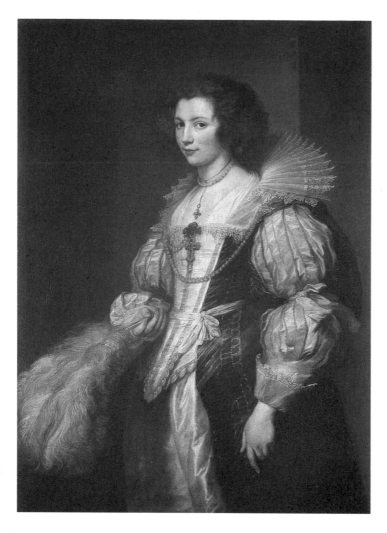

Anthony van Dyck
Portrait of Maria Louisa de Tassis,
c. 1630
Oil on canvas, 130 x 93.5 cm
Vaduz, Fürst Liechtensteinische
Gemäldegalerie

Below:
Anthony van Dyck
The Count of Arundel and his Son
Thomas, 1636
Oil on canvas, 187 x 162 cm
Madrid, Museo del Prado

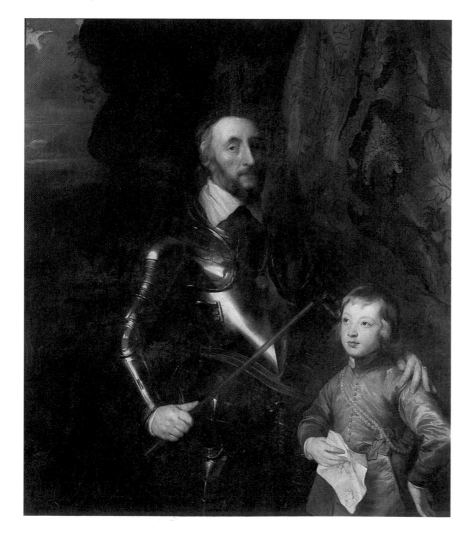

ANTHONY VAN DYCK
1599–1641

The outward trappings of nobility are magnificent armour and sumptuous silks. Whereas, in the work of Rubens, colour is the expression of something deeply rooted in all things of the cosmos, colour is used in the work of van Dyck as a reflection of superficial beauty. The woman in this portrait was the daughter of a wealthy Antwerp patrician, and van Dyck painted her portrait before he left for London.

At the time of painting this portrait of the Duke of Arundel, van Dyck was already a favourite portraitist of the English nobility; it became *de rigueur* for anyone of rank and status to have their portrait painted by him. As court painter to the king, he developed compositional forms particularly suited to the requirements of his task, and in doing so he set a pattern that was to have a considerable influence until well into the 18th century.

Compositions featuring a landscape view on one side and a drapery or pillared architecture on the other originated in the religious painting of 16th century Venice. Van Dyck adopted these compositional forms and transferred them to courtly portraiture. Moreover, his backgrounds are imbued with a lyricism that clearly removes the subject matter from the banality of everyday life. Portraits of children were not only fashionable at the time, but also highly esteemed. The lyrical and even sentimental underlying atmosphere of this painting gave even the landed gentry and military men a touch of beauty and humanist intellect.

The Stuart monarch Charles I embodies Baroque absolutism as well as the traditional ideal of the cavalier. Firmly believing in the divine right of Kings, he regarded art as an excellent vehicle for presenting the monarch as the human embodiment of divine rule. CAROLUS/REX MAGNAE/BRITANIAE reads the inscription on the panel in the tree at the right.

Ever since Titian's equestrian portrait of the Emperor Charles V (1548; Madrid, Prado), landscape had established itself as a particular form for this kind of portrait. Rubens created one version and there is also a version by van Dyck dating from the early 1620s, showing Charles V on horseback. For his portrait of the British monarch, he returned to the same technique of placing the rider in a picturesque landscape with a distant view on one side and a shady tree on the other. In a previous equestrian portrait of the same king, the monarch is portrayed frontally under a triumphal arch. Here, the landscape itself becomes a triumphal motif.

Anthony van Dyck
Equestrian Portrait of Charles I,
c. 1635–1640
Oil on canvas, 367 x 292.1 cm
London, National Gallery

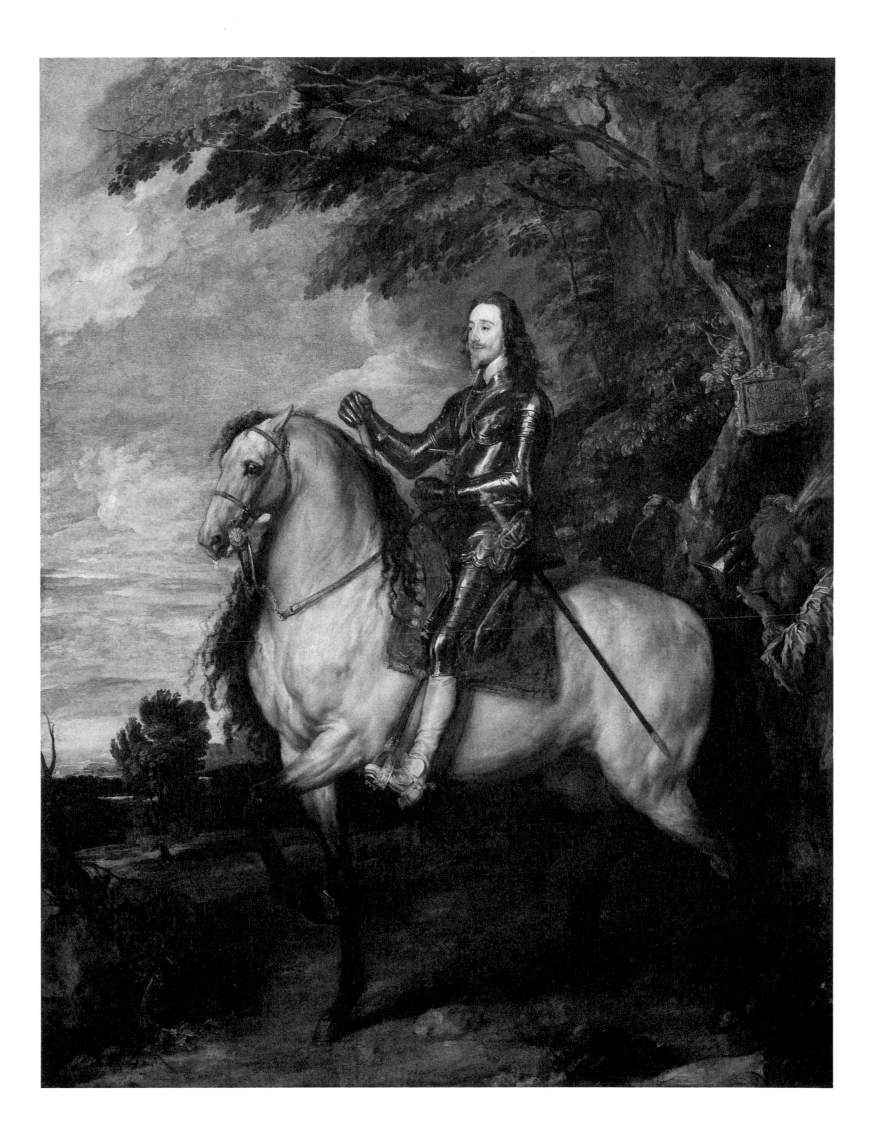

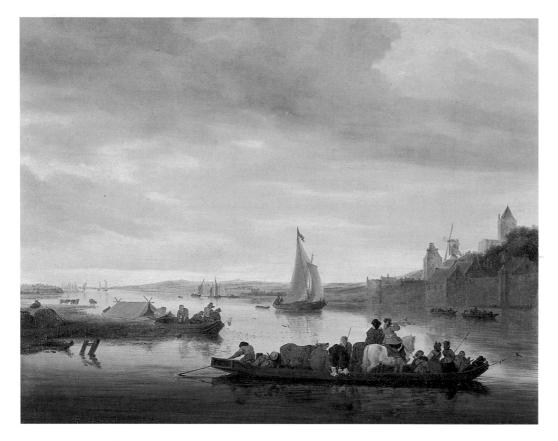

Salomon van Ruysdael
The Crossing at Nimwegen, 1647
Oil on canvas, 70 x 89 cm
Bonn, Rheinisches Landesmuseum

SALOMON VAN RUYSDAEL
c. 1600/03–1670

Although this painting portrays a flat riverscape with a city on its banks, the topographical situation of the Waal near Nimwegen is not entirely precise. Instead, Ruysdael combines individual elements also featured on some of his other paintings, such as the "Plompetoren" of Utrecht, whose tower was demolished in the 18th century. The artist is interested less in a faithful rendering of a certain geographic situation than in presenting the Netherlandish riverscape in the Rhine-Maas delta.

The river is broad and slow. Sailing boats and cargo tugs lie almost motionless on its mirror-smooth surface. In the muddy waters of a tongue of land, fishermen have cast out their nets and, slightly further into the distance, we see cattle standing in the shallow water near the riverbank. Right across the foreground of the painting, a ferry is crossing the river carrying a few passengers, two cows and two horses, with their riders still in the saddle. One of them is signalling his arrival with a trumpet blast.

This visible acoustic signal underlines the quiet calm of the landscape, emphasizing the fact that this tranquillity is in itself the actual subject matter of the painting. The colours of the painting are broken greys and blues, creating a tonality that makes everything appear as though seen through a veil of haze.

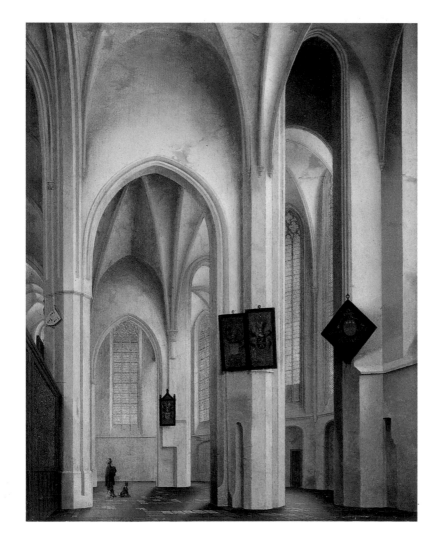

Pieter Jansz. Saenredam
Church Interior in Utrecht, 1642
Oil on panel, 55.2 x 43.4 cm
Munich, Bayerische Staatsgemäldesammlungen, Alte Pinakothek

PIETER JANSZ. SAENREDAM
1597–1665

This painting shows the interior of the Jakobikerk in Utrecht, built between the 14th and 15th centuries. Saenredam prepared the painting in a number of sketches and structural drawings.

Whereas earlier interiors tended to correspond more or less with the spectator's view into the painting, so that the picture frame acted as an introduction to the architecture portrayed, Saenredam has objectified the interior. Although Saenredam does not portray a diagonal detail of the room in which the movement of light is present, such as we find later in the work of de Witte, the painting nevertheless derives its sense of an interior through the handling of light and space rather than through perspective alone. The man walking alone with his dog seems almost lost in the church, further underlining the independence of the architecture as a motif. In contrast to the so-called "atmospheric interiors" of the following generation, Saenredam's interiors are described as "realistic spaces". What is meant by this, is that such rooms did not serve as a foil for something else, but were actually an independent, pictorial object. These were, to all intents and purposes, portraits, and were not adapted to fit in with any external compositional structure. In the work of Saenredam, the sparse colority and dry linearity of the architectural subject are fascinating.

ADRIAEN BROUWER

c. 1605/06–1638

In the work of Brouwer, who was born in Flanders and lived in Amsterdam and Haarlem before returning to Antwerp, we find a blend of Flemish and Dutch traditions. His influence on both parts of the Netherlands was considerable. Whereas his rough peasant types recall the work of Pieter Brueghel, the sheer vitality with which he presents human emotions such as pain, rage or humour, are reminiscent of Frans Hals, in whose studio he worked for a time.

The elements Brouwer adopted from the peasant scenes and parables of Brueghel were still new to the Dutch art world. Yet his paintings did not possess the many-layered meanings of 16th century pictorial narratives, being reduced instead to drastic and edifying individual anecdotes whose very conciseness was echoed in their small format. They are cabinet pieces whose effect owes much to their ability to capture a sense of great vitality in sweeping painterly gestures on a tiny area.

Around the turn of the 17th century, allegories tended to take the form of personifications with appropriate attributes. Now, however, they began to take the form of realistic scenes apparently drawn from everyday life. The anecdotal "genre" style distracts from the original underlying message of a "truth" or proverb which is invariably present in Netherlandish paintings. Often, these tell the parable of the prodigal son, using it as a vehicle for the presentation of brothel scenes or taverns with singing and brawling peasants.

Bearing this in mind, paintings can occasionally be interpreted in ways that are not immediately obvious. The popular motif of the *Barber-Surgeon* in which we see someone having a painful corn cut out of his foot borrows the iconographic forms normally used in portrayals of Christian martyrdom, a fact which does not prevent Brouwer from taking his portrayal of the characters to the point of caricature. Such adaptations can frequently be found in the work of the Utrecht school around the turn of the 17th century, where there were contacts with Italian painting, especially with the realistic chiaroscuro painting of Caravaggio.

Though Brouwer's paintings are not always part of a series, they do generally belong to the category of "five senses" pictures. Just as the "foot surgery" we see here represents the sense of touch, so too do the brawling, drunken or smoking peasants represent embodiments of taste and smell rather than pure genre portrayals. In Antwerp, the dens where people went to savour the forbidden pleasures of tobacco were known as "tabagie". Through the short clay pipes, the smokers would inhale so much nicotine that they not only experienced an intoxicating rush, but sometimes even suffered serious poisoning.

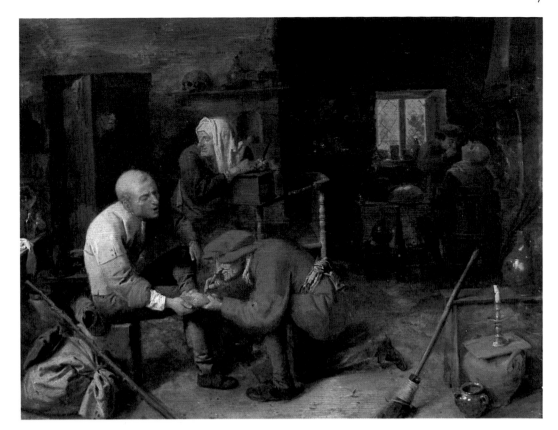

Adriaen Brouwer
The Operation, undated
Oil on panel, 31.4 x 39.6 cm
Munich, Bayerische Staatsgemälde-
sammlungen, Alte Pinakothek

Adriaen Brouwer
Peasants Smoking and
Drinking, c. 1635
Oil on panel, 35 x 26 cm
Munich, Bayerische
Staatsgemäldesammlun-
gen, Alte Pinakothek

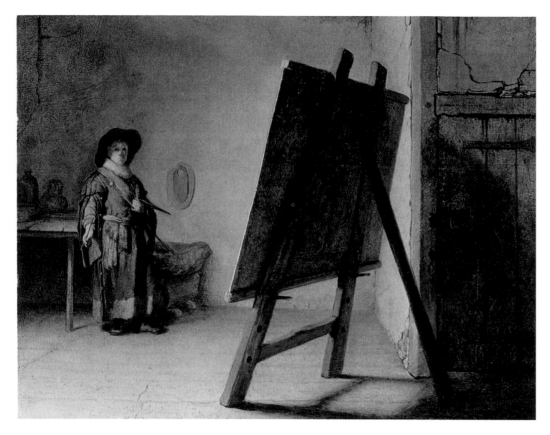

Rembrandt Harmensz. van Rijn
The Artist in his Studio, c. 1626–1628
Oil on canvas, 25.5 x 32 cm
Boston (MA), Museum of Fine Arts

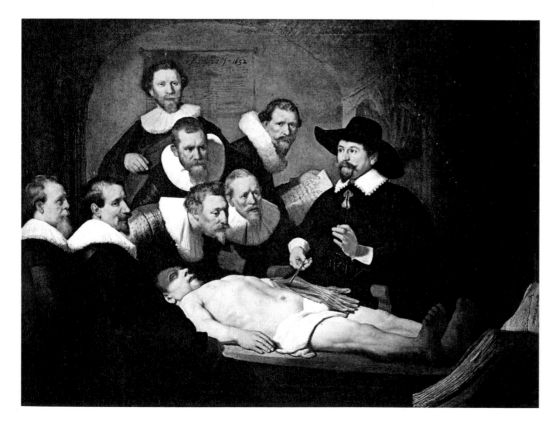

Rembrandt Harmensz. van Rijn
The Anatomy Lesson of Dr. Nicolaes Tulp, 1632
Oil on canvas, 162.5 x 216.5 cm
The Hague, Mauritshuis

REMBRANDT

1606–1669

While he was still in Leiden, the young Rembrandt painted himself as an artist in front of his easel, in what was to be the first of many artist self-portraits in Holland. This form of portrait provided an opportunity of presenting the professional status and lifestyle of the artist. For this, Rembrandt chose a highly unusual form.

We see the painter standing before us in extravagant garb, wearing an oversized coat as though in a masquerade. Vermeer's later studio painting (ill. p. 140) also shows the artist dressed in finery that indicates his status as master of a noble art rather than that of a simple craftsman. When Rembrandt adopts the stance of the well-dressed artist – which has a tradition going back all the way to Leonardo da Vinci – he seems to call it into question at the same time by lending it the air of a masquerade. This interpretation would seem to be borne out by the fact that the studio itself is sparse and poorly furnished. The artist standing in these bare surroundings looks rather lost, confronted with his canvas on the easel. All we see of it is the back of the painting, submerged in shadow; the light bathing the front of the canvas reflects into the room.

The same light in otherwise dark rooms can also be found in the young Rembrandt's portrayals of biblical miracles which take on a sense of the supernatural; it is an artistic device adopted from the Caravaggisti. Here, the light makes the painting on the easel light up as though from within. Small and forlorn in his humble surroundings, the young artist faces the great challenge of art.

This group portrait shows a famous Amsterdam physician surrounded by colleagues, students and interested onlookers in the rare and spectacular act of giving an anatomy lesson. The first known treatment of this subject is a painting by Keyser dated 1619. Whereas earlier anatomy lessons tended to use a skeleton, here the subject is a corpse. The dead man has been laid out as in portrayals of the Lamentation over the Body of Christ.

Anatomical lectures involving the dissection of a corpse were rare occurrences for which entry fees were levied and they met with enormous interest. Only one such lecture is documented in Amsterdam in the year 1632, when this painting was executed. The corpse is the body of a hanged gunsmith. The composition of the painting in which the audience (their names are recorded on the sheet of paper one of them is holding in his hand) are grouped in a semicircle around the head of the corpse, while Tulp stands slightly to one side, is an innovative approach: Rembrandt does not simply document the momentary situation of an anatomy lesson in progress, but creates a symbolic image. This is evident from the fact that the arm muscles of the corpse are rendered in the manner of a drawing from a book of anatomy. Andreas Vesalius, the great 16th century physician and founder of modern anatomy had published just such a book. We find it here, propped up open at the feet of the corpse.

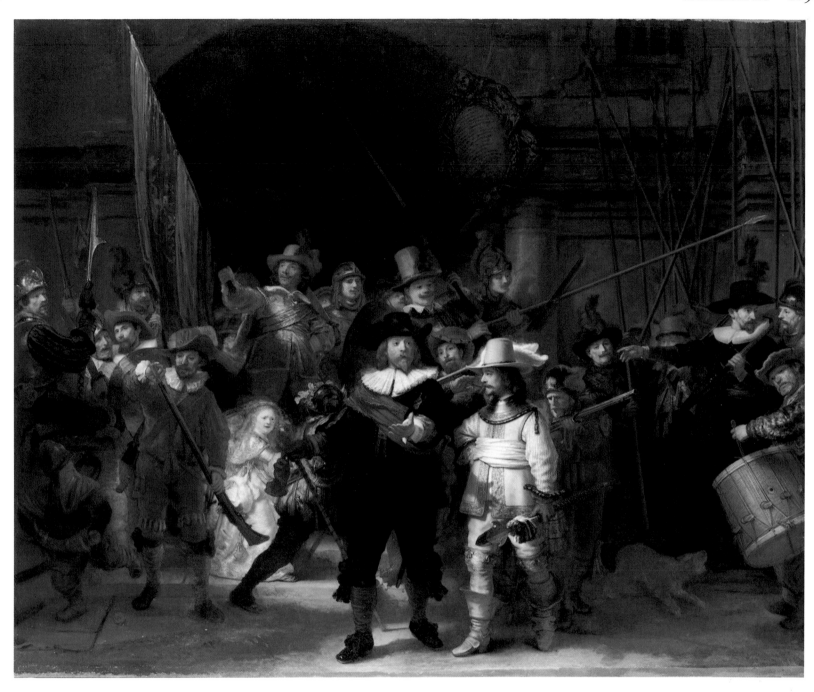

Probably Rembrandt's most famous and most controversial painting was given its erronious title *The Night Watch* in the early 19th century. The title referred to the subdued lighting and led art critics to seek all manner of hidden mysteries in the painting. The original title, recorded in the still extant family chronicle of Captain Banning Cocq, together with a sketch of the painting, sounds rather dry by comparison: "Sketch of the painting from the Great Hall of Cleveniers Doelen, in which the young Heer van Purmerlandt [Banning Cocq], as captain, orders his lieutenant, the Heer van Vlaerderdingen [Willem van Ruytenburch], to march the company out."

It is, therefore, a "Doelen" piece or group portrait in which the captain can be seen in the foreground wearing black and the lieutenant wearing yellow. What sets Rembrandt's group portrait apart from other comparable paintings is his use of chiaroscuro as a dramatic device. Interpretations seeking a plausible action fail to take into account that the scenery is made up more or less of individual "types". For example, the horseman with helmet and lance turns up again as *Alexander The Great* (Glasgow, Art Gallery) and we can also find the *Man with the Golden Helmet* (Berlin, Gemäldegalerie; recently no longer attributed to Rembrandt) in the *Night Watch*. Indeed, the painting includes the entire repertoire of portrait poses and gestures from Rembrandt's store of figures.

There is inevitably a sense of celebration in the portrayal of individuals in a Dutch group painting. Yet whereas Frans Hals, for example, draws together his individual participants around a banquet scene, Rembrandt breaks up the group, so that individual characters and participants become absorbed in their own actions, each standing alone.

Rembrandt Harmensz. van Rijn
The Night Watch (The Company of Captain Frans Banning Cocq and of Lieutnant Willem van Ruytenburgh), 1642
Oil on canvas, 363 x 437 cm
Amsterdam, Rijksmuseum

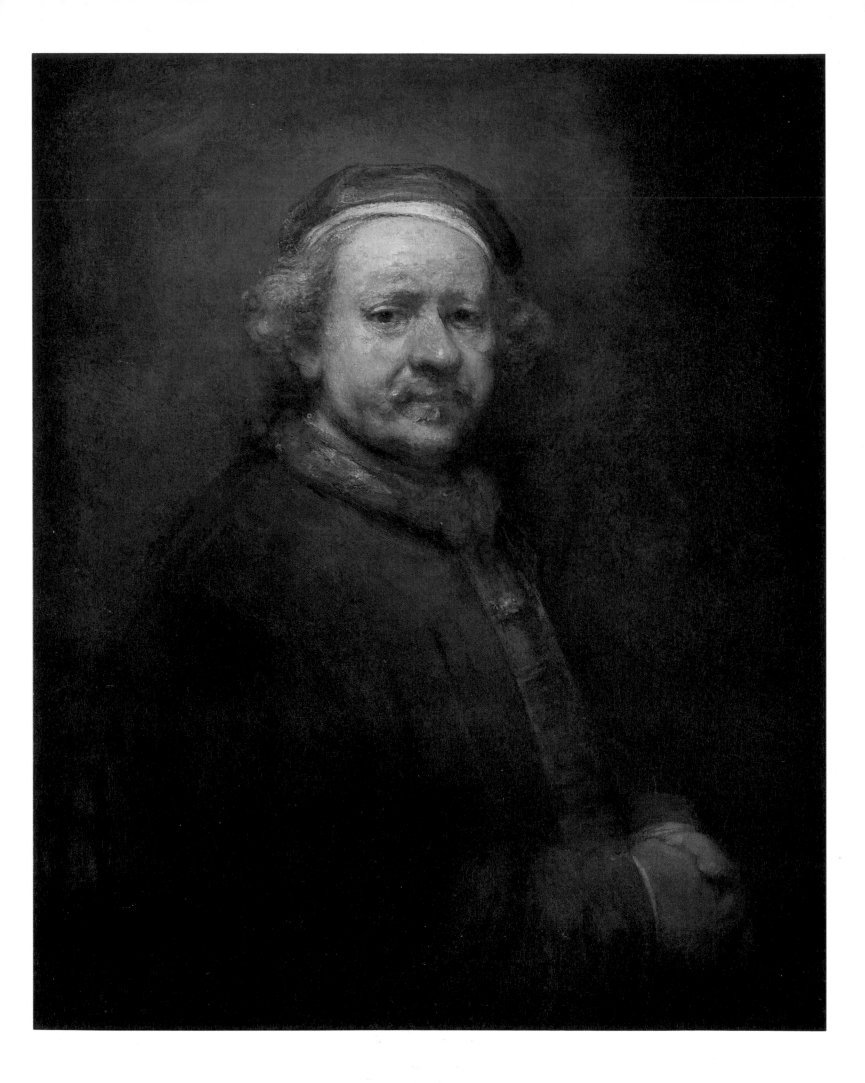

REMBRANDT

1606–1669

This self-portrait painted by Rembrandt in the year of his death is an image of passiveness, resignation, scepticism and irony. The blustering show of props and artistic affectation has given way to a more humble and homely mode of dress. The portrait underlines all that is personal, withdrawn, lonely and even eccentric about this elderly man. The brushwork seems deliberately rough and cumbersome, as though details were unimportant. The paint is applied so thickly that it creates an almost relief-like surface and the image of the ageing artist seems to be disintegrating before our very eyes. The colour itself, on the other hand, has a stabilizing effect; a deep and brilliant red shimmers through the brown ground with profound luminosity. Whereas all that constitutes form seems to be caught in the grasp of mortality and decay, and while even the brushwork seems brittle and crumbling, the strength of the underlying colour tells of life and hope.

In his *Descent from the Cross* which is part of a cycle depicting the Passion of Christ commissioned by the stadholder of the Netherlands, Rembrandt cites the altarpiece painted by Rubens for Antwerp Cathedral. A comparison of these two works can give us some interesting insights into his specific painterly technique. The strong contrast between the dark ground and the use of light is not used to heighten the pathos and drama of the Passion, but to underline the very human aspect of suffering and pain in the face of death. Light is not used here to divide the darkness, for the artist does not seek to present the triumph of light over the forces of darkness, but to portray the wan pallor of the shroud and the waxen skin of the dead Christ. In the chiaroscuro of Rembrandt's early works, light is not so much a sign of the supernatural as an emphasis of worldly reality.

There is something deeply disturbing about this painting. The bloody, fatty mass of the *Slaughtered Ox* seems to fill the canvas in the manner of a still life with a certain aesthetic appeal. This is in fact an increasing feature of Rembrandt's later works. The subject matter, even in portraiture or history painting, is either treated with a brushwork of almost brutal vigour and subverted to the point of unleashing the brilliance of the underlying colour – especially red – or else, as here, he chooses to portray a subject matter that has inherently the same subversive effect, as luminous as the finest still life. This particular example also illustrates the role played by the brownish background colour in Rembrandt's work. There is nothing colourful about this background brown, and yet it seems to harbour within its depths an inherent luminosity and colority that can burst forth at any moment.

Rembrandt Harmensz. van Rijn
Self-portrait aged 63, 1669
Oil on canvas, 86 x 70.5 cm
London, National Gallery

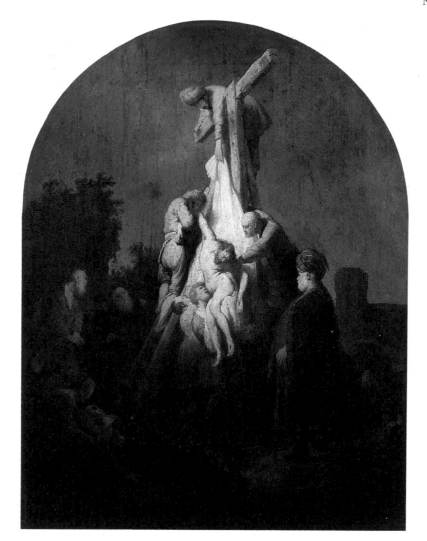

Rembrandt Harmensz. van Rijn
The Descent from the Cross, 1633
Oil on panel,
89.4 x 65.2 cm
Munich, Bayerische Staatsgemäldesammlungen, Alte Pinakothek

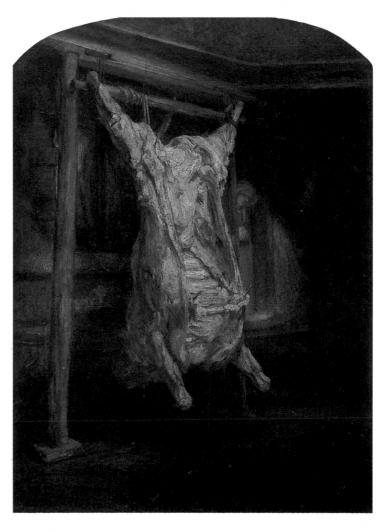

Rembrandt Harmensz. van Rijn
The Slaughtered Ox, 1655
Oil on panel, 94 x 67 cm
Paris, Musée National du Louvre

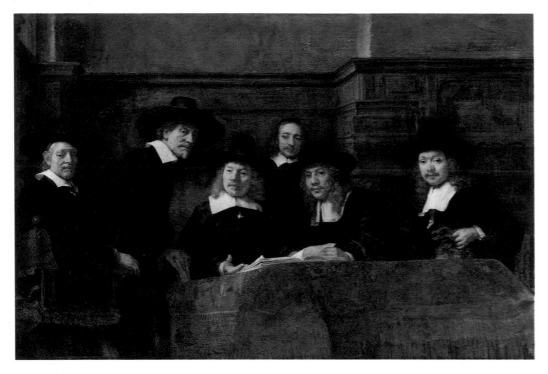

Rembrandt Harmensz. van Rijn
The Syndics of the Amsterdam
Clothmakers' Guild (The Syndics), 1662
Oil on canvas, 191.5 x 279 cm
Amsterdam, Rijksmuseum

Rembrandt Harmensz. van Rijn
Aristotle Contemplating the Bust of Homer, 1653
Oil on canvas, 143.5 x 136.5 cm
New York, The Metropolitan Museum of Art

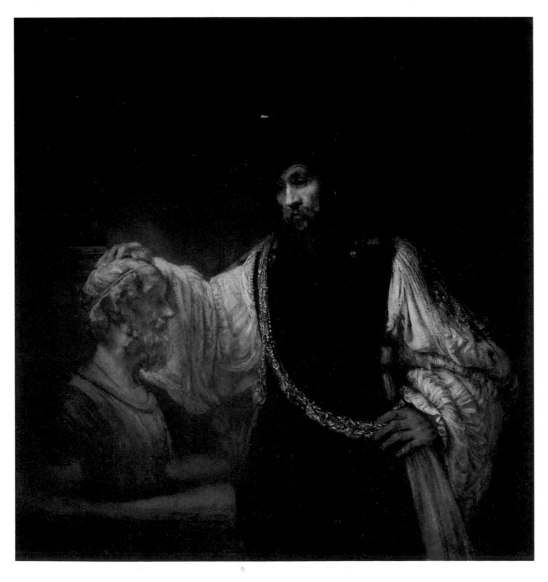

REMBRANDT
1606–1669

Behind a table draped in a red tapestry, with a
finely panelled wall in the background, sit the
five "Staalmeesters". This is probably a com-
mittee of the clothmakers' guild, the "Waar-
dijns van de Lakenen" who were in charge of
inspecting the quality of the cloth samples.
We know their names and the name of the ser-
vant standing in the background. On the back
wall, we can just make out a small oil paint-
ing depicting a lighthouse as a metaphor for
model behaviour and "lighting the right way".

As in the last two group portraits by Frans
Hals dated 1664, Rembrandt also reduces
drama and scenery (at its most lavish in his
Night Watch) to a minimum. The pathos for-
mula and showy stances have all but disap-
peared. For example, the "waardijn" second
from the left is half standing and half sitting,
and the gentleman next to him is quietly ex-
plaining something in the ledger. The lack of
scenic interaction isolates the individuals.

For many years, this painting was wrongly
interpreted. It was believed that the com-
mission of cloth inspectors had to defend
themselves against accusations, and that one of
them was drawing up a bill, while another was
greedily grasping the money bag. Such an in-
terpretation of this painting could hardly be
further from the truth. In fact, it is actually in-
tended to show five men with a firm sense of
responsibility, forming a group in which the
individuality of each is more important than
any pathos-laden dramatic scene. The main
distinction between this group painting and
the earlier *Night Watch*, however, is the reduc-
tion of vitality in the overall movement and
the distance created between the group and
the spectator.

Aristotle Contemplating the Bust of Homer was
commissioned in 1653 by the Sicilian noble-
man Don Antonio Ruffo, who paid Rem-
brandt five hundred guilders for it, about four
times the price of a comparable Italian paint-
ing. Later, Don Ruffo also commissioned two
further paintings, one of *Alexander the Great*
and one of *Homer*. The plastercast of the an-
tique Homer bust was in Rembrandt's home.

The pensive philosopher has placed his
hand on the bald stone forehead of the poet. It
is an encounter across the bounds of time, a
meeting of minds, symbolized by the warm
light that glows between the two figures. The
bust seems to come alive, just as the objects in
a Dutch vanitas still life speak to us.

At the same time, the living figure of Aris-
totle is drawn into the past; with an intro-
verted and contemplative gaze. The blind eyes
of Homer and the seeing eyes of Aristotle
meet directly, as it were, and at the point
where their gaze meets, the light of the paint-
ing is strongest.

JAN DAVIDSZ. DE HEEM
1606–c. 1683/84

De Heem's still life paintings initially followed the style of the Haarlem school, but later drew closer to the more lavish Flemish style of large-scale still lifes. Nevertheless, certain Dutch elements cannot be overlooked. In this painting, they are particularly evident at the points where a "dialectical principle" determines the compositional structure.

A mass of fruit and flowers ranging from ripe chestnuts to blackberries, from columbine to roses, has been arranged on a stone slab. A wide variety of surfaces, each with a different effect in light, with pure or iridescent colours, is spread out before us. Yet snails are already crawling across the vine leaves, the foliage is discoloured and withering and, the ears of grain are curling, the peach has burst its skin, the citrus fruit is half peeled, the white carnation is dried and drooping over the table edge.

At the very point where the image bears an iconographic message of the transience of worldly life in the form of nature's riches, we see these things in their last bloom of beauty. Just as a ruin could represent the picturesque appeal of architecture, so too can a vine leaf riddled with snails seem picturesque in the full and final flowering of its beauty.

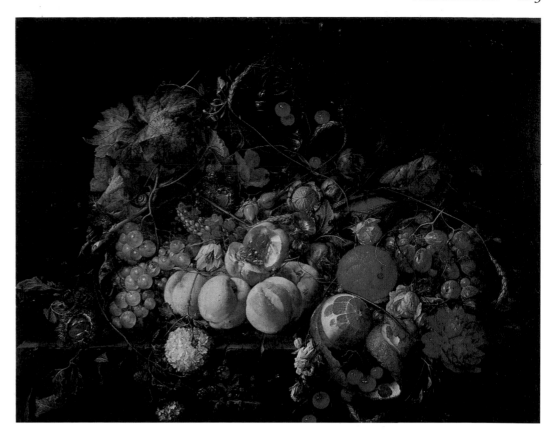

Jan Davidsz. de Heem
Still Life, undated
Oil on panel, 55.8 x 73.5 cm
Gent, Museum voor Schone Kunsten

JUDITH LEYSTER
1609–1660

Judith Leyster is one of the very few women to have been accepted as a member of the Haarlem Guild of Painters. Although a contemporary historian described her as a leading light in art (punning on her name Leyster, which means "lodestar") she remained unknown for a long time and her works were either believed lost, or were attributed to Frans Hals. She probably worked in his studio around 1630 and was also a friend of his family, for one year later she became godmother to Hals' daughter Maria.

Like Hals at the same time, the young Leyster adopted the style of the Utrecht Caravaggisti, with their strong chiaroscuro modelling in the manner of Caravaggio. From the mid-1620s, she concentrated more on vividly illuminated genre scenes, generally featuring half figures of merry musicians, gamblers and whores, strongly influenced by the painting of Terbrugghen and Honthorst.

While the Utrecht school of painters still rounded the surfaces of their objects smoothly between light and shade, Hals and his school adopted a broad, vibrant and independent brushstroke. Leyster's work can be distinguished from that of Hals through her generally more discordant handling of colour, her sketchier treatment of hands, the wryly distorted smiles of her figures and her altogether flightier brushwork.

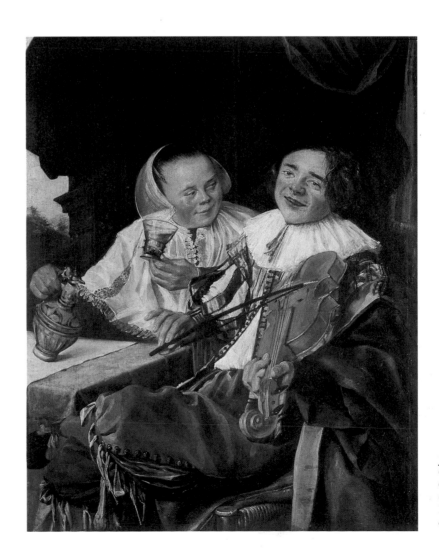

Judith Leyster
Carousing Couple, 1630
Oil on canvas,
68 x 54 cm
Paris, Musée National
du Louvre

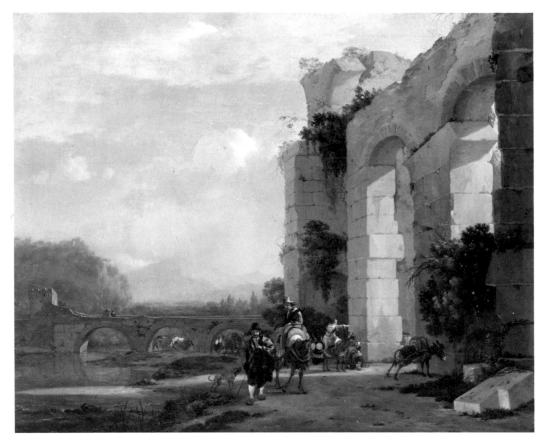

Jan Asselijn
Italian Landscape with the Ruins of a Roman
Bridge and Aqueduct, undated
Oil on canvas, 67 x 82 cm
Amsterdam, Rijksmuseum

JAN ASSELIJN
1610–1652

Asselijn studied for some time in France and
Rome. On his return to Amsterdam, he spe-
cialized in painting animals and Italianate
landscapes, which occupied a firm place in
Dutch painting. Motifs of the Roman Cam-
pagna, ruins, rocks and castles generally domi-
nate his settings peopled with riders and herds-
men. Yet his works owe less to real landscapes
than to painterly tradition. Some typical fea-
tures of the work by this Italianate Dutch art-
ist are the way he bathes his landscapes in at-
mospherically "romantic" golden hues in-
fluenced by Claude Lorrain's handling of light,
or adopts picturesque motifs in the manner of
Salvator Rosa.

Italianate as they may be, these paintings
are nevertheless easily identifiable as the work
of a Dutch artist, for the genre generally lacks
the pathos formula of the Baroque and the an-
tique ruins tend to blend into the rest of the
landscape like elements in a still life. The
genre components can be found in the pro-
cession of mules, their riders and the figures
on the bridge.

Like a piece of broken bread or a cracked
earthenware jug, the ruins unfurl their melan-
choly beauty in the tranquil evening light, re-
calling the transience of earthly life in a
highly aesthetic way.

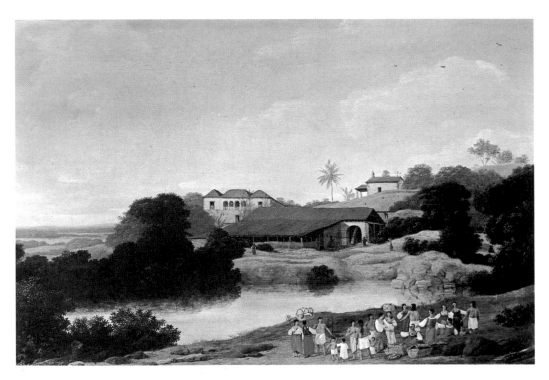

Frans Post
Hacienda, 1652
Oil on panel, 45 x 65 cm
Mainz, Mittelrheinisches Landesmuseum

FRANS POST
1612–1680

From 1637 to 1644, Post accompanied the
retinue of Prince Johan Maurits of Nassau
Siegen to Brazil, where he painted the land-
scape around Pernambuco and on a number of
oceanic islands, as well as genre scenes of local
life. This Dutch artist's sensitivity to specific
situations, landscape and people make Post's
Brazilian paintings an invaluable source of in-
formation regarding not only the flora and
fauna of the region, but also the dress and cus-
toms of the time.

On his return, Post settled in Haarlem and,
like all his Dutch colleagues, he specialized,
concentrating especially on tropical and exotic
views. In his paintings, we note that, although
he supplies details and specific information
about this far-off land, the paintings them-
selves are nevertheless organized along the
lines of conventional Dutch landscape paint-
ings. The gaze of the spectator is drawn from
the foreground into the depths of the land-
scape. This distant view with atmospheric
changes and a large proportion of sky, are typi-
cal features of Dutch painting. Genre-type
figures are also included in the compositional
structure of these Brazilian scenes.

ADRIAEN VAN OSTADE
1610–1685

Ostade's paintings of the 1630s bear eloquent witness to the influence of the early Rembrandt. Although Ostade studied in the Haarlem studio of Hals at the same time as Brouwer, the chiaroscuro of his paintings owes much to Rembrandt. Even his genre scenes of decayed and dilapidated inns and hovels, almost the sole motif in Ostade's œuvre, are to be found in the work of Rembrandt. For this reason, we should take any assertion that these paintings of brawling and drunken peasants represent everyday Dutch life with a considerable pinch of salt. A more likely explanation is that they represent a highly popular subject with a long tradition that had eventually developed into an independent genre.

In his early work, Ostade set his scenes in dark rooms using meticulously staged lighting. The handling of light and the humble architecture derive from the tradition of portraying the stable at Bethlehem. These peasant genre paintings were almost certainly aimed at an urban audience which saw its prejudices and clichéd notions of primitive and oafish peasant life confirmed by such caricatures and which could also appreciate the particular humour of such a painting. This perceived humour lay to some extent in the notion of "wasting" sophisticated artistic skills on such lowly motifs.

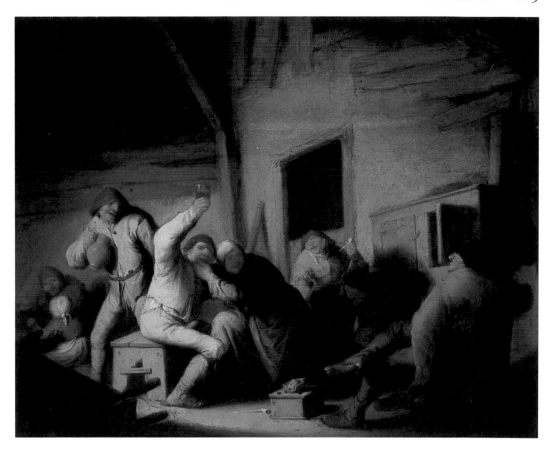

Adriaen van Ostade
Peasants Carousing in a Tavern, c. 1635
Oil on panel, 28.8 x 36.3 cm
Munich, Bayerische Staatsgemälde-
sammlungen, Alte Pinakothek

DAVID TENIERS The Younger
1610–1690

Teniers was the most popular genre painter of the 17th century in Antwerp and the southern Netherlands – the Flemish counterpart to the Dutch artists Steen and Ostade. This painting of a *Twelfth Night* celebration is from his early period, the 1630s, in which we can still recognize the distinct influence of Adriaen Brouwer's genre paintings. Later, when Teniers became court painter and curator of the art collection of stadholder Archduke Leopold Wilhelm in Brussels, he painted vedutas and galleries full of people.

From the 16th century onwards, particularly in the Netherlands, but also elsewhere, Twelfth Night (January 6) was celebrated in the form of a so-called "bean feast". A bean was baked into a cake and the person who found it became the Bean King. This provided ample opportunity for raucous travesties of courtly ceremonies. Here, we see a Flemish household boisterously roaring the traditional toast "The King drinks!"

Teniers' painting differs from comparable Dutch presentations of the same theme in its obvious leanings towards the work of Pieter Brueghel the Elder, whose daughter he had married, as well as in the number of figures in the narrative. Similar Twelfth Night scenes in the work of Ostade or Metsus tend to concentrate more on the one particular aspect of the "bean feast" and are often more brightly illuminated.

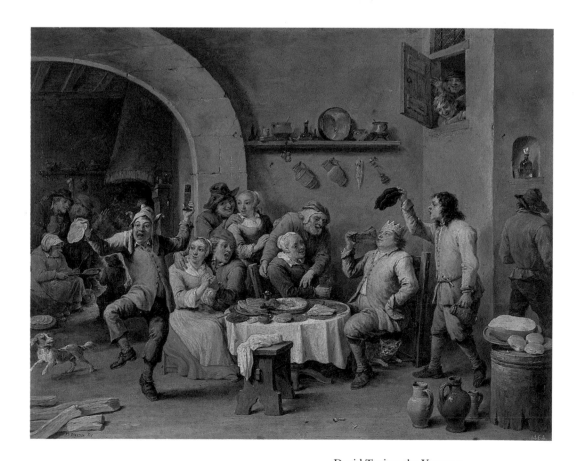

David Teniers the Younger
Twelfth Night (The King Drinks), c. 1634–1640
Oil on canvas, 58 x 70 cm
Madrid, Museo del Prado

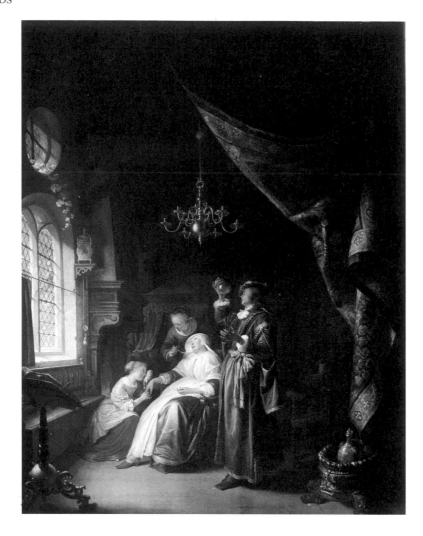

Gerard Dou
The Dropsical Lady
(The Doctor's Visit),
c. 1663 (?)
Oil on panel, 86 x 67 cm
Paris, Musée National
du Louvre

GERARD DOU
1613–1675

Gerard Dou was the leading representative of
the Leiden "fine painters". In his work, the
longstanding Netherlandish tradition of the
meticulously detailed rendering of objects,
painted using a fine brush and a magnifying
glass, is blended with the Dutch love of *trompe-l'œil*.

Dou, originally a stained glass artist, was re-
nowned for his technique of illusion, created
by painting such objects as draperies or win-
dow openings in the foreground in such a way
that they appeared to belong to the spectator's
sphere. These objects – and in particular the
light falling on their surfaces – are painted
with the finest of brushes.

Dou has a preference for genre scenes and
interiors. As in the work of Steen, these gener-
ally involve some moral, parable or joke. This
particular painting, which hangs in the
Louvre, is entitled *The Dropsical Lady*. The
title is almost certainly a later fabrication, and
The Doctor's Visit is much more appropriate.
Here, we see a doctor holding a urine sample
up to the light. In most paintings of this kind,
the joke lies in the fact that the woman who
thinks she is sick is being given a pregnancy
test. The urine glass and its contents are il-
luminated as in a still life, and the doctor is
looking at it as though enraptured by a vision,
while the servant and daughter bewail the pa-
tient.

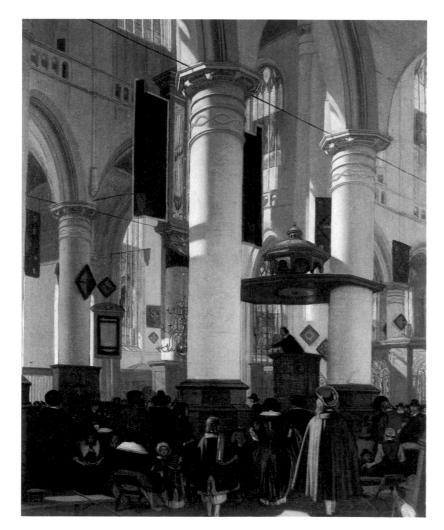

Emanuel de Witte
Church Interior,
c. 1660
Oil on canvas,
80 x 66 cm
St Petersburg,
Hermitage

EMANUEL DE WITTE
c. 1617–1692

Witte was evidently a representative of the
Delft school, even though he originally came
from Alkmaar and later settled in Amsterdam.
His church interiors bear comparison in many
respects with the work of Vermeer, in that the
light falling into the room is actually the sub-
ject matter of the painting.

The evolution of Witte's work sheds some
light on the practice of Dutch artists' specializa-
tion. Having initially tried his hand at genre
scenes and portraiture, he eventually settled for
church interiors, rendering the play of light and
wandering shadows on parts of the high, pil-
lared architecture. The Haarlem painter Saenre-
dam preceeded him in creating views that pres-
ent not only the function and size of an architec-
tural interior, but also its actual state. The work
of Witte has often been described as "atmos-
pheric", indicating that, in his paintings, the
structure of the architecture is secondary to the
momentary appearance of the interior in the re-
spective conditions of light.

This view of architecture no longer follows
the perspectives prescribed by the building,
but is determined as though by chance. Diago-
nals, corners and overlaps are the rule rather
than the exception. Light falling on certain
components is reflected as in a still life.

GERARD TERBORCH

1617–1681

After mid-century, Dutch genre and social painting changed. There was a shift towards more noble and semi-courtly society. In purely formal terms, the subtle treatment of textures and portrayal of a diversity of materials and surfaces became increasingly important. Terborch, who was of Vermeer's generation, typically embodies this last significant phase of Dutch genre painting that spans the period from about 1650 to 1680.

In his painting *The Card-Players*, we still find echoes of the Caravaggisti and the Utrecht school, which influenced not only the theme, but also the handling of light. Otherwise, however, it differs distinctly from similar paintings by Terbrugghen or Hals.

The woman in the foreground has her back to us. Silent, pensive and concentrated, the man standing beside her reaches out to grasp her cards, the player opposite her looks on silently, but attentively. In the work of the Caravaggisti, the players would have played towards us, the spectators, and the card game would have prompted some action with consequences. In this painting by Terborch, there is neither drama nor pathos in the card game.

The same is true of *The Letter*. A young man, dressed in all the finery of a cavalier, has entered the living-room to delivery a letter to the elegantly dressed lady. She, however, recoils, concealing her hand beneath her cloak rather than reaching out to take the letter. Her servant looks astonished, and the lady's lapdog barks at the courier.

To insiders, the meaning is clear: the letter is a love letter. The bed in the background says it all. The lady, however, is virtuous and chaste, as the still life objects on the table indicate: washbasin, ewer and brush are all signs of her purity and cleanliness, though the mirror and pearls suggest vanity. A tale begins to unfold.

The pictorial narrative expresses a moment of tension and a turning point in the story. It is not clear what will happen next. What is the courier to do with the letter? The lady has hidden her hand. The servant is waiting. This is not the climax of the story, but the moment we might describe as the "still life point" when, in Dutch paintings, everything, objects and people alike, seems to stop for a moment.

Terborch was also a talented portraitist. His skill in portraying subtle surface textures also stood him in good stead in rendering carefully observed individual traits. "Attentiveness" was frequently cited as a key feature of Dutch group portraits and it can certainly be detected in the faces of Terborch's characters. The "five senses" are attentive and alert.

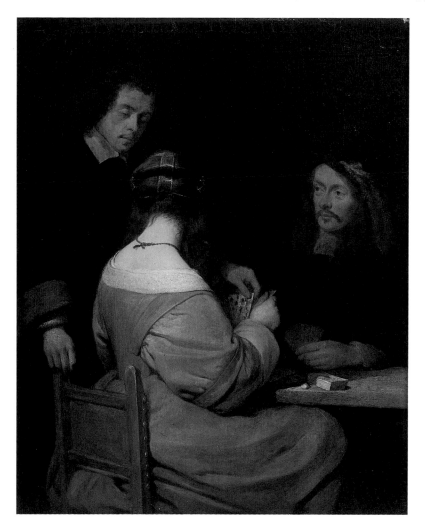

Gerard Terborch
The Card-Players,
c. 1650
Oil on panel,
25.5 x 20 cm
Winterthur,
Sammlung Reinhart

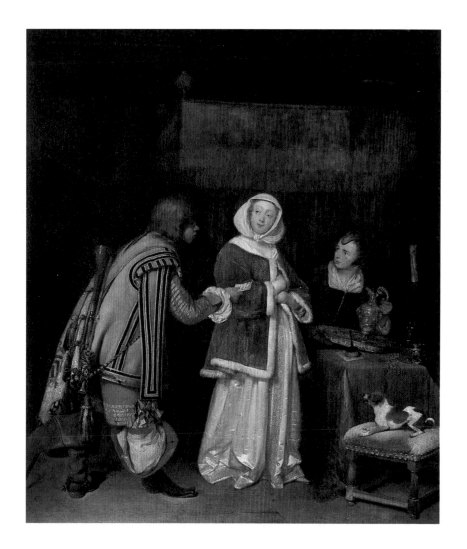

Gerard Terborch
The Letter, c. 1655
Oil on panel,
56 x 46.5 cm
Munich,
Bayerische
Staatsgemälde-
sammlungen,
Alte Pinakothek

Philips Koninck
Village on a Hill, 1651
Oil on canvas, 61 x 83 cm
Winterthur, Sammlung Reinhart

Willem Kalf
Still Life, c. 1653/54
Oil on canvas, 105 x 87.5 cm
St Petersburg, Hermitage

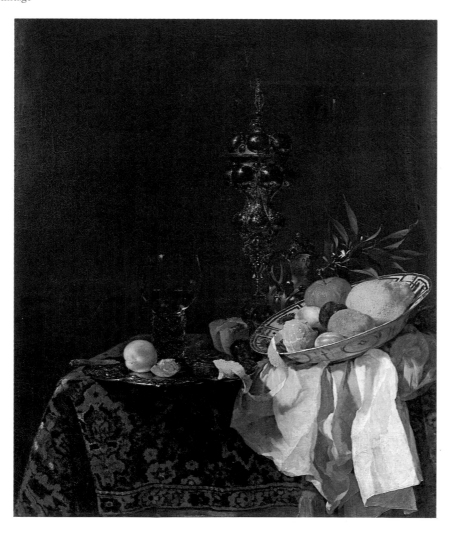

PHILIPS KONINCK
1619–1688

Koninck is one of the last generation of Dutch landscape painters. In the 1660s, there was a general tendency to "upgrade" the various genres. During this period, the interiors of Vermeer and de Hooch became increasingly elegant, and even the still lifes were freighted with "noblesse". In the work of Koninck, this trend even affected the landscapes, in which he positioned courtly figures and palatial architecture.

In the 1650s, by contrast, when Koninck was at the height of his creative powers, he produced landscapes of exceptional purity, bringing the flat panoramic landscape to its greatest perfection. A soft and golden light is cast across the flat countryside, illuminating things that are, in themselves, uninteresting: sandy dunes, the occasional tree, some water, a village. There is nothing remarkable or jarring. The sensation is where the brown earth is bathed in sunlight to a golden hue.

Koninck was influenced by Rembrandt's landscape painting, which represents a chapter in its own right within his enormous œuvre. Rembrandt's influence is evident in the golden-brown tone of his paintings and in the way Koninck occasionally integrates unexpected and fantastic objects such as a glittering bridge spanning the water, a ruin or a fairy-tale castle.

WILLEM KALF
1619–1693

Kalf's magnificent still lifes vary little in their structure, and most of them feature similar objects. A damask cloth or tapestry is draped upon a table on which there is sumptuous tableware, with gold and silver vessels, many of which have actually been identified as the work of specific goldsmiths such as Jan Lutmas. There is almost always a Chinese porcelain bowl, often tilted so that the beautiful fruits tumble out of it.

Nevertheless, it would be wrong to speak of "movement" in the still lifes of Kalf. The objects in his paintings possess a fragile equilibrium, and any suggestion of dynamic movement is reminiscent of a Flemish still lifes with its narrative component. However, in these still lifes, the painting is reduced to its contents alone and to the portrayal of the objects' beauty, captured at a single moment in time. They are brought to life by a seeming paradox. The objects are arranged almost coincidentally, in the manner of a vanitas painting: a half-peeled lemon, a loaf from which a piece has already been broken. At the same time, they are skilfully arranged, and it is this ordered coincidence that adds to their aesthetic appeal. The painterly technique recalls the work of Vermeer, another artist who portrays the appearance of light on the surfaces of objects in glittering points of luminosity and grainy precipitation.

AELBERT CUYP

1620–1691

This portrayal of three brooding hens and a proudly prancing cockerel guarding them jealously might be described as a genre painting from the world of birds. Dutch art lovers saw in it something familiar and amusing. The hens are resting contentedly in the sand, having pecked at some leftover fish and shells. Only the cockerel is posing, otherwise all is calm, and we can almost hear the drowsy cackling of the hens.

The scene bears certain similarities with the kind of conversation piece in which a gentleman courts a lady. There seems to be a lengthy pause in the conversation, and the light falling on the objects, the sand and the feathers has taken over the action.

Cuyp was a specialist in animal and landscape painting. His landscapes are regarded as his masterpieces for the manner in which the objects in them are transfigured by a warm, golden light. It was this skill that earned him the nick-name "the Dutch Claude Lorrain". His animal paintings also show his talent for creating atmosphere through the handling of light on objects. Cuyp left a considerable œuvre, yet recognition of his artistic achievement came late in the Netherlands, even though his work was highly esteemed in England.

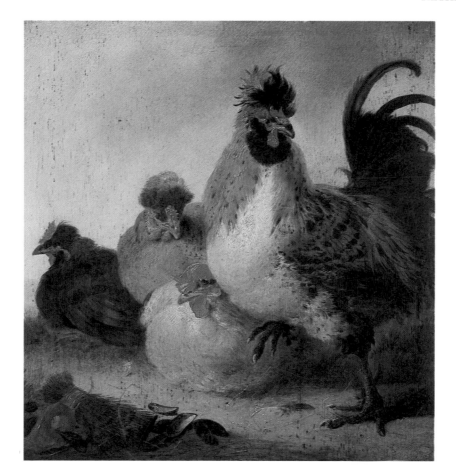

Aelbert Cuyp
Rooster and Hens,
undated
Oil on panel,
48 x 45 cm
Ghent, Museum
voor Schone
Kunsten

Abraham van Beyeren
Still Life with Lobster, 1653
Oil on canvas, 125.5 x 105 cm
Munich, Bayerische Staatsgemälde-
sammlungen, Alte Pinakothek

ABRAHAM VAN BEYEREN

C. 1620/21–1690

Although still life paintings were a prominent feature of Flemish painting, as in the great decorative pieces by Snyders, they did not become widespread in the Dutch art world until after mid-century. Just as conversation pieces by such artists as Metsu or de Hooch became increasingly noble, so too did the still lifes. In the work of Beyeren, we find sumptuous goldsmithing and expensive fruits in magnificent arrangements, with the dignified forms of a column and a drape in the background.

The open pocket-watch placed almost coincidentally amidst the fruit is clearly allegorical. It recalls time passing. Yet the very character of this arrangement of diverse objects suggests that the trappings of Luxuria had already by this time become aesthetic objects in their own right.

In keeping with the trend towards "nobility" in Dutch painting at the time, the portrayal of objects becomes harsher, the contours sharper and the surface smoother. In the work of Beyeren, no great distinction is made between the various materials, the handling of light is brash and rather schematic. The atmospheric touch so important to Dutch painting is barely discernible here.

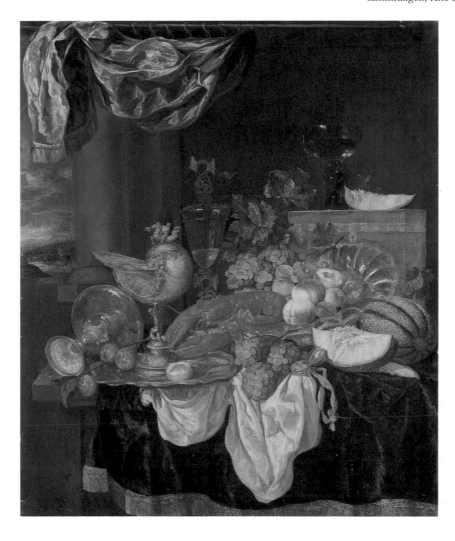

Carel Fabritius
The Goldfinch, 1654
Oil on panel, 33.5 x 22.8cm
The Hague, Mauritshuis

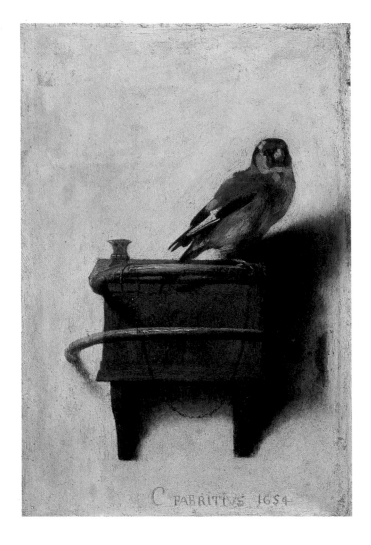

Below:
Paulus Potter
Peasant Family with Animals, 1646
Oil on panel, 37.1 x 29.5cm
Munich, Bayerische Staatsgemälde-
sammlungen, Alte Pinakothek

CAREL FABRITIUS
1622–1654

Originally, this picture of a captured bird was probably painted on a cupboard door, as was often the case with *trompe-l'œil* paintings, including portrayals of letter-holders and writing implements. What was important was the effect of making the objects seem close enough to touch, and so realistic that they might be mistaken for real objects. Something of this imitation of reality can also be found in this painting of a goldfinch sitting on its perch. It is not portrayed in a room, but in front of a surface which would appear to be the front plane of the picture. This notion of painting as imitation is a distinctive feature of Dutch painting.

Another important element is the fact that not only objects, but also living creatures – animals and sometimes even people – could be portrayed with the calm immobility of still life. Here, the captive bird has become still and is merely present. If it were a person, we might use the words "introverted" or "contemplative".

By choosing a brightly lit background, against which the object stands out clearly, Fabritius distances himself from his teacher Rembrandt, who preferred dark-toned backgrounds. In doing so, he paved the way for the handling of light by his most famous student: Jan Vermeer.

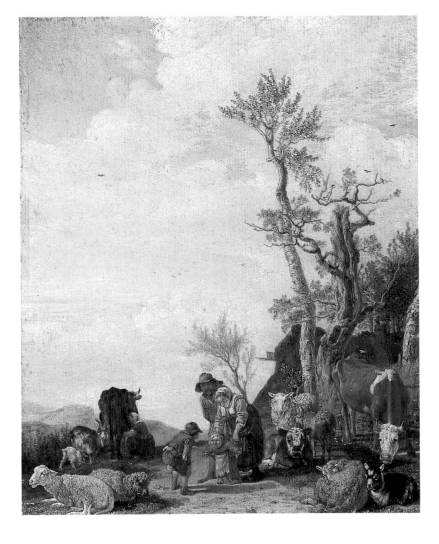

PAULUS POTTER
1625–1654

Potter, who died of consumption at the age of 29, loved the meadows, pastures and broad flatlands of his Dutch homeland, which he, like Jan van Goyen, portrayed bathed in warm sunlight. Perhaps his preference for bright and welcoming landscapes can be traced back to his Italianate contemporaries, such as Karel Dujardin, though he himself never actually visited Italy.

Potter specialized in animal painting, painstakingly detailed portraits of goats, sheep and, most notably, cows, which he presents in peasant surroundings. His most famous painting, the life-size *Young Steer* (The Hague, Mauritshuis) still astonishes spectators with its almost pedantic and obsessive detail.

The landscape, above which an atmospheric cloudy sky rises, is bathed in brownish-golden sunlight. In the foreground are the grazing animals, each one lovingly characterized and portrayed in typical pose, like people around a table in a group portrait. They are neither ornamentation nor mere staffage, but rather the main motif, taking precedence over space and landscape. Towards the end of the 19th century, Potter's art was renowned as "cabinet painting", particularly in England. Johan Heinrich Wilhelm Tischbein copied this painting in a watercolour study.

JAN STEEN
c. 1625/26–1679

Amongst the genre scenes that brought Steen popularity and fame, there are almost twenty showing a doctor's visit to a bourgeois home. As theatrical as any *Commedia dell'arte* play, they present scenes full of misunderstandings, secrets, assumptions and indiscretions. The "illnesses" of the patients are generally unforeseen pregnancy or lovesickness. The bed with the painting of lovers hanging over it, and the statue of Amor on the draughtscreen of the door immediately indicate to the spectator what is going on. The basin of coals in the foreground with the burning thread – quack doctors diagnosed pregnancy by "reading" the smoke – and the maid with her suitor at the door are further typical features of this genre. The patient, whose pulse the doctor is counting, has a note in her hand on which the following words are written: "Daar baat gen/medesyn/want het is/minepeyn" ("No medicine can cure the pain of love").

Though hardly a profound insight, these words constitute a moral of the kind that is almost invariably to be found behind these types of Dutch paintings. For all the autonomy of the subject matter, a painting without such a "deeper" meaning would have been inconceivable at the time, and indeed did not actually emerge until the 19th century.

Almost a century before Hogarth was to address a similar theme in England, Jan Steen created this painting of a fun-loving young couple letting their hair down. Drunk and sprawling in a most unmannerly way, but dressed in the very latest fashion, they are seated in the foreground. For the prim elderly couple lecturing him with their pious words from a book, the young man has only a mocking smile. Steen, although he worked for some time as a publican, was a pious Catholic. The house is extremely untidy. The servant has fallen asleep, the children are running free and the dog is stealing food from the table. A duck has alighted on the shoulder of the moral preacher and a pig is gobbling waste from the floor.

On the surface of it, this genre painting would appear to show a scene of utter chaos. On another level, however, it contains a number of morals. The panel on the steps at the right bears the inscription: "In weelde siet toe" (roughly equivalent to "better wit than wealth"). The basket hanging high and the precious things cast before swine are all references to morals and proverbs.

In this respect, the painting takes its place in a longstanding tradition that began even before Brueghel's proverb paintings. In the work of Steen, however, the painting can be regarded on different levels. The spectator can interpret the chaos as a collection of wise proverbs, but at the same time the drama and comedy of the situation can be seen as a source of pleasure and enjoyment in painting for its own sake.

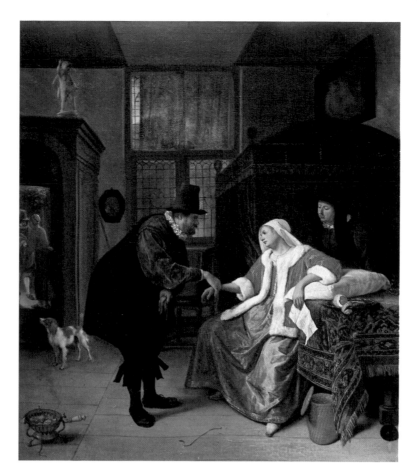

Jan Steen
The Lovesick Woman, c. 1660
Oil on canvas, 61 x 52.1 cm
Munich, Bayerische Staatsgemälde-
sammlungen, Alte Pinakothek

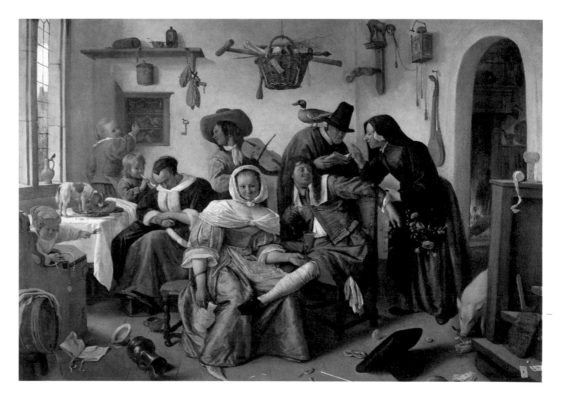

Jan Steen
The World Upside Down, c. 1660
Oil on canvas, 105 x 145 cm
Vienna, Kunsthistorisches Museum

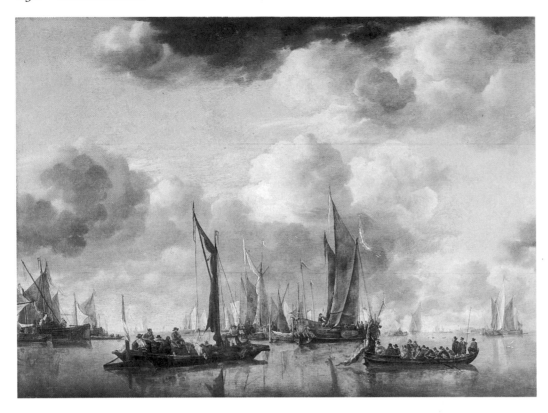

Jan van de Capelle
Shipping Scene with a Dutch Yacht Firing a Salute, 1650
Oil on panel, 85 x 115 cm
London, National Gallery

Willem van de Velde the Younger
The Cannon Shot, undated
Oil on canvas, 78.5 x 67 cm
Amsterdam, Rijksmuseum

JAN VAN DE CAPELLE
C. 1624/25–1679

There is little variation in Capelle's compositional structures. Around 1650, he painted several similar versions of a calm sea in a sheltered haven, full of sloops, lighters, dinghies and rowing boats, some of them carrying passengers, firing a salute, unrigged, almost motionless, lying at anchor.

A knowledgeable spectator may note the details and structural features of the ships, while at the same time being involved in a dramatic play of water, sky, clouds, haze, light and atmosphere. The horizon of the sea is so low that almost everything is dominated by a hazy sky. At the same time, the sails and clouds are reflected on the smooth surface of the water in such a way that the entire scene appears to be floating.

This painting shows more clearly than most how Dutch painting often avoided stabilizing structural elements such as architecture; here, the actual subject matter is the infinite and the mutable. Dutch paintings are not structured, but reflect characteristics of nature and the elements. The appearance of the objects is determined by reflections. The light reflects on surfaces in such a way that colours appear. These, in turn, are subdued and broken. The objects are often mirrored as well. Boats are mirrored in the water, as is the cloudy sky.

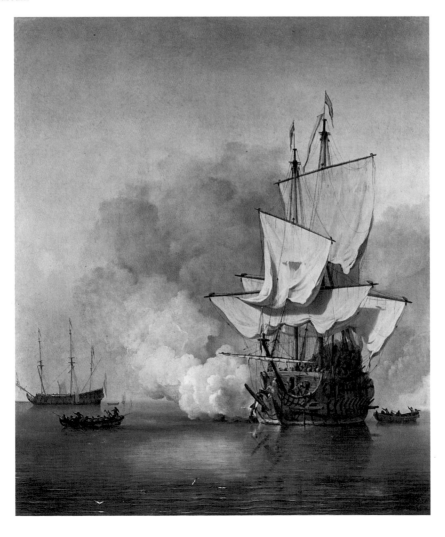

WILLEM VAN DE VELDE
The Younger
1633–1707

Van de Velde was a specialist in marine pieces or seascapes. More precisely, he was a portraitist of ships. Although he also executed history paintings in the form of sea battles, his marine pieces are differently structured. Ships of all kinds are lying at anchor and, as such, are remarkable subject matter.

The painter certainly knew his subject, and he would hardly have found any buyers for his drawings if the details of his ships, from hull to sails, had not been realistic. Yet the manner in which he arranges his meticulously rendered vessels is reminiscent of a still life composition.

A ship is firing a salute. The acoustic effect is rendered visibly as a cloud of smoke and steam, as an atmospheric drama, ringing out on a sea that looks like the resonating body of a musical instrument.

The French poet Paul Claudel described the painting as follows: "It is as though, at this signal, at this sudden burst of sound in a cloud of smoke, nature itself had paused for a moment: fire! It is as though the sea were listening attentively, and the spectator too. This is one of those paintings you can almost hear rather than see."

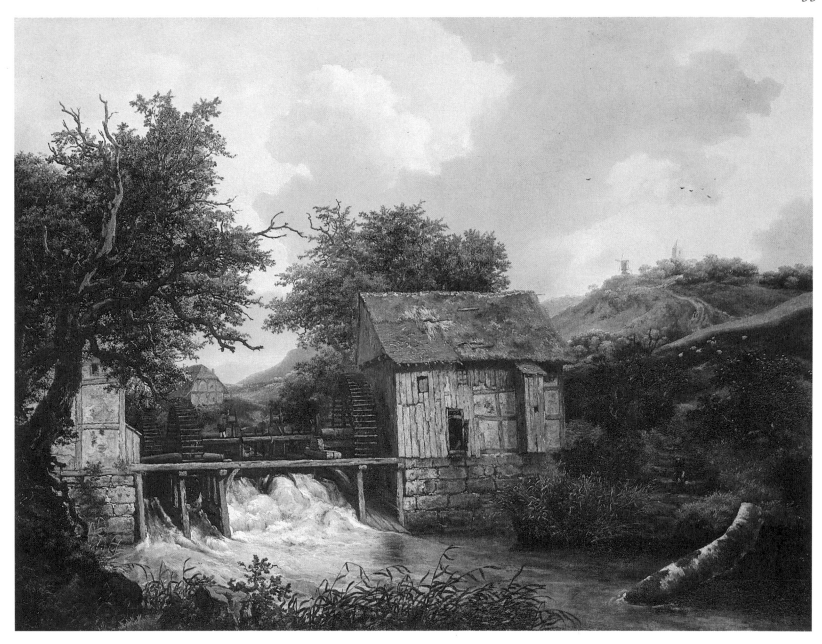

JACOB VAN RUISDAEL
C. 1628/29–1682

Jacob van Ruisdael's landscapes are poetic in a very special sense. They are first and foremost portraits of reality, in which each and every detail is drawn from daily experience and the Dutch landscape. In the context of the painting itself, however, these details are exaggerated and rearranged in such a way that they heighten the sense of atmosphere, sentiment and content.

In 1816 Goethe published an essay on "Ruisdael as poet" in the "Morgenblatt für gebildete Stände". In it, he wrote: "His works satisfy first and foremost all possible requirements in terms of appearance. Hand and brush, working with great freedom, achieve perfect precision. Light, shade, composition and overall effect leave nothing to be desired. Any art lover and connoisseur is aware of this at first glance. For the present, however, we wish to consider him as a thinking artist, indeed as a poet, and in this repect as well, we

must admit, that he deserves the highest accolade."

What caught Goethe's imagination was the fact that Ruisdael presented heightened versions of the familiar objects of local landscape that prompted contemplation and empathy: "The intention of the painting is to portray the present and the past, and this is achieved most admirably in a vivid combination of the living and the dead... opposite this building stands a nature copse of lime trees, planted long ago, yet still growing, indicating that the works of nature have a longer life than the works of man... this is an image successfully drawn from nature, successfully enhanced by cognition... an image that will always appeal to us..." Goethe wrote this essay at a time when landscape gardening was at its height as a means of appealing to the senses and arousing contemplation and sentiment with regard to landscape. The architects of this new 18th century gardening made the images of Ruisdael reality by copying them in their designs.

Jacob van Ruisdael
Two Watermills and an open Sluice
near Singraven, c. 1650–1652
Oil on canvas, 87.3 x 111.5 cm
London, National Gallery

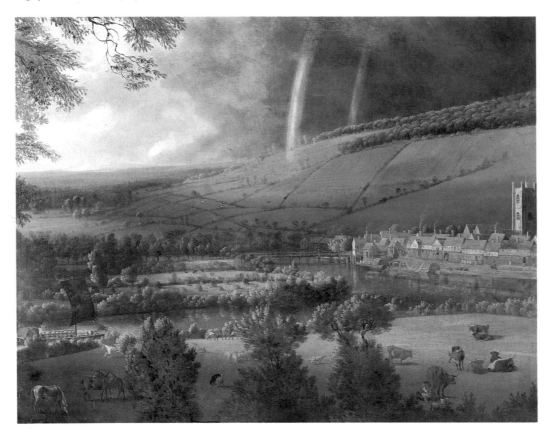

Jan Siberechts
Landscape with Rainbow,
Henley-on-Thames, c. 1690
Oil on canvas, 82.5 x 103 cm
London, Tate Gallery

JAN SIBERECHTS
1627– c. 1700/03

Even in its later period, Flemish landscape painting retains the main distinguishing characteristics that emerged as early as the 16th century in the works of such atrists as Pieter Brueghel and Momper.

This painting shows a sweeping view from a slightly elevated position, sloping down over the cattle pastures in the foreground towards a river plied by a cargo boat on the left and with a village on its banks to the right. Towards the background, the terrain slopes upwards again, with fields under changing sunlight and clouds, and a double rainbow in the sky. On the left, the view broadens out into the background towards the hills on the horizon.

A Dutch landscape painting, for example by Ruisdael, could hardly be described in this manner. Unlike Flemish landscape paintings. their Dutch counterparts rarely include so many different and contrasting elements. Here, we have proximity and distance, hill and plain, animals, people, boats and houses. While Flemish landscapes frequently have a universal theme, Dutch landscapes tend to concentrate on a single aspect. This painting is typical of the later work of Siberechts, who emigrated to England in 1672. Whereas his Flemish landscapes generally portray a small detail, his later work is topographically more precise; on the right we can recognize the village of Henley-on-Thames.

Samuel van Hoogstraten
Still Life, c. 1666–1668
Oil on canvas, 63 x 79 cm
Karlsruhe, Staatliche Kunsthalle

SAMUEL VAN HOOGSTRATEN
1627–1678

In Dutch painting there is a tendency towards imitation and the dissolution of the boundary between real space and pictorial space. Even Rembrandt painted "window pictures" in which the person portrayed is standing in a door or window whose frame is identical with the frame of the painting. The generation of artists who followed him took a particularly keen interest in *trompe-l'œil* techniques. Hoogstraten was a specialist in this field and the work shown here is typical of the genre. Because such *trompe-l'œil* effects do not work well in depth, but are most effective on the surface, the artist chose to portray flat objects that could be placed on the picture plane, to which relatively flat items could be added. Here, for example, we see a variety of everyday objects held by two leather straps over a wooden frame. That old chestnut about the spectator who is actually fooled by such painted objects is quite easy to imagine in this case, but we should not forget that such *trompe-l'œil* paintings were actually intended as a joke and that they were meant to produce a sense of surprise on discovering that the objects were painted rather than real. Even so, this approach towards reproducing reality in painting does tell us something about Dutch painting in general: it is highly "figurative" in the sense that its content is conveyed entirely through the portrayal of objects.

PIETER DE HOOCH

1629–AFTER 1684

Pieter de Hooch has gone down in art history as a painter who rendered Dutch domestic life with great precision. The private everyday life of the bourgeoisie in all its ordered tranquility, a world whose calm is never shattered by any sensational event, is the subject of his works. De Hooch opens a window on narrow alley-ways, small gardens and courtyards, and gives us a glimpse into the antechambers and living-rooms of the Dutch citizens. Like Jan Vermeer, de Hooch specialized in the portrayal of interiors.

Yet, whereas the paintings of Vermeer tend to be dominated by a self-absorbed figure paus-ing momentarily in some activity, de Hooch's paintings are dominated by the room itself, by its perspectives and views through doors and windows, where people become an integral part of the interior. Light is an important fac-tor, especially daylight, as in the work of Ver-meer, with its refractions and reflections ad-ding vitality to the rooms. Whereas people and animals interpose in their activities, light itself becomes the active element, permeating and moving over walls, floors and tiles, illumi-nating objects or casting them in shadow.

Like Vermeer, de Hooch also draws upon re-ligious paintings, translating them into scenes of everyday life. His painting of the housewife and her maid cleaning fish in a neat backyard, for example, recalls the topos of the Virgin Mary in the hortus conclusus. Rooms flooded with light take on aspects of the Annunciation or recall Jan van Eyck's *Madonna in a Church* in a church interior, lit by stained glass win-dows.

In the period between 1654 and 1665, when de Hooch was living in Delft, he created such works as *The Card-Players*, leaning heavily on the influence of Vermeer and the Rembrandt student Carel Fabritius. Although a certain tendency towards sumptuous interiors and ele-gant society is already evident here, the com-positional organization is charming, and the architecture of the room with its checkerboard tiles heightening the sense of depth and per-spective, is rendered with painstaking preci-sion.

When de Hooch moved to Amsterdam in 1667, where he moved in high circles, his inte-riors became increasingly elegant, and his simple "households" were gradually replaced by palatial interiors. At the same time, the portrayal began to lose its precision and the vi-tality of the Dutch genre painting began to fade.

His paintings also began to lose the strong colour values so aptly described by Eugène Fromentin, a 19th century painter as follows: "The subtlety of Metsu and the enigma of Pieter de Hooch depend on there being much more air around the objects, shadow around the light, stability in volatile colours, blend-ing of hues, pure invention in the portrayal of things, in a word: the most wonderful hand-ling of light and shade there has ever been..."

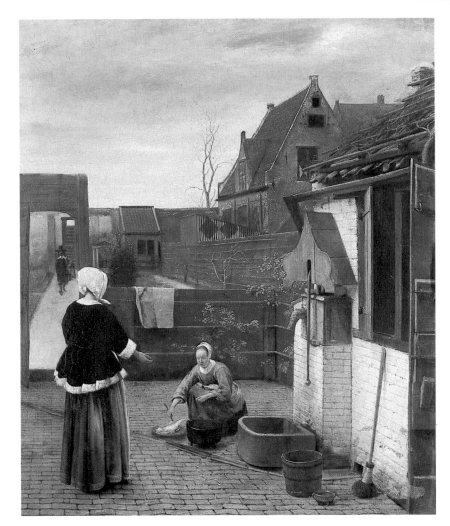

Pieter de Hooch
A Woman and her Maid in a Courtyard, 1660
Oil on canvas, 73.7 x 62.6 cm
London, National Gallery

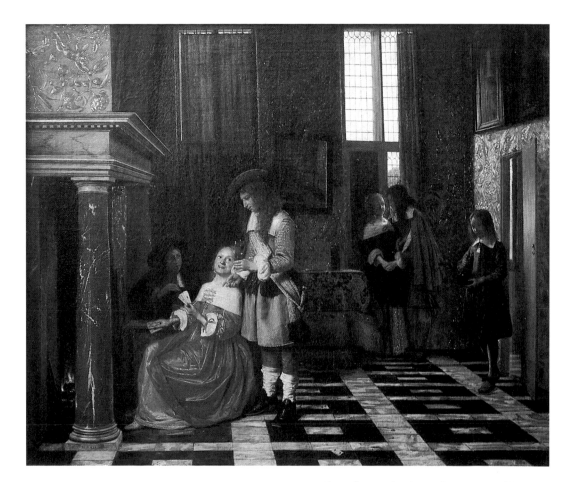

Pieter de Hooch The Card-Players, c. 1663–1665
Oil on canvas, 67 x 77 cm
Paris, Musée National du Louvre

Frans van Mieris
Carousing Couple,
undated
Oil on panel
Private collection

FRANS VAN MIERIS The Elder
1635–1681

The social or conversation piece was a particularly popular type of painting in Holland. Its origins reach back to late Mannerist painting, in which it was particularly the school of Utrecht that produced many portrayals of drinkers, musicians or lovers. There is undoubtedly a connection between the "privatization" of Netherlandish painting that went hand in hand with the decline in religious commissions and the increasing popularity of such "gallant" conversation pieces.

In this painting, the suitor is trying to fondle the woman of his choice, who is hesitantly drawing her clothes together. The payment for her services, however, is already lying in her lap. What is clearly a scene from the milieu of prostitution has been portrayed with beautiful objects from the world of still life and music in the tyle of the Leiden "fine" painters.

This particular theme originates in the biblical parable of the prodigal son who spent his money on whores and ended up in a pigsty. In spite of the underlying moral, the painting is a witty feast for the eyes.

There was also considerable specialization in the field of genre painting. In the work of Ostade or Brouwer, the peasant home and the inn were the most frequent setting, while the Leiden "fine" painters Dou, Metsu and Mieris included courtly elements.

Gabriel Metsu The King Drinks (The Beanfeast), c. 1650–1655
Oil on canvas, 80.9 x 97.9 cm
Munich, Bayerische Staatsgemäldesammlungen, Alte Pinakothek

GABRIEL METSU
1629–1667

Metsu's *Twelfth Night* was painted under the influence of Steen. However, whereas most depicitions of the toast to the person who has been arbitrarily elected "bean king" for a day show scenes of hilarious revelry (compare, for example, Teniers' *Twelfth Night*, ill. p. 125), Metsu has subdued the rough and raucous element. Even in the portrayal of such a dramatic and populistic scene, we can identify a trend that has been present in the genre painting since around the middle of the century. Even when a comic moment is illustrated, the portrayal pauses, becomes calm, takes on the traits of a still life.

The excesses of the "bean feast" celebrated on January 6 had become a thorn in the flesh of the Reformed church. The "king for a day" was granted a retinue of fools, and the joys of the table took on distinctly unmannerly forms in an otherwise strictly well-mannered country; what is more, this particular custom had its origins in Catholic countries. For these reasons, a number of cities banned such festivities for a time and portrayals of the revelries came to be regarded as something from the bizarre world of picturesque and raw peasant life.

Metsu's painting offers proof that Netherlandish painting never actually represented a direct report of reality, but that the art market incorporated certain fixed pictorial types in various forms.

MEINDERT HOBBEMA

1638–1709

When Hobbema painted this view of the little town of Middelharnis and the avenue approaching it while he was staying there, Dutch landscape painting had already passed its zenith. Nevertheless, it continued to lean heavily upon that tradition, which provided a positively inexhaustible source of material.

Profoundly influenced by Jacob van Ruisdael, Hobbema initially painted gnarled old trees in picturesque contrast against smooth and luminous water, deep woodland shadows against brightly lit clearings in the sun, full of picturesque details of ruins, mills and peasant hovels. In his later works, however, such details became increasingly sparse, revealing the compositional structure of the painting.

The view of Middelharnis is a veduta, albeit of a typically Dutch kind, in which the town and its houses appear almost coincidentally at the end of the avenue, so that the path leading towards it seems to be the main subject matter of the painting. This path has made the painting famous. The upper two-thirds of the picture are taken up by the sky, below which the flat land stretches out. Where the horizon line is drawn, we see the church and the houses of the town. The avenue runs from the spectator towards the exact centre of the horizon, and its vanishing point is exactly where the town covers the horizon. The perspective is of mathematical precision. Indeed, it is this very precision that underlines how strongly the land here has been shaped by the hand of man, by the people who dug ditches and built dykes.

Weather and time have made their mark upon this prosaic geometry. Gaps have been torn in the neat row of poplars lining the avenue and the wind has whipped their foliage into grotesque and spindly broomsticks. The straight path running between the two ditches is muddy, and the wheels of a cart have left their jolting tracks. A man, still small and distant, is coming towards us with his dog.

It is not easy to pinpoint just what it is that distinguishes Hobbema's late painting from his views of, say, the 1660s. The clearest distinguishing feature of his later work is the strong emphasis on linear structure and the scenes that intrude from either side, giving the impression of a stage setting viewed from a fixed standpoint.

Meindert Hobbema
Avenue at Middelharnis, 1689
Oil on canvas, 103.5 x 141 cm
London, National Gallery

Jan Vermeer
The Lacemaker,
c. 1665
Oil on canvas on
panel, 24 x 21 cm
Paris, Musée National
du Louvre

Below:
Jan Vermeer
Woman Holding a
Balance, c. 1665
Oil on canvas,
42 x 35.5 cm
Washington, National
Gallery of Art

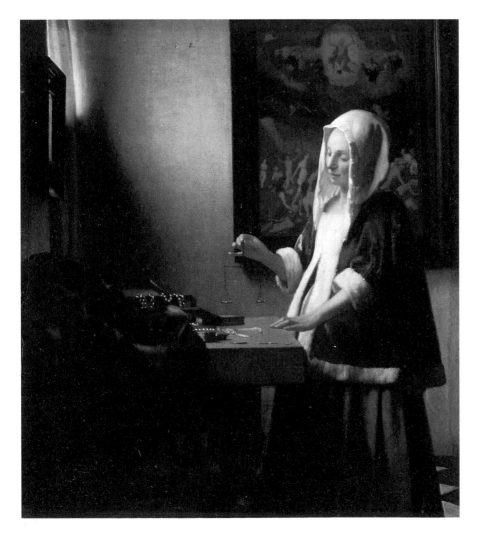

JAN VERMEER
1632–1675

Of the three great Dutch painters of the 17th century –Vermeer, Rembrandt and Frans Hals – Vermeer was the youngest. Very little is known about his life. He left an œuvre of only forty or so paintings, and his family suffered constant poverty. For almost two hundred years, his work was all but forgotten, only to be rediscovered towards the end of the 19th century at a time when the creation of pictorial light through colour had become a focal concern of impressionist painting. For Renoir, Vermeer's *Lacemaker*, along with Watteau's *Pilgrimage to Cythera*, were the most beautiful paintings in the world.

The *Lacemaker* is crouched over her work table, almost merging with it to create a single plane, on which light sets the accents. The light falls into this imaginary room from the right – an exception in the work of Vermeer – and models the form of the head in an interplay of shadow and light. Face, hair and hands are modelled by the light itself. Simple bright colours, the yellow of the blouse, the blue of the cushion and the red of the threads are not smoothly glazed, but grainy and interspersed with white, emphasizing the structure of the canvas. We can almost see the light lying on the body of the woman and the objects in the painting, creating the tranquility of a still life. Moreover, the atmosphere of light within the room itself seems almost physically tangible.

A young woman – probably the pregnant Catharina Vermeer – is standing, lost in thought, at a table in front of a curtained window. In her right hand, she is holding a set of scales: She is checking the weight of some gold coins; in front of her lie coins and shimmering threads of pearls, luminous against a deep blue cloth. Her right hand, holding the scales, forms the centre of the painting, where the diagonals meet.

The process of weighing and the painting on the wall depicting the Last Judgement suggest a possible interpretation: the trinkets of this world are mere vanities, they weigh too little in the scales, just as we ourselves shall be found wanting if we bind our lives to earthly things. Another interpretation is: life (including the life growing in a mother's womb) and death are close together. Little time is granted to us. The painting can be read like a vanitas still life. Yet just as a Dutch still life is not fully interpreted by determining its allegorical meaning, the same is true of the paintings of Vermeer. Here, interiors and even genre scenes may take on aspects of still life painting, the people in them are contemplative and pensive –"out of time" .Thoughts of eternity arise where everyday life comes to a standstill. Vermeer's great achievement lies in transposing elements and principles of still life to interior and genre paintings.

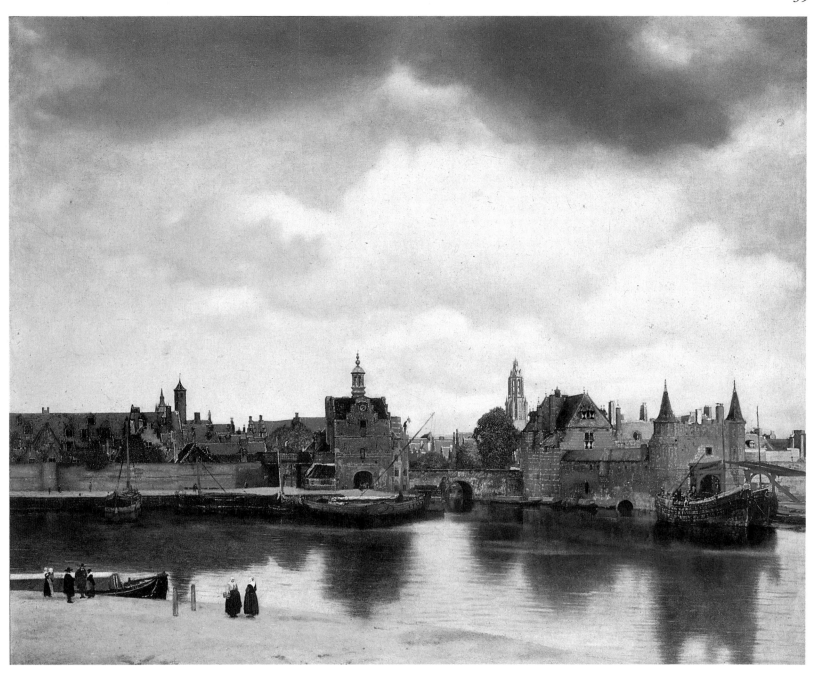

Even in the 17th century, it was already common practice to use optical aids in painting a veduta – a highly realistic view of a town or landscape. For his *View of Delft* Vermeer undoubtedly used a camera obscura. A few examples of such devices have survived. His hometown of Delft was in fact a centre of experimentation in the field of optics. Even the house from whose window Vermeer "drew" his view of Delft has been pinpointed. Yet the use of a technical aid by no means diminishes the artistic achievement of the painting, for the essential elements of the picture remain entirely the work of the artist.

Dutch views have a special place in the history of Baroque veduta painting. The artists were less concerned with an overall portrayal of the city than with finding certain "picturesque" aspects. In other words, the city is "characterized" rather than "represented" in the Dutch veduta.

A section of the port of Delft with its walls and gates, built mainly in red brick, forms the main view. The rooftops of the town sink behind it, and even the towers and spires are barely visible. The masonry is reflected in the water, and more than half the painting is taken up by the cloudy sky. The veduta shows the town of Delft in rapidly changing light and reflections on the water. There is no sense of action in this painting which portrays the town with all the remoteness and tranquility of a still life. Indeed, the actual subject matter of the painting would appear to be the atmospheric light, which shapes the appearance of Delft.

Here, as in his interiors, Vermeer has painted the effect of light on the brick walls of the houses and the hulls of the boats. A grainy white heightens the red and brown, conjuring up an impression of mutable and moving light on the old and immobile materials of wood and brick. A sense of quiet harmony is created in which the contrasts of tone and colour are finely balanced.

Jan Vermeer
View of Delft, c. 1658–1660
Oil on canvas, 98.5 x 117.5 cm
The Hague, Mauritshuis

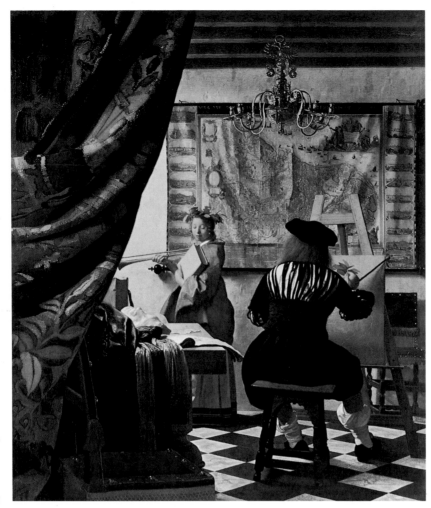

Jan Vermeer
Allegory of Painting
(The Artist's Studio),
c. 1666
Oil on canvas,
120 x 100 cm
Vienna, Kunst-
historisches Museum

JAN VERMEER
1632–1675

The studio painting is a frequent feature of
Dutch painting. Rembrandt painted himself
at his easel, as did Dou, Ostade and many
others after him. What is unusual about Ver-
meer's painting, however, is the fact that he
turns a self-portrait into a complex allegory.
Scholars and art historians have long debated
the "correct" interpretation of this allegory, a
fact which, in itself, merely underlines the
complexity of the painting. The interior is full
of artistic paraphernalia, and on the wall
hangs a map of the free Netherlandish prov-
inces. The painter is elegantly dressed, and
working in an equally elegant room. He may
well have been citing Leonardo da Vinci's
treatise in which he says of painting: "…the
artist sits in great comfort before his work,
well dressed, and stirs the light paintbrush
with graceful colours. He is dressed in apparel
as he likes it." Could this be a reference to the
superiority of painting over architecture and
sculpture?

The artist is in the process of painting the
laurel wreath worn by the model; she also has
a trumpet and a book in her hands, identify-
ing her as Fama, the allegorical embodiment
of fame. This studio scene, almost like a genre
painting, thus becomes an allegory of "the
fame of painting" in the Netherlands.

This corresponds to a generally widespread
Dutch possibility of incorporating "truths" or
general moral statements in what appears to
be a genre painting. An unusual feature in this
painting, however, is Vermeer's handling of
light, unparalleled in the art of the 17th cen-
tury and rediscovered two hundred years later
by the Impressionists. The light falls through
an invisible window onto the model, whom
the painter has positioned in the most
brightly lit spot. In this way, natural light
becomes glorifying light – as befits an allegory.

In Vermeer's late work – this painting was
probably executed around 1675 – some weak-
nesses become evident. The system of distri-
buting objects in the room – a painting on the
back wall, a drape to the left, the main figural
focus on the left – has become a stereotype for-
mula. The objects have harsh contours and the
detail of surfaces and textures imitate the
work of the "fine" painters.
A comparison with Vermeer's greatest works
of the 1660s reveals the source of his later
weakness. In his later work, light itself is no
longer the main subject matter of the paint-
ing. Here, it is "merely" a means of illuminat-
ing the objects, whereas before – as in *The
Lacemaker* – light seeping onto the surfaces of
objects had been the actual theme of the paint-
ing. Also, we find an increasing use of deep
black in the portrayal of shadows, a technique
Vermeer had not used in his earlier works.

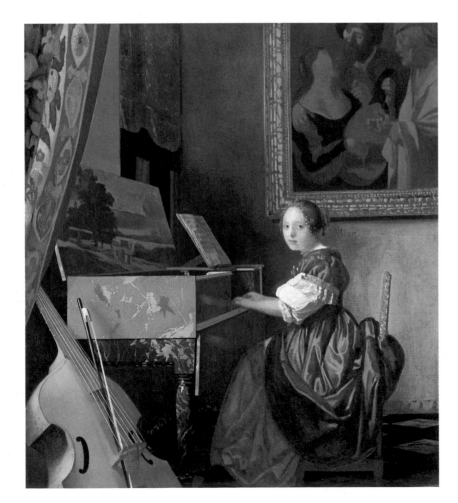

Jan Vermeer
Young Woman
Seated at a
Virginal, c. 1675
Oil on canvas,
51.5 x 45.5 cm
London, National
Gallery

ALBANI Francesco

1578 Bologna – 1660 Bologna
Although soon falling into oblivion after his death, Albani achieved considerable fame and prosperity during his lifetime. With Reni and Domenichino, he studied c. 1600 under Annibale Carracci in Rome. He assisted in decorating the Aldobrandi lynettes, designed the apse of Santa Maria della Pace in Rome and worked at the court of Mantua in 1621/22.

In 1625 he settled in Bologna for good. He owed his reputation as the "Anacreon of painting" to his landscapes with staffage figures. They were mostly mythological, gently balanced, set in an arcadian landscape. He was rediscovered in the 20th century because his manner of representing nature is reminiscent of Poussin and Claude Lorrain.
Illustration:
35 Sacra Famiglia (The Holy Family), c. 1630–1635

ALLORI Cristofano

1577 Florence – 1621 Florence
Allori received his initial training from his father Alessandro, through whom he had contact with his uncle Bronzino. But it was through his teacher Gregorio Pagani that he found his direction, initially as a painter of religious subjects. Soon he also established himself as a painter of portraits and mythological scenes. While his output was somewhat sparse on account of the painstaking care he took in preparing and executing a painting, the result was always of an unvaryingly high quality. In "Judith with the Head of Holofernes" (ill. p. 235), presumably a picture of his mistress and her mother, the rich materials vie with the deep,

glowing colours and sensuous naturalness. Allori was a painter who overcame the cold stiffness in Florentine painting.
Illustration:
35 Judith with the Head of Holofernes, 1613

ASSELIJN Jan

(also: Asselyn; "Crabbetje")
1610 Diemen or Dieppe – 1652 Amsterdam
He received his fundamental training from Esasias van de Velde, who influenced Asselijn's early work, as his equestrian scenes reveal. He then went through France to Italy, where he worked in Rome for a long time. Because of his crippled left hand he was given the nickname "Crabbetje", meaning little crab, by the Dutch "Bent" school of painters in Rome. Here he received encouragement from Jan Both, Pieter van Laer and most of all Claude Lorrain, whose lucid manner he transferred to the Dutch landscape.

Around 1645 he returned to Holland and settled in 1647 in Amsterdam, specialising in two categories: the animal portrait, of which "The Threatened Swan" (Rijksmuseum, Amsterdam) is the most famous example, and the landscape. His landscapes with motifs of the Roman Campagna, ruins and pastoral elements in chiaroscuro with well-observed light reflexes are representative of the Italianised direction of Dutch painting.
Illustration:
124 Italian Landscape with the Ruins of a Roman Bridge and Aqueduct, undated

AVERCAMP Hendrick

(Hendrick van Avercamp)
1585 Amsterdam – 1635 Kampen
Although born two generations after Pieter Brueghel the Elder, Avercamp showed himself a receptive student of the famous Flemish painter. He learned his art under Pieter Isaacsz in Amsterdam and subsequently in the studio of Gillis van Coninxloo.

After 1610 he went to Kampen, where his father had settled as an apothecary. Avercamp was deaf and dumb, which earned him the nickname "De Stomme van Campen". Besides landscapes depicting the sea and herds of cattle, Avercamp is known mainly for

his atmospheric winter scenes in which he shows, with great skill in the art of perspective combined with a strong colour sense, the frolickings of peasants and burghers on the ice of the lakes and canals of his homeland. Although not without an undertone of the comical, his pictures seem to belong to the pure genre, as opposed to those of his exemplar Brueghel who operated on various levels.
Illustration:
107 Winter Scene at Yselmuiden, c. 1613

BACICCIO

(Giovanni Battista Gaulli; also: Baciccia)
1639 Genoa – 1709 Rome
Baciccio's success and prosperity can be ascribed to his chosen fields: portraiture and the painting of ceilings. The style of his portraits shows the influence of van Dyck's pictures executed at Genoa. His portraits of Pope Clement IX (Rome, Galleria dell' Accademia Nazionale di San Luca) and Cardinal Leopoldo de' Medici (Florence, Uffizi) bear, however, the stamp of Baciccio's own lively perception and handling of light. When painting ceilings, he follows Cortona's decorative style to which he was introduced when in Rome, developing it further by extreme perspectival foreshortening. His principal works are the cupola of San Agnese and the nave vaulting and apse of Il Gesù. The sculptor and architect Bernini was Bacaccio's protector: he took the young man in when he had to flee from the plague to Rome. In 1662 he became a member of the painters' academy of San Luca, in 1674 its director. His influence as fresco painter continued into the 18th century.
Illustration:
41 The Apotheosis of St Ignatius, c. 1685

BASCHENIS Evaristo

1617 Bergamo (?) – 1677 Bergamo
Today his name no longer conjures up the battle scenes of his early years, but rather the still lifes with musical instruments from the legendary Cremona workshops of Amati, Girolama and Nicola. By employing artistic devices imported from the Netherlands, in particular the *trompe l'œil* effect, Baschenis represents his lutes and violins as strongly expressive special objects. He

puts these rotund sound chambers in juxtaposition to clear, flat surfaces and uses the warm tones of their wood to produce the overall colour effect. About his life we only know that he comes from a painting family and was a priest before devoting himself entirely to painting.
Illustration:
40 Still Life with Musical Instruments, c. 1650

BAUGIN Lubin

c. 1610–1612 Pithiviers (Loiret) – 1663 Paris
Several religious paintings of Baugin survive, including "Virgin with Child and St John" (London, Nancy, Rennes), "Birth of Mary" (Aix-en-Provence, Musée Granet). Because of his large-figured, mellow style and clear, extensive planes of colour, he was rightly called "Le petit Guide", the little Guido Reni, for he was strongly influenced by the work of this Italian painter. In contrast, his still lifes, signed "A. Baugin", are in the late style of the "School of Fontainebleau" with late Mannerist elements. Before 1789 the Cathedral of Notre Dame possessed eleven of his religious paintings. Baugin studied in Rome under Vouet, was accepted by the Académie de Saint Luc in Paris in 1645, was appointed "Peintre du Roi" in 1651, was expelled from the Academy on the grounds of founding a private school, and on closing it was re-elected. Baugin's long disputed identity is now established as these details tally exactly with those of the still life master.
Illustration:
46 Still Life with Chessboard (The Five Senses), undated

BEYEREN Abraham van

(also: Beijeren)
c. 1620/21 The Hague – 1690 Alkmaar or Overschie (Rotterdam)
Beyeren found scant recognition in his lifetime, yet today he is among the most important still life painters of his country. He was taught by his brother-in-law, the painter of fish, Pieter de Putter, which may be the reason why Beyeren began his career with the same subject matter. In 1640 he joined the Painters' Guild in The Hague, where he became a co-founder of the *Confrerie Pictura* in 1656. In 1657 he went to Delft, in 1663 he returned to The Hague, in 1672 he lived in Amsterdam and in 1674 in Alkmaar. He was always in financial straits; fleeing from creditors may have been the reason for his many moves and restless life. His true métier were sumptuous, tastefully arranged still lifes, breakfast tables with magnificent cloths, flowers, glasses, fruit and animals, showing the influence of de Heem. There are also fragrant flower pieces in the style of Jan Brueghel, seascapes, and his fish still lifes.
Illustration:
129 Still Life with Lobster, 1653

BLOEMAERT Abraham
1564 Dordrecht or Gorinchem –
1651 Utrecht

Bloemaert was trained in the workshop of his father Cornelis, a sculptor and later city architect in Amsterdam. At the age of 16 he went to Paris, where he worked under Jean Bassot and Hieronymus Francken, but was most influenced by Frans Floris, an important representative of Dutch Mannerism. He returned in 1583 to his father in Amsterdam, but then lived most of his life at Utrecht where he became superintendent of the painters' guild in 1611 and was given permission to keep a studio in the St Clare nunnery. His pupils included Cuyp, Terbrugghen, Honthorst, Weenix and Both. Bloemaert's work includes historical paintings, dramatic, multi-figured mythological scenes, and bucolic landscapes with "picturesque" huts. He never went to Italy, but through his pupils became familiar with Caravaggist chiaroscuro which had first been taken up in Utrecht and was to influence the entire country. Bloemaert's life spanned both the Mannerist 16th century at one end and the period of Rembrandt at the other.
Illustration:
93 Landscape with Peasants Resting, 1650

BOURDON Sébastien
1616 Montpellier – 1671 Paris

Bourdon led a restless life. At the age of seven he became apprenticed, and he was already painting the ceiling in a château near Bordeaux when fourteen. Lacking commissions, he became a soldier, but was, however, discharged and went to Rome in 1634, where he painted pictures for an art dealer in the styles of Claude Lorrain, Sacchi,

Poussin, Castiglione and L. Carracci. His brilliant technique and skill in copying were obstacles to the development of a personal style. He returned to Paris in 1637, feeling that as a Huguenot he was not welcome in Rome, and again produced "Italian" hunting and battle scenes for a dealer. Bourdon was highly regarded by his contemporaries.

In 1648 he was a co-founder of the Académie Royale, where he held a chair and was appointed rector in 1655. In 1652 he acted briefly as court painter to Queen Christina of Sweden, where he painted her seated on a horse (Madrid, Prado). In Paris he decorated the Galerie des Hôtel de Bretonvilliers, later destroyed, which, according to records, seems to have been his best and most individual piece of work.
Illustration:
53 The Finding of Moses, c. 1650

BROUWER Adriaen
c. 1605/06 Oudenaarde (Flanders) – 1638 Antwerp

By birth Brouwer was Flemish, by training Dutch. After the death of his father he probably went at the age of sixteen to Antwerp, a year later to Haarlem. Presumably he had contacts with Frans Hals at this time. In 1631 he returned to Antwerp, became a member of the Lukas Guild and ran a small workshop. Brouwer was always in debt, spending some months in prison.

Rubens, who owned 17 of his pictures, probably obtained his release. On his early death during the Plague seven creditors fought over his estate. Brouwer's work always calls to mind scenes of card-playing, smoking, quaffing and brawling peasants – his favourite subjects along with "operations" by the village barber. While early paintings are of strong colour, the more mature work, under Hals' influence, is in deep brown tones, and carried out with great artistic skill and precise psychological observation. After Brueghel, Brouwer is considered the foremost painter of bucolic themes, the greatest collection of 16 of his works being in the possession of the Alte Pinakothek at Munich.
Illustrations:
117 The Operation, undated
117 Peasants Smoking and Drinking, c. 1635

BRUEGHEL Jan the Elder
(also: Bruegel, Breughel, Breugel)
1568 Brussels – 1625 Antwerp

Because of his penchant for certain themes and glowing enamel paint, Jan, the second son of Pieter Brueghel the Elder, was given the nickname "Velvet" or "Flower" Brueghel. His work, which distinguishes itself from his father's by a refined technique and miniature-like delicateness, was given direction by his grandmother, a miniaturist painter, and his teachers, including Pieter Goetkint and Gillis van Coninxloo. Brueghel spent the years 1589–1596 in Italy; he worked in Rome in 1593/94 and then in Milan in 1596 for Cardinal Federigo Borromeo, who became his patron. In 1597 he returned to Amsterdam and became a member of the Lukas Guild. In 1610 the Archduke of Austria, governor of the Netherlands, appointed him court painter. Brueghel was well-to-do and respected, owning several houses in Antwerp as well as a considerable art collection. He was a friend of Rubens with whom he collaborated, including the magnificent flower garland in Rubens' "Madonna in the Flower Wreath" (Munich, Alte Pinakothek) while Rubens painted Adam and Eve in Brueghel's "Paradise" (The Hague, Mauritshuis).

Besides historical scenes, paradisiacal images of animals, and genre scenes, he was above all a painter of landscape, often with staffage figures and animals in the foreground, and of flower pieces. As a specialist of "accessories" he collaborated with Frans Francken, Hans Rottenhammer and Joos de Momper.
Illustrations:
83 The Animals entering the Ark, 1615
94 Great Fish-Market, 1603
94 Landscape with Windmills, c. 1607
95 The Holy Family, undated

CANO Alonso
1601 Granada – 1667 Granada

Cano, one of the most versatile talents in 17th-century Spain, learned architectural drawing from his father, carpenter and altar builder Miguel Cano, the art of sculpting under Juan Martinez Montanés in Seville, finally studying painting from 1616 to 1621 under Francisco Pacheco, the teacher of Velásquez. His best known architectural work is the facade of Granada Cathedral with its the-

atrically-baroque triumphal arch motif. On Velásquez' recommendation the king appointed Cano court painter and drawing teacher to prince Balthasar Carlos.

In 1643 he painted idealised images of Gothic kings for the Alcázar, which show him to be a painter with an individual style. He has been unfairly accused of eclecticism: his large-scale colour planes may be reminiscent of Reni, but the general approach is genuinely Spanish in its realistic observation and combines an independent manner with an imaginative historicism. Cano's life was eventful. In 1637 he had to flee from Seville to Madrid after injuring a duelling partner. In 1644 he was accused of the murder of his wife and threatened with torture and imprisonment, so he escaped to his estates in Valencia.

In 1650, with the king's help, he was given a sinecure by the cathedral of Granada, fell out with the clerics, was dismissed, took legal action, was ordained as priest in Madrid, and reinstated at Granada as subdeacon, where he died impoverished.
Illustration:
67 St Isidore and the Miracle of the Well, c. 1646–1648

CAPELLE Jan van de
(also: Cappelle)
c. 1624/25 Amsterdam – 1679 Amsterdam

Although quite untrained, this son of a prosperous cloth merchant belongs among the most important marine painters of the Netherlands. Painting was a pastime to him, sparked off through the study of Simon de Vlieger's drawings. It was within his means to have his portrait painted by Frans Hals and Rembrandt, and on his death he left not only a large legacy but also a collection of 197 paintings, including some by Rembrandt, Hals, van Goyen, Brouwer, and van de Velde. Capelle's seascapes, mostly in early morning or evening mood, depict ships on a calm sea or wide river estuaries, with the sunlight reflected on water, sky and ship silhouettes. Less important are his winter scenes, rustic idylls in the style of Aert van der Neer, of which some 40 remain.
Illustration:
132 Ship Scene with a Dutch Yacht Firing a Salute, 1650

CARAVAGGIO
(Michelangelo Merisi, Amerighi da Caravaggio)
1573 Caravaggio (near Milan) –
1610 Porto Ercole
Michelangelo Merisi was born in Caravaggio as the son of a ducal architect. His early training was under a little-known pupil of Titian. In 1592 he went to Rome, where he earned his livelihood by painting run-of-the-mill pictures. His contact with Cesare d'Arpino, the most popular painter and art dealer in Rome at the turn of the century, brought recognition but no material independence. However, it is through the art business that Caravaggio met his first patron, Cardinal del Monte, who not only held out the possibility of working independently, but also secured for him his first public commission, from the Contarelli Chapel in San Luigi dei Francesi. Here, Caravaggio developed his characteristic treatment of light, which shoots dramatically into the dark world of his pictures, creating an intensely sharp yet alien reality.

From then on he was inundated by public commissions. Yet because of his violent temper he was constantly in trouble with the authorities. In 1606 he became embroiled in murder and had to flee, finding refuge on the estates of Prince Marzio Colonna, where he painted the Vienna "Rosary Madonna". On his wanderings he paused at Naples, painting exclusively religious themes. In Malta he was put up by the Knights of St John and painted several portraits of the grand master, Alof de Wignacourt. In 1608 he was granted the title "Cavaliere d'Obbedienza". The artistically fertile Maltese period was again interrupted by imprisonment and renewed flight. Going through Syracuse and Messina, where some major late works came into being, Caravaggio went on to Palermo and from there again to Naples. Here the news of the Pope's pardon reached him and, on arriving at Porto Ercole by ship, he was again arrested but later released. By then the ship had sailed, including all he possessed. Struck down by a fever, he died without setting foot in Rome again.

The main stages of this story of a restless and finally hounded man are reflected in his work, albeit in an unexpected way. Just before 1600 the light, clear coloration of the early work is replaced, almost without transition, by his famous chiaroscuro, combining dynamism with dramatic expression. Then, from the Maltese period onwards, the intensity of this combination is steadily reduced. Perhaps because of his need to paint more rapidly, he began to paint more thinly, and the dark background becomes increasingly part of the overall composition, while the strong contrasting chiaroscuro effect is lessened to such a degree that it can no longer be understood merely as light and shade but as an indication of an increasing spiritualisation.
Illustrations:
10 The Young Bacchus,
c. 1591–1593
30 Basket of Fruit , c. 1596
31 The Fortune Teller (La Zingara),
c. 1594/95
31 The Supper at Emmaus,
c. 1596–1602
32 Bacchus, c. 1598
33 The Crucifixion of St Peter, 1601
33 The Entombment, c. 1602–1604

CARRACCI Annibale
1560 Bologna – 1609 Rome
CARRACCI Agostino
1557 Bologna – 1602 Parma
CARRACCI Lodovico
1555 Bologna – 1619 Bologna
Amongst the trio of Carraccis, Agostino, Annibale's elder brother, was probably less endowed artistically and rather more important in the role of scholarly theoretician, as emerged in the task of decorating the Palazzo Farnese for which he supplied the programme and iconography. As teacher, he advocated the often disputed "academic Carraccisms". Annibale took as his starting point the Mannerist style in his early work ("Butcher's Shop", Oxford, Christ Church Library Collections), developing it through his study of Correggio at Parma (1584/85) and the works of Titian and Veronese, to a sensual classicism enlivened by an inner unrest and true-to-life naturalness, as exemplified by his "Triumph of Bacchus and Ariadne" (ill. p. 29) in the frescos at the Palazzo Farnese. He had already left the "Accademia del Naturale", later called the "eclectic" school, in 1595, which he had founded in Bologna together with his cousin Lodovico and brother Agostino. In the 49 years of his life Annibale gained importance not only for his frescos, but also as a painter of Ba-roque altar pieces. Lodovico was the head of the school known for its rejection of Mannerism. He also trained both his cousins in his workshop at Bologna. In 1584 they collaborated in the decoration of the Palazzo Fava, in their native city, with mythological friezes which were attacked by the Mannerists and led to the founding of the school, enabling them to uphold their views artistically and theoretically. Lodovico's religious work, in particular, radiates a new, natural and genuine devoutness.
Illustrations:
13 The Jealous Cyclops Polyphemus Hurls a Rock at Acis, the Beloved of the Sea Nymph Galatea, c. 1595–1605
14 The Virgin Appears to SS Luke and Catharine, 1592
27 The Beaneater, c. 1580–1590
27 "Domine, quo vadis?", c. 1601/02
28 The Martyrdom of St Stephen, c. 1603/04
28 The Lamentation of Christ, 1606
29 Triumph of Bacchus and Ariadne, c. 1595–1605

CHAMPAIGNE Philippe de
(also: Philippe de Champagne)
1602 Brussels – 1674 Paris
First in the studio of Jean Bouillon, then at the workshop of the miniature painter Michel de Bourdeaux, Champaigne acquired in his native city the technical knowledge on which he drew in his later work, particularly his treatment of the surface of materials. In 1620 he entered the workshop of Fouquière, a landscapist and friend of Rubens, where he came into indirect contact with Rubens. He then went to Paris, met Poussin and worked under Georges Lallemand.

In 1628 he had to abandon plans for a visit to Italy as he was appointed court painter to the Catholic Dowager Queen Maria de' Medici, succeeding Duchesnes, whose daughter he married. He worked for the Palais du Luxembourg and decorated churches with frescos. The patronage of Louis XIII and Richelieu soon opened opportunities for portrait painting which he carried out with a new classical refinement and precision, a style that was taken over by the next generation. The loss of his wife in 1638 and of his son in 1642 deepened his religious devotion and he sought closer links to a Jan-senist monastery, Port-Royale de Champs, where he sent his two daughters in 1648. During this period his fine portraits of Mother Angélique Arnauld and the Paris Councillors (all in Paris, Louvre) were produced, and the recovery of his last remaining daughter Cathérine inspired him to his famous "Ex-Voto" painting (ill. p. 52).
Illustration:
52 Ex Voto (Mother Superior Catherine-Agnès Arnauld and Sister Catherine de Sainte-Suzanne, the Daughter of the Artist), 1662

CLAESZ. Pieter
c. 1597/98 Burgsteinfurt (Westphalia) – 1661 Haarlem
Born in Westphalia, Claesz settled in Haarlem in 1617. Through him and the painter Willem Claesz Heda, with whom he was often confused, Haarlem became the centre of Dutch still life painting. While in his early work he usually depicted a collection and arrangement of various striking objects, he later developed his so-called "monochrome Banketje", or "breakfast pieces", which show objects on a white cloth, such as filled glasses, a bowl of bread, a plate of fruit, or a cut cake, all arranged as if by chance. He worked in tones of brown, ochre, white and grey, and with only a few sharp accents. The attraction of his still lifes lies in the beautifully executed reflection of light on glass, pewter and copper. Claesz was the father of the landscape painter Nicolaes Berchem.
Illustration:
112 Still Life with Musical Instruments, 1623

COELLO Claudio
1642 Madrid – 1693 Madrid
His father, a bronze caster from Portugal, apprenticed him to the painter Francesco Rizi in order to equip him for taking over his workshop. Rizi, however, recognised the boy's talent for painting. Coello's further training included a visit to Italy and the study of the works of Titian, Rubens and Jan van Eyck, which were kept at the Spanish royal palaces. The court painter Juan Carreño de Miranda obtained access for him, and Coello became his successor in 1685. In 1691 the Chapter of Toledo Cathedral appointed him "titular painter" to the cathedral, where he had already painted the vestry in 1671 in collaboration with José Jiminez Donoso. Coello was predominantly a decorator of sacred buildings, including several frescos in the churches of Madrid, in the monastery of Paular and in the church of the Augustinian monastery La Manteria in Zaragoza – all painted by 1683. His masterpiece is the altar panel for the sacristy in the Escorial: "King Charles II and his Entourage Adoring the Host". Coello was pushed into the background when Giordano arrived in Madrid in 1692.
Illustration:
70 King Charles II, c. 1675–1680

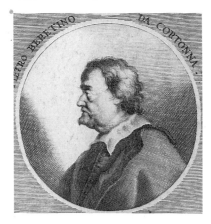

CORTONA Pietro da

(Pietro Berrettini)
1596 Cortona – 1669 Rome
As an architect and painter of easel
pictures and interior decorations, this
versatile and talented artist already
achieved fame in his lifetime. He re-
ceived his initial training under the
Florentine Andrea Commodi with
whom he went to Rome in 1613 to
complete his studies under Baccio
Ciarpi. Early works, such as the
"Triumph of Bacchus" (Rome, Pina-
coteca Capitolina, c. 1625), still show
the marked influence of Carracci.
From 1623 he worked under the
patronage of the Sacchetti, decorating
their villas in Ostia and Castelfusano
with frescos.

His greatest patrons were, however,
the Barberini. He not only painted for
them the frescos for the Santa Bibiana
church (1624–1626), including
various altar pieces, but also the ceil-
ing of the salon in the Palazzo Bar-
berini (Rome, 1633–1639) which con-
tained the greatest number of frescos
in contemporary Rome. Here, Cortona
proved himself as a great innovator of
interior decoration. From 1640 to
1647 he worked in Florence where,
under Ferdinand II, he painted the en-
tire upper floor rooms facing the street
in the Palazzo Pitti. Cortona also had
great talent as a panel painter, as can
be seen in such works as "The Sacrifice
of Polyxena" or the "Rape of the
Sabines" (both Rome, Pinacoteca Capi-
tolina).
Illustration:
38 Holy Family Resting on the
 Flight to Egypt, c. 1643

COTÁN Juan Sánchez

1561 Orgaz (near Toledo) –
1627 Granada
Cotán's life was uneventful. He was
trained by the Mannerist painter Blas
del Prado from Toledo. In 1604 he
joined the Carthusian order and entered
El Paular monastery near Segovia.
Eight years later he moved to the or-
der's monastery in Granada which he
decorated with frescos. He died there
aged 66.

Although the influence of his real-
ism continued into the later part of the
17th century in various respects, dur-
ing his lifetime Cotán's style seems to
have been uniquely personal. In particu-
lar in his "Bodegones", the kitchen pic-
tures, and in his still lifes, he developed

an unmistakable language of his own in
its umcompromising clarity and down-
right expression. The ascetic, so often
emphasised in the scenes of monastic
life and images of saints in baroque
Spanish painting, does not enter into
the world of inanimate objects in Co-
tán's work.
Illustration:
61 Still Life (Quince, Cabbage,
 Melon and Cucumber),
 c. 1602 (?)

CRESPI Giuseppe Maria

(called: Lo Spagnuolo)
1665 Bologna – 1747 Bologna
Despite the fact that Crespi never left
his home town, he has nothing in com-
mon with what marked the academic
school of painting at Bologna two
generations earlier. Crespi abandoned
the heavy corporeality in favour of
mobile, strong figures of a new natural-
ness. Luigi Crespi, his son, a mediocre
painter and his father's biographer,
stated that his father had studied the
effect of light in nature. In his set of
paintings "The Seven Sacraments"
(Dresden, Gemäldegalerie) Crespi not
only proves to be a close observer of
gesture, movement and facial ex-
pression, but that he also found new
ways regarding chiaroscuro. It is this ir-
regularity and unpredictability of light
and shade which animates his genre
scenes ("Peasant Family", Budapest,
National Museum; the "Fair of Poggio
a Caiano", Florence, Uffizi). In pic-
tures, such as "The Flea" (ill. p. 41) or
"Kitchen Maid" (Florence, Uffizi), his
persuasive power lies in the total ab-
stention from excessive allegorical ele-
vation and the humorous lightness of
the narrative style.
Illustration:
41 The Flea, c. 1707–1709

CUYP Aelbert

(also: Cuijp)
1620 Dordrecht – 1691 Dordrecht
Cuyp, whose repertoire embraces por-
traits, landscapes, animals and still
lifes, could best be compared to Rem-
brandt in terms of versatility, although
his reputation was based on landscape
painting. He was a pupil of his father
Jacob Gerritsz, and also a pupil of Bloe-
maert, but his study of the works of
van Goyen with his harmonious
golden-yellow coloration became the
decisive factor in his art. His favourite

subject matter was Dordrecht and its
surroundings with the canals, the
peaceful river flats and plains where
the cattle graze under a radiant sky im-
parting a warm glow to the scene. Be-
cause of his fine handling of light in
all its nuances he was called the
"Dutch Claude Lorrain".

In his later work, after 1660, the in-
fluence of the Italianised landscape and
classical pastoral, as depicted by Jan
Both, became even more pronounced.
The range of colours is extended, and
mountains and rocks, antique ruins and
idyllic shepherds enter his pictures.
Illustration:
129 Rooster and Hens, undated

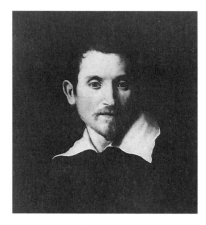

DOMENICHINO

(Domenico Zampieri)
1581 Bologna – 1641 Naples
Domenichino was, with Reni, one of
the most important successors of the
Carraccis. He was trained by Lodovico
Carracci in his home town, then as-
sisted Annibale Carracci in Rome from
1602 onwards. His early work, such as
the "Maiden and the Unicorn" (ill.
p. 36) shows that besides the influence
of both Carraccis there was already an
individual, classically clear style which
found expression in his characteristic
monumental work, including the fresco
in the oratorio of San Gregori Magno
(Rome), his depiction of the martyr-
dom of Andrew, and also his frescos of
the Nilus Legend in the Abbey of
Grotta Ferrato (1609/10). On Anniba-
le's death (1609) Domenichino became
the foremost Bolognese landscape
painter.

In his landscapes of a typically green-
ish-grey coloration he explored during
the years 1610–1615 new principles of
composition which were later taken

over by Claude Lorrain. In the field of
interior decoration he demonstrated al-
ternatives to the formulations of Cor-
tona, as can be seen in the choir and cu-
pola pendentives of Sant' Andrea della
Valle, Rome. His panel paintings were
masterly in their complex yet clearly
structured composition and dramatic ef-
fect. Dominichino later worked in
Naples, but there he met with hostility.
He died there without having com-
pleted his work in the cathedral, leav-
ing a great number of drawings which
tell us how meticulous his preparatory
work was.
Illustrations:
16 The Assumption of Mary
 Magdalene into Heaven,
 c. 1617–1621
36 The Maiden and the Unicorn,
 c. 1602

DOU Gerard

(also: Gerrit Dou)
1613 Leiden – 1675 Leiden
Dou was, during his lifetime and
throughout the 19th century, one of
the most respected genre painters in
Holland. He was taught by his father,
a stained glass artist, and went on to
be trained by Bartholomeus Dolendo,
a copper engraver, where he painted
on small copper plates. After a further
spell of training with another stained
glass artist and also in his father's
workshop, Dou studied from 1628 to
1631 under Rembrandt, who was
then just 22 years old. When Rem-
brandt moved to Amsterdam, Dou re-
mained in Leiden, set up his own
workshop in 1632 and became a
founding member of the Leiden Lukas
Guild in 1648. Dou was one of the
most talented and independent pupils
of Rembrandt, from whom he took
over the chiaroscuro effects and struc-
turing of interiors, sometimes ren-
dered in the light of candles or lamps
("Evening Class", Amsterdam,
Rijksmuseum), and also the scenes of
ordinary life. He is considered the
most important representative of the
so-called "fine painting", a very de-
tailed style of painting, requiring the
finest brushes and often a magnifying
glass to give a realistic rendering of
the smallest detail. His work ranged
from small genre scenes, with old
women and men at work, interiors of
small general stores, medical consulta-
tions ("The Dropsical Lady", ill.
p. 126), to biblical subjects, portraits

("Young Mother", The Hague, Marits-huis) and still lifes. Dou remained all his life in Leiden, even declining an invitation to work at the English court of King Charles II. His best known pupils were Frans van Mieris the Elder and Gabriel Metsu.

Illustration:

126 The Dropsical Lady (The Doc-tor's Visit), c. 1663 (?)

DUGHET Gaspard
(called: Gaspard Poussin)
1615 Rome – 1675 Rome
His brother-in-law Nicolas Poussin was his teacher, but Dughet soon be-came independent both financially and artistically, devoting himself almost en-tirely to landscape painting, including series of large frescos (Palazzo Dora, Palazzo Colonna and San Martino ai Monti, all of them in Rome). Although he never left Italy, he absorbed into his work a great variety of influences including foreign ones. Bril, Els-heimer, Domenichino, Rosa and Claude Lorrain were all just as important as Poussin in developing Dughet's style. His work was particularly popular in England and Germany in the 18th and 19th centuries. Goethe said that in these pictures there "seemed to live a human race of few necessities and noble thoughts".

Illustration:

52 Landscape with St Augustine and the Mystery of the Trinity, c. 1651–1653

DYCK Anthony van
1599 Antwerp – 1641 London
Van Dyck, next to Rubens the most important Flemish painter, was the seventh child of a well-to-do silk mer-chant in Antwerp. After the early death of his mother he was sent at the young age of eleven to be trained by the Romanist Hendrik van Balen. In 1615 he already had his own workshop and an apprentice. In 1618 he was ac-cepted as a full member of the Lukas Guild. From 1617 to 1620 he was the pupil and assistant of Rubens, who con-sidered him his best pupil. They be-came friends, van Dyck living at Rubens' house and painting many pic-tures on his own after Rubens' design. Van Dyck's great talent, his untiring diligence and perhaps also Rubens' friendship combined to bring him com-missions of his own very soon. Besides

religious and mythological scenes he also painted some important life-like portraits, which were to become his main work. His pride and ambition made it hard for him to stand in Rubens' shadow in Antwerp. He there-fore followed an invitation from the Earl of Arundel to London, where he stayed several months. From 1621 to 1627 he lived in Italy, studying the works of Giorgione and Titian. He en-tered Genoa on a white horse, a pres-ent from Rubens, also visiting Rome, Venice, Turin and Palermo. Titian's in-fluence shows clearly in his paintings of Madonnas and Holy Families; works such as the "The Tribute Money" or "The Four Ages of Man" could almost have been by the great Venetian painter himself.

In 1627 he returned to Antwerp, where he was given a triumphal wel-come. He received many commissions for churches, and became court painter to the Archduchess Isabella in 1630. In March 1632 King Charles I called him to England as court painter where he remained, apart from short visits abroad, until his end. Van Dyck be-came the celebrated portraitist of the English court and aristocracy, and cre-ated in this field a style typically his own. In under ten years he painted over 350 pictures, of which 37 were of the King and 35 of the Queen. His ex-travagant way of life – he had five ser-vants – required a constant flow of commissions and a large studio. Often he merely made a portrait sketch, painting face and hands and leaving the rest to be completed by his assis-tants. He worked feverishly, weakened by thirty years' hard work and perhaps already feeling signs of his impending illness, rushing in his last years be-tween England, Antwerp, Paris and back to England. But his great plans – frescos in the Banqueting Hall in Whitehall for the English kings, the decoration of the hunting castle of Philip IV in Madrid and a series of paintings in the Louvre for the French monarch – did not materialise, per-haps partly because his fees were exor-bitant.

Although van Dyck lacked the necessary vitality that Rubens pos-sessed in addition to his genius, he cre-ated with his representative portraits, which are marked by their dignity, elegance and detachment as well as close psychological observation and fine use of colours, a type of painting that influenced many generations. He was in particular a stimulus to English painters, such as Gainsborough, Rey-nolds and Lawrence.

Illustrations:

86 Portrait of a Member of the Balbi Family, c. 1625
113 Susanna and the Elders, c. 1621/22
113 St Martin Dividing his Cloak, c. 1618
114 Portrait of Maria Louisa de Tassis, c. 1630
114 The Count of Arundel and his Son Thomas, 1636
115 Equestrian Portrait of Charles I, c. 1635–1640

ELSHEIMER Adam
1578 Frankfurt am Main – 1610 Rome
If coping with mass was a central prob-lem of Baroque painting, it seems sur-prising that one of its most prominent founders worked only in small, even tiny, formats. Nevertheless the work of Elsheimer, who died at the age of 32, was largely taken up with this ques-tion. His earliest known work "Sermon of John the Baptist" (Munich, Alte Pi-nakothek, c. 1598) showed some new impressions in addition to the influence of the painters of the Danube School to whom his teacher Philipp Uffenbach had introduced him. In 1598 Elshei-mer had come by way of Munich to Venice, where he was much impressed by the work of Bassano and Tintoretto. These new influences already find ex-pression in his "Conflagration of Troja" (Munich, Alte Pinakothek), probably produced while still in Venice. On the small copper plate (Elsheimer painted exclusively on copper) he created a night-time drama of great fascination, achieved through his handling of light and with a bold combination of fore-ground scene and background.

In 1600 he moved to Rome where Bril and Rubens as well as Caravaggio and Annibale Carracci became of great importance to the gregarious and pop-ular Elsheimer. The figures of Caravag-gio and the landscapes of Carracci en-abled Elsheimer to find his own direc-tion, which was to make him famous: a new relationship between figure and space which is absolutely natural and convincing. This becomes apparent in works, such as "Myrrha" (Frankfurt am Main, Städelsches Kunstinstitut) and "Flight to Egypt" (ill. p. 57). The end of his not always very easy life was tragic. Goudt, the Dutch patron, imita-tor, copyist and posthumous forger of Elsheimer, who had supported him fi-nancially and found customers for his engravings, had Elsheimer thrown into the debtors' prison, presumably because not enough work was forthcoming. Shortly after his release Elsheimer died.

Illustrations:

57 The Glorification of the Cross, c. 1605
57 The Flight to Egypt, 1609

FABRITIUS Carel
1622 Midden-Beemster – 1654 Delft
His name is the Latinised form of "car-penter", a trade which Fabritius, the son of a schoolmaster, had at first taken

up. Between 1641 and 1643 he worked in Rembrandt's workshop in Amster-dam, whose most individual and im-portant pupil he was to become. In 1650 he moved to Delft, entering the Lukas Guild two years later. His short life ended tragically. He died in the ex-plosion of a powder magazine, which de-vastated almost a quarter of Delft, and with him perished the greater part of his work. Those that survive – only just under a dozen – are, however, quite un-like what would be expected of a Rem-brandt pupil. Fabritius did not take up a speciality as so many others did, but covered the wide range of portraiture, genre pictures and still life. In particu-lar, he opened up new ways in handling space and perspective, sometimes using *trompe l'œil* effects. He also differed from Rembrandt in the treatment of light, placing dark figures against a light background. During the few years he worked in Delft he had a great in-fluence on the local school of painters, especially on de Hooch and Vermeer. The latter was his pupil and continued to develop his particular conception of how light should be used.

Illustration:

130 The Goldfinch, 1654

FETTI Domenico
(also: Feti)
c. 1589 Rome – 1623 Venice
In his early years in Rome Fetti had dis-covered the landscape style of Elshei-mer which was clearly discernible in his work, such as "The Flight to Egypt" (Vienna, Kunsthistorisches Mu-seum). At that period he also became influenced by Saraceni and the Caravag-gists in his handling of light although in his work it became looser, more dif-fuse, hinting already at Guardi. In 1614 he was appointed court painter to Duke Ferdinand II of Gonzaga in Man-tua whose collection of paintings Fetti was able to admire. He was particularly enthusiastic about the brilliance of colour in Rubens' works.

Fetti is primarily known for his small parable pictures which in this form had not been painted before. The "Parable of the Labourers in the Vine-yard" (Dresden, Gemäldegalerie) and the "Parable of the Pearl of Great Price" (Kansas City, Nelson Gallery and Atkins Museum), in particular, demonstrate in their genre-like concep-tion and flowing brushwork Fetti's ar-tistic individuality. In Mantua Fetti

also painted frescos, including some monumental work carried out in the cathedral and the Palazzo Ducale. On returning to Rome, at the age of only 34, he died. Domenico Fetti can be considered as one of the founders of northern Italian painting of the 17th century.
Illustration:
37 Melancholy, c. 1620

FLEGEL Georg
c. 1566 Olmütz (Moravia) – 1638 Frankfurt am Main
Nothing is known of Flegel's beginnings, but presumably he received his training in the Netherlands. There is evidence that he worked at least from 1594 in Frankfurt am Main, at first as an assistant to Martin van Valckenborch, whose paintings he adorned with fruit and flowers. On his way to becoming the first, pure still life painter in Germany, his work as a miniaturist was of particular importance; for example, in about 1607 he illuminated the breviary of Duke Maximilian I of Bavaria. Flegel's early still lifes therefore bear strong marks of this finely detailed art, including small decorative additions ("Fruit Still Life", Kassel, Staatliche Kunstsammlungen, 1589; "Still Life", ill. p.58). Flegel subsequently (since 1611) arrived at a much more unified, considered composition. With one of his last pictures, the "Still Life with Candle" (Cologne, Wallraf-Richartz-Museum, 1636), he succeeded in creating a work of tremendous atmospheric power and artistic simplicity.
Illustration:
58 Still Life, undated

FRANCKEN Frans the Younger
1581 Antwerp – 1642 Antwerp
Francken was the most successful and productive member of an Antwerp family of artists. He received instruction from his father Frans the Elder, became master in 1605 and deacon of the Lukas Guild in Antwerp in 1614. He painted works for churches ("Altar of the Four Crowned", Antwerp, Koninklijk Museum voor Schone Kunsten), biblical and historical scenes as well as genre pictures. However, his special domain was the so-called "Kunstkammer" – the depiction of a picture gallery. His meticulous rendering of rooms with hung paintings or antiquities are a cultural and historical source of the first order. These

works give us an insight into art, not only at court, but also in private hands.
Illustration:
106 Supper at the House of Burgomaster Rockox, c. 1630–1635

GENTILESCHI Orazio
(Orazio Gentileschi Lomi)
1563 Pisa – c. 1639/40 London
During his apprenticeship with Aurelio Lomi, his brother or half-brother, and Bacci Lomi, his uncle, Gentileschi familiarised himself with the Florentine Mannerist tradition of Agnolo Bronzino and Jacopo Carrucci da Pontormo. In Rome, where he stayed in 1580, he studied the art of Caravaggio. Gentileschi was successful in uniting both these strands to a style of his own, such as in the "Baptism of Christ" for Santa Maria della Pace in Rome or the "Stigmata of St Francis" for San Silvestro in Capite (Rome). After a two-years stay each at Genoa and Paris, where he was in the service of Maria de' Medici, he followed the call of the Duke of Buckingham to the English court in 1625 where he executed interior decorations on a monumental scale though on canvas. Late works, such as the "Lute Player" (ill. p.30), are captivating because of their balanced coloration and composition as well as their brilliant painterly technique. Orazio's daughter Artemisia, stylistically close to her father, also achieved fame among her contemporaries.
Illustration:
30 The Lute Player, c. 1626

GIORDANO Luca
1634 Naples – 1705 Naples
Giordano, who obtained instruction from his father Antonio and from Ribera, ranks as the first Baroque "vir-

tuoso" in the sense of the 18th century. The number of his oil-paintings is estimated to be over 5000, which brought him the nickname "fa presto" (do it quickly). He also had the ability to copy any style. While he was greatly influenced by Ribera in his early years, he later developed a style which showed his familiarity with Rubens, van Dyck, Cortona, and most of all the great Venetian painters such as Titian and Veronese whom he had discovered on a visit to the northern parts of Italy in the early 1650s.
In 1654, having returned to his home town, he received a commission for two paintings for the choir of San Pietro ad Aram, and he produced the "Madonna of the Rosary" (Naples, Galleria Nazionale), the "Ecstasy of St Alexius" (Arco, Chiesa del Purgatorio) and "Tarquinius and Lucretia" (Naples, Galleria Nazionale). On a second visit to Venice in 1667 he painted there the "Ascension of Mary" for Santa Maria della Salute, which in its generous conception is reminiscent of Cortona. Giordano's fame was established with his two large St Benedict cycles for Monte Cassino (destroyed 1943) and San Gregorio Armeno (Naples). From 1679–1682 he worked spasmodically on the ceiling of the gallery in the Palazzo Medici-Riccardi in Florence. Charles II called him to the Spanish court in 1692, and in the following ten years Giordano produced major works, such as the frescos in the San Lorenzo church at Escorial and the Bible scenes in the Buen Retiro palace near Madrid. He returned via Genoa, Florence and Rome to Naples in 1702. One of his last important works was the fresco in the cupola of Tesoro Certosa di San Martino.
Illustration:
40 The Fall of the Rebel Angels, 1666

GOYEN Jan van
1596 Leiden – 1656 The Hague
Van Goyen was born ten years before Rembrandt in Leiden. His father sent him as a child to learn drawing, then to several unimportant painters to be trained, but van Goyen does not seem to have much profited by it. He travelled for a year in France, then in 1616 took up studies under the skilled landscape painter Esaias van de Velde in Haarlem. He then returned to Leiden, became a member of the Lukas Guild in 1618 and moved to

the Hague in 1631. He won and lost money in property speculations and became the victim of a large tulip-bulb swindle. This compelled him to produce a large output, which in turn had a negative effect on the price of his pictures, although all his work was of a high standard. Van Goyen specialised in landscape painting and was one of the most important painters in this field at the time, although his true worth was not recognised until he was rediscovered by the Impressionists. He depicted quiet, peaceful scenery with dunes, the sea and rivers, also seascapes and winter scenes in a style quite of his own. His early work showed the influence of van de Velde with strong colouring, a great many figures, coral-like trees and heavy clouds.
From about 1630 his style changed, becoming more simplified with almost monochrome colouring in green-greys or yellow-browns. After 1640, in his "toned period", he used almost exclusively a warm brown. Uncluttered river scenes with low horizons and vast areas of sky predom-inate. His most important pupil was his son-in-law Jan Steen.
Illustrations:
111 Landscape with Dunes, c. 1630–1635
111 River Landscape, 1636

GUERCINO
(Giovanni Francesco Barbieri)
1591 Cento (near Bologna) – 1666 Bologna
"Il Guercino" (the squint-eyed) was a nickname given because of the squint in his right eye. He was the leading painter of the Bolognese school alongside Reni. He was taught by Paolo Zag-

noni in Bologna and was influenced by the work of Lodovico Carracci. Between 1615 and 1617 he painted interior decorations in Cento and produced religious works ("The Four Evangelists", Dresden, Gemäldegalerie) and landscapes ("Landscape in Moonlight", Stockholm, National Museum). At the commission of Cardinal Alessandro Ludovisi, later Pope Gregory XV, he painted the frescos in the oratorio of San Rocco, Bologna. His visit to Venice in 1618, where he met Palma il Vecchio, served to develop his style further ("Et in Arcadia ego", Rome, Galleria Nazionale d'Arte Antica; "Martyrdom of St Paul", Modena, Galleria Estense). In subsequent years his pictures became increasingly lively and dramatic, primarily achieved by the contrast of light and shade. In 1621 he followed a call to Rome by Pope Gregory XV, for whom he worked until his death. Here he painted his best-known work, the "Aurora", on a ceiling of the Villa Ludovisi. He explored his Roman experience when he returned to his home town, drawing in particular on Domenichino and Reni ("The Virgin with St Bruno", Ferrara, Pinacoteca Nazionale; "Ecstasy of St Francis", Dresden, Gemäldegalerie). There was now more pathos, and his freshness was replaced by an idealised Classicism; light and colour became cooler. On Reni's death in 1642 Guercino became the head of the Bolognese school. His attempts at regaining his former lively style were, however, not always successful.
Illustration:
38 The Return of the Prodigal Son, 1619

HALS Dirck
1591 Haarlem – 1656 Haarlem
Dirck was the younger brother of Frans Hals who was probably also his teacher, but the painters who influenced Dirck were Esaias van de Velde and Willem Buytewech. Apart from a few small portraits, he devoted himself exclusively to the painting of conversation pieces – the cheerful domestic life of prosperous burghers in their houses or gardens. He was not interested in the serious side of life; in his work he depicted people in conversation or while flirting, making music and dancing, eating and drinking. His interiors are hardly worked out, all the emphasis is put on fashionable dress and colourful representation. He succeeded in putting across people's high spirits through facial expression, costly dress, posture and loose grouping.
Illustration:
104 Merry Company, undated

HALS Frans
c. 1581–1585 Antwerp (?) – 1666 Haarlem
Frans Hals was the son of a clothmaker from Mecheln. He was Flemish by birth and was born in Antwerp or Mecheln. His parents moved to Haarlem, where his younger brother Dirck was born in 1591. Apart from one or

two short visits to Antwerp and Amsterdam, Hals never left Haarlem. About 1600–1603 he was trained in the workshop of Karel van Mander who is most remembered for his writings on the history of art. In 1610 he became a member of the Lukas Guild, and in 1644 its head. He was highly esteemed in Haarlem, as is shown by the fact that he received altogether eight commissions for the large civic guard pictures. But Hals was often in debt as his portraits were not "elegant" enough for contemporary taste, so that he never became a fashionable painter. Also, he had to provide for ten children from his two marriages. In 1652 he had to auction his furniture and his paintings to pay the baker, and shortly before his death he received poor relief in the form of money and peat. It is often maintained that his poverty was the result of his extravagant lifestyle, but there is no evidence for this.

Hals is the most important Dutch portrait painter. His surviving work comprises about 300 paintings, and the majority of these are portraits and group portraits. Although also a genre painter after 1626 when he had become familiar with the Utrecht Caravaggists, these still remained portraits except that they also contained symbolic accessories or were painted in a narrative manner. Hals certainly was the foremost painter of the Dutch group portrayal. Already with his first commission, 1616, the "Banquet of the Officers of the St George Civic Guard" (ill. p. 101), he revolutionised this branch of painting which had so far been restricted to lining up several single portraits. But he never presented the scene in a theatrical fashion, as Rembrandt did with his "Night Watch", and each of his sitters is given individual and equal attention. His last two group portraits were the "Regents" (Haarlem, Frans-Hals-Museum, 1664) and "Regentesses of the Old Men's Almshouse in Haarlem" (ill. p. 104). These represent the end of the great era of this type of painting – there are just a few examples of it in the 18th century, and with its waning, the vitality and Baroque theatricality are replaced by a pessimistic, melancholic resignation about the human condition.

In his large single or double portraits, as in the life-size "Portrait of Willem van Heythuysen" (ill. p. 103), Flemish elements and the influence of

Rubens become evident, with the background showing views and scenic staffage. His special devices used for livening up the picture are most evident in his genre portraits ("The Gypsy Girl", ill. p. 102; "The Merry Drinker", ill. p. 102; "Malle Babbe", Berlin, Gemäldegalerie, c. 1629). With a spontaneous and seemingly improvised brushstroke, he produces light reflections on the faces, objects, cloth and lace, thus creating an effect of immediacy as well as vitality. Apart from his son Dirck and the imitator of his style, Judith Leyster, his pupils included the Ostade brothers; he also greatly influenced Steen and Terborch.
Illustrations:
87 Two Singing Boys, 1626
101 Banquet of the Officers of the St George Civic Guard in Haarlem, 1616
101 Young Man with a Skull (Vanitas), c. 1626
102 The Merry Drinker, 1628
102 The Gypsy Girl, c. 1628–1630
103 Portrait of Willem van Heythuysen, c. 1625–1630
104 Regentesses of the Old Men's Almshouse in Haarlem, 1664

HEDA Willem Claesz.
c. 1593/94 Haarlem – 1680 Haarlem
Along with Pieter Claesz., with whom he is often confused, Heda was the most important representative of the Haarlem school of still life painting. Little is known about his life. In 1631 he was a member of the Lukas Guild, and in 1637 he is mentioned several times as its chairman. After painting a small number of portraits and religious pictures, he began to specialise in the "breakfast" still lifes with their tasteful arrangements. These are not depictions of heavily-laden, magnificently appointed festive boards, but ordinary tables with just a few items, such as the remains of a cake, a half-empty wineglass, a pewter jug, cracked nuts or a burnt-out clay pipe, giving the impression that a simple meal has just been finished. The description "still life" did not exist until mid-century. There was the distinction between "Ontbijtje", the breakfast arrangement, and the "Banketje", the light meal. Heda's still lifes are conservative in their coloration, moving between a golden yellow, brown, grey and a silvery white. Therefore Heda's and also Claesz.'s works are referred to as "monochrome banketjes".
Illustration:
110 Still Life, 1631

HEEM Jan Davidsz. de
1606 Utrecht – c. 1683/84 Antwerp
De Heem came from a family of Dutch-Flemish still life painters. He probably received his early training from his father, then from Balthasar van der Ast in Utrecht. The years between 1628 and 1631 he spent in Leiden, then settled at Antwerp where he became a member of the Lukas Guild in 1636. In 1669 he returned to Utrecht, and records show that he

was again in Antwerp in 1672. This shows that he was active in both the northern and southern parts of the Netherlands, and this is reflected in his work. His first still lifes are in tone still reminiscent of Heda and Claesz., while later flower pieces and fruit baskets suggest the influence of the Flemish painters Daniel Seghers and Snyders in their Baroque-like magnificence of coloration.

De Heem's speciality were large, elaborate pictures of opulently appointed dining tables laid with silverware, fine glass and fruit baskets, often accompanied by a large lobster to provide a brilliantly coloured accent. He also painted beautifully arranged and minutely detailed flower and fruit pieces, combining subtly painted botanical details with elements of the vanitas type of still life (caterpillars attacking the fruit, beetles in the flower buds). These pictures, in all their richness and glory, are almost without comparison in Dutch painting.
Illustration:
123 Still Life, undated

HILLIARD Nicholas
(also: Heliard, Hildyard, Helier)
c. 1547 Exeter – 1619 London
The great English art of portraiture of the 18th century had its beginnings in the works of Hilliard more than a hundred years earlier. Having no examples in this field to draw on, he used as a starting point for his painting the highly developed traditions of book illumination and the goldsmith's art. Himself the son of a goldsmith, he went to London to be trained by the goldsmith and jeweller to Queen Elizabeth I from 1562 to 1569. With great technical precision, he painted a

portrait of the Queen as early as 1570 (Welbeck Abbey). In the next decade Hilliard's style gained in elegance of both form and conception (Self-portrait, London, Victoria and Albert Museum, 1577). Already in the late 1560s, and after a visit to France, Hilliard was the leading miniature portraitist of royalty, as confirmed by his picture of James I, and going on to include the entire royal court. After 1580 he introduced the oval form of his, now often full-length, miniatures of which the "Young Man among the Roses" (London, Victoria and Albert Museum, c. 1588) is one of the finest examples. During this period he also succeeded in conveying individual expression in his pictures, and it is in this that he was of particularly valuable service to the next generation.
Illustration:
56 Portrait of George Clifford, Earl of Cumberland, c. 1590

HOBBEMA Meindert

1638 Amsterdam – 1709 Amsterdam
Hobbema was the son of a bargee. He lost his mother early and grew up in an orphanage. Between 1657 and 1660 he was a pupil of Jacob van Ruisdael, on whose style his work was largely based, to the extent that it is easy to confuse their works. He always lived in his home town, except for brief visits to Deventer, Haarlem and Middelharnis. In 1668 he married a servant of the mayor, who procured him the position of weights and measures inspector, which involved calculating wine and oil casks according to Amsterdam measures. During this time he seems to have given up painting, especially as it had not provided him with an income. One of the few authenticated works dating from this late period is "Avenue of Middelharnis", 1689 (ill. p. 137). Hobbema was a landscape painter, but not of the typically flat Dutch coastal scenery. He rendered overgrown dunes and wooded tracts with powerful trees and dark, dense foliage, enlivened by rivulets and mills, cottages and small figures. His colours were a strong green, yellow and brown, later interspersed with light, silvery tones. His landscapes provide a bridge to 18th-century landscape painting.
Illustration:
137 Avenue of Middelharnis, 1689

HONTHORST Gerrit van

(also: Gerard van Honthorst; called: Gherardo della Notte)
1590 Utrecht – 1656 Utrecht
Honthorst was one of the most versatile Dutch artists. His work included biblical scenes, allegories, genre pictures, portraits and wall and ceiling decorations. He was also one of the few to achieve great prosperity. At first he studied under Bloemaert in Utrecht. In 1610 he went to Rome for ten years, where he was greatly influenced by Caravaggio and, although he did not meet this great artist himself, he systematically explored his

chiaroscuro effects in his work. Dark rooms lit by candles, torchlight, hidden or channelled sources of light in dark spaces – these became typical subjects of his work. Because of his taste for artificially lit night scenes he was called "Gherardo della Notte" while in Italy. On his return to Utrecht in 1622 he became a member of the Lukas Guild. In Rome he had painted mostly religious subjects ("The Nativity", "Adoration of the Shepherds", both Florence, Uffizi), but now he turned to mythological subjects and genre scenes of soldiers, card-players and carousers ("Cheerful Company", Munich, Alte Pinakothek). Most of his many commissions were for portraits. In 1628 he went to England to paint portraits of King Charles I and the Queen. In 1637 he became court painter to Prince William of Orange and settled in The Hague. He painted many illustrious persons, including King Christian VI of Denmark and the Elector of Brandenburg, and he gave painting lessons to the Bohemian Queen Elizabeth and her daughter. His financial position was such that he could lend her the large sum of 35,000 guilders in 1651. Honthorst spent his final six years in his home town of Utrecht.
Illustration:
110 The Incredulity of St Thomas, c. 1620

HOOCH Pieter de

(also: Hoogh, Hooghe)
1629 Rotterdam – after 1684 Amsterdam (?)
His career as a painter developed very slowly. The son of a bricklayer, he received his early training under Nicolaes Berchem in Haarlem. Around 1650 he

worked for a cloth merchant and art collector in Rotterdam as painter and *valet de chambre*, whom he had to accompany on his travels to Leiden, The Hague and Delft. After his marriage in Delft he was accepted as a member of the Lukas Guild in 1655 although not actually a citizen of the town. In about 1667 he moved to Amsterdam, where he remained to the end of his life. De Hooch's most important creative period was his years at Delft.
Under the influence of Vermeer and the Rembrandt-pupil Fabritius he painted genre scenes which depict the idyll of Dutch domestic life, including interiors, courtyards and garden scenes. A gentle light radiates the scenes, and the figures and objects seem to pause as if in a still life. Typical for de Hooch, whose colours are warmer and softer than Vermeer's, are perspectival rooms and vistas through open doors. In his Amsterdam period, where he liked to move in elegant society, his often plain and simple interiors were replaced by grand rooms with marble mantelpieces and pilasters. His rendering became hard and over-meticulous, his coloration cold and dry.
Illustrations:
88 The Courtyard of a House in Delft, 1658
89 Dutch Family, c. 1662
135 A Woman and her Maid in a Courtyard, 1660
135 The Card-Players, c. 1663–1665

HOOGSTRATEN Samuel van

(also: Hoogstraaten, Hoogstraeten)
1627 Dordrecht – 1678 Dordrecht
Hoogstraten received his earliest training from his father Dirck at Dordrecht, then in 1642 entered the workshop of Rembrandt and returned in 1648 to his home town. In the 1650s he stayed in Vienna to carry out work for the Emperor Ferdinand III and also visited Rome, which was exceptional in the tradition of Dutch painting. He married in 1656 in Dordrecht and went with his wife to London from 1662 to 1666. On his return to The Hague he joined the painters' guild "Pictura". In 1670 he finally settled in Dordrecht, where he was appointed provost of the mint. Hoogstraten was less known as a painter than as an experimenter and art theorist. In 1678 he wrote his *Inleyding tot de Hooghe Schoole der Schilderkonst*. He worked with optical instruments and con-

structed perspectival "peepshow" boxes (London, National Gallery), specialising in *trompe l'œil* illusionism. In his painting he initially followed Rembrandt, but then developed his own manner and subject matter.
Illustration:
134 Still Life, c. 1666–1678

JORDAENS Jacob

1593 Antwerp – 1678 Antwerp
The son of a linen merchant, Jordaens was the pupil of Adam van Noort, under whom Rubens had studied briefly. He was classed as a "water painter" when joining the Lukas Guild in 1615, probably because he painted water-colours on linen which served as wall-hangings and which his father sold. In 1621 he was appointed deacon of the Guild. His reputation as designer of decorations brought in 1634 a commission from the Antwerp magistrate to collaborate on the decorations for Prince Ferdinand's visit under the supervision of Rubens, in whose workshop Jordaens had been employed previously. Within the orbit of Rubens he not only carried out the latter's designs, such as the large canvases for the Torre de la Parada near Madrid, but adopted his style, making it his own. After Rubens' death, he became the leader of the Antwerp school, carrying out innumerable commissions for Church and Court between 1640 and 1650, including 22 pictures for the salon of Queen Henrietta Maria at Greenwich, work for the Scandinavian and French courts, as well as the "Triumphs of Prince Friedrich Heinrich of Nassau" at the Huis den Bosch near The Hague, one of the few decorations of this kind to be found in Dutch palaces. Jordaens painted historical, allegorical and mythological scenes and was also a painter of religious themes and genre pictures. He was one of the great Flemish Baroque painters along with Rubens and van Dyck.
Illustrations:
108 Allegory of Fertility, c. 1622
108 The Family of the Artist, c. 1621
109 The Satyr and the Farmer's Family, after 1620

KALF Willem (also: Kalff)

1619 Rotterdam – 1693 Amsterdam
Kalf was considered by his contemporaries as having exceptional intellec-

tual gifts and being well-versed in the arts. He probably received his training from Frans Ryckhals and Hendrick Pot. In 1640 he went to Paris for six years, where he was a success with his pictures of kitchens and interiors of peasant dwellings. With these pictures of untidy storage rooms and passages cluttered with tools and female servants, he created a genre that Chardin was to revive in the 18th century. But he was first and foremost a still life painter, initially depicting simply laid breakfast tables with the remains of the repast, glasses and pewter or silver vessels, which were reminiscent of the "monochrome banketjes" of the Haarlem painters Claesz. and Heda. In compliance with the demands of the well-to-do Dutch merchant class, Kalf later produced luxurious still lifes with rich table covers, Venetian glass, Chinese porcelain and silver bowls containing tempting fruit. These are never gaudy, as can be the case with Flemish pieces, and they captivate by their suggestion of texture. Brilliant colours and the sensitive use of light effects suggest Rembrandt's influence. Most of these pictures date from the Amsterdam period between 1646 and 1663. From then on Kalf seems to have given up painting in favour of art dealing.
Illustration:
128 Still Life, c. 1653/54

KEYSER Thomas de
c. 1596/97 Amsterdam –
1667 Amsterdam
De Keyser was the son of a sculptor and architect and, until Rembrandt's arrival in Amsterdam in 1632 the town's leading portraitist. He specialised in large-scale group portraits and also painted smaller, crowded pictures of families and groups ("The Anatomy of Dr Sebastiaen Egbertsz. de Vry", Amsterdam, Rijksmuseum). He abandoned painting altogether between 1640 to 1654 and became a dealer in basalt stone. Later he produced pictures of the rich Amsterdam middle classes mounted on their steeds – a way of depiction formerly reserved for the aristocracy. From 1662 until his death he supervised the building of the new Amsterdam town hall.
Illustration:
112 Equestrian Portrait of Pieter Schout, 1660

KONINCK Philips
(also: Coning, Coningh, Goningh, Koning)
1619 Amsterdam – 1688 Amsterdam
Koninck's father was a goldsmith, his older brother Jacob a painter, who taught him from 1639 to 1641 in Rotterdam. He returned to Amsterdam in 1641, possibly becoming a pupil of Rembrandt who became a friend to whom he owed much.
 Characteristic of his work are large-scale panoramic landscapes, mostly seen from a slight elevation allowing a view over wide stretches of flat or slightly hilly land under a great expanse of sky. Waterways and paths intersect the land-

scape, houses are dotted in the foreground. These landscapes were most mostly carried out in warm, brown-yellow tones. As a side-line, Koninck operated a ferry service between Amsterdam and Rotterdam.
Illustration:
128 Village on a Hill, 1651

LANFRANCO Giovanni
(also: Giovanni di Stefano)
1582 Terenzo (near Parma) – 1647 Rome
As the pupil of Agostino Carracci he worked from 1600 to 1602 on the decoration of the Palazzo del Giardino in Parma. A short time after his master's death he was mentioned in Rome in the circle surrounding Annibale Carracci. In 1605, while in Rome, he decorated the Camerino degli Eremiti in the Palazzo Farnese (destroyed). Around 1610 he returned briefly to his home town, painting altarpieces for churches in Parma and Piacenza. Again in Rome, he carried out the two works which were to make him famous: the ceiling in the Loggia des Casino Borghese with its extreme foreshortenings ("Olympian Meeting") and the fresco in the cupola with the "Assumption of the Virgin" for Sant'Andrea della Valle. These were to serve as an example to Pozzo and Baciccio with their characteristic powerfulness and monumental grandeur. In 1633/34 Giovanni Lanfranco made his way to Naples, where he carried out a number of large commissions, including the cupola of Gesù Nuovo and the frescos in Santi Apostoli, where he concentrated on achieving dramatic vividness rather than careful execution.
Illustration:
37 Hagar in the Wilderness, undated

LASTMAN Pieter
1583 Amsterdam – 1633 Amsterdam
Rembrandt was briefly a pupil of Lastman around 1622/23 and copied his master's work in his early career, and yet Lastman has almost been forgotten. The son of a messenger, Lastman was apprenticed to Gerrit Sweelinck, a pupil of Cornelis van Haarlem, which explains the influence of the old Haarlem school on his work. However, more important was his visit to Italy in about 1603–1607 which took him to Venice and Rome. His meeting with Caravaggio and the Carraccis, and most of all his close contact with Elsheimer, whose landscape composition and figure painting impressed him deeply, gave him a new direction. On his return to Amsterdam he dedicated himself to history painting centering on biblical scenes and ancient mythology. He tells his stories in a manner that is both realistic and original. His landscapes of antiquity are often arranged with groups of figures in splendid dress and rich colours ("Odysseus and Nausicaa", various versions are at Brunswik, Augsburg, Munich; ill. p. 100).
Illustration:
100 Odysseus and Nausicaa, 1619

LA TOUR Georges de
1593 Vic-sur-Seille (near Nancy) – 1652 Lunéville
Even in his lifetime La Tour must have been one of the most admired painters. He was ennobled, appointed "peintre du Roi", lived a luxurious life, had powerful patrons and so was able to charge enormous fees (such as for his "Peter Denying Christ", Nantes, Musée des Beaux-Arts, 1650). This is especially surprising as he never left his home ground, except for a brief visit to Paris and a still disputed journey to Rome, and yet he produced up-to-date work without subordinating himself to modish tendencies. He soon fell into oblivion after his death, until the revival of his work in the 1920s when artists of the New Objectivity (Neue Sachlichkeit) mistakenly thought they had discovered in him an artistic predecessor of their own concepts.
 Only about twenty of his works survive, and these can be divided into his early stylised "day pieces" and the later "night pieces". But both attribution (he only rarely signed his work) and chronological order must remain questionable. Unlike the Utrecht Caravaggisti, La Tour, who was probably introduced to Saraceni, Caravaggio or Gentileschi by his colleague Leclerc, gave less and less attention to accurate detail. His strange lighting effects, particularly in his late work, do not create blurred forms but instead always sharp contours. His figures, even when only barely and in part illuminated, have an extraordinary plasticity. In a work like the "The Card-Sharp with the Ace of Spades" (ill. p. 44) the figures seem to embody an inscrutability which is further enhanced by the enamel-like, opaque painting technique.

Illustrations:
44 Hurdy-Gurdy Player, c. 1620–1630
44 The Card-Sharp with the Ace of Spades, c. 1620–1640
45 St Sebastian Attended by St Irene, c. 1634–1643

LE BRUN Charles
1619 Paris – 1690 Paris
Having been the pupil of Perrier and Vouet, Le Brun was appointed "peintre du Roi" at the age of eighteen and received his first commissions from Cardinal Richelieu in 1640. Two years later he went with Poussin to Rome, where he studied and copied the works of Reni, the Carraccis, Raphael and Cortona. After returning to Paris in 1646 he soon developed his own style and was commissioned to decorate various great houses (Hôtel Lambert, Hôtel Nouveau), became co-founder of the Académie Royale in 1648 and there held the first of his famous "leçons" in the same year.
 His contact in 1657 with the government minister Fouquet resulted in the commission for the design of decorations in the Vaux palace (ceiling and wall frescos, 1658) and his appointment as director of the Gobelins manufactory. His introduction at court by Mazarin in 1660 brought him many commissions and the appointment as "first court painter" (1662). As the virtual dictator of the arts, Le Brun also designed furniture of massive silver, triumphal arches, fireworks and catafalques.
 Twenty years later he worked with his assistants on the decorations of the Petit Galérie des Louvre, designed decorations for Versailles, where he also decorated the Grand Escalier (1674–1678, destroyed) and decorated Colbert's Sceaux palace (destroyed) and Marly (destroyed). Le Brun, who in his lifetime was the most comprehensive, famous and influential artist of his epoch, is almost forgotten today.
Illustrations:
54 The Martyrdom of St John the Evangelist at the Porta Latina, c. 1641/42
54 Chancellor Séguier at the Entry of Louis XIV into Paris in 1660, 1660

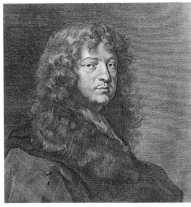

LELY Peter

(Pieter van der Faes)
1618 Soest (near Utrecht) –
1680 London
After studying in Haarlem, Lely
travelled to England in 1641 when
William of Orange married Mary of
England; he obtained access to the
court by painting the bridal couple.
He also was in the service of the Earl
of Northumberland, copying paint-
ings by van Dyck for him. This work
was to have a key influence on his
style. Lely also admired the work of
Dobson and Fuller, as can be seen
from his portraits of the "Duke of
York" (London, Syon House) and the
"Children of Charles II" (Petworth).
In 1656 he was given leave to visit
Holland; the effect was the replace-
ment of the van Dyck elegance of his
painting with Flemish elements, such
as landscape backgrounds in his por-
traits. Charles II appointed him princi-
pal painter in 1661 at a considerable
salary, and at the time of the Restora-
tion Lely dominated Stuart portrait
painting. During this period he paint-
ed his best work, including portraits
of ten ladies of the court known as
the "Windsor Beauties", 1662–1665
(Hampton Court). His late work is
characterised by a velvety chiaroscuro –
again close to van Dyck's work – and
looser brushwork. His success was
crowned by the bestowal of a knight-
hood in 1680.
Illustration:
56 Henrietta Maria of France,
Queen of England, 1660

LE NAIN Louis
c. 1593 Laon – 1648 Paris
LE NAIN Antoine
c. 1588 Laon – 1648 Paris

LE NAIN Mathieu
1607 Laon – 1677 Paris
The three brothers, who all used the
same signature on their work and there-
fore represent an attribution problem
to this day, probably trained under an
unknown Dutch master in Laon and
then settled in Paris.
Louis, also called "Le Romain" be-
cause of the Italian influence in his
style, was probably artistically the
most important of the three. Starting
with the narrative genre of the so-
called "Bambocciades", he developed
an individual manner of portraying
rural life ("Peasants at their Cottage
Door", ill. p.43). His work is
marked by sparse but cleverly used
coloration in tones of brown and grey
and an atmosphere of solemnity and
peace.
Antoine, master painter to the
Abbey St Germain-des-Prés from 1629,
showed the Dutch influence most. He
preferred the small format, painting
single and group portraits in a strong,
dramatic manner ("Family Meeting",
Paris, Louvre, 1642). In 1629 he be-
came a citizen of Paris, where the three
unmarried brothers amassed a consider-
able fortune, appointing each other
heirs to their estates. He and his
brother Louis were founding members
of the Academy (1648).
Mathieu seems to have concentrated
on religious subjects, such as "The Na-
tivity" (Paris, Louvre). Van Dyck's in-
fluence is apparent in such works as
the "Tric-Trac Player" (Paris, Louvre),
whose elegance stands out against the
rustic pictures of Antoine and Louis.
On the death of his two brothers
Mathieu completed their unfinished
works, adding to the already existing
difficulty of distinguishing between
them.
Illustrations:
43 La Charette (The Cart), 1641
43 Peasants at their Cottage Door,
undated

LE SUEUR Eustache
1616 Paris – 1655 Paris
The decoration of the Hôtel Lambert
in Paris announced a new style which
was established by Le Sueur in the
1640s. While his early mythological
paintings from 1644 still owed much
to his master and friend Vouet, whose
workshop he entered at the age of fif-
teen and with whom he had painted
the ceilings in the Cour des Aides and

the Hôtel Bouillon, his later work,
such as "Melpomene, Erato and Polym-
nia" (ill. p.55) or "Phaëthon in the
Chariot" (1647–1649) were strongly
influenced by Poussin. The academic
classicism of Le Sueur, who also made
Gobelin designs after Raphael's loggia
frescos, is shown clearly in his 22 pan-
els on the life of St Bruno for the Char-
treuse de Vauvert (1645–1648). He
often collaborated with his brothers
Pierre, Antoine and Philippe, and at
times was also assisted by his brother-
in-law, Thomas Goussé. Le Sueur, who
was one of the founders of the
Academy in 1648 and was appointed
court painter in the same year, com-
bined cool clarity with an almost sen-
timental sensitivity, detached dignity
and skill at conveying the idea of
movement.
Illustration:
55 Melpomene, Erato and Polymnia,
c. 1652–1655

LEYSTER Judith
(also: Leijster)
1609 Haarlem – 1660 Heemstede
With her father, a Haarlem brewer,
Judith came to Utrecht in the 1620s.
There she was introduced to the charac-
teristic handling of light by the
Utrecht Caravaggisti, such as Hont-
horst and Terbrugghen. In about 1630
she was probably a pupil of Frans Hals
in Haarlem, whose style she followed in
her portraits and genre scenes, but
giving the impression of some super-
ficiality compared with her mentor.
In 1636 she married the genre painter
Jan Miense Molenaer and achieved for a
brief period a personal note with her
small multi-figured genre scenes and
her preference for light blue and light
grey tonality.
Illustration:
123 Carousing Couple, 1630

LISS Johann (also: Jan Lys)
c. 1595 Oldenburg – c. 1629/30
Venice
His surviving works are few, the facts
about his life sparse. After an early
training by his father, he went by way
of Amsterdam, Haarlem, Antwerp and
Paris to Venice where he remained, ex-
cept for a stay in Rome of unknown
duration, until his death during the
Plague. The significance of his time in
Haarlem can be seen clearly in his
many genre scenes which show his

familiarity with late Haarlem Manner-
ism, specifically the works of Goltzius
and Buytewech. His later work in
high Baroque owed more to the young
Jordaens in Antwerp. When in Rome,
Liss became influenced by Fetti, the
Carracci and Bril, as well as by the
Caravaggists, whose ideas were already
known to him through the Flemish
branch. Poelenburg in Rome provided
a contact with mythological painting
which in Liss's work, however, always
remained bound up in landscape.
While the "Outdoor Morra-Game"
(Kassel, Staatliche Kunstsammlungen,
c. 1622) still showed the Dutch genre
painter, his late religious work, such as
the altarpiece with the "Inspiration of
St Jerome" (Venice, San Niccolò da
Tolentini), characterised by its flaky-
loose brushwork and light coloration,
was to become significant for 18th-cen-
tury Venetian painting.
Illustration:
58 The Death of Cleopatra,
c. 1622–1624

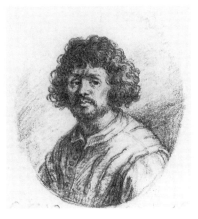

LORRAIN Claude
(Claude Gellée, called: Le Lorrain)
1600 Chamage (Lorraine) – 1682 Rome
At the age of fourteen Lorrain came to
Rome and, while working in artists'
studios, came to the notice of Agostino
Tassi, the landscape painter, who gave
him lessons. Except for a period in
Naples (1619–1624) and in his home
country (1625–1627), he always re-
mained in Rome. There he painted
frescos of landscapes in the Palazzo
Crescenzi and Palazzo Muti. He be-
came a member of the Accademia di
San Luca in 1634, and three years later
was regarded as the leading landscape
painter in Rome. He attracted the at-
tention of the leading nobility and
church dignitaries. Amongst others,
the King of Spain commissioned seven
religious paintings for his palace Buen
Retiro. However, all his life his spe-
ciality remained the landscape in
various forms, presenting it as veduta,
as mythological scene and as a stage for
stories from the Old Testament. His
figure representation, influenced by the
so-called multi-figured "bamboc-
ciades", was not very adept and often
not carried out by himself. His land-
scapes, unlike those of Poussin, are char-
acteristic in their relaxed, peaceful air,
and painted in a large range of muted
tones. With their bright atmosphere
and their use of pieces of architecture of

antiquity as items of stage scenery they set an example for classical landscape painting in the 18th and 19th centuries.

Illustrations:

18 Moses Rescued from the Waters, c. 1639/40
50 Landscape with Cephalus and Procris Reunited by Diana, 1645
50 Landscape with Apollo and Mercury, c. 1645
51 Seascape in Sunrise, 1674

LOTH Johann Carl
(also: Lotto, Carlotto)
1632 Munich – 1698 Venice

After receiving instruction from his mother and father Johann Ulrich, who himself had been inspired by Caravaggio and Saraceni in Rome, Loth went to Italy in 1653, stopping first in Rome. There he studied the works of Caravaggio and his successors, and proceeded to Venice where in 1663 he was given the title "gran miniatore" by his fellow artists. His lively manner of depiction was to set an example for southern German Baroque painting, introduced by his pupils Rottmayr, Strudel and Saiter. This style already marked his work in the churches of Venice and the Terra Ferma. Loth's contact with the Venetian Tenebrosi (so-called because of their contrasting use of light and shade and sombre coloration) is apparent in his "Death of St Andrew Avellino" (Munich, Theatinerkirche, 1677). This work also shows his own, closely human approach to the subject. For his mythological and religious scenes he favoured large-figured compositions, defined and dominated by the figures in the foreground. Late works, such as "St Joseph and the Child Jesus, God in his Glory, and Mary" (Venice, San Silvestro, 1681), show his great talent in fusing earthly and heavenly elements to achieve a realistic whole. Loth, who was greatly esteemed in his lifetime, is now largely, though unfairly, forgotten.

Illustration:

60 Mercury Piping to Argus, before 1660

METSU Gabriel (also: Metzu)
1629 Leiden – 1667 Amsterdam

Metsu received early instruction from his parents who were both painters. Later he probably studied under Nicolaus Knüpfer in Utrecht, as did Steen.

Initially he worked in Leiden, where he became a founding member of the Lukas Guild in 1648, but moved to Amsterdam in 1657. His early work comprised historical, biblical, mythological and allegorical works influenced by the Rembrandt school. After 1650 he concentrated on interiors and genre scenes, depicting refined middle-class life in warm colours and soft outline. Under the influence of the Leiden fine manner he later paid great attention to detail, particularly rich fabrics, without becoming over-polished.

Illustration:

136 The King Drinks (Beanfeast), c. 1650–1655

MIERIS Frans van the Elder
1635 Leiden – 1681 Leiden

Mieris, whose father was a goldsmith and diamond cutter, was first apprenticed to a glass painter. He then studied under Dou, the grand master of the very detailed style of painting developed in Leiden, who called him "a prince amongst his pupils". In 1655 he became a member of the Lukas Guild, in 1658 its deacon. He never left Leiden, even refusing an invitation from Archduke Leopold William, governor of Holland, to work at the court in Vienna. He specialised in portraiture and small-sized domestic scenes as well as conversation pieces with an erotic overtone. His cabinet pictures are considered his best work with their delicate handling of light and colour and precise rendering of detail ("House Concert", Schwerin, Gemäldegalerie; "Oyster Feast", St Petersburg, Hermitage).

Illustration:

136 Carousing Couple, undated

MIGNARD Pierre
1612 Troyes – 1695 Paris

At the age of twelve Mignard entered the workshop of Bouchers in Bourges, then continued his studies at Fontainebleau, decorating the chapel of the palace Coubert en Brie when aged fifteen. After studying several years under Vouet in Paris, he went to Rome in 1636, where he worked first as a copyist but soon received commissions for portraits, altarpieces and room decorations. His Madonna pictures, known as "Mignardes", met popular taste in their soft, light manner. The portrait

of Pope Alexander VII, painted in 1655 after visits to Mantua, Parma, Bologna, Modena and Venice, showed his great skill in characterisation. On his return to Paris in 1660, his artistic and stylistic approach brought him the enmity of Le Brun but also a great number of commissions, including portraits of the Queen Mother, Mazarin and King Louis XIV. In collaboration with his friend Dufresnoy, he painted the much admired decorations in the cupola of Val-de-Grâce in 1663. In 1664 he was appointed director of the Académie de St Luc, and he was ennobled in 1687. On the death of Le Brun in 1690 he became "principal court painter" and director of the Royal Academy.

Illustration:

53 Girl Blowing Soap Bubbles (Marie-Anne de Bourbon), 1674

MOMPER Joos de
(also: Joost, Joes, Josse, Jodocus de Momper)
1564 Antwerp – c. 1634/35 Antwerp

As Bloemaert's influence in Utrecht reached far into 17th-century Baroque, so did Momper's in Antwerp. He was a member of an artistic family and was trained by his father Bartholomew. In 1581 he joined the Lukas Guild and became its principal in 1611. It can be assumed that Momper went to Italy and that this journey also took him to Treviso, where the Flemish landscape painter Lodewijk Toeput (Pozzoserrato) worked. In 1594 he was engaged for the decorations for Archduke Ernst's reception in Antwerp. Momper's landscapes, whose subject is frequently mountain scenery, were reminiscent of Pieter Brueghel and followed the usual

colour scheme: brown foreground, grey-green middle ground and blue background. But he avoided all Mannerist artificiality, letting nature speak for itself, as did his successor Seghers. Momper also painted summer and winter scenes of his home country.

Illustration:

93 Winter Landscape, c. 1620

MURILLO Bartolomé Esteban
c. 1617/18 Seville – 1682 Seville

Murillo was the youngest of fourteen children of a doctor in Seville, where he probably remained all his life, a visit to Madrid in 1642 being unsubstantiated. Orphaned at the age of ten, he was apprenticed early to a painter by the name of Castillo. He gained sudden fame with the cycle of paintings he did for the cloisters of the the Franciscan monastery in Seville (1645/46). While his earliest works show him working in a tenebrist style derived from Zurbarán and then in the style of Ribera with a preference for cool colours, he soon developed his characteristic style of soft forms and warm colours, which owed something to the works of van Dyck, Rubens and Raphael which he had studied in local collections. Today considered somewhat sentimental, his genre scenes nevertheless represent a new way of perception ("Grape and Melon Eaters", Munich, Alte Pinakothek; "Little Fruit Seller", ill. p. 69). When Hegel said about Murillo's beggar children that they sat on the ground "contented and blissful almost like Olympian gods", he cleared them of pathos, and so brought out the sensitisation for simple objects and feelings which would first find full expression in the 18th century. Murillo's many devotional pictures, particularly of the Madonna, reflect a piety which was sensitive and close to the people. Apart from this new approach he commanded a brilliant painterly technique, which made him the head of the Seville school. He also founded the Academy of Seville and became its president.

Illustrations:

24 The Beggar Boy, c. 1650
25 The Pie Eater, c. 1662–1672
67 Annunciation, c. 1660–1665
68 La Immaculada, undated
68 The Toilette, c. 1670–1675
69 The Little Fruit Seller, c. 1670–1675

OSTADE Adriaen van
(Adriaen Hendricx)
1610 Haarlem – 1685 Haarlem
The father, Jan Hendricx, came from Ostade near Eindhoven, and his sons Adriaen and Isaac adopted this name as painters. In 1627 Adriaen was a pupil of Frans Hals in Haarlem (as probably was the somewhat older Adriaen Brouwer), where he joined the Lukas Guild in 1634. He was one of the most popular Dutch painters, specialising from the start in genre painting of peasant life. Initially he painted small pictures showing humble interiors and shabby inns with peasants in dim lighting carousing or brawling. Later the tones became warmer, the interiors more pleasant, and open-air scenes were added, including genre portraits of organ-grinders and pedlars.

From about 1650 this tendency continued, the work showing greater accuracy and lighter colouring. One could say that the development ran from Rembrandtesque chiaroscuro towards Delft genre painting. The exaggerated manner of his early work had little to do with Dutch peasant life but was meant to make the town-dweller laugh. Ostade's most important pupils were his younger brother Isaac, and Steen.
Illustration:
125 Peasants Carousing in a Tavern, c. 1635

POST Frans
1612 Leiden – 1680 Haarlem
Post is unique amongst Dutch painters in that he depicted almost exclusively Brazilian landscapes, being the first European to paint views of South America. From 1637 to 1644 he accompanied Prince Johann Moritz von Nassau-Siegen, the governor of the region colonised in 1630 by the Dutch West India Company. Post spent most of his time in Pernambuco and the delta region of the Rio São Francisco.

On his return to Haarlem, where he became a member of the Lukas Guild in 1646, he painted about a hundred pictures of his impressions of his travels, using his sketches and drawings, and also improvising from memory. These works were exotic views of grey rivers coursing through green, hilly landscapes, with realistic renderings of the flora and fauna, and natives in traditional costume in their villages under palm trees. A bluish-green tone predominated, and he retained the traditional pattern of Dutch view painting.
Illustration:
124 Hacienda, 1652

POTTER Paulus
1625 Enkhuizen – 1654 Amsterdam
Potter was probably trained by his father Pieter, a landscape and still life painter, who had moved from Enkhuizen to Amsterdam. He became a member of the Delft Lukas Guild in 1646, lived sporadically in The Hague, but the last two years of his life again in Amsterdam. Potter is famous for his animal pictures, mostly sheep, goats and cows grazing peacefully and in complete harmony with the landscape. He is regarded as the actual founder of animal painting, in that his animals become the subject rather than playing an incidental role. His life-size "Bull" (The Hague, Mauritshuis) is still admired today. Although a painter of realism, he also adopted elements of Italianised pastoral landscape, probably attributable to his collaboration with Karel Dujardin.
Illustration:
130 Peasant Family with Animals, 1646

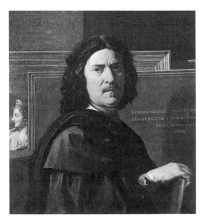

POUSSIN Nicolas
c. 1593/94 Villers-en-Vexin (Eure) – 1665 Rome
The son of an impoverished family, Poussin received some early training from the painter Varin, who was travelling through his town. More thorough training followed in Paris, 1612–1624, as assistant to Champaigne and pupil of the Mannerist Lallemand, reinforced by independent study of predominantly Italian art in the Royal Collections. After several unsuccessful attempts, he finally went to Rome in 1624 with his patron and supporter Marino. The latter was a celebrated poet who introduced Poussin to ancient mythology and Ovid's works. Marino wrote an epic entitled *Adone* (1623) which was illustrated by Poussin. In Rome he worked for some time with Domenichino and developed his own style by exploring and perfecting Annibale Carracci's ideas on classical landscape painting.

Already in his thirties, his palette became lighter and he showed a tendency to poetical and idealised representation of subjects from antiquity and the Bible ("The Inspiration of the Epic Poet", Paris, Louvre, 1630; "Martyrdom of St Erasmus", Rome, Musei Vaticani, 1629). His knowledge of the literary and pictorial traditions of antiquity and of the Renaissance, and his contact with contemporary intellectuals, plus his knowledge of history, all combined to turn Poussin into the prototype of a classical painter. With his Arcadian yearnings, his idealisation of friendship and manly virtues, and his predilection for sentimental resignation, he set a course for the moral and doctrinal tendencies of future generations of painters. During a brief stay in Paris, 1640–1642, he painted the Hercules scenes for the Louvre at the invitation of Richelieu and Louis XIII. Finding the artistic climate unfavourable, he returned to Rome and friends such as Dughet and Lorrain, and never left the city again.
Illustrations:
15 Triumph of Neptune and Amphitrite, 1634
17 The Poet's Inspiration, c. 1630
47 Midas and Bacchus, c. 1630
47 Landscape with Three Men, c. 1645–1650
48 Echo and Narcissus, c. 1627/28
48 Moses Trampling on Pharaoh's Crown, 1645
49 St Cecilia, c. 1627/28

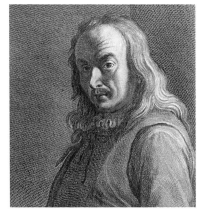

PRETI Mattia
(called: Il Cavaliere Calabrese)
1613 Taverna (Calabria) – 1699 Valletta (Malta)
Preti joined his brother in Rome in 1630. He probably studied in Modena, Parma, Bologna and Venice until 1641, when he returned to Rome to become a member of the Maltese Order. Initially influenced by the Roman High Baroque, including Lanfranco and Cortona ("Alms-Giving of St Charles Borromeo" for San Carlo ai Cartinari, c. 1640), he developed a vigorous style of his own which reflected the influence of Guercino combined with a Venetian treatment of colour, as shown in his frescos in Sant' Andrea della Valle (1651) and San Biago (Modena, 1653–1656). Between 1656 and 1659 Preti produced votive pictures against the Plague in Naples, using sombre colours which show his great skill at rendering the human figure. "Absalom's Feast" (Naples, Galleria Nazionale, before 1660) and "Belshazzar's Feast" (also Naples, before 1660) typify Preti's complicated method of composition and his startling light effects. Preti spent his last years as a Knight Hospitaller in Malta where he achieved a most touching depiction of human deeds and sufferings with his "Scenes from the Life of St John the Baptist" for San Giovanni (Valletta).
Illustration:
39 The Tribute Money, c. 1640

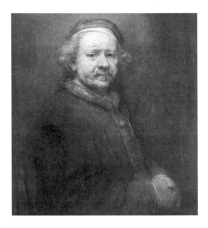

REMBRANDT
(Rembrandt Harmensz van Rijn)
1606 Leiden – 1669 Amsterdam
Rembrandt, the son of a miller and a baker's daughter, was originally intended to become a scholar. He went to Latin School and then enrolled at the University of Leiden. After only a year he left to become apprenticed from 1622 to 1624 to a mediocre Leiden painter, Jacob van Swanenburgh. More important for his artistic development, however, was the short period of about six months that he spent training under Pieter Lastman in Amsterdam. In 1625 he began a working association with his friend Jan Lievens in Leiden, finally moving to Amsterdam in 1631/32.

In the history of Dutch painting this date represents an important milestone, as Rembrandt was to become the incomparable representative of Amsterdam art. He soon established himself in Amsterdam, received many commissions and opened a large workshop. In 1634 he married Saskia, a lawyer's daughter, who brought a considerable dowry into the marriage. In 1639 he bought a large house, never quite paid for, which he filled with works of art and curios. Soon his passion for collecting exceeded his finances. In 1642, the year he painted "The Night Watch" (ill. p. 119), Saskia died, and from

1649 he lived with Hendrickje Stoffels whom he could not marry without losing Saskia's legacy to their son Titus. In 1656 he went bankrupt, and his house and all possessions were put up for compulsory auction. Rembrandt spent his final years in poverty and isolation in rooms on the outskirts of Amsterdam, his powers of creation undiminished.

Rembrandt was the most universal artist of his time and he influenced painting for half a century, irrespective of schools or regional style. From his many fields of activity his pupils developed their own specialities, ranging from *trompe l'œil* painting to the very detailed Leiden style. Unlike most Dutch painters of the time, who worked in fairly narrow fields, Rembrandt depicted almost every type of subject. Although Amsterdam's leading portraitist for a decade ("Jan Six", Amsterdam, Foundation Six), also doing group portraits ("The Staalmeesters", ill. p. 122), he was a painter of numerous biblical scenes ("The Sacrifice of Isaac", St Petersburgh, Hermitage), of mythological works ("Philemon and Baucis", Washington, National Gallery) and landscapes ("Landscape in Thunderstorm", Brunswik, Herzog-Ulrich-Museum) as well as still lifes ("The Slaughtered Ox", ill. p. 121). In his work, branches of painting often overlapped, as for example in the group portrait "The Night Watch", where he took liberties with a number of rules.

Rembrandt's fame rests on his continual development of pictorial devices and unvarying excellence of execution (unlike the works of Rubens, many of which were left in part to workshop routine), as well as on his brilliant handling of light and shade and his ability to suggest states of mind through facial expression.

Apart from his greatness as a painter he was a powerful draughtsman and etcher. About 300 of his etchings survive. In this field he extended the technical and artistic possibilities, for example introducing the chiaroscuro effect, raising it to an art form in its own right. Amongst his approximately 1500 drawings, the landscape scenes are particularly captivating in their serenity and harmony despite the spontaneous handling of line.
Illustrations:
78 Self-portrait with Stick, 1658
79 Hendrickje Bathing in a River, 1654
118 The Artist in his Studio, c. 1626–1628
118 The Anatomy Lesson of Dr. Nicolaes Tulp, 1632
119 The Night Watch (The Company of Captain Frans Banning Cocq and of Lieutnant Willem van Ruytenburch), 1642
120 Self-portrait aged 63, 1669
121 The Descent from the Cross, 1633
121 The Slaughtered Ox, 1655
122 The Syndics of the Amsterdam Clothmakers' Guild, 1662
122 Aristotle Contemplating the Bust of Homer, 1653

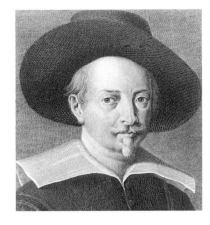

RENI Guido
1575 Calvenzano – 1642 Bologna
The son of a musician, Reni was also musically gifted, but began his training as a painter at the age of nine in the workshop of Calvaert, then at thirteen in that of the Carracci brothers. In 1598 he was already involved in the facade decoration of the Palazzo Pubblico in Bologna. He went to Rome with Albani in 1602; he returned to Bologna and again left for Rome in 1605, where he was to spend many years. His patron Cardinal Caffarelli-Borghese secured innumerable commissions for him, causing him to employ assistants. Later, he went in for mass production to pay for his passion for gambling.

In 1622 he returned to Bologna and became the leader of the Bolognese school on the death of Lodovio Carracci. In early works, such as the "Coronation of Mary, with Saints" (Bologna, Pinacoteca Nazionale, 1595), Reni combined Mannerist and also northern elements with those of the Roman High Renaissance, that had been revived by the Carracci. The "Crucifixion of St Peter" (Rome, Pinacoteca Vaticana, 1603) may be seen as an example of his Caravaggist period, which was followed by the development of a personal style around 1608 (Samson frescos, Vatican). His most celebrated work, "Aurora", a ceiling fresco in the Palazzo Rospigliosi, 1612–1614, combines a clear palette and harmonious composition with masterly figure representation. His Madonna pictures (e.g. "Madonna del Rosario", Bologna, Pinacoteca Nazionale), to which Reni owed his fame in his lifetime and until the 19th century, no longer appeal today with their grand and monumental perfection.
Illustrations:
34 The Massacre of the Innocents, 1611
34 The Baptism of Christ, c. 1623

RIBERA Jusepe de
(also: José de Ribera; called: Lo Spagnoletto)
1591 Jàtiba (near Valencia) – 1652 Naples
In Valencia Ribera was trained by Ribalta, who introduced him to his tenebrism, a technique of painting in a dark, low key, characterised by contrasting use of light and shade. On his

travels to Parma, Padua and Rome, Ribera became acquainted with the works of Raphael, Correggio, Titian and Veronese. In 1616 he settled in Naples and developed a style which owed much to Caravaggio. There he became painter to the Spanish Viceroy and later to his successor, the Duke of Monterrey, who procured for him commissions from the Augustine monastery in Salamanca ("Nativity", "Pietà", "The Virgin with Saints Antony and Augustine", 1631–1635). He subsequently abandoned the dark and sombre style, finding new ways of treating light and using brilliant colours (12 pictures of the prophets, Naples, Museo Nazionale di San Martino, 1637/38). His "Boy with a Clubfoot" (ill. p. 61) is typical of his more mature style, both thematically and in terms of pictorial composition. During this period of realism he had a leaning towards harrowing subjects, the crippled and malformed. Italian, Spanish and Flemish painters were engaged in his workshop, and while Ribera was of particular importance to Neapolitan art, great painters, such as Rembrandt and Velázquez, also found him an inspiration.
Illustrations:
23 The Holy Family, 1639
61 The Boy with a Clubfoot, 1642
62 Archimedes, 1630
62 Martyrdom of St Bartholomew, 1630
63 St Christopher, 1637

RIGAUD Hyacinthe
(Jacinto Rigau y Ros)
1659 Perpignan – 1743 Paris
Rigaud's surviving business records reveal that he had an extensive workshop and employed speciality painters for

flower decorations, textiles and background battle scenes and landscapes. After his early training in Montpellier and Lyon, Rigaud went to Paris in 1681, where already in 1682 he aroused Le Brun's interest with his historical painting "Cain building the City of Enoch".

Le Brun urged him to take up portrait painting, and Rigaud soon became popular, and also known in court circles, where his van Dyck-inspired manner was met with approval under the absolutist monarchy of Louis XIV. Despite the fact that he used assistants, Rigaud proved to be an acute reader of character, as is evident in his portraits of "King Philip V" (Madrid, Prado, 1701) and that of "Elisabeth Charlotte, Duchess of Orléans" (Brunswik, Herzog-Anton-Ulrich-Museum, 1713). In his famous portraits of the "Sun King", however, he showed his mastery as a colourist and ability to satisfy ceremonial demands in pose and expression.
Illustration:
55 Portrait of Louis XIV, 1701

ROSA Salvator
1615 Arenella (near Naples) – 1673 Rome
Rosa was one of the most versatile talents of his period, working as painter, poet, etcher, actor-musician and composer. After an apprenticeship with his uncle and brother-in-law he studied under Falcone, in whose style he later painted the wild battlepieces which made him famous ("Battle Scene", Florence, Palazzo Pitti, c. 1640). In his bizarre scenes of witchcraft and dramatic landscapes he showed an emotional and personal world which was the antithesis of the Classical stereotype.

In the second half of the 1640s Rosa began to paint allegories of death, which have only now found due recognition (*L'umana fragilità*, Cambridge, Fitzwilliam Museum, 1651/52). He left Rome for Florence in 1640, where he lived for nine years and founded the Accademia dei Percossi, where he gathered a circle including painters of all kinds. Rosa was highly educated, and his intellectualism found expression in his philosophically condensed art and in the complex thoughts found in many of his pictures.
Illustration:
39 Democritus in Meditation, c. 1650

ROTTMAYR Johann Michael
1654 Laufen (Upper Bavaria) –
1730 Vienna
Trained by his mother, Rottmayr received decisive inspiration from Loth, in whose workshop in Venice he worked from 1675 to 1688. He came through Passau and reached Salzburg in 1689 (mythological ceiling frescos, Archbishop's Palace). During this period he also produced panel paintings which still owed much to the Venetian "tenebrosi", but he soon evolved his own powerful, drastic style with popular appeal. He visited Frain (in Moravia) and Prague, and then moved on to Vienna. While there he succeeded in getting commissions around Austria and southern Germany. Particularly in his fresco painting Rottmayr was successful in freeing himself from the illusionist manner of presenting architecture, as practised by Pozzo, for example, and in discovering illusionist devices in the field of colour and figure composition (Apotheosis in the cupola of the ancestral hall of Vranov castle, Frain, 1696).

Like Altomonte, Rottmayr prepared the way to a new form of monumental painting by closing up all ceiling space and introducing a coloration which foreshadowed the Rococo. The finest examples of this are the ceiling frescos of the castle at Pommersfelden (1716–1718), those in the church of Melk monastery (1716–1722), and the Karlskirche in Vienna (1726).
Illustration:
60 St Benno, 1702

RUBENS Peter Paul
1577 Siegen (Westphalia) –
1640 Antwerp
His father was a Calvinist and so had to live in exile from Antwerp, so Rubens grew up in Cologne. On his father's death, his mother returned to Antwerp in 1587, where he was brought up and educated in the Catholic faith. At the age of fourteen he entered the household of a Flemish princess as a page, and later studied under Tobias Verhaecht, a landscape painter, then under Adam van Noort, and the last four years until 1600 under Otho Venius. While still working in the latter's workshop he was accepted as master in the Lukas Guild in 1598. In 1600 he visited Italy, and while in Venice attracted the attention of Duke Vincenzo Gonzaga, finally taking up residence at his court in Mantua. Rubens accompanied the duke on his travels to Florence and Rome, and was sent by him with gifts and paintings on a diplomatic mission to Spain in 1603. In Venice, Rome and Genoa, Rubens copied Titian, Tintoretto and Raphael, and also the works of contemporaries, including Caravaggio, the Carracci and Elsheimer. Having already executed several large commissions in Italy, he returned as a successful painter to Antwerp in 1608.

There he was appointed court painter in 1609 to the Regent Albert and Isabella, receiving an annual salary of 500 guilders, and was exempted from the guild's restrictions and taxation. He received permission to establish himself outside the regent's residence, which was in Brussels, and married Isabella Brant, daughter of the town clerk (ill. p.97). In 1610 he built himself a large house and studio. During his Antwerp period, until 1622, he received a flood of commissions from the church, state and nobility, employing in his large workshop many pupils who later became famous to help with the work. They included van Dyck, Jordaens, Snyders and Cornelis de Vos. The Gobelin factory produced tapestries after his sketches, and engravers used his paintings, disseminating the "Rubens style" all over Europe. His largest commission was for a series of 21 paintings of the life of the Queen Dowager Marie de'Medici for the Palais Luxembourg in Paris, for which he received a fee of 20.000 ducats (ill. p.98).

Between 1623 and 1631 he travelled frequently on diplomatic missions, visiting London and Madrid, where he received peerages from both Charles I of England and Philip IV of Spain. The most important painter of the International Baroque thus became the first artistic aristocrat, whose fame and wealth constantly increased. Isabella Brant died in 1626; a year later he sold his great art collection, which included works by Raphael, Titian, Tintoretto and himself, for 100.000 guilders to the Duke of Buckingham, and in 1630 he married the 16-year-old Helene Fourment, whom he immortalised in many portraits. After the death of Queen Isabella he gradually withdrew from court and bought Steen castle near Mechelen. His last big commission was the decoration of the Spanish king's hunting lodge, Torre de la Parada near Madrid, which he designed but was no longer able to carry out himself.

Rubens, the great Baroque master, successfully brought together in his style northern and Flemish elements of this period with those of Italy. His influence on the painters of his century was enormous, as it was on sculpture and architecture. His sometimes gigantic "pictorial inventions", which do not always appeal to today's taste, were pioneering in composition, design and the art of colour, taking as subject all major themes of painting: biblical scenes and lives of the saints, mythology and subjects of antiquity, and also peasant scenes, landscapes and portraiture. "My talent is such", he wrote, "that no undertaking, however large and varied in theme, has ever gone beyond my self-confidence."
Illustrations:
76 Portrait of Susanne Fourment (La chapeau de paille), c. 1625
80 The Little Fur (Helene Fourment), after 1635
81 Venus at a Mirror, c. 1615
96 The Four Philosophers, c. 1611
96 Stormy Landscape with Philemon and Baucis, c. 1620
97 Rubens with his First Wife Isabella Brant in the Honeysuckle Bower, c. 1609/10
98 The Landing of Marie de' Medici at Marseilles, c. 1622–1625
98 The Rape of the Daughters of Leucippus, c. 1618
99 Hippopotamus and Crocodile Hunt, c. 1615/16
100 The Three Graces, 1639

RUISDAEL Jacob van
(also: Ruysdael)
c. 1628/29 Haarlem – 1682 Haarlem
Ruisdael's father was a frame-maker and art dealer. He probably studied under his uncle Salomon or the landscape painter Cornelis Vroom. He was already accepted into the Lukas Guild in Haarlem at the age of 20, but also seems to have studied medicine and to have practised it although he did not receive his doctorate until 1676. Ruisdael belonged to the greatest of Dutch landscape painters and was certainly dominant in this field in the second half of the century. During his early period he mostly painted dune landscapes in the surroundings of Haarlem. After 1650 he visited with his friend Berchem the eastern parts of Holland and the wooded, hilly regions of the Rhineland. His range from then on included hilly landscapes traversed by rivers, with mighty, gnarled oaks, picturesque waterfalls and old water mills, often spanned by clouded sky. These works were to have a particularly strong influence on the Romantics. In the 1660s, after Ruisdael had settled in Amsterdam, he also painted panoramic views of cities, winterscapes and vedutas. His most important pupil was Hobbema.
Illustrations:
84 The Windmill at Wijk bij Duurstede, c. 1670
133 Two Watermills and an Open Sluice near Singraven, c. 1650–1652

RUYSDAEL Salomon van
(also: Ruisdael)
c. 1600–1603 Naarden –
1670 Haarlem
Ruysdael, the uncle of Jacob van Ruisdael, came to Haarlem in 1616, where he probably trained in the workshop of Esaias van de Velde, and became a member of the Lukas Guild in 1623. He must have been highly respected because he was made borough councillor, 1659–1666. His early dune and wood scenes, painted predominantly in yellow-browns and grey-greens, are reminiscent of his teacher and of the works of van Goyen.

His best works were produced after 1645: landscapes with wide, peaceful rivers, fringed with trees, on which drift boats or ferries, houses and spires, and a deep blue sky with only a suggestion of cloud formation on the far horizon.
Illustration:
115 The Crossing at Nimwegen, 1647

SAENREDAM Pieter Jansz.
(also: Zaenredam)
1597 Assendelft – 1665 Haarlem
The son of a famous engraver, Saenredam worked for ten years in the workshop of Frans Pietersz Grebber before becoming independent in 1623. He specialised in architectural views and especially in church interiors, establishing this theme as a branch of painting in its own right in Dutch art. He minutely prepared each work with sketches and drawings, and with his accurate representation of perspective and proportion, and skilled handling of light effects, achieved a wonderful suggestion of lightness and spaciousness with only a few colour tones. Saenredam also produced exterior views, faithful representations of actual buildings, whose main attraction lies in their sparse linearity.
Illustration:
116 Church Interior in Utrecht, 1642

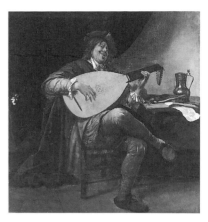

detail. Typical of his work are landscapes which are often dotted with ancient ruins or with a Noah's ark in the background, with all kinds of beasts romping about, both native and exotic. Despite their faithfulness in observation and detail, these pictures suggest in their bold coloration a paradisiacal, fairy-tale world.

Illustration:

105 Landscape with Birds, 1628

SANDRART Joachim von

1609 Frankfurt/Main –
1688 Nuremberg

Today Sandrart is less known for his painting than for his theoretical work *Teutsche Academie der edlen Bau-, Bild- und Mahlerey-Künste* [German Academy of the Fine Arts and Architecture] (Nuremberg, 1675–1679), a historically arranged compendium of great significance to German art history writings. In Strasbourg (training under Stoßkopf), Prague (assistant to Sadeler), Utrecht (working with Honthorst), London, Bologna, Venice and Rome, Sandrart had met the most famous artists of his time, including Rembrandt, Rubens and Liss. From today's point of view he seems to have had little originality, yet his contemporaries regarded him as the best German painter of his generation. His large repertoire included portraits, altarpieces, mythological and allegorical scenes as well as historical paintings.

Illustration:

59 November, 1643

SAVERY Roelant

(also: Ruelandt Savery)

1576 Kortrijk – 1639 Utrecht

In 1590 Savery came with his parents to Holland, living first in Haarlem, then in Amsterdam. This is reflected in his work, which shows Dutch and Flemish influences. He worked for the Emperor Rudolf II in Prague, 1604–1612, and in 1615/16 went to the court of the Emperor Mathew in Vienna. He then lived at Utrecht, becoming a member of the Lukas Guild in 1619. He delighted in late Mannerist extremes, taking as starting point the wild, romantic landscapes of van Coninxloo and Jan Brueghel's love of

SCHÖNFELD Johann Heinrich

1609 Biberach an der Riß –
1682 Augsburg

After an apprenticeship in Memmingen, Schönfeld went via Basle, where he studied Callot's works and the Dutch Mannerists, to Rome and Naples for further studies in 1633. In 1652 he settled in Augsburg, where he lived until the end of his life. He began to apply all he had seen and learned: the serene, classical landscapes of Nicolas Poussin in Rome, the multi-figured, lively compositions of Salvator Rosa in Naples, the fine coloration of the Venetian masters. From being a painter of small-figured, mythological and biblical scenes in broad atmospheric landscapes, Schönfeld developed under the Italian influence, and particularly the Neapolitan example, into an imaginative, original and versatile artist whose themes included mythology, triumphal processions, historical subjects, battle-pieces, genre scenes and imaginary landscapes. He also took up new subjects ("The Treasure-Hunters", Stuttgart, Staatsgalerie, 1662), developed a finely-graded, light coloration and had many followers in southern Germany. He was regarded as the most important German painter between 1630 and 1680.

Illustration:

59 Il Tempo (Chronos), c. 1645

SIBERECHTS Jan

1627 Antwerp – c. 1700–1703 London

Siberechts joined the Antwerp Lukas Guild around 1648/49. Before that he had probably visited Italy, as his early works bear a resemblance to the Italian landscapes painted by the Dutch painters Both, Berchem and Dujardin. In the 1660s his Flemish landscapes usually concentrated on a limited view, such as a meadow, a ford or a

roadside embankment, with carts, animals, peasants or servant girls in grey-green or bluish coloration and silvery light. In 1672 he went to London, where he carried out commissions for the Duke of Buckingham. In England he painted actual views of country estates. His landscapes, now in warm brown tones, began to open outwards.

Illustration:

134 Landscape with Rainbow,
Henley-on-Thames, c. 1690

SNYDERS Frans

(also: Snijders)

1579 Antwerp – 1657 Antwerp

Snyders' parents kept an inn well-known for good food, which many artists frequented. In about 1592/93 he studied under the younger Pieter Brueghel, then Hendrik van Balen. In 1602 he joined the Lukas Guild, then travelled in Italy for a time, returning in 1609.

In 1611 he married a sister of the painter Cornelis de Vos. Apart from his domestic scenes, which showed the Mannerist influence, Snyders created two new categories of painting: the hunting still life and the "larder" picture. He excelled as a painter of still lifes, often magnificent, tastefully arranged banqueting scenes in intensive colours, showing game, poultry, fruit and all kinds of tableware fit for a palace, which he sometimes further enlivened by adding living, jumping animals. Snyder transformed the still life into a lively scene, and also produced minutely observed, dramatic hunting scenes. He was one of Rubens' assistants, who employed him as specialist for animals, fruit and flowers.

Illustration:

105 Still Life, 1614

STEEN Jan

c. 1625/26 Leiden – 1679 Leiden

Steen and Ostade were the two most popular and versatile of the Dutch genre painters. Steen led an unsettled life, often moving home, but he cannot have been an undisciplined drunkard, as has often been suggested, because he produced around 800 paintings. Steen was the son of a Leiden brewer, and there he was introduced to the very detailed style of painting developed in Leiden which was to become important in his later career. He enrolled briefly at the university in 1646, probably to avoid military service. In 1648 he was one of the founding members of the guild.

He probably received his training in Utrecht and worked in the workshops of Ostade and van Goyen. In 1649 he married a daughter of van Goyen in The Hague, where he remained until 1654. He then took over a brewery in Delft, which soon failed, and then moved to Warmond near Leiden. From 1661 to 1670 he was in Haarlem, and finally settled for the last ten years of his life again in Leiden where he obtained a licence to operate a tavern. In his portrayal of merry or riotous drinking scenes, weddings, fairs and other themes drawn from popular life, he proved himself a most acute observer of this particular milieu, whose study his life and occupation had given him ample opportunity.

But he was also at home with the depiction of refined society and modish interiors. His style was never fixed, tending sometimes towards Ostade and Brouwer, then again towards de Hooch, Terborch or Vermeer. He treated human follies and weaknesses with humour and wit, revealing the hidden moral and "truth" as Molière did in his comedies.

Illustrations:

82 Rhetoricians at a Window,
c. 1662–1666

131 The Lovesick Woman,
c. 1660

131 The World Upside Down,
c. 1660

STROZZI Bernardo

(called: Il Cappuccino)

1581 Genoa – 1644 Venice

Strozzi received his early training under the Sienese painter Sorri, who introduced him to Tuscan traditions and the works of Barocci. Further influences on

his development came from Lombardian artists, notably Crespi. But it was Rubens, who came to Genoa in 1607, and the works of van Dyck that were to become the inspiration of his work in the first decade of the 17th century. This was most noticeable in his handling of colour and the amplitude of the female figure, as shown in his picture "Woman Playing the Gamba" (Dresden, Gemäldegalerie). Strozzi, who had entered the Capuchin Order at the age of 17, executed fresco paintings only in his early youth. His knowledge of the works of Caravaggio and his followers found expression in his genre scenes, which also reveal Flemish inspiration.

With his move to Venice in 1630 he entered a new creative phase which led to a simplification of composition and greater serenity ("St Sebastian", Venice, Museo Correr), during which he gradually approached the personal, free character of his mature work.
Illustration:
36 Vanitas Allegory, c. 1635

TENIERS David the Younger
1610 Antwerp – 1690 Brussels
While his father David Tenier the Elder, from whom he received his principal instruction, had been unsuccessful and was even put into the debtors' prison, Teniers the Younger became known all over Europe and amassed a considerable fortune. In 1633 he became a master in the Antwerp Guild, and in 1637 he married a daughter of "Velvet Brueghel", who brought a large dowry into the marriage. In 1645 he was elected deacon of the Lukas Guild, and in 1651 he was appointed court painter to Archduke Leopold Wilhelm and keeper of his pictures in Brussels. He painted still lifes, landscapes and portraits, but was happiest in his scenes of popular Flemish life depicting rustic interiors with card-players, village fêtes, taverns and other themes, in which he was much influenced by Brouwer.

Of particular note are his gallery pictures, in which he showed the works contained in the Archduke's collection as in a photograph. He also made small-scale copies of 246 pictures in this collection, another record which helped to retrace the fate of several Titians, Giorgiones and Veroneses.
Illustration:
125 Twelfth Night (The King Drinks), c. 1634–1640

TERBORCH Gerard
(also: Gerard or Gerrit ter Borch)
1617 Zwolle – 1681 Deventer
Terborch studied drawing under his father, then was apprenticed to Pieter de Molyn in Haarlem. In 1635 he started on his five-year travels, visiting England, Italy and France, later also Spain. On his return he worked in Haarlem, Amsterdam and Münster, where he painted "The Treaty of Westphalia" (Peace Treaty of Münster) which marked the end of the Thirty Years' War, before settling at Deventer in 1654. In his predominantly small-scale interiors and conversation pieces and in his masterly portraits, Terborch depicts the life of refined society, limiting himself to one or only a few figures and presenting sparsely furnished interiors. His pictures have an air of stillness and restraint and are characterised by a beautiful, cool tonality and an exquisite ability to render the texture of rich materials, features which point to Metsu, de Hooch and Vermeer.
Illustrations:
85 A Concert, c. 1675
127 The Card-Players, c. 1650
127 The Letter, c. 1655

TERBRUGGHEN Hendrik
(also: Hendrick ter Brugghen)
c. 1588 near Deventer – 1629 Utrecht
Terbrugghen grew up in Utrecht, where he received instruction from the late Mannerist painter Bloermaert. In 1604 he went to Italy for ten years. There he may have been in direct contact with Caravaggio, either in Rome or Naples, and also met his followers, including Gentileschi and Saraceni, whose influence became decisive. With Baburen and Honthorst he brought the chiaroscuro technique to Utrecht,

where he became a member of the Lukas Guild in 1616. His religious, half-length figure pictures probably met with little enthusiasm, for he increasingly turned to genre painting, choosing as subject matter drinking, card-playing and musical scenes. He was the most vital and uncompromising member of the Utrecht school. The soft lighting developed by him anticipated the Delft school.
Illustration:
107 The Duo, 1628

VALDÉS LEAL Juan de
1622 Seville – 1690 Seville
Valdés Leal, who was trained by Castillo y Saavedra in Córdoba, developed a very personal, unusual style which he retained all his life. Already in the pictures painted for the Clares of Carmona in 1653/54 ("Saracens Attacking the Monastery of St Francis") he showed a high degree of exaltedness in form and expression which was to mark the entire work of this last great exponent of Andalusian Baroque. Within his style he employed two diverse ways of treating colour side by side, one being marked by a palette of delicate, fine pinks and grey tones of lucid quality, and the other by deep, often sombre shades of green, violet and deep reds. While he employed the first method for a series of pictures of the St Jerome cycle for the monastery of San Jeronimo in Seville (1657/58), he chose the second technique for greater effect in his two large Vanitas Allegories for the hospital de la Caridad, also in Seville (1672).
Illustration:
70 Allegory of Death, 1672

VALENTIN DE BOULOGNE
(also: Jean de Boullongne)
1594 Coulommiers – 1632 Rome
As the most important representative of the French Caravaggists, Valentin de Boulogne came to Rome in 1612, where he was introduced to Caravaggio's work by Vouet and Manfredi. Valentin subsequently developed geometrical rules to deal with chiaroscuro, working out a system for light and shade effects. In Rome he belonged to a group of Scandinavian and German artists who called themselves "Bentvögel" and had chosen the motto "Bacco, Tabacco e Venere" (To Bacchus, tobacco and Venus). Through this group he came into contact with thieves, drunks, prostitutes, receivers of stolen goods and other members of an underworld which he vividly portrayed. Apart from scenes of popular and soldiering life ("Disputing Card-Players", Tours, Musée des Beaux-Arts; "Musicians and Soldiers", Strasbourg, Musée des Beaux-Arts), he also produced religious works, preferably scenes from the Old Testament ("Judgment of Solomon", Paris, Louvre; "Judith and Holofernes", Valletta, Nationalmuseum).
Illustration:
46 The Concert, c. 1622–1625

VARIN Quentin
c. 1570 Beauvais – 1634 Paris
Today his name is usually mentioned in connection with Poussin, whose first teacher he was. Varin himself was trained in Beauvais by François Gaget, then worked as a journeyman in the workshop of Duplan in Avignon (1597–1600).

Maria de'Medici became his patroness in Paris, where he also assisted in decorating the Luxembourg and became "peintre du Roi" in 1623. He adopted some formal elements of the Fontainebleau school by emulating them at a somewhat superficial level, and painted his figures in strangely elongated proportions on his oversized canvases.
Illustration:
42 Presentation of Christ in the Temple, c. 1618–1620

VELÁZQUEZ Diego
(Diego Rodríguez de Silva y Velázquez)
1599 Seville – 1660 Madrid
Velázquez' father was the descendant of a noble Portuguese family, which was to become a significant factor in his career at the Spanish royal court. He studied briefly under Herrera the Elder, then was apprenticed to Francisco Pacheco whose daughter Juana he married in 1618. During that year his first dated painting was produced. In 1622/23 he travelled with his father-in-law to Madrid, to be introduced at the court. There he was appointed "pintor del Rey", but, as was the custom of the day, without a fixed income. Thanks to Pacheco many valuable details of Velázquez' early career have been handed down. For example he recorded that his son-in-law took samples of his art to present at the court, and these consisted of "bodegones", interior scenes with a strong still life element, such as "The Water Seller of Seville" (London, Wellington Museum, c.1619/20) and "Christ in the House of Martha and Mary" (ill. p.71). Pacheco remarked that this kind of painting was still new in Spanish art and that he generally disapproved of it unless "painted as Velázquez painted it".

Velázquez' estimation at court rose rapidly. After a painting competition in 1627 he was appointed court doorkeeper and later, in 1652, court marshall. Important was his meeting with Rubens, who visited the Spanish court on a diplomatic mission in 1628. Per-

haps this inspired him to visit Italy, where he met Ribera in Naples. After having been appointed painter to the royal chamber in 1643, he had another opportunity to visit Italy five years later in order to buy pictures for the royal collection. In Rome he was honoured by being made a member of the Accademia di San Luca after having exhibited one of his pictures publicly. Two years before his death he was made a knight of the Order of Santiago. This was due to the King's mediation, as it required proof of never having earned his living by working with his hands. As one of the foremost artists of the 17th century, he owed something to the School of Seville, but achieved a style which was entirely his own. Although open to the innovations of Titian, Caravaggio and Rubens, he transformed any inspirations he received in his own inimitable manner.

Illustrations:

2 Infanta Margarita, c. 1656
22 Portrait of Philip IV of Spain in Brown and Silver, c. 1631
71 Christ in the House of Martha and Mary, c. 1619/20
71 Los Borrachos (The Drinkers), 1628/29
72 The Surrender of Breda, 1635
72 Prince Baltasar Carlos, Equestrian, c. 1634/35
73 A Dwarf Sitting on the Floor (Don Sebastián de Mora), c. 1645
74 Venus at her Mirror (The Rokeby Venus), c. 1644–1648
74 Las Meninas (The Maids of Honour), 1656/57

VELDE Willem van de, the Younger

1633 Leiden – 1707 London

With his father, also a marine painter, Willem came to Amsterdam in 1636. Here his brother Adriaen was born, who became a landscape and animal painter. Willem received early instruction from his father, then was apprenticed to Simon de Vlieger, who specialised in seascapes.

In 1652 he was made an independent master in Amsterdam, and in 1672 King Charles II called him to England, where he was made court painter. Together with Capelle he introduced a new type of marine painting, giving his ships individuality as in a portrait and presenting sea-faring as a dramatic event. His sea-battles and ships at sea,

usually in calm or only slightly choppy waters, are notable for their precision of detail and fine colour and for the light effects which skilfully convey mood and atmosphere.

Illustration:

132 The Cannon Shot, undated

VERMEER Jan

(Jan van der Meer, Jan Vermeer van Delft)

1632 Delft – 1675 Delft

Although Vermeer was one of the greatest of Dutch genre painters, with Frans Hals and Rembrandt, and his work is unique in the history of art, very little is known about his life. He was the son of a weaver in silk and satin, who later became an art dealer and inn-keeper. Vermeer was probably a pupil of Fabritius. In 1653 he married Catharina Bolens, whom he often portrayed in his pictures, and became a member of the Delft Lukas Guild. He worked slowly and therefore his output was small, and insufficient to keep a large family, although he achieved fairly high prices. Vermeer tried to supplement his income by acting as an art dealer, but this also failed. Only one of his 36 surviving paintings is dated ("The Procuress", Dresden, Gemäldegalerie, 1656).

"Diana and her Companions" (The Hague, Mauritshuis) and "Christ in the House of Martha and Mary" (Edinburgh, National Gallery) probably date from about 1655, a period when he explored Italian art and came to terms with the Utrecht Caravaggists. These were followed by genre scenes, conversation pieces, in which detail and gestures are still somewhat overemphasised. The pictures with which Vermeer's name is now mostly associated were painted shortly before and after 1660, including "Girl Reading a Letter at an Open Window", "The Milkmaid", "Woman Holding a Balance" (ill. p. 138) and "The Artist's Studio" or "Allegory of Painting" (ill. p. 140). In these intimate scenes, light itself seems to have become the subject of the picture; a moment of stillness captured on canvas. Vermeer stands apart from his contemporary genre painters through his superb draughtsmanship and skill in perspective, his colour harmonies, in which cool blue and a brilliant yellow predominate, and his incomparable ability in setting enamel-like high-

lights which impart a glow to surfaces. In his late work his treatment of light lost some of its poetry, his drawing became less fluid, and the interiors less simple. On his death his pictures were auctioned off and he was forgotten, and it was not until towards the end of the 19th century that his true significance was recognised.

Illustrations:

90 The Milkmaid, c. 1658–1660
91 Street in Delft ("Het Straatje"), c. 1657/58
138 The Lacemaker, c. 1665
138 Woman Holding a Balance, c. 1665
139 View of Delft, c. 1658–1660
140 Allegory of Painting (The Artist's Studio), c. 1666
140 Young Woman Seated at a Virginal, c. 1675

VOS Cornelis de

c. 1584 Hulst (Zeeland) – 1651 Antwerp

Vos was the brother-in-law of Snyder and was accepted as a master in the Antwerp Guild in 1608, but worked as an art dealer for a time. In 1635 he worked with Jordaens as assistant to Rubens on the decorations for the reception of Cardinal Ferdinand. From 1636 to 1638 he worked with Rubens on the decoration of the hunting-lodge Dorre de la Parada near Madrid. Vos was primarily a portrait painter of Antwerp society and of family groups. In their restrained elegance and fine observation of character his portraits approach those of van Dyck. Among his best works were those of children ("The Painter's Daughters", Berlin, Gemäldegalerie), which stand out for their freshness, naturalness, and alertness of expression and fine colouring.

Illustration:

106 The Family of the Artist, c. 1630–1635

VOUET Simon

1590 Paris – 1649 Paris

Vouet received only basic training from his father, a sign painter, but his talent developed rapidly; he is said to have been called to England at the age of fourteen to paint portraits. After visiting Constantinople and Venice, he came to Rome, where he became influenced by Caravaggism in the manner of Valentin ("The Birth of Mary", San Francesco a Ripa, c. 1622). Reni's monumentality, the classical serenity of

Domenichino's work and the ideas of Lanfranco and Guercino were also to have a lasting effect. In Genoa, where he met Strozzi, he produced one of his major works, the Crucifixion for San Ambrogio (1622). Louis XIII recalled him to France as "peintre du Roi" (1627) where Vouet – always intent on furthering his career and never turning down a commission – produced works of great beauty and loftiness. Apart from painting altarpieces and portraits he also designed tapestries in his richly decorative style. He worked in the royal residence St Germain, the Palais du Luxembourg, Fontainebleau and the Louvre.

His most important paintings include "Lot and his Daughters" (Strasbourg, Musée des Beaux-Arts, 1633) and the "Allegory of the Victor" (Paris, Louvre, 1630). In his studio many of the great decorative painters of the age were trained, including Le Brun, Mignard and Le Sueur.

Illustrations:

21 The Toilet of Venus, c. 1628–1639
42 Saturn, Conquered by Amor, Venus and Hope, c. 1645/46

WITTE Emanuel de

c. 1617 Alkmaar – 1692 Amsterdam

Witte, who became a member of the Lukas Guild in 1636, initially painted mythological and religious scenes as well as portraits. When he settled in Delft around 1640, he began to specialise in scenes of church interiors, perhaps having been inspired by Fabritius' perspective art.

From 1651, when he moved to Amsterdam, until his death by suicide, he concentrated almost exclusively on architectural painting. But unlike Pieter Jansz. Saenredam, whose main concern was accuracy of representation, Witte also painted imaginary buildings or mixed features of several churches. He chose unusual interior sections, in which architectural elements often appear askew, and used light effects in the typical Delft manner, so that the atmosphere thus created seems to become the actual subject of the picture. His large airy compositions are often relieved by dark figure groups in the foreground, perhaps in conversation or listening to a sermon, and often accompanied by dogs.

Illustration:

126 Church Interior, c. 1660

ZURBARÁN Francisco de
1598 Fuente de Cantos (Estremadura) –
1664 Madrid

Zurbarán was trained in Seville in 1616/17 by an unknown painter and settled in 1617 near his birthplace to paint a large number of religious pictures for the monasteries of Seville. His work included many pictures of saints at prayer and devotional still lifes in the spirit of the Counter-Reformation. His tenebrist style, reminiscent of Herrera the Elder, with its massively simple figures and objects, clear, sober colours and deep solemnity of feeling expressed in thickly applied paint, made him the ideal painter of the austere religion of Spain.

In Seville, where he settled in 1629, he became the leading artist. There he produced many altarpieces and decorated a number of monasteries with extensive fresco cycles. His fortunes fell with Murillo's rise. Having been appointed "pintor del rey" in 1634, he was compelled to supplement his income by acting as an art dealer only a decade later. In 1658 he moved to Madrid, where he entered the Santiago Oder. Caravaggio, Velázquez, El Greco, Cotán, Dürer, Raphael, Titian – all these left traces in his work, which is nevertheless of great originality.

Illustrations:

64 The Death of St Bonaventura,
 1629
64 St Hugo of Grenoble in the
 Carthusian Refectory, c. 1633
65 St Margaret, c. 1630–1635
66 The Ecstasy of St Francis,
 c. 1660
66 Still Life with Lemons, Oranges
 and Rose, 1633

Photo credits

The editor and publisher wish to express their gratitude to the museums, public collections, galleries and private collectors, the archivists and photographers, and all those involved in this work. The editor and publisher have at all times endeavoured to observe the legal regulations on the copyright of artists, their heirs or their representatives, and also to obtain permission to reproduce photographic works and reimburse the copyright holder accordingly. Given the great number of artists involved, this may have resulted in a few oversights despite intensive research. In such a case will the copyright owner or representative please make application to the publisher.

The locations and names of owners of the works are given in the captions to the illustrations unless otherwise requested or unknown to the publisher. Below is a list of archives and copyright holders who have given us their support. Information on any missing or erroneous details will be welcomed by the publisher. The numbers given refer to the pages of the book, the abbreviations a = above, b = below, c = column.

Antella (Firenze), Scala Istituto Fotografico Editoriale S.p.A.: 29, 31a, 32 – Berlin, Archiv für Kunst and Geschichte: 13, 14, 17, 18, 23, 24, 48a, 79, 80, 89, 90, 141c1a, 141c1b, 142c2, 142c3, 143c2, 143c3, 144c1, 144c2, 144c4, 145c3, 146c2b, 146c4, 147c4a, 148c2b, 149c2b, 150c1a, 151c3a, 151c3b, 152c3, 153c2, 153c3a, 155c3a, 156c1, 156c2a, 157c1 – Berlin, Bildarchiv Preussischer Kulturbesitz (Photo: Jörg P. Anders): 45 – Ecublens, Archiv André Held: 44a, 45, 111a, 121a, 126b, 127a, 128a, 130a, 138a, 138b. – Marburg, Bildarchiv Foto Marburg: 142c4, 144c3b, 146c2a, 151c1, 151c2, 153c3b, 155c1a, 155c3b – Milano, Gruppo Editoriale Fabbri: 27a, 28b, 33b, 35b, 37a, 40a, 41a, 41b, 43b, 48b, 50a, 54b, 55b, 64b, 67a, 96a, 101a, 104a, 105b, 112a, 122a, 139 – Munich, Archiv Alexander Koch: 47a, 47b, 49, 51, 56a, 57b, 58a, 62a, 62b, 63, 65, 66a, 67b, 68a, 68b, 71a, 71b, 72b, 71, 74a, 74b, 93a, 94a, 94b, 95, 97, 99, 103, 104b, 106a, 106b, 107a, 107b, 108b, 110a, 110b, 113a, 114a, 114b, 115, 116a, 117b, 120, 123a, 123b, 125a, 125b, 126a, 127b, 129a, 130b, 131a, 132a, 134a, 135a, 135b, 136a, 136b, 137, 140b – Munich, Interfoto: 158 – Paris, © Réunion des Musées Nationaux: 42b, 43a – Peißenberg, Artothek: 58b, 69, 109, 111b, 116b, 129b – Paris, Roger-Viollet: 148c2a, 150c2 – Tokyo, Archiv Kodansha: 29 – Weert, Smeets: 119. – Vienne, Kunsthistorisches Museum: 40b.

The remaining illustrations used belong to the collections mentioned in the captions or to the editor's archive, the archive of the former Walther & Walther Verlag, Alling, the former archive of KML, Munich, and the archive of Benedikt Taschen Verlag, Cologne.